Animating with Blender

Animating with Blender
How to Create Short Animations from Start to Finish

D. Roland Hess

AMSTERDAM • BOSTON • HEIDELBERG • LONDON
NEW YORK • OXFORD • PARIS • SAN DIEGO
SAN FRANCISCO • SINGAPORE • SYDNEY • TOKYO

Focal Press is an imprint of Elsevier

Focal Press is an imprint of Elsevier
30 Corporate Drive, Suite 400, Burlington, MA 01803, USA
Linacre House, Jordan Hill, Oxford OX2 8DP, UK

 Recognizing the importance of preserving what has been written, Elsevier prints its
books on acid-free paper whenever possible.

Library of Congress Cataloging-in-Publication Data
Hess, D. Roland.
 Animating with Blender : how to create short animations from start to finish/by
D. Roland Hess.
 p. cm.
 Includes index.
 ISBN 978-0-240-81079-9 (pbk. : alk. paper) 1. Computer animation. 2. Three-
dimensional display systems. 3. Computer graphics. 4. Blender (Computer file) I. Title.
 TR897.7.H485 2009
 006.6'96—dc22

 2008026274

British Library Cataloguing-in-Publication Data
A catalogue record for this book is available from the British Library.

ISBN: 978-0-240-81079-9

For information on all Focal Press publications
visit our website at www.elsevierdirect.com

09 10 11 12 13 5 4 3 2 1

Typeset by Charon Tec Ltd., A Macmillan Company. (www.macmillansolutions.com)

Printed in China

Contents

Contents

Contents

Contents

Foreword

Prenatal Vitamins

The Beast is a 4 minute short animation produced entirely by me in a little over 200 hours. Although those 200 odd hours were spread over many months, it could have been compressed down to five 40 hour weeks, or, even worse, three or four 60 hour weeks. While the finished project has its shortcomings (I am not a hard core animator), it was designed from the beginning to work as a learning tool for this book.

Animating with Blender: How to Create Short Animations from Start to Finish assumes a great degree of familiarity with Blender. It is not for the beginner. Users who are entirely new to Blender are encouraged to read my previous work, *The Essential Blender*, which is a no-knowledge-assumed guide to learning this wonderful piece of free software. *The Essential Blender* is available from the normal book outlets through No Starch Press, directly from the Blender Foundation's e-shop (http://www.blender.org/e-shop), or for free online in Wiki format at http://wiki.blender.org/index.php/Books/Essential_Blender_%28text%29..

On the disc that comes with this book you will find all of the production files for *The Beast*. If you start digging through the files before reading this book, there are a lot of things that probably won't make sense, but they will be a valuable resource for you as you go through the examples in the chapters. Once you reach Chapter six, the organization and structure of the files will hopefully become clearer to you. Before you start fiddling with the production files, though, please watch the "production release" of *The Beast*, which can be found in the folder called **the_beast**. The video itself should play fine on most computer systems out-of-the-box, but if you have difficulty with it, the VLAN video player included in the **software** directory is the best all-purpose player I have found, and will play it without a hitch.

All of the production files for *The Beast*, including the finished animation, are released under a Creative Commons Attribution-Noncommercial 3.0 Unsupported license, of which a plain language summary and full legal text are included on the disc. What this means is that you can use the files themselves—the textures, sets, models, sounds—in your own works as long as you credit the original creator. This also means that you can examine, copy, and redistribute the files in noncommercial ways: as part of a tutorial, a library, etc. While the Blender Foundation's own projects such as *Elephants Dream* and *Big Buck Bunny* have also made their production files available in a similar fashion, the complexity of those projects make them extremely difficult for

even a dedicated Blenderhead to pick apart and analyze. Hopefully the files included with *The Beast* will be straightforward enough that anyone can learn from them.

However, the files for *The Beast* that come with this book are not the final set of production files. Deadlines and production schedules meant that, while the animation was "finished" in time to make the disc, it was far from "finished" for my own sense of artistry and animation. So if you notice discrepancies between the version of *The Beast* that you can see online and the version included with the book, it simply represents the difference that one or two more rounds of refinement and two more months of render time can make in your own production. A piece of art is only finished when you run out of time.

One of the great truisms of learning a skill is that by the time you've finished a project, you're finally ready to begin it. This will certainly be true of your experience creating a short animation. I hope this book functions as a bit of a substitute for some of that first-time experience, giving you a better shot than most people. So don't be too hard on yourself during your initial foray into animation. Well, be hard on yourself during production. But when you've put your short animation to bed for whatever reason and have called it "done," take one hard, critical look at the final product so that you can remember the lessons you've learned for the next time. Then forget the pain and bask in your accomplishment, just a little.

An Overview of the Short Animation Process

Creating a Short Animation

Creating a short animation from start to finish is a complicated, time-consuming task. It uses all of the skills you have developed while learning your way around your 3D software, while calling for an even broader range: storytelling, asset and time management and organization, acting, and editing. As you work through the process, you will find that each step necessarily builds on everything that went before, and that to shortchange or entirely skip one of the steps will lead, surely, to disaster.

No single step in producing a short animation is difficult by itself. Certainly, no individual portion of the short animation process is harder to learn to do than, say, getting the hang of doing back handsprings or integral calculus. The steps are fairly easy. It turns out that the single most difficult thing to do with a short animation is, simply, to finish it. Doing so takes dedication, lots of available time, a willingness to keep pushing through when things are less than fun, and, most importantly, a plan.

Avoiding Death By Natural Causes

No doubt you've seen a hundred animation projects announced on web forums, in chat rooms, and inside cozy little restaurants over too many coffees. Although born with zeal, they slowly fade away into a shadowy death.

Say, why'd that project die?
We're not sure. It just kind of . . . fell apart.
Oh. "Natural Causes," then.
Natural Causes, indeed.

How to avoid your project fading into the oblivion of Natural Causes? You need a plan.

Fortunately, there is a time-honored structure for actually finishing animation projects. It consists of three stages: **preproduction, production,** and **postproduction.** Mysteriously and oddly named, to be sure, but there they are.

Preproduction

Preproduction encompasses everything you do before you touch a single polygon of 3D. Story development, storyboarding, a rough sound track, and the assembly of a story reel become the bedrock of the rest of your production. The time you spend here will make the modeling, animating, rendering, and compositing worthwhile.

Before anything else, though, comes the story. Without a good story, your production will be little more than a study or an extended animation test. A "good" story, though, is not only one that will interest or amuse your viewers, it is one that is producible with the time and resources that you have available. Choose too ambitiously, and you're on your way to "Natural Causes" before a pixel ever hits the screen.

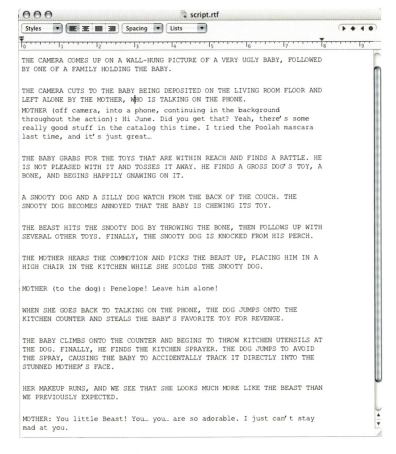

Figure 1.1 *A script*

A good subject for a short animation is more like a "short short story" than a novel or any of the longer narrative forms. It will grab the viewer's interest, sympathy, or comedic sense almost right away. It will focus exclusively on expressing the theme of the story, or setting up the joke, if that's what you're going for. At this stage, it is a balance between your resources and ambition, and you are advised to save the 20,000 character epic battles for later in your career.

When your story is in order, you proceed to creating storyboards. Storyboards are shot-by-shot (and sometimes pose-by-pose) breakdowns of your story in a visual format. Usually done as line illustrations, they help to organize your thoughts on how the written story will translate onto the screen. You don't have to be the world's greatest sketch artist to pull off an effective storyboard for your short

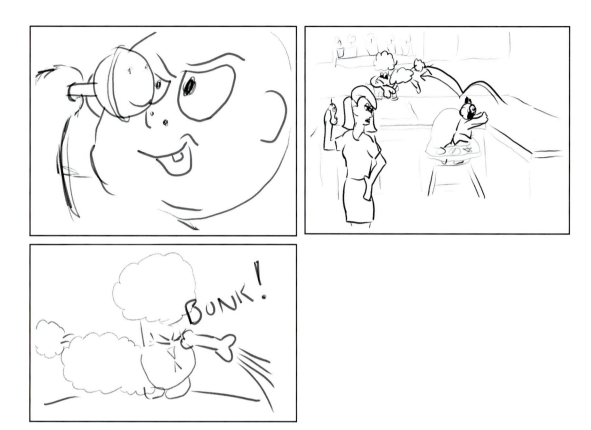

Figure 1.2 *Several digital storyboards*

animation, but the more time you spend on it, the less effort will be wasted later when it's time to actually animate.

With your storyboards in hand (or on disk), you create a simple, very rough soundtrack. This is most easily done by sitting in front of an inexpensive PC microphone and speaking all of the dialog and making the sound effects with your mouth while you visualize the animation. It's crucial not to let anyone get their hands on this rough track because it will probably be personally embarrassing and most likely cost you any chance of ever running for political office.

Figure 1.3 *Storyboards assembled with a soundtrack*

The temporary soundtrack is matched to the storyboards so that it forms a primitive version of what will someday be your masterpiece. This rough representation of your animation is called the **story reel**. It will be the Bible for the rest of your production.

Production

Now you get to do all the things you were aching to do from the start of the project: character design and construction, and, if you're a masochist, rigging. Modeling and rigging your characters reaches both backward

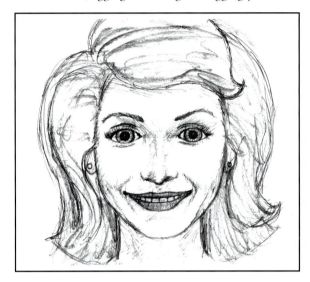

Figure 1.4 *Character sketch*

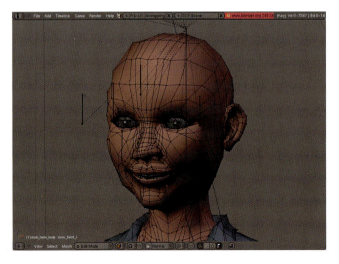

Figure 1.5 *Wireframe model of a character*

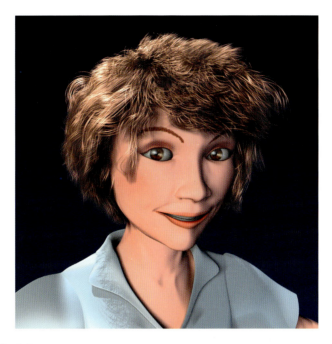

Figure 1.6 *The rendered character*

and forward in the production process. It is informed by the themes of the story but bows to the require-
ments of animation, and later, to the minimization of render times.

At this point, the modeling of the lead character can be finished,
but as long as you organize your project properly and use the
correct tools, things don't need to be completely finalized before
animation begins. Unlike creating still images, surfacing (materi-
als and texturing) can be skipped almost entirely at this stage.

With a good start on your characters, you set up your control
rigs. This is the first place that good storyboarding pays off. You
build and test your rigs to the specific actions your characters
will take. It could be that one character never gets out of his or
her seat—you can skip IK leg controls. It could be that another
character's face is never really seen—you can skip facial anima-
tion controls. By looking at who does what in your storyboards,
you can decide what sort of controls each character is going to
need. Of course, you could spend several months creating a bril-
liant all-purpose rig for each and every character, but it would
only be a waste of time, both now and later when the calcula-
tion of each and every bone takes its toll on rendering times.

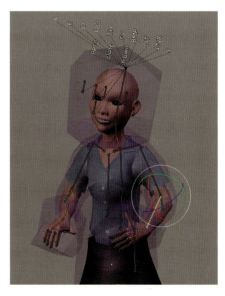

Figure 1.7 *A control rig and mesh for a character*

5

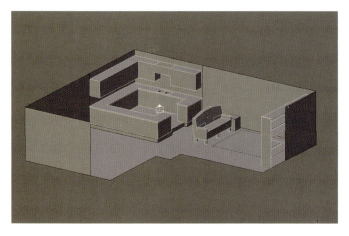

Figure 1.8 *A roughed-in set, consisting of placeholder blocks*

Along with the characters, you build rough sets, as in Figure 1.8. Really, all you need at this point are placeholders for final set elements—boxes that represent chairs, rocks, or statues of Abraham Lincoln. Whatever your animation needs.

When characters and rough sets are created, you can begin to build scenes, one file per shot from the storyboards, trying your best to match camera angles and composition in your 3D scenes to the images in the storyboards. You may find that certain things you had drawn for the storyboards don't work out so well when you have to recreate the scene in an environment that obeys the laws of size and proportion. In those cases, you can adjust your composition on the fly, or, if the change is drastic, rethink that part of the scene and redraw the storyboards.

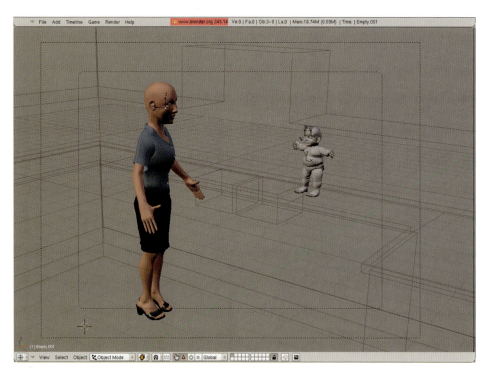

Figure 1.9 *A blocked scene featuring characters and a rough set*

At some point during the character creation and rough set portion of the production, you need to obtain a quality recording of any dialog that may occur in the animation. Environmental sounds will be filled in afterward, but any quality character animation that must accompany the spoken word needs to be built correctly from the beginning.

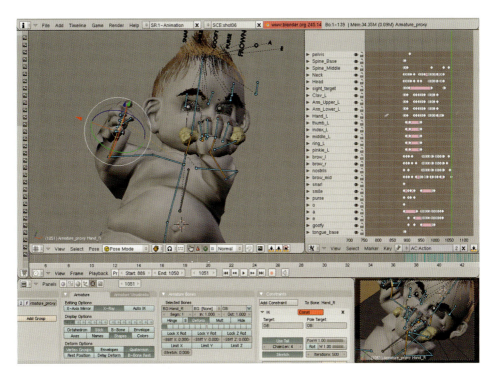

Figure 1.10 *A character during the animation process*

Only then, after weeks (or months) of buildup and work, do you actually get to animate. The best way to accomplish this stage is to lock yourself away from the rest of humanity so they won't see you obsessively performing the same intricate hand motion over and over to learn *exactly* how the fingers flare and in what order and position they come to rest when your character performs a specific motion. It's also better if no one sees you doing the silly walk that your character needs to perform, around and around and around. Regardless of the level of self-ostracism you choose, the process of animating will require time and patience. It may also require that you go back and adjust your models and rigs. If you've done things correctly, though, if you've followed the plan, this sort of minimal backtracking will not hurt the production.

As you complete the animation for each shot, you get to do what is probably more fun than any other single part of the process. You put your animated version of each shot back into the story reel, covering up the relevant portions of the storyboards. With each new shot you finish, the story reel evolves from a series of still images into a moving compendium of your animation genius. And frankly, at this point you hope it's genius, because you'll have soaked months of your life into it.

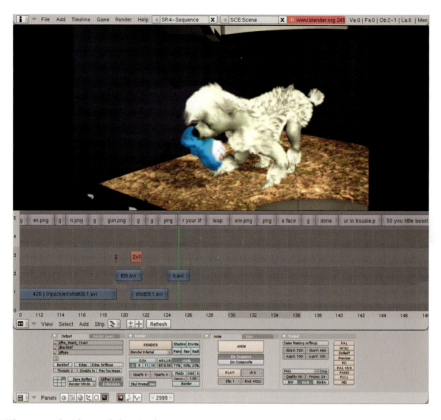

Figure 1.11 *The story reel with several shots in place*

After the final shot is animated, and you can stand to watch the whole full motion story reel without wincing too frequently, you finish the sets, surfacing, and lighting. Of course, what you do with the sets and lighting can be helped along by the storyboards and a careful analysis of the current state of the story reel. Just like rigging, you could spend a nearly infinite amount of time creating beautiful, detailed surfaces for every element of your imagined set. But it could be that only certain items and spaces that appear in close-up need that level of attention. Some things may appear at a distance, or only briefly, or moving so quickly as to be smudged by motion blur, and those elements can be given an appropriately smaller slice of your time.

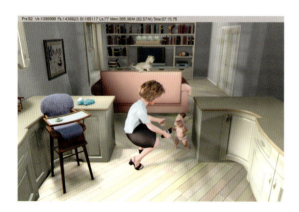

Figure 1.12 *Render time for a single frame out of thousands*

And then, when you've surfaced, built, and lit appropriately, you render. Go get a cup of coffee. This is going to take a while.

Postproduction

So you have gigabytes of rendered frames that must be compiled into a final animation. You bring them into an editor that is designed for cutting audio and video sequences together. You watch it over and over, adjusting the timing of the cuts between the different shots so that the action seems to be continuous throughout, even though it probably isn't.

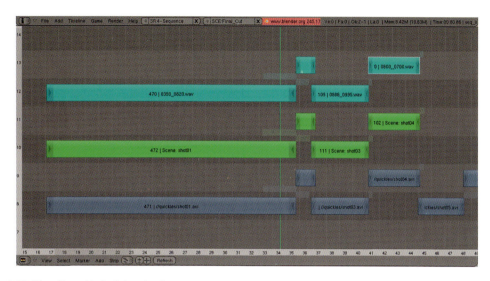

Figure 1.13 *The editor with final shots in place*

When the timing is right and the animation does exactly what you want it to do, you raid the kitchen and the garage for anything that will make noise. Turn on a microphone and act out the shots, trying to sync your noisemaking with what happens on the screen. Get a friend to help you, if you have any left. Find some music that suits the theme of the story and approximates the running length of the final cut.

Put the sound effects and music on top of the dialog track you recorded earlier, and you are . . . finished?

Maybe.

Maybe there's that one shot that bugs you. Your friends think it looks fine, but you know better. It's the shot you animated first, and it just doesn't cut it.

Go back. Make a duplicate file and redo the animation.

Then again, if you're out of time, maybe you won't.

At some point, you'll have to exert some discipline and call it done, whether it's ready or not. Rest assured that even major animation companies release material that they would like to have spent just "a few more weeks" on. Listen to the DVD commentary tracks on some of the best animated movies, and you'll hear open admissions of things the animators and directors feel are lacking in the finished product.

The Importance of Following the Work Flow

All of that was just the barest overview. It should be obvious that creating a decent short animation is a very specific and involved process. However, should you find yourself thinking, "Oh, well, I can just skip that step! What could possibly go wrong?" Here is a brief list of what, exactly, could go wrong:

Problem: No story. **What happens:** The animator begins by fully modeling detailed props and characters. The project has no direction and never passes the modeling stage. Doom!

Problem: Too much story. **What happens:** After the third year of the project, you begin to think that you should have concentrated on the character of Pecos Rose, instead of her fourteen sisters. Disaster!

Problem: No storyboards. **What happens:** Without storyboards to guide your shot breakdown and composition, you waste countless hours/days/years of your life animating actions and creating and detailing elements that will never see a final render. Also, the vision of the story is created on the fly, which can lead to narrative and visual dead ends and more wasted work. Peril!

Problem: Creating detailed sets and surfacing before animation. **What happens:** Much work is wasted because things inevitably change during animation. That entire set of kitchen knives you painstakingly modeled and textured (with little food bits!) were part of a shot that was cut because the animation just didn't turn out well enough. Shame!

Problem: Poor asset organization. **What happens:** You put weeks into a complex shot then realize that you used the wrong versions of the set and characters, meaning that you either have to completely redo the entire thing or have it stick out in the final production like a line drawing at a Monet impersonator convention. Horror!

From these few examples, it may be apparent to you that most of the really crushing problems will come from skipping or short changing the preproduction steps. And really, if you've done the preproduction properly, you're not going to skip any of the normal production or postproduction steps.

Summary

The short animation process is a time-tested set of steps that, if followed, will help you to see your animation project through to completion. The process involves an extended preproduction phase during which you develop the story and work out the overall timing through the creation of storyboards and a story reel. The production phase finds you working directly in your 3D application, building models and sets and actually performing the animation. Finally, postproduction is where you render your work and composite and edit it into a final animation.

The greatest mistake committed by first-time producers, and the one that will certainly kill a project, is to jump into the production phase without adequate preparation. Without a producible story and the planning provided by good storyboards, so much time will be wasted that the project will never see a successful end. Skipping the preproduction process is like furnishing your house before you draw up the blueprints, lay the foundation, and build the walls. It may seem quick and easy to put the decorative items into place, but it will almost certainly turn out poorly in the long run.

Although the work flow as presented in this book has its idiosyncrasies, it follows a proven formula. To ignore this formula is the animation equivalent of criminal negligence, and if you do it, I promise that a bunch of little key-framed lawyers will show up at your house, exhibiting crowd-simulated swarming behavior and waving tiny digital court documents in the air.

On the other hand, if you follow the steps and keep yourself focused on the process, in the end you will have something that very few other people have produced: a successfully completed short animation project.

Story Story Story

Objectives

- What makes an engaging story?
- Writing it down
- Story scope, your resources, and reality
- How long is my story?

If you don't have a good story, you will not have a successful short animation.

Of course, "good" could mean a lot of things. In the context of animation production, it means, specifically, both "engaging" and "producible."

It's not a shocker to hear that a story must be engaging, but the need is magnified when you are dealing with the limited run length of a short project. With only a couple of minutes of the viewers' attention available, you have to grab them right away, make your point quickly, and not stray from the theme.

That said, a weak story will not kill your production.

However, an unproducible story will. But, as the "producibility" aspect involves the artists' favorite topic—math—we'll save it for last. On top of that, this chapter is light on illustrations and heavy on copy, so you visual types should prepare to exert some self-discipline right now and work your way through to the end. It will be a good exercise because the ability to keep going, even though you would rather not, will be invaluable to your project in the coming weeks.

What Makes an Engaging Story

The short animation format does not leave much room for traditional story development. Time is extremely limited, and, as we will see later in the chapter, costly. Therefore, the story must do its job quickly and without extraneous elements. You will, essentially, be creating a visual short story.

The late author, Roger Zelazny, a prolific writer of short stories, once said that his short stories were born either from a **plot**, a **character**, or an **image**. Sometimes an idea for a character is so resonant that you find yourself wanting to put him or her into every story line you can think of. Other times, the plot will come first—a situation of interest that you just can't shake. And then, in a way that is probably already familiar to you as a digital still artist, a single image grabs you—a framed picture of a situation and characters in action. Any of these can be used to begin the story building process, but the best finished products will include all three.

Plot versus Character

In many weaker stories, the **plot** defines the **character**. Much more difficult to do, though, is to have the characters drive the plot. Your characters will be put in different situations (though in a typical short animation there is probably only enough time to deal with one major situation), and the details of their character should cause them to act in certain ways. Those actions will have consequences, which will cause other characters (possibly) to make choices, until a conclusion is reached. If you find that you have a plot before you have characters, make sure that the characters you eventually settle on fit the decisions they seem to make that drive the plot.

For example, if your plot requires someone to make clever, perceptive deductions for the action to progress, don't choose a "school bully" to fill that role. It wouldn't fit. If you choose an appropriate character, it may suggest other details that help you strengthen and continue the story.

Be careful, too, with a "plot-first" story that there will in fact be a character that can fit the role. If your plot requires a character to react with extreme anger in several situations, then to be instantly happy and then instantly sad, you may have a problem. There are not many believable characters that would act that way (although a few spring to mind), making it tough to create an engaging story.

However, if you created the characters before the plot, the choices that they make will often lead the plot in directions you had never intended. This is actually okay and will often lead to a stronger story in the end. Remember, **character** drives **plot**, while at the same time a well constructed plot will help a character to change in return.

A well developed short story that is appropriate for animation will also include a **hook**, a **theme**, and a **turn** (sometimes called a "twist"). We'll discuss each of these, as well as the previous three elements, as we look at how the story for *The Beast* evolved.

NOTE
Plot, character, and an image: while the animation and mechanics of the story will make your project *watchable*, taking the time to get these three right will make it *memorable*.

The story for *The Beast* was originally presented to me by a friend, Tom Musgrove. In its initial stage, it looked something like this:

"There is a baby who is left watching TV. The family cat is nearby. The baby is very bad (hence the nickname 'The Beast') and battles the cat, unintentionally wrecking the house in the process."

This could easily be visualized as a Tom and Jerry style cartoon, and, in fact, has about the same levels of plot and character as those kids' animations. Beyond that level, though, the idea had appeal. Most likely, it was the image it conjured of an unnaturally physically gifted baby relentlessly pursuing a nasty cat that has bitten off more than it can chew. Kind of like *The Terminator* with a diaper.

To make it really work as something more than silly kids' entertainment, it had to change. It could have worked fine as a madcap tour-de-force of suburban mayhem, but my sensibilities led me in another direction.

> **NOTE**
>
> Don't be afraid to change your story to make it better. Your characters, your plot points, your images—show them no mercy. Sometimes a story will evolve while you refine it to the point where it resembles almost nothing from the original idea. That is okay, as long as the whole thing still lights enough fire in you to pursue it as an animation project.

At this point, you have to let your creative instincts wander a bit. Talk the story through with some friends. Listen to them when they say, "Wouldn't it be a blast if . . ." or, "Wouldn't it be awful if . . ." and let their ideas point you in new directions. Not every direction is equally valuable, though. What you are trying to do is to find a story line that will help to develop a **theme**.

The theme of a story is sometimes seen as "the point of the story," but that's a simplification. A story's theme is its entire reason for being. The theme gives you hints about how events in the story should develop and what sorts of details should populate your world. To put it into terms a 3D artist can appreciate, the story itself is the 3D model, while the theme is a lamp. The lamp can shine on the model from different directions, with different shading and shadowing characteristics, and with different colors and patterns. Although the objects remain the same, different lighting will produce completely different effects for the viewer.

In my quest to find a theme for *The Beast*, I began to think about the common animation trick of having names be reflected in the physical appearance of a character, either directly or ironically (e.g., calling the tall guy "Tiny"). I decided to go with the former, and I made the Beast a nasty looking little thing (Figure 2.1).

But how did that push me toward a theme? Well, as soon as I decided that the baby would be ugly and behaving badly, it wasn't a stretch to realize that audience sympathies would tend away from the Beast. He would appear to be the villain. That, in turn, got

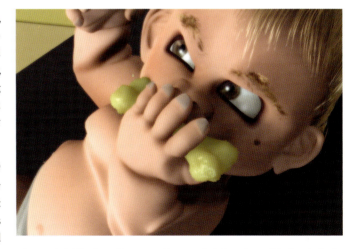

Figure 2.1 *The Beast lives up to his name both in action and in how he looks.*

15

me thinking about how we normally think of babies (innocent, docile, nice-smelling-some-of-the-time). A theme suggested itself: how we perceive beauty and ugliness, and how that affects our assumptions and sympathies. Not exactly the most original theme in the world, but when it comes to theme, originality isn't important. There are a finite number of themes in fiction. What matters is your presentation of that particular theme.

With a theme in hand, many of the details and plot points begin to arrange themselves.

To show a contrast between beauty and ugliness, another character was added: the mother. She would be pretty and well put together. Of course, she would generally ignore the Beast, most likely because of the way she perceived his ugliness. Maybe, in keeping with the theme, she could talk on the phone the whole time in the background, selling makeup!

The theme also took hold of the cat.

For starters, the cat changed into a dog. To be honest, that had nothing to do with the theme. I just like dogs better and happen to have one at my house that comes in handy for observation at animation time (score one for producibility!).

However, the theme requires the Beast's nemesis to fall on the other side of the pretty/ugly line. Because the Beast was acting badly and had the looks to match, I decided that the dog would act just as badly, but have the opposite appearance: a prim poodle with poofy fur. Right away, then, the theme was beginning to inform and strengthen several aspects of the story: character and plot.

The baby had a visual and behavioral counterpart and contrast in both the mother and the dog. It made sense to me that other elements in the story, details really, would have counterparts too. Because the baby was most directly contrasted with the mother, the dog needed a foil (a dramatic opposite) as well. And thus was born the unkempt, always-friendly, always-panting poodle.

Although it isn't a part of the story, you will notice in the final animation that many things come in contrasting pairs: the Beast's toys, the kitchen props, and some of the furniture. In the final product, portions of the theme are found throughout: the plot, characters, actions, sets, and props. Adding details like this without being horribly obvious in pointing them out serves to strengthen your theme, and consequently, your story.

I also had to adjust the plot to fit more closely with the theme. The Beast and the dog just pointlessly running around would be . . . well, pointless. For the theme to really come through in the plot, the decisions that the Beast made and the consequences of his actions would have to affect the realm of beauty versus ugliness. I decided that several times in the story, the Beast would have the opportunity to choose between something pristine and something a bit nasty. His choices would be informed by both the nature of his character and the theme itself.

His first choice is: What toy to chew? He discards the nice baby rattle and picks the doggy chew bone. The dog is not happy (the dog's snotty character informs this action), and his activity gets the Beast's attention. Another decision for the Beast: Which dog to attack? The ugly/beauty theme again takes hold.

And so, throughout the rest of the story, you see the Beast and the dog taking turns attacking one another in a theme- and character-appropriate fashion, culminating in the Beast's failed sprayer assault, which drenches the mother.

Now that the plot was in place and working with the theme and the characters, I was faced with how to work it to add both a *hook* and a *turn*.

The hook is something at the beginning of the animation that draws your viewers in. It gets them to commit to the story. It could be as simple as something immediately funny, creepy, beautiful, or sad, depending on which way your project is going. It could be a particularly lifelike facial expression, given by a well-animated character. Or, if you already have a reputation as an animator, it might simply be your name in the opening titles that gets someone to trust you as a storyteller.

In *The Beast*, I knew that the action would start slow and build, so it could not begin in full animal versus baby battle mode. A baby picture then, something most people are familiar with, but with a twist: the baby is ugly. Not disfigured ugly, but *Oh dear Lord I'm glad that's someone else's child* ugly. That look, contrasted with what people usually see in a picture of that sort, yet prominently displayed in a nice frame on a wall, should be enough to get the viewer to commit to seeing more.

For many animations, and for your first project, a surprise will work nicely for a hook. Make the audience think one thing for a moment, then show them something different. I'm not talking about an *Aqua Teen Hunger Force* style non sequitur. Instead, it often works to show the viewer something brief that sets up one expectation but delivers something different, as long as that delivery still makes sense. People like to be pleasantly surprised.

At this point in *The Beast*, we have the characters and a general sense of the action in place, as well as a hook. To satisfy the action and theme, I needed an appropriate turn.

The turn is the punch line of your comedy. It is the last, ironic revelation of your tragedy. It is the final, horrible fate of your gothic horror. It is the resolution of your person versus the universe tragic-horror-comedy.

In *The Beast*, the turn comes when the mother tells the Beast that she can't stay angry at him because he is too cute and the viewer goes "Wha-?!" The camera cuts to the framed picture shown at the beginning, pulling back to reveal that it was in fact the mother's baby picture. We see several shots of her growing up and changing her looks into her present splendor, and realize, hopefully, that the way that *we* have seen the Beast this whole time is completely different from the way *she* has seen him.

Your turn does not need to be that complex, but it should in some way give satisfaction to the characters, the action, and theme, all at once. Creating the proper turn for your short animation story will probably be the most difficult part of the story creation process. There are certainly a lot of constraints to meet.

If you can't come up with something that satisfies your sense of the story, here are questions to ask yourself that can spur some new ideas:

- Are the decisions of your characters driving the action or are they merely tossed around by circumstance? If character-based decisions drive the action, then ask yourself how the characters would resolve things if they were creating the story. If your characters are not driving the action, then consider "circumstance/ the universe/fate/God" to be a character, and ask it the same question.

- Tell someone else the story without delivering a conclusion. Act as though you have a conclusion but want them to guess what it is first. This seems underhanded, and it might feel like cheating, but there may be something obvious that you're missing due to being so absorbed in the details. Or your friend may just be a better storyteller than you and deliver a great idea. If that's the case, be sure to credit them on the finished product.

- Act out the story (in a door with a lock, preferably), taking the place of the character most able to take action just before the turn. When it comes to that point, what do you feel you should do? Try it again, but act out the part of another, less powerful character, and see if it suggests a new course of action.

- If your story is a tragedy or is sad, try giving your character what they have been striving for but in an unexpected way that makes them wish they had not accomplished their goal. If your story tends to be a comedy or on the light side, stick your character with whatever fate they have been trying to avoid but have it be pleasantly and unexpectedly rewarding for them.

Sometimes, no matter what you do, you cannot find a satisfying turn or conclusion to your story. This is a sign that you have missed something earlier in the process. Are your characters acting consistently in character? Are there actions, characters, or ideas involved that do not support the theme? If so, it is time to take a step back and begin to rework the story.

- Make sure that the characters are consistent. While complex characters who change gradually throughout the tale are a hallmark of good long form fiction, you just don't have the time here. A character, while it can contain interesting contrasts, should always act in character.

- If there are elements of the story—actions, characters, or ideas—that do not support the theme, either change them or get rid of them. As I mentioned before, have no mercy. They are there to hurt your project.

One last possibility is that you are just telling the wrong part of the story. Most likely, the story is bigger than the part you are telling. If the story of *The Beast* with all of its relevant information were ordered purely chronologically, it would go like this:

A very ugly baby grows up into a beautiful woman and has a baby who is just as ugly as she used to be. She loves him despite his looks, never seeing any point to the negative reactions and expectations of others. One day, he gets in a fight with the family dog and ends up throwing flowerpots around and drenching the mother with the sink sprayer. Although angry at first, she is overcome by his "cuteness." We assume that under her loving care, the Beast grows up in a similar fashion to her, hopefully changing his looks for the better as he ages.

Notice that the actual action as presented in the animation only makes up two of the five sentences of that summary. The story as presented above is called the *objective story line*. It is objective because it is the overall, fully encompassing view. It is the story as your Deity of Choice would tell it. No doubt there were other incidents along the way that were similar to the one highlighted in the animation and ones that were different. But from the entire time span of that objective story line, a single incident was chosen to demonstrate the theme. That story as presented in the animation is called the *subjective story line*.

Your story is most likely a subjective story. Think for a moment about what the objective story is. How does the story you are trying to tell look in the greater context of the character's existence? Could the theme have

been better demonstrated by an entirely different situation or incident? Or, more easily, did you choose the best part of the story to tell? What about the 2 minutes before or after the portion you chose to tell?

Sometimes refocusing on a slightly different portion of the objective story line can make the difference in finding the right turn and creating a fully satisfying story.

If you can pull together a good character, plot, and image, unify them with a strong theme, grab your viewers with a hook, and satisfy them with a well-crafted turn, then you have a story worth slaving over for the next several months.

Writing It Down

With the story taking shape, your next task is to write it if you haven't already. Although actually writing the story down is not completely necessary for such a short, visual production, it can help to give form to your thoughts and provide a good reference for later steps.

Stories that are destined for film or video are usually written in *screenplay format*. To bother with the entire format for this limited production won't really be useful, so we'll borrow some elements from it but strip it down to suit our needs. Here is the final script of *The Beast* so you can get a look at the format:

THE BEAST

THE CAMERA COMES UP ON A WALL-HUNG PICTURE OF A VERY UGLY BABY, FOLLOWED BY ONE OF A FAMILY HOLDING THE BABY.

THE CAMERA CUTS TO THE BABY BEING DEPOSITED ON THE LIVING ROOM FLOOR AND LEFT ALONE BY THE MOTHER, WHO IS TALKING ON THE PHONE.

MOTHER (off camera, into a phone, continuing in the background throughout the action): Hi June. Did you get that? Yeah, there's some really good stuff in the catalog this time. I tried the Poolah mascara last time, and it's just great...

THE BABY GRABS FOR THE TOYS THAT ARE WITHIN REACH AND FINDS A RATTLE. HE IS NOT PLEASED WITH IT AND TOSSES IT AWAY. HE FINDS A GROSS DOG'S TOY, A BONE, AND BEGINS HAPPILY GNAWING ON IT.

A SNOOTY DOG AND A SILLY DOG WATCH FROM THE BACK OF THE COUCH. THE SNOOTY DOG BECOMES ANNOYED THAT THE BABY IS CHEWING ITS TOY.

THE BEAST HITS THE SNOOTY DOG BY THROWING THE BONE, THEN FOLLOWS UP WITH SEVERAL OTHER TOYS. FINALLY, THE SNOOTY DOG IS KNOCKED FROM HIS PERCH.

THE MOTHER HEARS THE COMMOTION AND PICKS THE BEAST UP, PLACING HIM IN A HIGH CHAIR IN THE KITCHEN WHILE SHE SCOLDS THE SNOOTY DOG.

MOTHER (to the dog): Penelope! Leave him alone!

WHEN SHE GOES BACK TO TALKING ON THE PHONE, THE DOG JUMPS ONTO THE KITCHEN COUNTER AND STEALS THE BABY'S FAVORITE TOY FOR REVENGE.

THE BABY CLIMBS ONTO THE COUNTER AND BEGINS TO THROW KITCHEN UTENSILS AT THE DOG. FINALLY, HE FINDS THE KITCHEN SPRAYER. THE DOG JUMPS TO AVOID THE SPRAY, CAUSING THE BABY TO ACCIDENTALLY TRACK IT DIRECTLY INTO THE STUNNED MOTHER'S FACE.

HER MAKEUP RUNS, AND WE SEE THAT SHE LOOKS MUCH MORE LIKE THE BEAST THAN WE PREVIOUSLY EXPECTED.

MOTHER: You little Beast! You... you... are so adorable. I just can't stay mad at you.

SHE HOLDS HIM, AND THE CAMERA FADES TO THE WALL PICTURES. THIS TIME, WE SEE A PROGRESSION OF PICTURES THAT LEAD US TO THE CONCLUSION THAT IT IS THE MOTHER IN FIRST PICTURE WE SAW, AND NOT THE BEAST.

Just for kicks, here is the script for *The Beast*, typed into Blender's text editor:

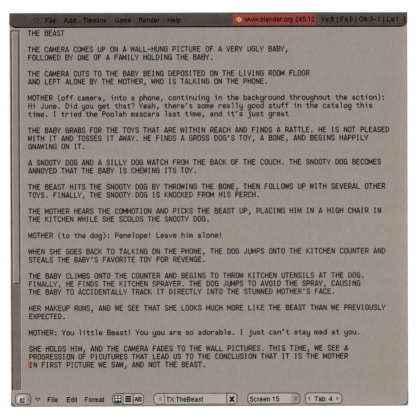

Figure 2.2 *If you want to go 100% Blender, you can write the script in a text editor window.*

All you need is a title, stage directions, and dialog. The division of the stage directions is a bit arbitrary, but is analogous to paragraph breaks in standard writing: Each little group of stage directions should represent a unit of action. If you are already visualizing how this will look in 3D, those divisions will occur naturally, and they often represent camera cuts in the final production.

One thing you may notice is the absence of all of the theme elements we discussed previously. Traditionally, a screenplay has been a common reference for the actors and director, and, while some writers like to put certain details of set and action that support the theme directly into the script, it is not necessary. The art direction, the actual content of the action, and even the way the actors perform are all managed by the director whose creative vision and sense of theme will make or break the production. Because you are the writer, producer, director and "actors" of your production, communicating such things through the script is unnecessary. Of course, if you have any particularly good ideas that you don't want to forget, you can always include them. The script is a living document—always available for revision, inclusion, or omission.

Story Scope, Your Resources, and Reality

You've really sweated over your story so that it works in all the ways we discussed in the previous section. There is another pitfall, though, that could send you back to square one: producibility. Whether or not you can turn that story into a finished animation will be a competition between the combined might of your personal discipline, available time, your skills as an artist, and the unholy alliance of distractions, the desires for sleep and human companionship, and the mountains of work that lay ahead.

And so it is a good idea to make sure that you actually have a shot at completing this task. How much time will it really take? While I cannot tell you that doing *this* or *that* will take exactly *x* or *y* hours, I can say that the work that you face will be a function of several distinct things: the number and complexity of sets and characters that appear in the animation, the amount of special effects such as water, hair, and clothes, and the actual amount of time that each character is animated.

If you haven't done so already, watch The Beast on the included disc.

Not counting the credits or the still images at the beginning and end of the animation, the amount of "live" time for which animation was required is around 3 minutes. The story features three characters: the mother, the bad dog, and the Beast. Although there is a second dog, notice that it never leaves it initial pose and does nothing but pant and move its head. It is little more than a complex prop. In several shots, all three characters appear together, which requires correspondingly more work. Mostly, though, each shot focuses on a single character.

For effects, you see hair for the mother and the Beast, fur for the dogs, a physics simulation for the crashing flower pots, and some particle work for the sprayed water.

Think about your resources: Are you working by yourself or with a partner or small team? Remember, you (or your team) will be responsible for every aspect of the production: storyboarding; the modeling and surfacing of all characters, sets, and props; the rigging, skinning, and animation of all characters; rendering and compositing;

sound; and final editing. Think about the longest amount of time you've spent on a single project prior to this. Three months? Six?

If you've never worked on a short animation project before, here's a suggested scope. It will give you a nice finished product, and provide a little room for narrative structure, but minimize some of the more difficult aspects of the process:

- One character
- One location
- No/minimal dialogue
- No/minimal effects

Because everyone works at different speeds and has different amounts of time available for work, it's not really possible to know how long such a project would take you in absolute terms. It is possible, though, to make a guess and to see how the inclusion of additional elements can affect the overall scope.

For example, let's say that a short animation that met the preceding specifications was going to take something like 300 hours of work to complete. That time would roughly break down as follows:

- Story/storyboarding: 20 hours
- Character creation, modeling: 20 hours
- Rigging, skinning, and animation testing: 20 hours
- Rough set creation: 10 hours
- Main animation: 100 hours
- Final sets and props: 40 hours
- Final surfacing and lighting: 40 hours
- Compositing/editing/sound effects: 50 hours

Those estimates don't include render time because we're just counting the time you actively have to spend in front of the computer.

Now we're going to do some math. If you're coming at short animation production from the artistic side, you may want to grab your uncle the accountant to help you.

Scope Example: Adding a Second Character

Adding a second character to the suggested scope causes the following change: Both character creation and rigging/skinning/testing times will double. Time spent on final surfacing will only go up a bit, say, by 10 hours, because only a quarter of the original time was going to be spent on the single original character. However, the main animation time will only go up based on the percentage of time that both characters appear in a shot at the same time. If the running time remains the same, and the scenes constantly cut between separate shots of the two characters, you will only be animating each character for half the time. On the other hand, if they spend 80% of the time in a shot together, you will be doing 80% more animation work. For this example, let's say that through judicious storyboarding and editing, the additional character will only appear with the original during 30% of the running time. This means that the main animation phase goes from 100 hours to roughly 130 hours.

The end result of adding a second character to our story of limited scope is to create an extra 80 hours of work, a little more than a 25% increase. If you estimated that the project would take 6 months to begin with, it will now take closer to 7 and one-half months.

Scope Example: Adding a Second Location

A second location or scene means the creation of an additional set and props. While careful planning can let you reuse some of the elements from the first set, the odds are that you are creating a separate location to provide contrast and therefore will be creating most of its assets from scratch. In that case, double both the rough set and final set and prop creation times. Also, non-character-related surfacing and lighting will also double.

A fully realized second scene or location in your project will add another 80 hours onto the project.

Scope Example: Adding Length

For one last example, assume that you will not be able to adequately tell your story within 1 minute. Your storyboards and rough sound track work much better at the 90-second mark—a 50% increase. With all other things staying the same, how does that affect the workload? Main animation, storyboarding, compositing, and editing times will all increase in direct proportion to the running length. Based on the preceding estimates, this equates to an increase of 85 hours of working time.

Of course, all of these changes reinforce one another. Using the original estimate, adding a second character, another location, and 30 more seconds of animation would result in an additional 285 hours of work—almost doubling the original scope of the project! Obviously, it is important to maintain control of the scope of your story before it gets out of control. It is equally important to realize that removing unnecessary elements can significantly reduce the amount of work you will have to do.

How Long Is My Story?

It's easy to count characters, sets, and effects ahead of time, but it can be harder to guess the actual length of the final animation. The simplest way to do this is to act out the story in real time.

To get the best estimate, outfit yourself as closely as you can to match the characters and events of the story. If your story is about intelligent alien space probes squabbling over who gets to keep the moon, then grab a couple of space ship toys and a ball. If you're doing a simple man-versus-nature story about someone who gets attacked by a mountain lion while walking in the forest, get a pair of boots and a stuffed animal. If you're doing a story about a bad baby and a dog, well, *do not* try on a diaper in front of a window or anywhere that your neighbors can see. I'm just saying.

With that done, find a clock with a second hand and act the thing out. Say everything that is said. Do any sound effects with your mouth. Adding the sound will help you to keep the timing real. It's easy to make things go too quickly or too slowly in your head, but actually doing the things and hearing them will exert a normalizing force. Try it through three or four times and see what the clock says. As long as you are getting fairly consistent results, you can use this time as a good guess at the length of your animation.

> **NOTE**
>
> As you act out the story, you may realize that something about it that seemed good on paper or in your head just doesn't work. That's okay. Of course, it means that you have to go back to the story stage again. Hopefully, it will be a simple fix that you can work out as you act, but if you need to take the buzz saw to the story, don't be afraid. Any time you spend now getting things right will be given back to you later when you successfully finish the project. You will thank the Lords of Animation that you followed the correct procedure and didn't discover these problems after 200 hours of animation.

Summary

Creating a satisfying story that is appropriate for a short animation can be difficult. The best stories have a memorable character, a plot, and iconic imagery. From the perspective of storytelling mechanics, you need to have a unified theme, as well as a hook and a turn. The choices made by the characters create the plot, and everything is watched over by the theme, which adds depth to actions and details.

The story must also be within your capabilities to translate into the short animation format. Overly ambitious stories with many characters, sets, and effects can easily overwhelm a lone or small group of animators. Keeping a handle on the length and scope of the story and whether or not it is producible is just as important as having an engaging story to begin with.

It cannot be emphasized enough that a "rough around the edges" animation with a great story is far better to show the world than a short full of amazing effects and a subpar story line, or worse still, a great looking project that never gets finished.

> **The Peach Perspective**
>
> Peach Perspective: A Q&A with Sacha Goedegebure (Director), Nathan Vegdahl (Rigger/Animator), and Andy Goralcyzk (Art Director) of the Blender Institute's Peach project movie *Big Buck Bunny*. You can see the full animated short in HD on the disc that came with this book, or on the Internet at `www.bigbuckbunny.org`, as well as read the full production blog. If you want to support the Blender Institute and continued Blender development, you can purchase the *Big Buck Bunny* DVD from there as well, which comes with all of the production files and tons of extras.
>
> *On Story: How do you balance entertainment value for the audience with being true to your internal vision of the story during story development?*
>
> Sacha: Writing an entertaining story is exactly what I want, so it's my main drive. Though I make what I make because I have the need to express myself; it would be hollow if I couldn't share it with others. Being able to show my work to the public is what makes me want to express myself. The only problem for me with the Peach project was that we kind of knew what "the public" was, and that it was big and of all ages. Normally with my personal projects I never have any restrictions; eventually I'll find a public or the public will find me. In the case of Peach, I did need to think about how far I could take it.

Organization

Objectives

- Your digital assets
- The way that Blender handles assets
- A suggested organizational structure

Inbox

Nothing.

Your Digital Assets

By the time you are finished with your short animation, you could have dozens of production files and thousands of rendered frames to keep track of. If you don't approach file management with a plan, you will almost certainly end up rendering the wrong version of some file, or worse yet, accidentally saving bad files over good ones, which can potentially ruin weeks of work.

The digital assets of your project will consist of storyboards, sounds, models and rigs, sets and props, materials, textures, animation, and renders. Although we will be extending the way that those assets are organized within each chapter, it's important to begin with a good baseline and an understanding of how Blender locates and deals with them.

The Way That Blender Handles Assets

Any asset, whether it is a texture, a set, or a sound clip, is seen by Blender in one of three ways:

- *Local*: Local assets are contained directly within a particular BLEND file. If you've only worked with still images or very small projects so far, the odds are that you've been working entirely with *local* assets. Blender does not need to go looking on the disk for them. If you have the BLEND file loaded in Blender, the assets are self-contained. You would use very few local assets in a typical short movie project.

- *Absolute*: Absolute assets are ones that are not contained in the BLEND file itself, but that Blender references by way of an *absolute* disk path. For example, an absolute path is one that contains the entire drive and directory structure, including the filename of the asset. If you are using a Microsoft® Windows®-based computer and you have a texture image file in your My Pictures folder, the absolute disk path would look something like this:

```
C:\Document and Settings\User\My Documents\My Pictures\
texture.png
```

As you will learn later, assets from one BLEND file on disk can be linked to another, just as a texture or sound file.

- *Relative*: Relative assets are the same as *absolute* assets except that the disk reference is a little more complex. Instead of referring to an asset by an absolute disk path, *relative* creates a path based on how to get to the referenced file from the active BLEND file. In Figure 3.1, you see a directory structure with a BLEND file called "cliff.blend" finding a path to a texture image file. There is a standard code for writing relative paths: a move to the left is represented by two periods (".."), while a move to the right is shown with a forward slash and a directory name ("/dir"). In Figure 3.1, the relative path of the texture image from the BLEND file is:

```
../../textures/rock/granite.png
```

because you have to go two steps to the left then right through both the "textures" and "rock" directories.

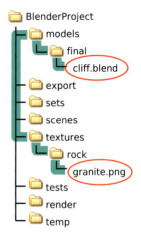

Figure 3.1 *A relative path from the BLEND file to the texture image*

Almost all of the assets in your project will be created in individual files, which will be brought together by relative linking. It's not important that you know how to do this yet, or that you know the specifics of path construction, but it is important to understand the value of organizing things properly from the beginning.

If you were going to model, texture, and animate the entire production in a single BLEND file, it would not only be huge—due to production issues, it may turn out to be impossible. For that reason, using local assets will not work. To streamline production and render times on anything but the simplest of projects, you will have many scene files, and they will need a way to efficiently reference the same set of assets.

Using absolute disk paths, which is Blender's default, will work if you plan to never move the project from you own computer's hard drive. However, if there is a possibility that you may want to work on the project in more than one location, or that you may someday archive the production files to disk and want to resurrect them in the future, you must use relative paths. Throughout the rest of this book, you will be reminded to use relative paths when you work with your assets. Relative paths make your project much more flexible and less likely to suffer a failure at some point in the production's future.

A Suggested Organizational Structure

Figure 3.2 shows a good way to organize your work.

- *Export*: You will probably want to send out test renders to friends or post animation clips and other in-production materials on the Internet or your local network. Having an export folder is a good idea so you will always know where to look when you need to send an asset out.

- *Models*: All of your model files go here. Each main object, such as a character or a major set piece will have its own separate model file. If you are going to have large numbers of characters, sets, and props (but you're not, right?), you can create subfolders for each of them. What you want to avoid a list of model files that you have to scroll through several times to find what you need.

- *Renders*: This folder is for rendered images and animations. Within the render folder are subfolders for the files associated with each individual shot. Within those, you will have additional subfolders for *raw* renders and *composite* frames. Also in the *renders* folder will be a folder called *quick*, which contains low-resolution animation files for each shot, good for intermediate use in your story reel.

- *Scenes*: The actual scene files go here. These files bring together all of the assets you have created and are where you will do the actual animation. There will be a separate scene file for each shot in your project.

- *Script*: Any files pertaining to the screenplay, including the script go here. You probably won't refer to this too often after you've entered the production phase, but you need a place to keep it for posterity when you win all those awards.

- *Sets*: Although sets may consist of either full BLEND files with the props stored locally, or files that simply contain links to files in the *models* directory; different sets will be linked as a single asset, so they should have their own organizational niche.

- *Sound*: This is for sound files, including the rough soundtrack, dialog, and final sound effects and music.

- *Storyboards*: Your storyboard files will go in this folder. If you are using a program that has a "working file format," such as Photoshop (PSD), you may want to create a subfolder for working files and leave the main storyboards folder for the actual storyboard images.

- *Story reel*: You'll learn about the story reel in the next chapter. The BLEND file that represents the current state of the story reel goes here, along with any previous versions you may have saved.

- *Tests*: You may need to do render tests or create small BLEND files to try a new technique or feature. Those files can be put here.

- *Textures*: This is the location of all your image texture files. If you have many characters or sets, you can create a subfolder for each one.

Figure 3.2 *A directory structure for organizing a short animation*

Summary

Before you begin to create files, it is important to create a directory structure on your hard drive to hold them. Using a good directory structure along with relative file paths for your Blender assets will make your project more flexible and portable.

Outbox

You will learn from this chapter a directory structure that will help to organize your project in later chapters.

Storyboarding and the Story Reel

Objectives

- Storyboarding basics
- Suggested tools
- Creating the storyboards
- Telling the story
- Recording a temporary soundtrack for timing
- Assembling a story reel in Blender's Sequence Editor

Inbox

Coming into this chapter, you need:

- A finished story

Storyboarding Basics

Before you take your story into 3D, you need to visualize it in a less time-consuming medium. Storyboards provide an efficient way to move the ideas and words of your story into a visual format. At their most basic, storyboards are a series of drawings, either real (on sheets of paper) or virtual (drawn directly into a digital painting program), that show the sequential action of your story. They can become incredibly detailed for shots that feature complicated action, showing every character pose. Depending on your speed and ability at sketching, you may opt for a more simplified work flow, making sure that all of the major actions are shown.

Each storyboard represents an actual shot from the animation, framed as it would appear in its final form on the screen.

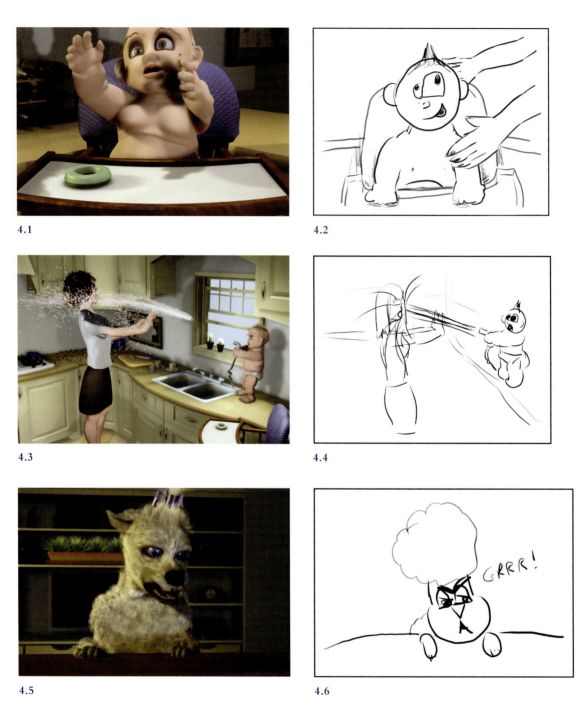

4.1

4.2

4.3

4.4

4.5

4.6

Figures 4.1–4.6 *Several storyboards from* The Beast *along with the accompanying production shot*

Notice how closely the final shots follow the composition of the corresponding storyboards. Without the mechanics of animation and 3D to worry about, you can concentrate on quickly developing the compositional strength and organization of the story. If you make a bad drawing, it only costs you a few minutes to draw it again. If you compose a scene poorly in 3D, it may cost you weeks.

In addition to static images, storyboards can also contain notes, arrows, or lines to indicate motion and camera directions.

4.7

4.8

Figures 4.7–4.8 *Camera directions and motion lines*

Let's take a look at a portion of the script from *The Beast* and follow the process of storyboarding. Here's the excerpt:

THE BEAST HITS THE SNOOTY DOG BY THROWING THE BONE, THEN FOLLOWS UP WITH SEVERAL OTHER TOYS. FINALLY, THE SNOOTY DOG IS KNOCKED FROM HIS PERCH.

Immediately you are hit with a directorial decision: How to frame this shot? There are several ways to do it:

- A long to medium shot that shows both the dog and the Beast at the same time. This in turn could be done from behind the Beast, with him taking up most of the foreground, from behind the dog, or from a more neutral, omniscient position.
- From the dog's point of view.
- From the Beast's point of view.

4.9

4.10

4.11

Figures 4.9–4.11 *Both characters are in the shot from several perspectives*

Figure 4.12 *The dog's point of view*

Figure 4.13 *The Beast's point of view*

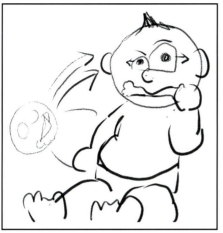

4.14

4.15

4.16

Figures 4.14–4.16 *The Beast sits up, looks at the dog, then pelts it with the bone*

I wanted the actual hurling of the bone and impact on the dog's head to be a surprise, so I had to choose a way of showing it that hid the Beast. The only real option then was to use the Beast's point of view from Figure 4.13. So the sequence goes: We see the Beast with the bone, then the dog, then the dog getting hit (Figures 4.14–4.16).

After that, according to the script, follows "several other toys."

Notice how the next two storyboards split the crucial moment in time where the golf ball (ouch!) makes impact:

4.17

4.18

Figures 4.17–4.18 *The dog gets ready for impact and is struck*

Remember that storyboarding is a guide to action that is later used for animation. All of your important poses, facial expressions, and moments in time should have a storyboard.

Continuing, we see a determined expression on the dog's face, followed by a miss!

4.19

4.20

Figures 4.19–4.20 *The dog dodges!*

Figure 4.21 *The silly dog only pants and grins. Don't blame him, he's only a prop!*

Now, I had to decide how to hit the dog so hard that it is knocked from its perch. I really didn't want to show a bone-crushing impact, after all this is supposed to be somewhat funny, but it still had to happen. One way to lessen the visual distaste of something like this is to put it off screen. So I decided to try cutting away to the silly dog for a moment.

I realized that this may create the expectation in the viewer that the silly dog will be next on the Beast's hit list. But when the next toy goes sailing past, and the silly dog doesn't even blink—he's that clueless—it will be another minor surprise, hopefully leading to a laugh. Once again, the crucial moment is split, with the toy car suspended just before impact in one storyboard and the crunch lines and sound effect in the next (Figures 4.22–4.23).

Looking ahead in the script, I knew that I had to switch perspectives at some point to bring the mother and the kitchen into the story. Because the snooty dog was off camera anyway and there was a strong visual line of action with the flying toy car, this seemed like a decent place to change the point of view. The next shot then, showing the snooty dog recoiling and falling, is from an entirely different angle. In retrospect, this is probably the weakest directorial decision in the animation. Changing to a complete reverse angle for a shot is generally inadvisable, and, although the continuous action of the dog's recoil and the wider shot that includes the mother helps it to work, it only barely scrapes by.

4.22

4.23

Figures 4.22–4.23 *Is that a car coming my way?*

4.24

4.25

Figures 4.24–4.25 *The dog succumbs to the Beast's missiles*

Note the motion lines and sound effect notations throughout these storyboards that help to show the action in the still images, giving them a comic book panel effect.

The storyboards for the rest of the animation are available in the production files portion of the included disc in the "storyboards" folder.

Suggested Tools

Many artists prefer to prepare storyboards in "real life" as opposed to digitally. The advantage of doing so is that small cards with sketches are extremely easy to arrange and rearrange to test different orders of action

and scenes. It is also simple to swap variations on a particular storyboard to see how it changes the flow of the shot.

If you will be creating your storyboards using traditional tools, you will need the following:

- *Paper*: Unlined 3″ × 5″ index cards will work well.
- *Pencil*: Any drawing implement will work, but if you have a favorite artist's pencil, feel free to use it.
- *A board*: You'll need a cork-backed bulletin board and pins or a blank wall or artist's table and masking tape.

Your finished drawings will be arranged in sequence on the board (or wall or desk), like this:

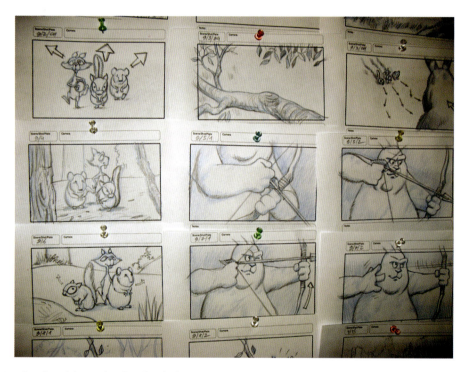

Figure 4.26 *A wall used for storyboarding.* © *Blender Foundation | peach.blender.org*

Other artists, myself included, prefer to create their storyboards digitally. To accomplish this, you will need a pen tablet, some kind of painting program, and a program that can help you to organize the storyboards.

Pen Tablets

Although you could just paint using your mouse, you'd be silly to try. Using a pen tablet is significantly more responsive and is the generally accepted way of digital painting. If you've never used one before, a pen tablet consists of a hard drawing surface and a pen, which is connected through a USB port. As you move the

pen across the surface, it controls the cursor on screen. Most pen tablets include *pressure sensitivity*, which means that the harder you press with the pen, the more "force" is applied digitally when painting or drawing, mimicking the response of real artists' media. Some better tablets are also sensitive to the angle that the pen is held at for an even more realistic experience.

The industry standard product is sold by Wacom® and their excellent reviews in a variety of publications and online boards, as well as personal experience, show the reason why. In the context of a larger production, their expense is negligible, but to someone producing their own short animation, it will seem high. Wacom currently makes a series of tablets called Bamboo™ that are fairly inexpensive (the smallest is under $100), and still receives great reviews both on quality and responsiveness. Of course, depending on your skills as a sketch artist, even this may be more than you need. A simple product search on the Internet will turn up a number of off-brand or generic pen tablets that cost significantly less and that, as long as they have pressure sensitivity, will work just fine for creating simple storyboards.

Figure 4.27 *My workstation setup, with very cheap pen tablet*

Paint Software

In addition to the commercial-grade, relatively expensive image editing and paint programs like Adobe® Photoshop® and Corel® Painter™ X, there are a number of free or low cost alternatives that have suitable functionality for drawing your storyboards.

While the GIMP (GNU Image Manipulation Program, `www.gimp.org`) is the current open source option for image editing, my personal favorite is a program called ArtRage, a natural media painting application from Ambient Design, a New Zealand-based graphics software company. The full edition of the software is available for Windows and Macintosh computers from `http://www.ambientdesign.com` for only $25.

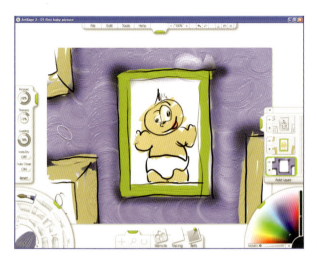

Figure 4.28 *ArtRage 2.5*

All of the storyboards for *The Beast* were drawn in ArtRage.

Blender's Image Editor

If you have Blender and are not the finicky type, you already have an image editor sufficient for the needs of storyboard creation.

To find it, run Blender and configure a screen so that a single window dominates. Change that window to the **UV/Image Editor** type.

If you have ever worked with real media (pastels, oil paints, etc.), you will find that ArtRage mimics the experience very well. Many of the techniques you use in traditional art have a great digital counterpart, allowing you to make illustrations and paintings that appear as though they were done with the traditional tools.

Figure 4.29 *A faux oil painting created with ArtRage*

Figure 4.30 *Blender featuring a UV/Image Editor window*

Before you can use this window for painting, you need to create a new image. Do this by selecting **New** from the **Image** menu on the window header. The dialog that pops up gives you options for naming the new image and choosing a size. For now, set the **Width** to **800** and the **Height** to **600**. Using the color picker between the **Width** and **Alpha** controls, select a pure white (RGB 0,0,0) for the background.

Figure 4.31 *The New Image dialog*

Aspect Ratio

It is a good idea to choose your finished format and size before you begin to create your story-boards so that the framing you work out will translate properly into 3D. There are some small technical considerations, but the real question is, "How do you want your finished animation to look, and where will it most likely be viewed?"

The main choices are film, high-definition TV, and standard video.

While you almost certainly won't be rendering your animation at film resolution (2048 × 1108), the aspect ratio (1.85:1) can be attractive if you want your project to look like a movie.

If your target is to show on widescreen TVs or DVDs, then a widescreen HD size (1920 × 1080; 1280 × 720; or 852 × 480) and aspect ratio (16:9) will make sense.

Finally, standard video resolution (648 × 486 for NTSC in the United States or 720 × 486 PAL in Europe) and aspect ratio (4:3) is still hanging around and fits well for full screen playback on many existing and new computer monitors and televisions. Please note that these screen aspect ratios are not the same as the pixel aspect ratio, and should not be entered into the AspX and AspY fields on the Render Buttons Format panel.

When you click **OK**, the **UV/Image Editor** is filled with your new blank image. Press the **1** key on the number pad to have Blender zoom the image to 100%. Before painting, choose **Save** from the **Image** menu on the header, then assign the image a filename. The image is saved in the format specified in the **Format** panel of the **Scene** buttons (**F10**).

Figure 4.32 *The Format panel of the Scene buttons*

To enable the paint tools for this particular image, either click the pencil icon on the window header or choose **Texture Painting** from the **Image** menu (Figure 4.33).

Figure 4.33 *Enabling Texture Painting*

Finally, press the **C** key to bring up a panel with the image painting brush tools. This panel allows you to choose paint colors, brush type and settings, and color blending modes. While Blender's image editor isn't the most advanced paint application in the world, it does have enough options to make settings appropriate for sketching a little hard to come by. Figure 4.34 shows the panel configured for a decent approximation of a sharp-pointed felt tip marker.

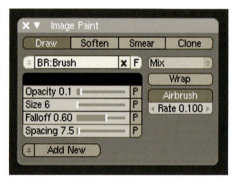

Figure 4.34 *Felt-tip marker settings*

The settings in Figure 4.35 show a configuration appropriate for washing some color into a storyboard after the sketch, if you choose to do that. The brush size can be adjusted depending on the overall size of the image and the area you are coloring.

Remember that if you choose to sketch your storyboards directly within Blender's image editor, there is only a single level of Undo, and your image will not automatically be saved if you accidentally close the program. Unlike other image editing programs, there are no selections or masking available and no easy way to actually erase mistakes.

Creating the Storyboards

At this point, your artistic sense must begin to take over a bit. Read through your script, close your eyes, and try to visualize

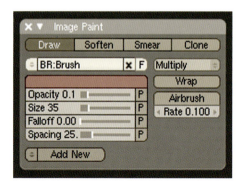

Figure 4.35 *A good setup for applying some color*

the first shot. Using your storyboarding tools of choice, draw it. Line characters or whatever is appropriate to your skill level in sketching are fine, as long as you will be able to tell one character or item from another.

When you have the first shot drawn, pin it in the upper left corner of the board if you are using physical tools (pencil and index cards). If you are creating your storyboards digitally, save the image into your storyboards directory, using the following convention:

Board Number + Description.Extension

Board numbers should start with "005" and go up by fives (010, 015, etc.). You do this so that if you decide to enhance a sequence of storyboards with a few extra drawings, then you can keep them numbered sequentially without renaming all of your files. If you're really nervous about it, you can number by tens.

The description is a very short description of what the storyboard depicts.

Of course, the extension is dictated by the format in which you choose to save the illustrations. The PNG format is usually a good choice for storyboards because it keeps a good balance between file size and image quality, although you are free to use your favorite format, as long as it is one that Blender will be able to import later.

A segment of the "storyboards" folder from *The Beast* can be seen in Figure 4.36. Notice how several storyboards have been inserted into the "by fives" numbering sequence.

Name ▲	Size	Type	Date Modified
095 priss dog.png	461 KB	PNG File	6/13/2007 10:50 PM
096 goofy dog.png	489 KB	PNG File	6/13/2007 10:51 PM
100 baby decides.png	514 KB	PNG File	6/13/2007 10:57 PM
105 priss dog again.png	461 KB	PNG File	6/13/2007 10:57 PM
110 hit with the bone.png	481 KB	PNG File	6/13/2007 10:59 PM
112 golf ball pre-impact.png	476 KB	PNG File	6/13/2007 11:01 PM
114 golf ball impact.png	492 KB	PNG File	6/13/2007 11:03 PM
116 priss ready for action.png	459 KB	PNG File	6/13/2007 11:04 PM
120 missing binky.png	484 KB	PNG File	6/13/2007 11:06 PM
125 goofy dog looks on.png	476 KB	PNG File	6/13/2007 11:08 PM
130 car flying by.png	507 KB	PNG File	6/13/2007 11:09 PM
132 whomped by car.png	500 KB	PNG File	6/13/2007 11:11 PM
135 on the phone.png	544 KB	PNG File	6/14/2007 5:38 PM
140 dog falls off couch.png	545 KB	PNG File	6/14/2007 5:43 PM
145 dog is back.png	531 KB	PNG File	6/14/2007 5:46 PM
150 there you are.png	545 KB	PNG File	6/14/2007 5:48 PM
155 dog closeup.png	473 KB	PNG File	6/14/2007 5:50 PM

Figure 4.36 *A partial listing of the storyboard files from* The Beast

As you proceed to draw your storyboards, make sure that you include a storyboard for each action or significant moment that takes place. It can be useful, as shown earlier, to create before and after storyboards of quickly occurring actions. Add arrows to show motion. Scribble notes on camera movement, sound effects, or anything else that you think is important. Include bits of dialog where applicable. Relevant set elements and props should be drawn, but don't become bogged down drawing every detail of every shot.

If you are working with index cards and a board, you will see your story develop with each sketch that you add. If you are drawing directly on the computer, you will need an additional tool to see the storyboards as you would in real life.

On a Windows PC, one such program is IrfanView, a free image viewer and browser available from `www.irfan view.com`. Figure 4.37 shows IrfanView's **Thumbnails** view, found by clicking on **Thumbnails** in the program's **File** menu. Through the Thumbnails view's **Options** menu, you can increase or decrease the size of the thumbnail images. Pressing the **F5** key will refresh the thumbnail display each time new storyboards are added.

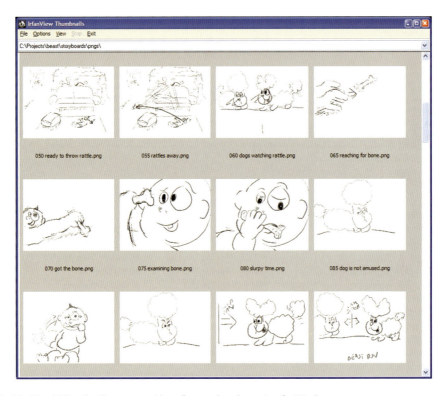

Figure 4.37 *IrfanView's Thumbnails screen provides a fast storyboard overview for Windows users*

Macintosh users can use the bundled iPhoto application to achieve a similar effect. If you are an Adobe Photoshop owner, you can use the Contact Sheet utility that is found under **Automate** in the **File** menu.

Telling the Story

One of the things that animation directors do after storyboarding is to use their storyboards to actually show and tell the story to an audience. Even though your production is short, this is still a good idea. Find yourself an audience, most likely friends and family, and walk them through your storyboards.

If you have a physical wall full of storyboards, grab a yardstick, tell the story and begin to direct your audience's attention to the relevant boards. If you are doing it digitally, you can show each image full screen with the slideshow feature of any number of applications such as IrfanView, iPhoto, or Google's Picasa™. In either case, the point is to show someone *who doesn't already know the story* the storyboards, while you narrate. This last point is critical because what you are looking for here is feedback on what the viewers misunderstood (or completely failed to understand), what they thought went on too long, whether your jokes worked, and if anything just plain didn't make sense. Sometimes when you've lived with a story for several weeks or months, certain things become so obvious to you that you completely forget to mention them to your audience. Doing this, while potentially cringe inducing, is a valuable part of the short animation creation process. It's a chance to get the bugs worked out of everything long before you begin to put in the real time and hard work. Also, you may have lived with the story for so long already that the plot points, jokes, and twists may have lost their punch for you. A fresh audience can, hopefully, restore your faith in the project.

Of course, there will be problems. One of the benefits of working with storyboards, though, is that they are quick to make and easily replaced. If your test audience pointed out that you missed giving out a crucial bit of information, add a couple of new storyboards. If you are having difficulty getting a strong vision of a certain set of actions, storyboard it from several perspectives and see which works best.

Rearranging sections of your story can help too, but that is easier to do in real life with physical cards than it is to do digitally. If you want to rearrange entire sections of your digital storyboards, it can be a little more involved because we want to keep the images in the proper sequence when the files are arranged alphabetically. It will become easy to rearrange digital sections in the next step, so you may want to wait until then.

Whatever the case, you should come out of the process with a series of storyboards that properly lead the audience through the story you intend to tell. At this point, if you have been working with physical storyboards, you will need to scan them into your computer as a numbered series of image files. When scanning, it is a good idea to follow the naming and size/aspect ratio conventions mentioned earlier in this chapter. The need to scan and name each of the sketches is one of the arguments for creating the storyboards digitally to begin with. *The Beast* has only 86 storyboard sketches, and I would not have wanted to scan them all.

Recording a Temporary Soundtrack for Timing

Remember back during the story creation process where we had you acting out the story in real time to make an estimate of the running length? Well, it is time to finalize that process. In the next step, you will be compiling your storyboards into an animated, timed slideshow, set to a temporary sound track.

Grab a cheap PC microphone, fire up whichever bundled sound recording application came with your system (you can see Chapter 8 for more information on recording sound), and get ready to act again. What fun! You had no idea you'd be up to these kinds of shenanigans when you started this project!

Your vision of the story has no doubt solidified as you worked through storyboard creation. You should have an excellent idea at this point how the story will actually function on screen.

Press **Record** in your sound application and act the story directly into the microphone, visualizing the storyboards while you do so. If more than one person talks at a time in your production, get a friend to help you.

The actual timing of individual words or hard dialog isn't as important right now as getting the overall timing correct. Make sounds to signal the start and end of actions (grunts, smashing noises, screams, and so forth) so that you will be able to place their storyboards properly in time.

Place this recording in your project's sound folder under a name such as "dirt track" or "temp sound." (For some embarrassing fun, you can find the "dirt track.wav" file in the sound folder of the included disc to hear my own preliminary soundtrack for The Beast.) If the recording program gives you options and formats to choose from, choose 16-bit WAV format at 44,100 kHz. If not, don't worry about it. Those are the most common settings. Now open up the slide show viewer you used when you narrated the story for your test audience, play the audio you just recorded, and try to follow the soundtrack by advancing the slide show manually at the right times. Give it a few tries to make sure that there are no parts of the action you missed when creating the temporary soundtrack. If you did miss something, just go back and make a new recording. It will only take a couple of minutes.

Just like when you were estimating the length of the animation in the story phase, building a soundtrack adds a real-world time scale to your project.

Assembling a Story Reel in Blender's Sequence Editor

With the storyboards and a rough soundtrack created, you will assemble them into an animated *story reel*. When you paged through your storyboards as a slideshow with the soundtrack playing, you were actually making a temporary story reel on the fly.

The story reel is a self-playing animation that marries your storyboards to your rough soundtrack. If done well, it will give an excellent sense of the look and feel of the action in the finished animation. In fact, as you proceed with your work later in the project, you will be replacing the storyboards in the story reel with previews and a final, rendered animation as you complete them. In this way, the story reel evolves over time until it becomes the final edit of your finished, rendered animation!

Because of this, the story reel is vital to your project. All of your work in story, planning, animation, and rendering come together there. It will be your guide.

You can create your story reel directly within Blender's Video Sequence Editor.

The initial story reel file for *The Beast* is called, "beginning_story_reel.blend," and it is available in the included disc's storyreel directory.

Let's examine the way that you build a story reel in the Sequence Editor.

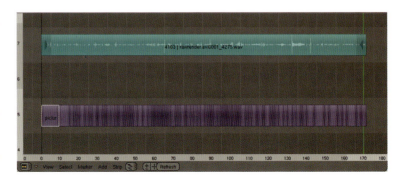

Figure 4.38 *The finished storyboard-based story reel for* The Beast

> **NOTE**
>
> The Video Sequence Editor screen is often referred to in online and printed documentation as either the *Sequencer* or the *VSE*. You should become familiar with both terms so that you can make use of other tutorials without confusion.

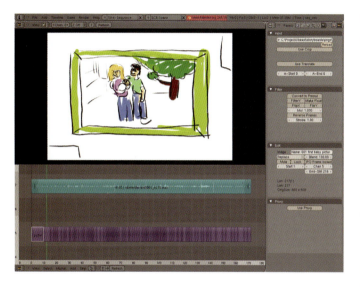

Figure 4.39 *A Sequence Editor configuration. Depending on your window configuration, the panels may be arranged in a different order than presented here*

In Figure 4.39, you can see that the larger part of the screen has been split horizontally, and both halves have been set to **Video Sequence Editor** windows. The bottom one is the default visualization of the Sequencer. The top has been switched to display the Sequencer preview, as shown in Figure 4.40. On the right side of the screen is a buttons window showing the **Sequencer Buttons** context of the **Scene Buttons (F10)**.

The Video Sequence Editor is one of the "black holes" of Blender. If you've never done any video work, you may have known it was there but considered it to be advanced Blender voodoo. Its primary purpose is to string together sequences (the name!) of still images and video

Figure 4.40 *Choosing the **Preview** visualization*

clips, sync them up with audio tracks, and output a single, long piece of video or animation. Sounds like it's exactly what you need to create the story reel. Images and video will be added and manipulated in the bottom half of the screen, while the preview of the current frame will be shown in the top. The VSE obeys most of Blender's interface conventions, as you will see.

With the mouse over the timeline in the VSE workspace, press the space bar to pop up the **Add Sequence Strip** menu, just as if pressing **space** to add an object in Blender's 3D view. From the menu, choose **Image Sequence**, as in Figure 4.41.

This brings up the file chooser screen. Using the right mouse button, select all of the storyboard image files that you placed in your storyboards directory. The images will be brought into Blender in alphanumeric order, so it is important that you've named them as specified before. With all of the image files highlighted for selection, (1) enable **Relative Paths** at the bottom of the screen and (2) click **Select Images** (Figure 4.42).

Figure 4.41 *Adding an image sequence*

Figure 4.42 *Selecting multiple files and enabling Relative Paths*

When the VSE workspace returns, a Sequence strip will be stuck to your mouse cursor in transform mode. This is just like moving objects in 3D in Blender; clicking the right mouse button will cancel, while clicking the left mouse button will drop the strip at the cursor's current location. Be careful if you use the right

mouse button to cancel the transformation because the import will still have taken place, dropping the images in sometimes very hard to find places in the workspace. Notice (Figure 4.43) the different elements of the Sequencer **Image Strip** while it is being moved:

- The numbers on either end of the strip indicate the start and end frames the strip would have if you accepted the current transformation.
- The first number inside the body of the strip indicates how many images (your storyboards) are contained in the strip.
- The full disk path and file name of the first image file in the strip is given

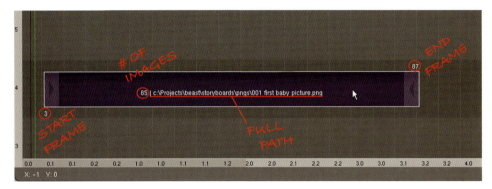

Figure 4.43 *An Image Strip in transform mode*

Move the strip until the indicator for the start frame is 1, meaning that the sequence of images will begin on frame 1 of the animation. The particular horizontal channel the strip is in is not important right now. Press the left mouse button to accept the position. If something went wrong and the strip ended up somewhere other than frame 1, just follow the Blender convention to move something: select the strip with the right mouse button and press the **G** key to begin a movement transform.

When the image strip is in proper position, try scrubbing through the VSE's timeline by holding down the left mouse button and dragging in the workspace. As you scrub across the area occupied by the image strip, you should see the images display and change in the preview window in the upper portion of the screen. If the preview image is very small, or if you are only seeing an extremely magnified version, position your mouse over the preview window and use the mouse's scroll wheel and middle mouse button to adjust the zoom and positioning.

If you watch carefully, you'll see that each image occupies only a single frame in time, hardly the effect we're looking for. In a moment, we'll see how to change that, but first we need to get Blender ready for our animation.

> **WARNING**
>
> If you forget to set the frame rate, resolution, or aspect ratio at this step, it can lead to mismatched render sizes, audio/video sync problems, and timing issues that could spell disaster for your project. If you've saved your project's animation settings as a Blender default as suggested in the last chapter, you should be fine.

If you haven't already done so, switch the buttons window to the **Render Buttons** context, and set the frame rate and render size in pixels to match that of your finished animation (Figure 4.44). In the **Sequencer** panel of the **Sound Block** context, enable the **Sync** and **Scrub** options (Figure 4.45). **Sync** forces Blender to maintain accurate time during sequence playback, causing it to skip the display of frames if things are taking too long to process. **Scrub** causes Blender to play audio as you use your left mouse button to scrub along the timeline, making it easier to synchronize your storyboards with events in the rough soundtrack.

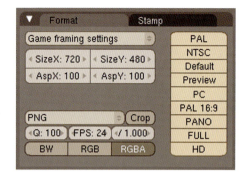

Figure 4.44 *FPS and size adjusted*

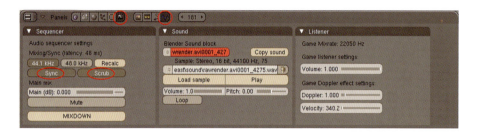

Figure 4.45 *Sync and Scrub enabled*

With the animation settings prepared and confirmed, add your rough soundtrack. Press the space bar over the VSE workspace and choose **Audio (wav)**. Select the audio file you created as a rough soundtrack (the WAV file) and place it in the VSE beginning on frame 1, just like the image strip. With the audio in place, pressing **Alt-A** (the standard Blender command to **Play Animation)** should cause the sound to begin to play while the storyboard images flash past in the preview window.

The **Edit** panel back in the **Scene Button's Sequence** context will show the start and end frames of the audio clip in the **First** and **Last** information fields. You will most likely have to use the mouse's scroll wheel (or just press the **Home** key) to fit the entire audio strip onto the screen at once. In Figure 4.46, you can see the small size of the purple image strip (85 frames), compared to the much larger green audio strip (4103 frames). When you have the audio strip positioned, make sure that it is selected (right mouse button), and then enable the **Lock** button in the **Edit** panel.

Also, using the information shown about the sound strip in the display, set Blender's **End** frame animation counter in the **Render Buttons** to the last frame of the sound strip.

Figure 4.46 *Audio and image strips from* The Beast

Now that the audio strip is in place, you get to do some math!

Divide the total number of frames from the audio, shown in the **Len** field in the **Edit** panel, by the number of images in the image strip and round the result down. In the case of *The Beast*, this yielded 48 (a 4103 frame sound divided by 85 images = 48.27). This number represents how many frames each storyboard image will need to be to fill the available time. Of course, we'll have to make adjustments, but it's a good place to start.

Use the right mouse button to select the image strip and either press the **Y** key or choose **Separate Images to Strips** from the **Strip** menu on the VSE workspace's header. A dialog pops-up asking for an **Image Duration**. We are breaking the single image strip with all of the storyboards in it—into individual strips, end to end, so that we can adjust their start and end points to match the audio track. For **Image Duration**, enter the value you just calculated. The image strip will be broken into a series of strips, the last one falling near the end of the audio strip, if you did the math correctly (Figure 4.47). If not, just use **Ctrl-Z** to undo and ask someone else to do the arithmetic.

Figure 4.47 The Beast's *image strip separated into its components*

And now begins the somewhat tedious task of adjusting the timing of the storyboard images. The workflow proceeds like this:

- *Identify a sound cue.* Press **Alt-A** to play the story reel and listen for the first definitive audio cue that you can sync to. It may be a bit of dialog, a crash or some other sound effect, or the fake trumpet sound you made with your mouth to announce the arrival of your character.
- *Note where in the timeline the sound cue takes place.* Remember that you can use the left mouse button to scrub in the timeline and hear specific portions of audio to narrow it down. The waveform preview on the audio strip can also help.
- *Locate the storyboard that matches that cue.* You've been working with the storyboards for long enough now that you should know which image you are looking for. Also, if you are working sequentially, the next storyboard in line will almost certainly be the one that you need. This is where any notations or dialog that you've drawn directly into the storyboards can be very helpful.
- *Position the storyboard to match the location of the sound cue on the timeline.*

Figure 4.48 shows the dog's yelp matched up with the bone striking its head.

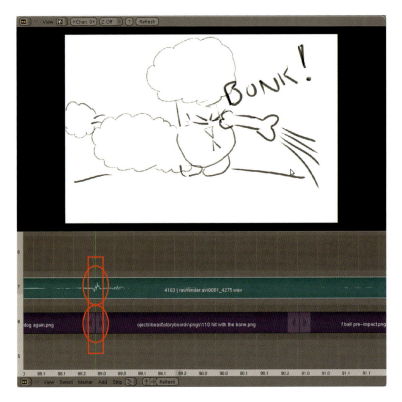

Figure 4.48 *Sound synced to the proper storyboard in* The Beast

There are several techniques to move the image strips around that we will discuss next, but this is the basic procedure. As you match storyboards to sound cues, you press **Alt-A** to preview your work, tweaking things a frame at a time if necessary.

Sequencer Tools for Working with Image Strips

Although the Video Sequence Editor shares some of the rest of Blender's commands and work flow, it has its own quirks and hidden secrets. Actually, by bringing in a series of images and a sound clip and splitting them into their components, you have already acquired significantly more Sequencer knowledge than a great many Blender users.

First, a little more Sequence strip anatomy. Notice the inward pointing arrows on either end of each image strip. Image strips can be right mouse button selected and moved with the **G** key, just like any other Blender object. The handles, though, can be individually selected and **G** key moved, allowing you to extend the length of time that the strip covers. In Figure 4.49, you can see that the top strip has had its right handle moved to the right, and the bottom one has had its right handle moved to the left, making them longer and shorter, respectively, than the one in the middle. The bottom strip is in the middle of its transformation, with the right most handle selected.

Figure 4.49 *Adjusting the handles to lengthen and shorten sequence strips*

Sequence strips may also be selected and moved in groups. The standard right mouse button and **B** key selection methods apply. Selected strips can be deleted with the **X** key or duplicated with **Shift-D**.

When moving a sequence strip (or several at once), Blender will not allow you to move it into a space already occupied by another strip. If this happens, the outline of the moving strip will turn red as a warning. If you accept the transform by pressing the left mouse button while the strips are overlapping, the moved strip will be automatically placed adjacent to the blocking strip, if there is room, or put into a neighboring channel if there is not (Figures 4.50–4.51).

Figure 4.50 *A strip transforming to overlap will be outlined in red*

Figure 4.51 *The transformed strip has been offset because overlap is not allowed*

The main tool you will use when working with a list of image strips laid out end to end like this is the **Extend from Frame** command, which is triggered by the **E** key. If you are familiar with Blender's modeling work flow, you can think of it as an **Extrude** tool for sequence strips. **Extend from Frame** looks at three things: which strips are selected, where the current frame marker lies, and where the mouse is when the **E** key is pressed. It then enters a grab/move/transform mode that lets you move all handles on the mouse side of the frame marker together. That sounds odd, but Figures 4.52 and 4.53 show its practical use. If you have all image strips selected and place the frame marker in the middle of one of the strips, using **Extend from Frame** will cause that strip to grow and shrink, while all others attached to it move along with it, maintaining their original boundaries.

Figures 4.52 *Using Extend from Frame causes all handles and strips on the right of the current frame marker to transform together*

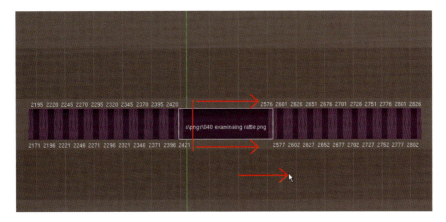

Figures 4.53 *Using Extend from Frame causes all handles and strips on the mouse side of the current frame marker to transform together*

So if you have used the **A** key to select all of the strips in the sequencer and moved them so that the beginning of a particular strip matches a sound cue, you now have an easy way of making that strip shrink or grow so that the next strip begins at the next sound cue. With all of the strips selected (this is why we locked the sound strip earlier—to prevent it from being affected when we did this), position the current frame marker with the left mouse button in the middle of the strip whose position you are sure of. If you need to move the right side of the strip, put your mouse to the right of the current frame marker; if you need to move the left handle of the strip, position the cursor to the left. Press the **E** key and move the mouse back and forth to see how the transform functions. All other strips on the side of the cursor that are adjacent to the central strip will move along with it, allowing you to grow and shrink the central strip without introducing gaps or causing overlap.

The great advantage to using this method of adjusting the image strips over simply grabbing the handles individually and pulling them around is that you never have to worry about gaps or overlaps occurring between images. Everything stays neatly together. Although the description of the functionality is complex, after using it a few times, its value will become apparent.

However, if you do need to break things up and start really shuffling strips around, here are some tools that can make your life easier:

- *Ctrl or Alt right mouse button*: Using either Ctrl or Alt (not both at once), while right mouse button selecting a strip selects both the strip and one that immediately borders it. If you use Ctrl, it selects the one on the left. Alt selects the one on the right. In addition, the two handles on the border between the strips are directly selected. This is useful for adjusting the boundary frame between the two strips without moving their outer limits (Figure 4.54). This selection method adds to any existing selections, so you may want to use the **A** key to make sure that nothing else is selected first.
- *Ctrl or Alt right mouse button* × 2: Adding a second click to the previous command will select all strips to the right or left of the directly selected one. This allows you to quickly and easily select and move entire blocks of strips at once, say, to make room for an additional strip.

- *Ctrl-Alt right mouse button*: Using both modifier keys at once while selecting a strip selects the strip, plus any strips that border it immediately on the left and right. The interior handles are directly selected, allowing you to move the center strip back and forth while the outermost handles remain in place (Figure 4.55).

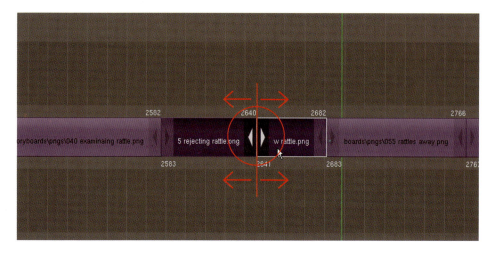

Figure 4.54 *Changing the boundary between two strips with Ctrl-Alt selection*

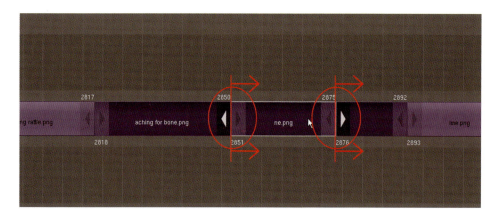

Figure 4.55 *Moving a strip between two others with Ctrl-Alt selection*

Watching and Exporting the Story Reel

As you've been working, no doubt you have been using **Alt-A** to watch the evolving story reel in the preview window of the Sequence Editor. As long as you are using fairly modern hardware, Blender will easily be able to show it in real time.

Before exporting the story reel as an animation, there is one more thing to do. The **Scene Buttons** contain a **Stamp** panel that begins its life docked behind the **Format** panel. By bringing that panel forward and clicking the **Enable Stamp** and **Draw Stamp** buttons, you can have Blender burn various informational notes into the animation for later reference. Set the panel up as in Figure 4.56 to include both the frame number and the time stamp in the animation. This will make it very easy later on to use the story reel as a reference for timing.

If you would like to show the animation outside of Blender, the render controls that you use for making and saving still images all apply, with a

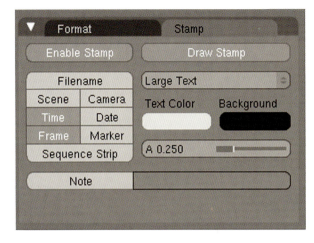

Figure 4.56 The Stamp panel

few additions. First, you must enable the **Do Sequence** button in the **Anim** panel of the **Render Buttons** (**F10**, Figure 4.57). Then you choose one of the animation formats from the **Format** panel: either MOV, AVI, or FFMPEG, depending on your operating system and needs. Finally, you enter a path and filename on the **Output** panel so that Blender knows where to store the animation. Clicking the folder icon to the left of the path field will open the file picker so that you can interactively choose the save path. A good suggestion at this point would be to use the export folder you created in the last chapter. The **Output** and **Format** panels are shown in Figure 4.58. When you are ready to generate an animation of your story reel, press the **Anim** button, as opposed to the **Render** button.

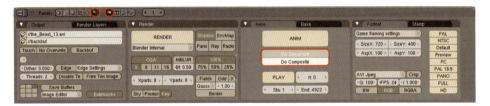

Figure 4.57 The Do Sequence button tells Blender to "render" the strips in the sequencer

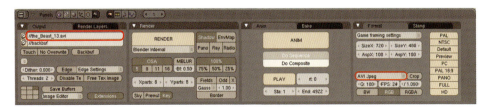

Figure 4.58 The Output and Format panels set to save an animation

Summary

Storyboarding involves the creation of a comic-like series of images that describe the action in your story. Storyboards help to organize your thoughts in the way that action and staging will take place in 3D and can also point out problems in the way the story was constructed.

While storyboards can be drawn with either traditional or digital tools, at some point, they must be brought into the computer and organized. When there, the storyboards are synced with a temporary soundtrack to create a story reel. The story reel becomes the core of your animation production and provides your first chance to get a feel for timing and action.

Outbox

- A series of storyboards that effectively tell your story
- A rough soundtrack to assist with timing
- A master story reel BLEND file that will serve as the basis for all future animation work

The Peach Perspective

On storyboarding: How closely were the storyboards for BBB followed once production began? When you deviated from them, did you reboard or just plow through without them?

Sacha: The storyboards were followed as closely as possible during the entire process. We're talking about composition, action, body language, facial expressions, and so on. When changes in a later phase were necessary, we went back to the storyboard and placed them directly into the animatic. The importance of a storyboard (and later the animatic) also showed the danger of it: Minor flaws that found a way into the storyboard could always be unintentionally copied in the final work. Sometimes storyboards were less detailed, which gave the artists more freedom for interpretation, just as long as it fit in the whole.

Character Design and Creation

Objectives

- Designing in line with your theme and reality
- Modeling based on storyboard requirements
- Mesh animation issues

Inbox

- A story with a well considered theme
- A strong idea about who your characters are
- An ability to use Blender's mesh modeling tools

Designing in Line with Your Theme and Reality

If you have already drawn your storyboards and assembled your story reel, then you have a number of sketches of your characters. If not, that is okay. While basic character design may begin before the story—especially where the story line is driven by the character—character development continues throughout the story development and storyboarding process. It is often useful when working on a project of this size to have several tasks going at once, so that when you are not feeling particularly inspired by one aspect of the production, you can switch to another for a while.

Your instinct may be to sit down with a pencil and pad of paper and start sketching away, and, in fact, that is what you will do soon enough. First, though, there are some things to think about.

The design of a character should reflect and support the theme of your story. For example, let's say that your story is about a lonely monster who wanders the hills in search of the last mossy patch on which to rest its aching bottom, and the theme is something like, "The things we need (i.e., a place to rest, companionship)

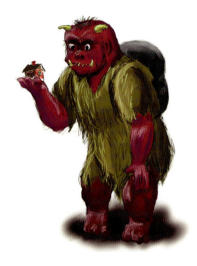

Figure 5.1 *A monster with his world on his back, thinking of home*

are often closer to home than we expect." There are a number of ways you could design such a monster, but before beginning any artwork, you can use that story and theme to narrow your creative search. The monster is lonely, so it must have a bit of sadness to it. It also has a sore backside, which can be reflected in a hunched, awkward looking back configuration, or lopsided legs, etc., so that he walks painfully. Because the theme is one of looking for home, he would probably carry more than just the standard monster gear (club, goat hides, sacks for lost children). The theme suggests that he carries trinkets and mementos of his home with him. If you wanted to go funny, he could carry little monster-style tchotchkes around, tied to his backpack, such as Precious Moments figurines but brown and scaly. If you wanted to go sad, you could have him carry shards of rock or wood from his forest home that had burned to the ground.

When you have the theme foremost in your thoughts, you will find it much easier to create telling and interesting character details.

In addition to theme, you must also decide what level of reality you want to represent. Character design can produce anything from extreme abstraction and stylization to photorealistic digital actors. How you choose to position your characters along that line will depend on the action required in your story, your available resources and, once again, the theme.

The more realistic you make your characters, the more work you will be making for yourself. After a certain point, characters that are very realistic, but not quite perfect, feel creepy to the viewer. This effect is called

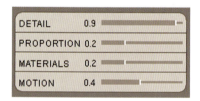

Figure 5.2 *A pretend set of sliders for controlling character realism*

"the uncanny valley," and represents a serious shortfall that you need to avoid. A character that has perfect physical modeling and photorealistic textures will have to move just like a real person. The human brain interprets it visually as "real," and when the motion is off it looks bizarre. As you approach the stylized side of the scale, you have more artistic freedom, both in character creation and in the eventual range of motions and actions when you animate.

If you think of things in terms of a 3D interface such as Blender, there are four "sliders" that control the realism/stylization level of your characters, represented on an imaginary control panel like the one in Figure 5.2.

The axes you can control are:

- *Modeled detail*: Is your character simply modeled, with very few small details, or can you see every muscle striation and skin crease?
- *Proportion*: Standard human proportions, and those for other animals, are well documented. The further you move from the standards (giant head, tiny legs, etc.), the less realistic your character will be.
- *Materials*: This runs the gamut from a completely untextured, default shaded character to one with photographic skin and accompanying normal, specular, and reflectance maps.

- Motion: Can the character squash and stretch beyond the boundaries of what a real skeletal structure would allow? How much? Must it obey the laws of motion of a physical character?

You can mix things up to achieve the appropriate level of realism and stylization for your project. If you look at a promotional shot for *The Beast* (Figure 5.3), you will see that although there is a fair amount of detail in the models, the proportions have been altered from the human ideal, and the materials are very simple. While the character of the mother obeys normal laws of motion and structure, the Beast has the ability to squash and stretch to emphasize his level of babyhood chubbiness and flexibility.

If the action of your story requires some pretty wild things, then you will probably be better suited toward the more stylized end of the scale.

Whichever level of realism versus stylization you choose, you should try to keep it relatively the same for all of your characters. Even if things end up rather abstract, you want to give your viewer the illusion of a believable world with actual characters. It doesn't have to be like our world, but it should at least be internally consistent, which means that the character style should be as well.

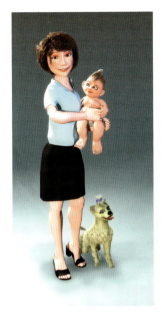

Figure 5.3 *A promotional shot for* The Beast

NOTE

Remember that your character design, with respect to manners of stylization, will need to, in turn, influence your set and prop design. Notice in *The Beast* how the sets are modeled with a fair degree of accuracy, yet, like the characters, use basic materials and shading to keep them from appearing too far to the realistic end of the stylization scale.

The Beast

In *The Beast*, the theme directly informs the look of the characters.

It was decided early on that the Beast would be tough to look at. Quite literally "a face only a mother could love." At the same time, he had to be able to elicit some sort of sympathy from the viewer for the story's ending to work. So the theme and story called for him to be ugly but cute, which was not the easiest thing. With a target in mind, though, I was able to start sketching. While I used ArtRage for digital convenience in storyboarding, I returned to my traditional pencil and paper roots for this stage.

The first attempts were all too nasty to elicit sympathy at any point. The final one, Figure 5.4, was given stamps of approval from friends and family. He's still

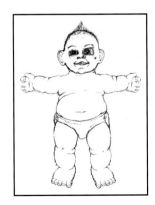

Figure 5.4 *The final sketch of the Beast*

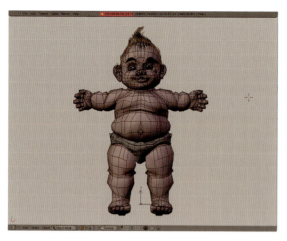
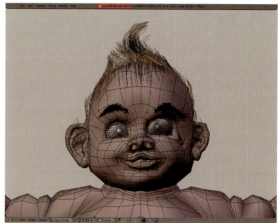

Figures 5.5A–5.5B *The final production model of the Beast*

seriously ugly, but the addition of the single tooth and the large eyes gave me something I could work with when going for a sympathetic facial expression. In Figure 5.5, you can see how closely the final model followed the sketch.

From a practical standpoint, I had to decide how to clothe the little monster. The diaper was obvious, but how did the theme affect the rest of his outfit? Obviously, I decided against giving him anything else to wear. One of the character points created by the theme was the interplay between the Beast and the mean dog: While one is ugly and the other is "well put together," they share their traits of meanness and quickness to hostility. The theme dictated that, because they were different parts of the same idea, the Beast should be as animal-like as possible. So, bare skin.

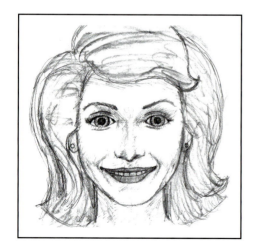

Figure 5.6 *The original sketch of the mom*

The Mom

The mother proposed a particular challenge. Some artists find it easy to create appealing female characters with just the right look. I, on the other hand, do not. The theme and story required that she be pretty and dress nicely. At the same time, I wasn't shooting for a knockout stylization like Jessica Rabbit or grossly overexaggerated anime females. I was feeling particularly creative one evening and got the right look on the very first sketch (Figure 5.6).

The line drawing overemphasized the contours of the face to assist with modeling later, though making the sketch appear older than the final product. Completing the "put together" look that worked with the theme, I gave her a button-down

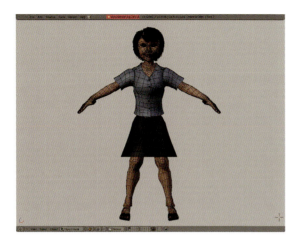

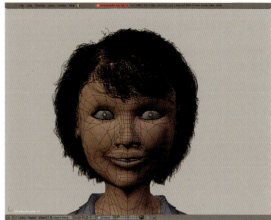

Figures 5.7A–5.7B *The finished mother model*

satiny blouse, a black skirt, and heels. Perhaps a little much for walking around the home, but I wanted, in line with the theme, to make it clear that she puts effort into her appearance.

While the Beast was modeled completely from scratch, I didn't want to take the time to tackle the more realistic requirements of the arms, legs, hands, or feet. Other people have done that time and again, and better than I, so I decided to tap into someone else's assets. For a full discussion of when and how to get outside help, you can see Chapter 13. For now, it's enough to know that those particular elements of the mother character were adaptations of the free MakeHuman project (`http://www.makehuman.org/blog/index.php`).

The Dogs

The dogs are . . . dogs. Because I had made humans from the ground up in Blender before, but never any quadruped mammals, time constraints dictated that this was another area in which I would use an outside asset. I found a free model of a generic dog and modified it to fit my idea of the characters. I knew they would be furry, so the exact underlying geometry wasn't crucial. The rendered fur would mostly cover the underlying polygons, so a clean deformation structure wasn't a necessity. The look called for by the theme and the story was one of a prim and proper poodle-like dog. The fur and curls were carefully placed and groomed, and a bow was added. Because the mean dog was going to be like the Beast in character but not in appearance, the

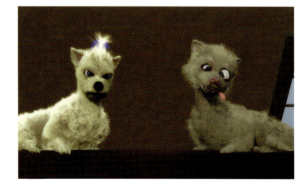

Figure 5.8 *The dogs together*

silly dog needed to have some sort of physical resemblance to the Beast. With all of the fur and nonanalogous anatomy, there weren't a whole lot of options. One of the defining characteristics of the Beast's look was the

lopsided, darkened eyes, and that was carried over to the silly dog. The fur on this dog was less well kept, darker, and had less gloss.

Modeling Based on Storyboard Requirements

A careful examination of your storyboards and the story reel can save you time when designing and modeling your characters.

Faces, Hands, and Clothes

For each of your characters, follow their progress through the story reel to see if complicated modeling items such as faces and hands actually appear on screen, and if so, for how long. It is possible that certain characters would never have a full frame face shot, or that their hands would never appear in the frame without being in motion. If that's the case, you may be able to save modeling time by only using simplified versions of those portions of the model.

Remember that anything that moves quickly will be obscured to a certain degree by motion blur, which can be very forgiving.

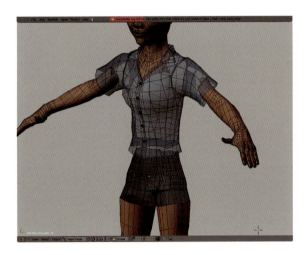

Figure 5.9 *The mesh of the mom from* The Beast

Also, I have seen many people model an entire body with great muscle definition and detail, only to cover it with clothing in the end. All of the time spent modeling the body was wasted. Unless you plan to use the cloth simulator to create real clothing that drapes and deforms along with an underlying body structure, there is no need to model it. Even if you plan to use the cloth simulation tools, you still need to only provide a basic structure to drive the cloth. In Figure 5.9, you can see that there is no body under the shirt and that the anatomy of the upper legs and pelvis are minimal: just enough to provide a reference when animating. For example, the lack of shoulders under the shirt won't be a problem as long as the camera never shoots from an angle that allows it to see clearly up the sleeve.

> **NOTE**
> If you really want to, you can model every character with the maximum degree of detail that your theme and design demands. Keeping in mind the lethal pitfalls mentioned in Chapter 1, though; at this point in the production, you should be wondering, "What can I get away with?"

Level of Detail

The ideal level of mesh detail in your character models will be whatever it takes to not show polygonal edges on curves in your render.

In Figure 5.10, you can clearly see the polygonal nature of the character. However, the same model with a subsurfacing modifier properly applied shows a smooth edge (Figures 5.11–5.12). When working with an animation, it is often better to create models with relatively low base polygon counts and use subsurfacing to

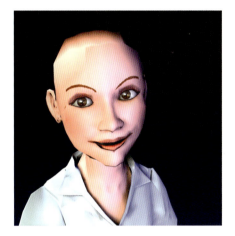

Figure 5.10 *The mom model rendered without subsurfacing*

Figure 5.11 *Rendered with subsurfacing*

smooth them. The ability to quickly and easily change subsurfacing levels and to disable it altogether will save immeasurable time during both animation and rendering.

Figure 5.13 shows the Beast's mesh structure without subsurfacing. It has only 4013 faces, which makes the mesh deformations that happen while animating very responsive. Of course, rendering this sort of model will produce ugly, boxy results. With a subsurf setting of 2, the curves and surface of the Beast's face are appropriate for even extreme close-ups.

Figure 5.12 *The subsurface modifier in the Edit Buttons*

So unless you need to build fine details directly into the mesh, using a simpler basic model that is smoothed with a subsurface modifier works to your advantage in animation. In fact, it is a "built-in" *level of detail* system.

Level of detail refers to rendering models at varying levels of complexity depending on how much of the rendered frame they occupy. If the Beast were to appear far in the background, taking up less than, say, 20 pixels from top to bottom in the final render, there would be no reason to enable the subsurface modifier. The 4013 face base model would be more than sufficient, and to use it unmodified could potentially save a great deal of

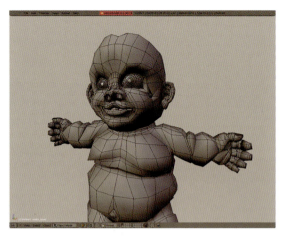

Figure 5.13 *The raw Beast model*

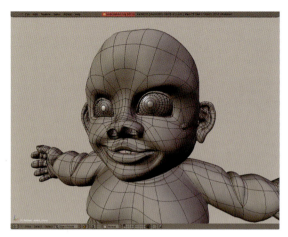

Figure 5.14 *A close-up of the Beast with two levels of subsurfacing*

render time. We'll revisit this sort of optimization in Chapter 15 when we look at rendering and compositing, but the strategy begins at modeling time.

Normal Mapping for Greater Detail at Lower Resolutions

Even if you need to have fine details in your model, you can often get away with using a lower resolution model and the help of a *normal map*. A normal map changes the way the renderer draws surfaces. It can give the illusion of a much higher level of mesh detail than actually exists. Blender allows you to have two versions of a model, one with a resolution useful for animation and fast rendering and one with very high resolution that contains carefully sculpted details. The high resolution details are baked into a normal map, which is then applied to

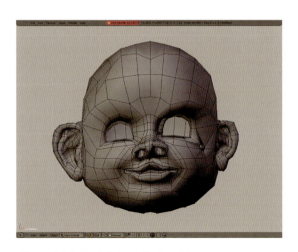
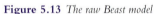

Figure 5.15 *The baby's raw head model*

the normal resolution model. Although the technique was not used in *The Beast*, we'll demonstrate the feature with model of the baby.

Let's say that we wanted to add a nasty scar to the Beast's forehead but didn't want the very high polygon counts it would require if we added it directly to the model.

Figure 5.15 shows the unmodified head model of the baby. It has 1,248 faces. To add detail and create a normal map, we must make a duplicate of the model (**Shift-D**). On the duplicate, any modifiers are removed to ensure that we are working on a "clean" copy. Then four levels of multiresolution are added through the **Multires** panel of the Edit buttons. If you have not worked with multiresolution

and the sculpting tools before, it is enough to know that Multires is a sort of interactive subsurfacing that allows you to work on the model at any level of detail without losing alterations made at other levels.

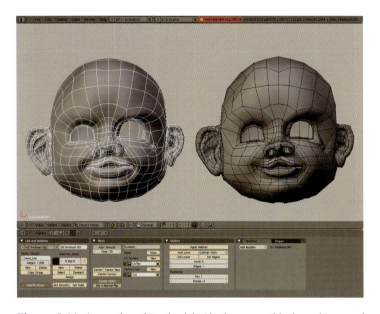

Figure 5.16 *A smooth multires head beside the raw model; the multires panel appears at the bottom*

The high-resolution duplicate has 318,831 faces, which would be a nightmare to work with during animation. Details such as forehead wrinkles are added, either via traditional mesh editing tools or sculpting. In this example, I have placed a horrific scar and bump on his forehead with the sculpting tools, which the mean dog no doubt gave him after the conclusion of the animation (Figure 5.17).

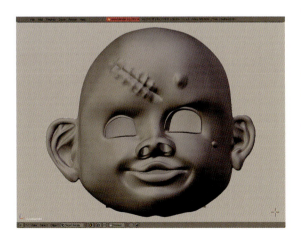

Figure 5.17 *The high resolution mesh with finely sculpted detail*

The low resolution model must then be given UV coordinates so the normal map knows where to go. If you have already unwrapped your character model, then this step is already finished. If not, you don't need to be overly concerned with an optimized mapping. Simply adding a few strategic seams to the model and choosing the default **Unwrap** option from the **U** key pop-up menu will most likely be good enough. The low resolution baby's head unwrapped with two seams can be seen in Figure 5.18. At this point, it is crucial to add an image to the unwrapped mesh in a **UV/Image Editor** window. If you don't add an image, the bake will be lost.

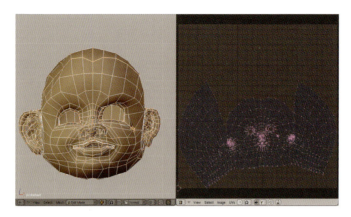

Figure 5.18 *The default unwrap for the head*

Now, the two models must be placed at the same point in space, which can either be accomplished through using the Snap tools or selecting both objects and using **Ctrl-C**. Then, on the **Bake** panel of the Render Buttons, both the **Selected to Active** and the **Normals** buttons are enabled and the normal space is set to **Tangent**, as in Figure 5.19.

The baking process moves from *selected object* to *active object*, so be sure to select the high-resolution mesh first, followed by the low-resolution one. With both selected, and making certain that the low-resolution mode mesh was selected last, making it the active object, press the **Bake** button. Blender will chug for a little bit because it is rendering an image that represents the difference between the normals of the high and low resolution objects. When it is finished, check the **UV/Image Editor** window to see the result (Figure 5.20).

Figure 5.19 *Ready for Normal baking*

At this point, you should save the normal map to a file so you don't lose it. It can then be used on the low-resolution model by setting your materials appropriately. The crucial settings are the **Normal Map** and **Tangent** settings in the Texture buttons, and using **UV** texture coordinates and the **Nor** button in the Material settings, as shown in Figure 5.21. Make sure to use the **Image** texture type and to **Load** the saved normal map image into the texture.

Now a render shows the scar appearing on the low-resolution head, but without the almost 400,000 polygons of the sculpted model. A side-by-side comparison shows very little visual difference between the two rendered

Figure 5.20 *A simple normal map*

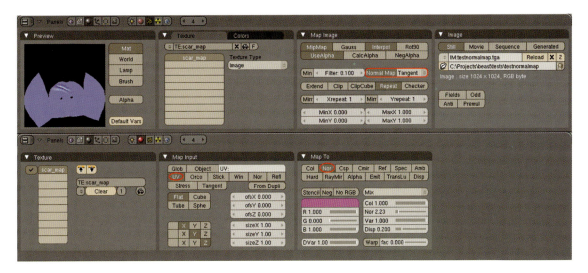

Figure 5.21 *Material and Texture settings to use a Tangent Space Normal Map*

models (Figure 5.22), with the exception of shadows cast by the displaced geometry. Try not to let the image of the disembodied scarred head of a mean baby haunt you.

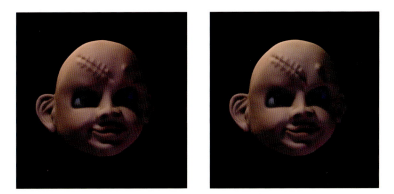

Figure 5.22 *Both the high-resolution and low-resolution, normal mapped models, rendered*

Clearly, this technique can save you large amounts of render time while allowing you to add fine detail to your models, which is ideal for animation. Remember, though, that this is only a shading technique. Normal mapping will not add real geometry to your models. This means that while it is ideal for adding wrinkles, small scars, and skin texturing, it will not be useful for adding horns to a forehead or any other kind of pronounced structures.

Mesh Animation Issues

Modeling a character for animation is different than working toward a still image. All of the same skills and techniques apply, but there are some additional restrictions and targets to keep in mind.

Quads, Edge Loops, and Joints

Rule number one when modeling organic characters for animation: triangles are right out.

When working with animation in which armatures and other structures will be deforming your character's mesh, everything simply works better with quads. You will almost certainly be using **Subsurf** modifiers on your models, too, which likewise produce better results with quads. If you've been modeling with triangles exclusively, this may take some getting used to.

Figures 5.23 and 5.24 show the Beast with both triangles and quads. You wouldn't think it would make much of a difference because quads are just two triangles with a concurrent edge, right? Figures 5.25 and 5.26 show a close-up of the Beast with his arm raised and the mesh structure with a subsurf modifier in place. The one using triangles (Figure 5.25) shows a repeating rosette-style pattern of faces and some ugly glitches in the deformation. The deformation and subsurfing done with quads (Figure 5.26) maintain the original mesh structure, only at a higher resolution.

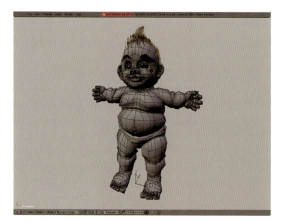
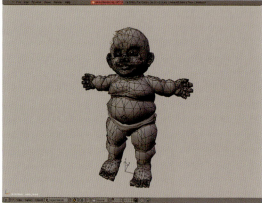

Figures 5.23–5.24 *The Beast model with both triangles and quads*

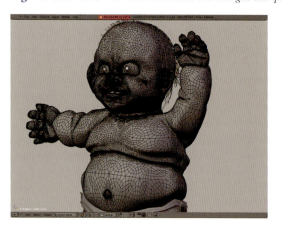
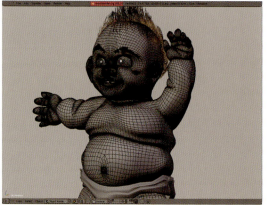

Figures 525–5.26 *The triangle and quad meshes deformed and subsurfaced*

When you use quads for your modeling, you can construct what many (but not all) consider to be the Holy Grail of animation meshes: the *loop*. Face loops are rings of quad faces that follow the contours and underlying musculature of a character. They produce significantly more realistic deformations when animated than would be created with a simple grid pattern of faces. In Figure 5.27, two edge loops have been highlighted on the Beast's face. Edge loops and face loops are closely related, with the distinction being that face loops are composed of faces and edge loops are composed of … shockingly, edges. Although edge loops will help in almost any deformation situation, they are most important around the eyes and mouth because they are the most expressive parts of the face.

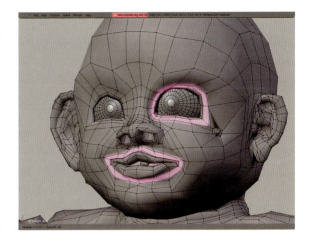

Figure 5.27 *Eye and mouth edge loops*

Entire books have been written about the mesh topology of human models. Some animators and modelers spend a large portion of their time painstakingly tweaking their characters until every single triangle is eliminated and the edge looping structure is a thing of simple elegance. Indeed, you may find someday that you, too, want to do that. But my guess is that today, you want to get working on your character.

On the disc that comes with this book is a generic head structure, with edge loops already in place and nary a triangle to darken your deformations (Figure 5.28, basic_head.blend on disc). This mesh structure can be laid

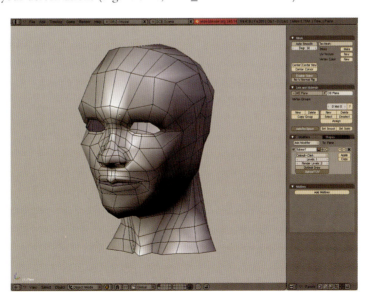

Figure 5.28 *A basic, low resolution edge looped head*

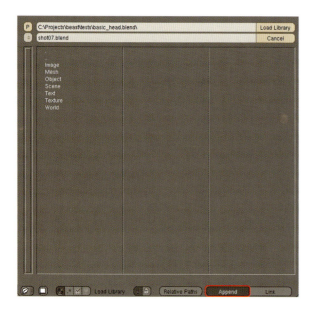

Figure 5.29 *The Append Library window*

on top of a reference image and the mesh pushed around to fit. It will not fit every single case you can think of, but I have been using it as a starting point for my characters' heads for a while, and it has yet to fail me.

If you want to use the looped head as a basis for your own model, here is how you can do it. First, create a new BLEND file and press **Ctrl-F1** to open the file browser. **Ctrl-F1** opens the browser in a special mode that does not load a new file entirely, but lets you pick and choose parts of other BLEND files to add into the current one. Browse to the basic_head.blend file on the disc and click on the filename with the left mouse button. You will see a list of Blender data types that looks like Figure 5.29.

Confirm that the **Append** button is enabled at the bottom of the screen, as it is highlighted in the figure. Left mouse button click on **Object**, followed by a middle mouse button click on the entry **basic_head**, which is the head object within the other file. The 3D view returns with a copy of the basic head model added to your scene.

At this point, you can play around with it freestyle to see how far you can push the geometry. Or, if you have reference drawings, you can load them in as a background image. On the 3D view header, select **Background Image** from the **View** menu. This brings up a floating panel that lets you choose and load an image for reference, as in Figure 5.30. If the image is the wrong size or out of position, you can use the panel's **Offset** and **Size** controls to adjust it. When working on a face like this, it can be useful to divide the Blender screen into two 3D views, one for a front and one for a side view. Each view can have its own reference simply by setting different images on their respective Background Image panels. Figure 5.31 shows such a setup.

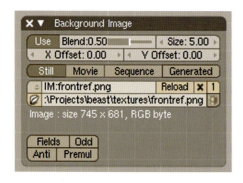

Figure 5.30 *The Background Image panel*

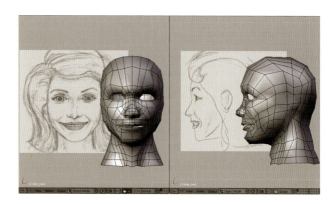

Figure 5.31 *A front and side view with separate references*

Now you begin switching back and forth in the different views, pulling the vertices to match the contours of the references. It is usually easiest to start with the eyes. Of course, if you want to make things even easier, you can simply select and delete half of the head mesh and enable a **Mirror** modifier. The odds are slim that your reference will be exactly symmetrical, but it should be close enough that you can begin to work this way.

Occasionally leave Edit mode (**Tab** key), and use the **Z** key to toggle into and out of **Solid** mode to see how your work is coming along. To enhance the preview, add a **Subsurf** modifier and use the **Set Smooth** command on the mesh from the **W** key specials menu.

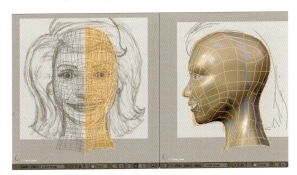

Using this work flow, you can quickly get a model with good mesh topology that looks reasonably like your reference. To get closer to the reference, you will have to apply both the subsurf and mirror modifiers and begin working at a finer level of detail. In the end, the amount of detail you add and how

Figure 5.32 *A work in progress head, mirrored and using subsurfacing*

closely you match your reference is up to you. However, when you're in 3D, don't let yourself be a slave to the reference. If something looks good when you begin to model, and it still fits with the theme of the story and how that applies to your character design, go with it, whether or not it exactly matches your original plan. Many wonderful things can present themselves when you are in a creative groove, and it would be a shame to ignore them.

In addition to the face, the one other area of geometry that is crucial to good animation is the joints. Anywhere that your character will bend and twist requires enough geometry to do so smoothly, while not so

much that it becomes difficult to deal with. Also, if a joint is going to bend until a crease forms in the skin, like the inner portion of an elbow joint, you need to make sure that the geometry provides a good line for the crease. The real trick to working with joints lies in the rigging and skinning, which we will cover in a later chapter, but like so many other things, it helps to have the proper work in place from the beginning.

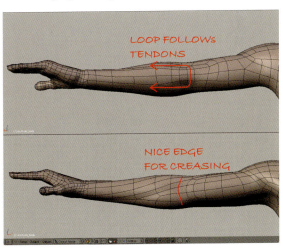

If you take a look at the excellent elbow joint modeling (Figure 5.33) from the MakeHuman project mentioned earlier, you can see both a nice line of edges that will form the inner crease of a bent arm on the bottom and an edge loop around the outside portion of the elbow where the tendons wrap under the skin at the top.

Figure 5.33 *The MakeHuman elbow, with an edge line for the inner crease*

Bind Pose

A character modeled for a still image can often be created from the ground up near its final pose. When working with animation, you have to create the character in a neutral position so that it can later be rigged and then posed with the animation tools. The optimal position in which to create your character looks like Figure 5.34.

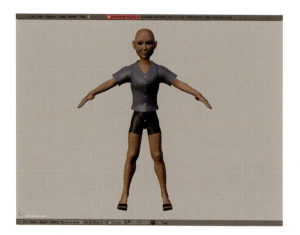 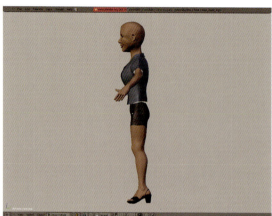

Figure 5.34 *The unposed mom character mesh*

Figure 5.34 is called the *bind pose* because it is the pose to which you will bind the armature or other rigging tools that will make it capable of animation. Notice how each of the joints is slightly flexed. This gives the eventual armature, which we will look at in Chapter 9, some guidance when deciding how to move.

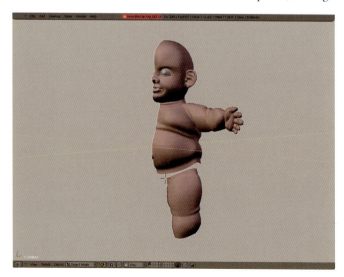

Figure 5.35 *The half of the Beast that was actually modeled*

Modeling in the bind pose, called *Rest Position* in Blender and sometimes called the *Jesus* or *T Pose* in online documentation, can save you time because it begins its life symmetrically.

When creating your character model, be sure to use the **Mirror** modifier, at least in the early stages. Figures 5.35, 5.36, and 5.37 show the Beast during the creation process with the mirror modifier in place and with symmetry removed after the modifier is applied.

Figure 5.38 shows the mirror modifier settings that are most useful. The **Do Clipping** button makes any vertices of

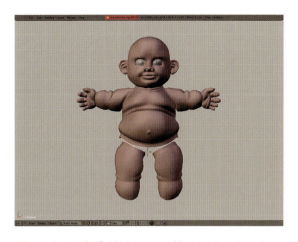

Figure 5.36 *The finished Beast model with Mirror turned on*

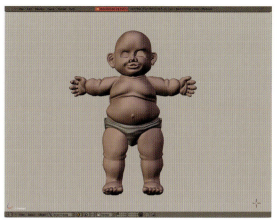

Figure 5.37 *Mirror has been applied, and the model has been altered asymmetrically*

Figure 5.38 *The modifiers panel, with a Mirror modifier added*

your model that cross the mirror line stick to it. This guarantees that your model won't end up with any open spaces along the middle when you **Apply** the modifier. While working with the Mirror modifier, you will find that you can only select and work with the vertices on the "original" side of the model. If you want to be able to work directly on either side, you need to enable the "Live in Edit Mode" icon on the modifier, highlighted in red on Figure 5.38.

If you plan to also use a **Subsurf** modifier, it should appear below the Mirror modifier in the **Modifiers** panel. Placing it above the mirror modifier or failing to enable **Do Clipping** can cause Blender to treat the two halves as separate entities as opposed to a single, joined model, leading to the results in Figure 5.39. Note the shading seam down the center line of the model.

Polygon Count

In the level of detail section of this chapter, we talked about keeping the polygon count to a minimum and using both the subsurf modifier and normal mapping to produce high quality renders while allowing flexibility in the work flow.

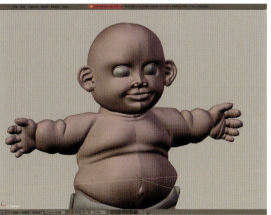

Figure 5.39 *Blender subsurfacing a mirrored model without joining the halves*

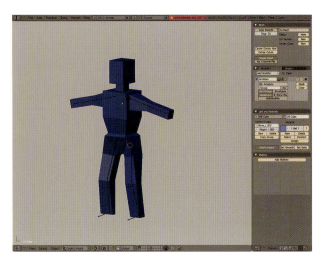

The maximum number of polygons that your particular system will be able to work with while animating is impossible to predict. To help you figure it out, we have included a file called, "animation_poly_testing.blend" on the disc that comes with this book. When you open the file in Blender, you will see the screen in Figure 5.40. The file includes a simple mesh and a control armature. In its raw state, the mesh only has 92 vertices, and no computer made in the last 5 years should have trouble deforming it in real time.

Figure 5.40 *The animation responsiveness test blend*

Right mouse button select either of the foot bones or the orange arm or neck bones and move them around. This is as responsive as the animation system gets. What we're going to try to do is to find the upper limit of your system's responsiveness.

Figure 5.41 *Subdivide Multi on the W key specials menu*

Select the mesh again, go into **Edit Mode** with the **Tab** key, and select all of the vertices with the **A** key. From the **W** key specials menu, choose **Subdivide Multi**, as in Figure 5.41, and set it to use **3** cuts. This will bring the mesh's vertex count to 1442. Leave edit mode and play with the armature again. You should still be fine.

Do another **Subdivide Multi** on the mesh, this time choosing **2** cuts, to bring the vertex count to 12,962. At this point, depending on how powerful your system is, you might experience something a little different when you move the armature. It will still be very responsive, but it will not be the same as previous rounds of the test. If it still feels the same to you, then feel free to keep going until you can really notice a slowdown in the way Blender responds to moving the armature and deforming the mesh.

Your goal is to find a level of polygonal detail that will allow you to model with relative accuracy but still give you a good feel while you are animating. On *The Beast*, which was mainly animated on an Athlon 64 X2 with 2 GB RAM, an NVIDIA FX550 card and Windows XP, I decided to keep the basic meshes below 10,000 vertices.

When you actually get to animating, there will be things that frustrate you: complicated rigging situations you hadn't considered, character/prop interplay, glitches. Don't let a vertex count that is too high for quick working animation response compound those problems.

So, in line with the advice given previously in the section about level of detail, you will want your character models to remain under the vertex level where your system begins to slow when animating and use a **Subsurf** modifier and possibly normal mapping to provide the additional smoothness and detail you need for great final renders.

Preparing the Model for Future Work

Before we leave the world of character design and modeling, there is one more crucial thing you must do. The next time we visit the character models, we will be rigging, skinning, and performing test animations. For that to work without surprises, and for your characters to be successfully integrated into your scenes, the following rules must be obeyed:

- Apply any mirror modifiers.
- Use the **Center Cursor** button on the **Mesh** panel of the **Edit buttons** in conjunction with the **3D Cursor** to place your character object's center point near its center of gravity (usually somewhere in the pelvis).
- Use **Alt-G** to reset your character model at the origin of the scene.
- Make sure that your character is in scale with any other characters already created. If you need to, use **Shift-F1** to append another character model you've already created into the file (we'll learn all about this kind of "importing" functionality in the next chapter). If this is your first character, then it becomes the reference for all others that come after it.
- Use **Ctrl-A** to apply any scaling or rotation that has been done to your model.

WARNING

If you do not do these simple things, you could literally waste weeks of work. The rigging, skinning, and animation tools work best with a model for which scale, rotation, and origin are all at the defaults, like the **N** key pop-up panel in Figure 5.42.

✕ ▼ Transform Properties	
OB: Cube	Par:
LocX: 0.000	RotX: 0.000
LocY: 0.000	RotY: 0.000
LocZ: 0.000	RotZ: 0.000
ScaleX: 1.000	DimX: 15.049
ScaleY: 1.000	DimY: 3.080
ScaleZ: 1.000	DimZ: 18.372
Link Scale	

Figure 5.42 *The scale, translation, and rotation values for a properly prepared character model*

Summary

The design of your characters is constrained by the theme, how the characters are used in the storyboards, and by the needs of maintaining responsiveness during animation and good deformations in the final render.

Character design will both be informed by and strengthen the theme. The realism of characters will depend upon your resources and the goals of your animation.

While modeling characters, they need to be high enough in resolution to look good when rendered but small enough in face count to provide a good experience when working with the animation tools. Often a subsurface modifier and normal mapping can provide an excellent solution to this dilemma. The requirements of animation must also be respected, with quads and edge loops playing a major role in achieving good deformations later.

Outbox

● Character models ready to be rigged and skinned for animation

The Peach Perspective

On character design: When designing the characters for BBB, how closely were your decisions informed by the technical constraints you knew you would face in production? Did it limit your designs, or did you simply think, "The coders can catch up?"

Sacha: We wanted to show what we're capable of, so limiting the design just for the sake of "not getting into problems later on" wasn't an option. It was actually more the other way around. At one point we decided to give a character a special ability—the flying squirrel—which made things much more complicated for us. For some time we thought about whether to use it or not, but because it was too cool we decided to just go for it. The only kind of limitation we kept in mind was the amount of characters to have in the movie. But even with that we took it a bit too far. "Hey, let's add a bird as a side character..."

Libraries and Linking

Objectives

- Libraries, and why you should bother
- Linking assets that do not animate
- Linking assets for object-level animation
- Linking assets for character animation
- Managing your links and libraries

Libraries, and Why You Should Bother

Imagine for a moment that you are working on a large-scale animation project that includes many scene files, each representing a different camera view and portion of the overall timeline. Of course, because this will eventually be edited into one continuous animation, the different scene files all need to contain the same models of the characters and sets, the same materials, and the same lighting. The most obvious solution is to create one master scene file that contains all of your characters, sets lamps, and cameras. Then you create a bunch of duplicate files and rename and use each duplicate for a separate shot.

Perfect, right?

Well, what if after you begin working, you realize that the way you weight painted the main character's mesh just isn't giving good enough deformations? And let's say you've already animated 5 out of 20 shots. Or more simply but significantly worse, "What if you want to tweak a material setting? Do your characters share materials or do they contain duplicates? Will you have to edit every duplicate of that material in every shot file to get it all to match?" Immediately you see the shortcoming of the simple duplication method: Any change you make to any element must be made in the same way on every copy of the file.

That could be . . . cumbersome and result in a lot of potentially large BLEND files.

In a hidden hole of functionality even darker than the one where the Video Sequence Editor hides, Blender has an entire workflow devised to solve this very problem: the *library* and *linking* system. Using this system, each and every BLEND file you have created or will create can be treated as a library of assets: models, armatures, materials, lamps, cameras, and even entire scenes.

You can import those assets into your current BLEND file, making them *local* (duplicated) assets, as discussed in Chapter 3, or, you can choose to import them as *links*. When an asset is brought into another BLEND file as a link, it appears but is for the most part "untouchable." You cannot edit or change the linked version of the asset in the current BLEND file. However, if you go back to the original file that holds the local version of the asset and make changes, those changes will show up in each and every BLEND file that has linked to it. This is the magic you're going to need for a project that will span dozens of files and months of time!

Unfortunately, not every part of a BLEND file is a linkable asset. Things such as node networks and groups of render settings are not linkable. User interface configurations are not linkable. However, almost all of the assets you will use to produce your animation—mesh models, armatures, materials, lamps, even entire scenes—are linkable. Basically, if you can assign a name to it in Blender, you can link to it as a library.

Before you learn how to actually link to assets, let's take a look at the way that one of the final shot files from *The Beast* is constructed so you know where we're headed. If you want to examine this file in Blender for yourself, it is called, "beast/production/scenes/shot07.blend" on the included disk.

A

B **C**

Figures 6.1A–6.1C *A shot file from* The Beast *in production*

Although it is full of everything you need to successfully render a scene, this file (Figure 6.1) has very few local assets. The characters (Figure 6.1A), including their materials and particle systems, are all linked to their respective files in the /production/models/ directory. The set and almost all of the lamps (Figure 6.1B) are linked as an entire scene to the appropriate set in the /production/sets/ directory. The toy car that bounces off the dog's head and the phone in the mother's hand (Figure 6.1C) are linked to their own files in the *models* directory. The few assets that are local to the shot07.blend file are: the actual animation data for the characters and the spot lamps that follow the characters.

If that BLEND file is moved out of the organized directory structure and opened, it will not know where to find all of its linked assets, and it will appear as it does in Figure 6.2. All that is left are the local assets of the spot lamp, the skirt, and a couple Empties that acted as animation stand-ins for the phone and car.

Figure 6.2 *shot07.blend opened without its library linked assets*

Each "shot" file in the scenes directory is constructed this way, meaning that any changes made to assets in the sets or models directories will automatically carry through when that shot's file is opened for work or rendering.

In fact, each individual asset has its own master BLEND file, either in the models or the sets directory. Figure 6.3 shows the file patheticbear.blend from the models directory. This file contains the Beast's stuffed animal toy. The file has mesh objects, an armature, and a deformation lattice, all of which are necessary to animate the toy. These objects are all named appropriately (pathetic_arm, patheticbear, path_eye, path_mouth, path_lat), so they are easy to keep track of when part of a crowded scene, and they are easy to identify when creating the asset links. In addition to the assets that we want to link to, the file also contains a camera and some lamps, which were used for test renders while building the model. These objects can be left in the file for later testing and tweaking because they can simply be ignored during the linking process.

Figure 6.3 *The Beast's pathetic bear toy*

As a best practice, both the main mesh object and the controlling armature have no transformations applied to them within the library file. Looked at through the **N** key **Transform Properties** pop-up panel, they show Locations of 0, Rotations of 0, and Scales of 1 (Figure 6.4). The **DimX/Y/Z** fields show the actual dimensions of the object, so you don't need to worry about forcing them to any specific values.

So your models directory will eventually consist of one file for each separate asset in your final production. You can see the directory listing from *The Beast*'s models directory in Figure 6.5.

Figure 6.4 *A "zeroed" transformation panel*

Name	Size	Type ▲	Date Modified
📁 !temp		File Folder	2/9/2008 11:31 AM
badpoodle.blend	14,162 KB	Blender .blend File	1/24/2008 9:45 PM
badpoodlelaying.blend	7,706 KB	Blender .blend File	2/8/2008 11:15 PM
ball.blend	215 KB	Blender .blend File	11/23/2007 9:55 AM
bay-window.blend	192 KB	Blender .blend File	5/7/2007 6:20 PM
binky.blend	311 KB	Blender .blend File	11/22/2007 9:52 PM
bonetoy.blend	6,559 KB	Blender .blend File	11/6/2007 9:49 PM
chewtoys.blend	300 KB	Blender .blend File	12/4/2007 7:13 PM
concept-sedan-02-sport.blend	746 KB	Blender .blend File	11/23/2007 9:19 PM
couch.blend	890 KB	Blender .blend File	1/16/2008 9:01 PM
dogwords.blend	187 KB	Blender .blend File	11/14/2007 6:10 PM
exterior-door-07.blend	199 KB	Blender .blend File	5/7/2007 6:11 PM
flowerpots.blend	1,201 KB	Blender .blend File	12/11/2007 2:23 PM
fridge.blend	127 KB	Blender .blend File	5/7/2007 7:01 PM
kitchen-sink-double.blend	303 KB	Blender .blend File	5/7/2007 7:19 PM
mom_harmonic.blend	22,265 KB	Blender .blend File	2/8/2008 10:23 PM
mom_Words.blend	119 KB	Blender .blend File	11/26/2007 10:00 PM
oriental-rug.blend	1,977 KB	Blender .blend File	5/7/2007 7:16 PM
patheticbear.blend	1,252 KB	Blender .blend File	12/7/2007 9:02 AM
phone.blend	288 KB	Blender .blend File	11/27/2007 7:38 PM
rattle.blend	298 KB	Blender .blend File	10/30/2007 8:27 PM
roughset.blend	144 KB	Blender .blend File	9/4/2007 8:52 PM
sillypoodle.blend	7,105 KB	Blender .blend File	1/27/2008 10:49 AM
sillypoodlelaying.blend	8,527 KB	Blender .blend File	2/8/2008 11:16 PM
sprayer.blend	226 KB	Blender .blend File	12/17/2007 7:20 PM
the_Beast_harmonic.blend	7,740 KB	Blender .blend File	2/8/2008 6:59 PM
the_Beast_headless.blend	5,957 KB	Blender .blend File	12/4/2007 12:03 AM

Figure 6.5 *The models directory of* The Beast

Let's examine each of the pieces in the shot from Figure 6.2 to learn the different ways to link and use your assets.

Linking Assets That Do Not Animate

In an animation production, assets that do not move are called the *set*. Linking set assets is the simplest form of library use and a good place to start.

Create a new BLEND file and save it.

> **WARNING**
>
> It is crucial that you save any new BLEND file before attempting to link assets into it. If you do not save the file first, the assets will be linked with the wrong settings, possibly causing problems when you go to render months from now. We'll look at how to fix linking problems like this later in this chapter, but you should get in the habit of immediately saving your files upon creation.

Press **Shift–F1**, or choose **Append or Link** from the main **File** menu, which will bring up the file picker/browser as shown in Figure 6.6. Just as in Chapter 5, you navigate to the BLEND file that contains the assets you would like to link and click on it as though the file itself were just another directory that you would like to browse. In fact, it is just that. Blender presents the contents of the file in a directory-like format, showing all of the categories of assets that are available. For now, we will only be diving into the **Object** "directory." This example, shown in Figure 6.6, will link in the model of the refrigerator from the file fullset.blend in the sets directory from the Beast production.

As you can see, the list of available objects is extensive. Before selecting the fridge object, you need to enable both the **Link** and **Relative Paths** buttons on the bottom header of the picker window. They are

Figure 6.6 *The contents of the Object directory within fullset.blend*

highlighted in Figure 6.6. If you use **Append** instead of **Link**, a full local copy of the fridge would be created in the current BLEND file. It would be the equivalent of "importing" the object and would not maintain any kind of link to the original asset. If **Relative Paths** is not used, then Blender will look for the fridge asset in the same place in the computer's directory structure as it is now. That may seem like a good thing until you realize that you may be working with these files on different computers and sending them to a render farm at some point. When that happens, unless the drive names and directory structures of all other systems you will use are identical to the original machine, the link will fail.

With **Link** and **Relative Paths** enabled, you can click on the fridge entry in the list with the middle mouse button to immediately link it into the current file.

> **NOTE**
> Middle mouse button in the file picker is a shortcut for selecting the file and clicking the **Load Library** button.

If you are following along on your computer, you may have to enable all layers (` key) and zoom out a bit to find the fridge object. The first thing you will notice is that the fridge appears in the scene in the same location it held in the original library file.

> **NOTE**
> Linked assets will appear in your scene with the transformation they currently have within their original library file.

Also, although it is not easily seen in a solid view (Figure 6.7), the fridge's outline and wireframe representation are a light blue (Figure 6.8). An object that is linked in from a library file has a dark blue wireframe

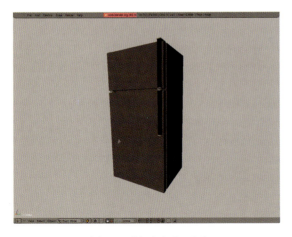

Figure 6.7 *A solid view of the linked in fridge*

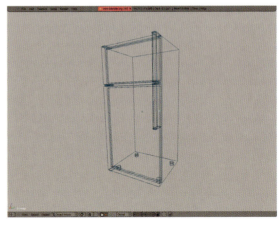

Figure 6.8 *The same object in wireframe*

when not selected and a light blue one in its selected state. The normal colors for a local object are black and white, respectively (or purple, if you are using Blender's default theme.).

Remember how we said that this was the linking method to use for objects that did not move? If you select the fridge object and attempt to transform it in any way, nothing will happen. The fridge is anchored in place. This is because everything about the object, including transform data such as location, rotation, and scale, is merely being referenced from the original library file.

There are a couple of things you can do to such an object, though, to help organize your scene.

- You can move linked library objects to different layers. Pressing the **M** key to pop-up the layers panel lets you send the fridge to a different layer.
- Linked objects can be added to and removed from Groups. Groups are used for both organizational purposes and for restricting certain lighting and simulation effects.
- The visibility, selectability, and renderability of linked objects can be toggled in an Outliner window (Figure 6.9).

Figure 6.9 *The three toggles in the Outliner window*

While we're on the topic of the Outliner, notice the little "Li" icon to the right of the fridge entry. It indicates that the designated object is, in fact, linked in from a library.

Of course, there may come a time when all of the indicators that an object is linked and not local escape you, and you try to do something to the object that is not allowed, such entering **Edit Mode** with the **Tab** key. If you try to perform an operation on a linked object, you will see the message in Figure 6.10, "Error: Can't edit external libdata".

Figure 6.10 *The error message for trying to edit a linked object*

With the fridge object selected, examine the **Materials** context (F5) of the **Edit** buttons. You will see, as in Figure 6.11, that the object's materials have also been brought in as links automatically. Note the "Li" icon

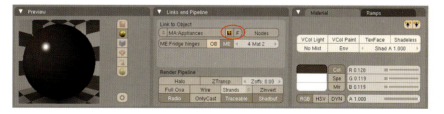

Figure 6.11 *The linked fridge material*

beside the material name. And, just like with the object itself, attempting to alter this linked material results in the same error message as before.

Of course, your set will probably consist of more than a single object, and to link every element of the set into each of your shots piece-by-piece would grow tedious.

Let's back up a step to find the solution. Within a single BLEND file, you can have several **Scenes**. If you've only worked with still imagery, you may not have encountered anything other than the default scene. Now is the time. Located on the main header is the drop-down menu for choosing and adding Scenes (Figure 6.12). A scene itself is a single library asset that you can link into another file.

Figure 6.12 *The Scene selector on the main header*

Delete the fridge object from the current scene, and reopen the **Append or Link** file picker with **Shift–F1**. Blender returns you to the same place in the file that you were before, the Object directory. Click on the **P** button or the **".."** (Figure 6.13) in the file list to go up to the listing of asset types. From there, choose **Scene**, and select the scene called **fullset**, making sure that both **Link** and **Relative Paths** are enabled on the header. The scene is linked into your current file, even though nothing looks different right now.

To see the newly linked scene, look at the main header where the Scenes drop down presents you with a second scene to choose from. Select **fullset** from the menu, and you will see Figure 6.14 (you may have to enable all layers and adjust your 3D view to see it exactly like this).

That would have been a lot of stuff to bring in had it been done object by object! Notice the orange "Li" icon beside the scene's name, indicating that it is a linked asset.

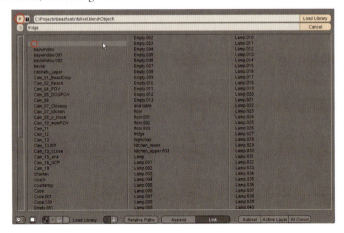

Figure 6.13 *Moving up a level in a file's asset structure*

Every object that is in the Scene called "fullset" in the library file is here, including the lamps and cameras. Selecting any of these objects that were brought in as part of the linked scene shows the same color scheme of blue outlines. There is one difference, though, from the linked fridge object we brought in before. Notice, in Figure 6.15, that the "Li" icon beside their object names in the Outliner is red. Hovering the mouse over one of these icons reveals that they are called "Indirect Library Block[s]." You may have guessed that this is because the scene itself is the directly linked object, while any items brought along with it are only there through that first link. Thus, they are *indirectly linked*.

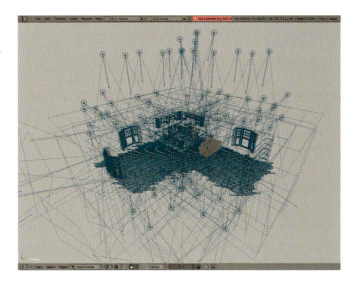

Figure 6.14 *The linked set*

Because these objects are indirect links, you cannot even move them to other layers as you could with a directly linked object. If your sets are well constructed, though, this is not a problem.

Back in the original blank scene (not the one called "fullset"), check out the Scene buttons (**F10**). Here's one more Blender secret: There is an unlabeled control on the Output panel that lets you use another scene as an unselectable set, which appears ghosted in wireframe view. Clicking the pop-up control highlighted in Figure 6.16 brings up a list of all scenes in the BLEND file. It doesn't care whether the scenes are local assets or links. So, selecting "fullset" from the menu that comes up uses the linked "fullset" scene as a set for the default scene. Figure 6.17 shows how the set appears grayed out, or ghosted. The great advantage of using this function is that nothing in this set is selectable from the main scene, meaning that you are free to work without the large number of objects that make up the set getting in your way as you select and work with your characters and interactive props.

Figure 6.15 *The icon that designates an indirectly linked asset*

Figure 6.16 *The Sets pop-up menu on the Output panel of the Scene buttons*

Now witness the power of this fully armed and operational linking system: You can link in as many set scenes as you care to. If you have half a dozen set files that are optimized with lighting schemes and levels of detail for different camera angles, you can link each and every one into your shot files with almost no overhead. It costs next to nothing to do so from Blender's standpoint, and you can easily switch between sets by choosing different ones from the pop-up in the Scene buttons. And, because the set scenes are all linked in from your master files, any changes that you make to the original models, lighting, or anything else in your sets automatically propagates to every shot file in your production. Your files are always up to date. Problem solved!

In the chapter on set creation, we will look at exactly how to build and structure your set file (or files) to make the best use of this system.

Linking Assets for Object-Level Animation

Obviously, if you are producing an animation, certain things are going to have to be, well, animated. Before we get to character animation, we'll take a look at dealing with the animation of objects that don't contain control structures such as armatures, and that don't require deformation. This type of object is called a *prop*. It is something that the characters in

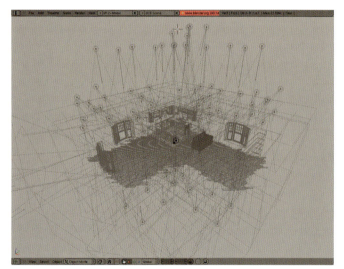

Figure 6.17 *"Fullset" brought in as a set for the main scene*

your story will interact with. It can change over time and will often have to be synced with the actions of the characters. Therefore, it cannot be a part of the set. There are two techniques to achieve this functionality, each with their own strengths and drawbacks.

Creating an Animation Proxy

The first and simplest method is to create a **proxy** of the linked object and use that proxy object for animation. A proxy, by its definition, is a stand-in for the real object. In Blender's case, creating an animation proxy makes a local duplicate of the object in question that retains its reference to the original library asset.

If you are working along, use **Shift-F1** to link in the object called "phone_ob" from the library BLEND file phone.blend in the models folder. Doing so will make a wireless phone handset appear at the origin (0,0,0) in

the main scene, as in Figure 6.18. Select the phone and press **Ctrl-Alt-P**. A confirmation appears asking if you really want to create a proxy object, and, of course, you really do.

The outline color immediately changes to pink, and the wireframe view reverts to the normal colors, indicating that this is now a local asset. You can now keyframe the object for transformation just like an ordinary object. Mesh modifiers can be added, so that you could, for example, add subsurfacing to the proxy even if it wasn't applied to the library file. You can also examine its material and other settings, although you still cannot change them. If you attempt to enter edit mode on the object with the **Tab** key, you'll find that it works! Indeed, you can edit the mesh of

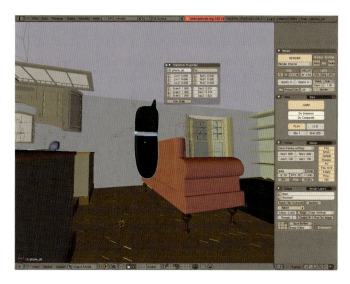

Figure 6.18 *The phone brought in as a link*

the phone. However, and this is the danger of using a proxy object for animation, any changes you make to the mesh will disappear the next time the file is loaded.

When a file with proxied links is opened, Blender retrieves all of the supporting information for the object from the original library file, replacing any changes you may have made the last time you worked with the proxy. Any animation work that you have done is retained. The animation itself is saved in a separate asset (an Ipo) that is local to the BLEND file. But if you are in the middle of a work session with a proxy object and decide that you need to alter the mesh a bit . . . you'll be surprised the next time you open the file to find that your work is gone.

If you want on-the-fly simplicity, the ability to examine settings and parameters of the object, and can restrain yourself from working directly on the local version of the object, using a **Ctrl-Alt-P** proxy is a good solution for linking objects that need to have object-level animation.

> **NOTE**
> In Blender 2.46, there is a bug in object proxy creation that causes materials to not display properly after proxy creation. Saving and reloading the file will set everything right.

Creating and Linking a Dupligroup

The other method of applying object-level animation to linked assets requires a bit more preparation. If you're following along with the files on disk, delete the proxied phone from the scene before you continue. Figure 6.19 shows the master file for the phone. Notice that the phone's mesh outlines are green. Green object lines in Blender indicate that the object is a part of a Group.

In Blender, Groups are simply groups of objects that have been assigned a unique name. You add objects to a Group by selecting them in the 3D view and pressing **Ctrl-G.** Doing so brings up a pop-up menu asking if you want to create a new group for the objects or add them to an existing group, if there are any. We'll look at exactly how to do this in a moment. Groups are handy for a number of things, most of which deal with object management. Materials can restrict their lighting to lamps from certain groups. Rendering, force fields, and particle systems can also make use of Groups to restrict their effects.

The reason that the phone has been added to a Group (called, incidentally, "phone"), is that Groups are library assets themselves, which means they can be linked into other files, and that Groups can be used with Blender's dupligroup function. A dupligroup is the ability for a Blender object to act as a stand-in for an entire group. Figure 6.20 shows two Empties. The one on the left is a traditional Empty. The one on the right is an Empty that has been enabled to act as a dupligroup and has been set to use the "phone" group.

Here's how to prepare the objects in your library files for linking as a group:

- Select all objects that will be a part of the prop in the original library file.
- Create a new group for these objects with **Ctrl-G**, **Add to New Group** (Figure 6.21).
- Give the group a descriptive name in the **Object and Links** panel of the **Object buttons** so it is easy to identify in a crowded scene (Figure 6.22).
- Save the library BLEND file.

Figure 6.19 *A wireframe view of the phone.blend file*

Figure 6.20 *An Empty set to use dupligroups*

Figure 6.21 *The Group pop-up dialog*

Figure 6.22 *Assign a name in the "GR" field of the panel*

After you do this even a few times, adding an object to a group and assigning it a name will turn into a reflex operation that you can accomplish in a few seconds.

On the other side of the process, let's link a group into the working scene file. Figure 6.23 shows the shot file from the previous example with the full set linked in as a separate scene and enabled as a set. Also, an Empty has been added to act as the stand-in for the group.

Next, use **Shift-F1** and browse to the Group section of the phone.blend file, as in Figure 6.24, and select the "phone" group, enabling **Link** and **Relative Paths**. Unlike the other items you've linked so far, this one will not cause an immediate reaction in the 3D view. To make use of the linked group, you need to turn to the **Anim Settings** panel of the **Object buttons**. Figure 6.25 shows the panel, with the Empty selected in the 3D view.

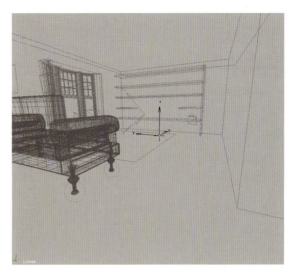

Figure 6.23 *The shot file prepared to receive and use the linked group*

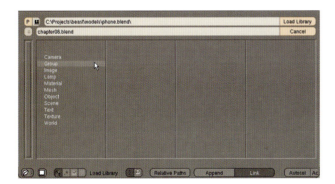

Figure 6.24 *Selecting "Group" from the asset list*

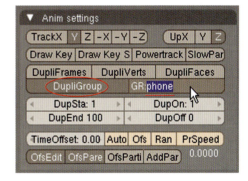

Figure 6.25 *Entering the name of the linked group in the dupligroups control*

The **DupliGroup** button is enabled and the name of the linked group is entered into the control to its right. Don't forget that you can begin typing the name, then press the **Tab** key to have Blender autocomplete the name for you. After doing this, the 3D view still shows the Empty, but the library object is superimposed upon it. Because the Empty itself is a local asset, you are free to animate it as you wish.

When you use dupligroups, the Object Center of the Empty (or whatever you use for a stand-in) acts as the origin for the linked group. If the library of your group has its center at (0,0,0), then it will appear in exactly the same space as the stand-in when activated. However, if the objects that make up the group are transformed away from the origin (or rotated and scaled), they will likewise appear a similar distance away from the center of the stand-in object. Figures 6.26 and 6.27 demonstrate this behavior.

Figure 6.26 *A group whose object's center is on the origin and its dupligroup visualization*

Figure 6.27 *A group whose objects are away from the origin. Note how the rattle is now offset from the Empty*

Although this method is a little more involved than using **Ctrl-Alt-P** to create a proxy object, it has some distinct advantages. First, there is no chance that you will forget what you're doing, enter Edit mode, and start fooling around with the Mesh. Second, if your prop actually consists of more than one object, it is a convenient way to select and animate them as a single asset. Additionally, adding or removing objects from the group in the library file will cause the group to update properly in your shot files.

There are some limitations to the method, though. You cannot examine any of the settings of the object in the group, like materials or modifiers. Because the object itself is not directly selectable, only the group, you won't be able to show object-level information. For the same reason, you cannot add Mesh modifiers to assets linked in this way, so there is no per-shot customization of modifiers available.

Which Method to Choose?

I prefer to use the groups/dupligroups method if I can get away with it. All of the props in *The Beast* use this method. It's safer and uses fewer resources. However, if you think you will need to see an object's settings or add shot-specific modifiers while working, you should use a standard direct link and make it into an animation proxy.

Linking Assets for Character Animation

Properly bringing characters into your shot files with links requires a little more preparation but builds on the techniques already used. In the next chapter we'll look at rigging and skinning your characters, but some of the object preparation advice given there mirrors what was said in the last chapter: Make sure that all rotations and scaling are applied to your character components in their master files before you attempt to do any animation.

Just like working with a single prop, you navigate to the Object section of your library file. In Figure 6.28, you can see the listing for all objects in the mom_harmonic.blend file. When building this library file, I made sure to begin the name of all of the components of the mother character with "mom" so that they could be easily identified when it was time to link them into a shot file. Using the right mouse button, you select all of the pieces of the character, which will most likely consist of the model objects themselves and any control structures you have built. These pieces will be highlighted, as in Figure 6.28, and all linked in at once when you click the **Load Library** button.

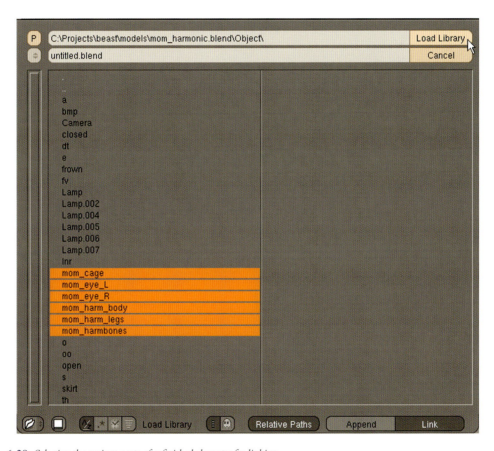

Figure 6.28 *Selecting the various parts of a finished character for linking*

All of the objects are linked into the current scene. Now, instead of creating animation proxies for all of these objects, Blender allows you to proxy only the control structure, which is probably an armature object. Select the armature and press **Ctrl–Alt–P** to create the proxy. Blender automatically retargets all of the rest of the linked objects toward the new proxy armature. This means that you can animate the character and all of its components with the proxy armature. Notice in Figure 6.29 that the outlines of the mesh objects for the character are still blue, indicating that they are linked assets, even though they are controlled by the local proxy of the armature.

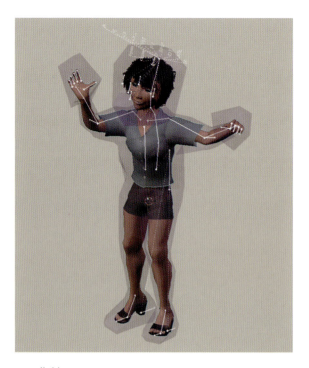

Figure 6.29 *A linked character controlled by a proxy armature*

Managing Your Links and Libraries

Blender gives you several tools to examine and manage your linked libraries. Figure 6.30 shows an Outliner view set to show linked assets by choosing **Libraries** from the pop-up menu on the window header.

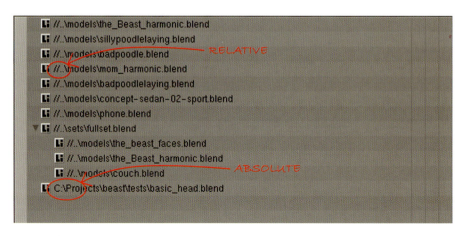

Figure 6.30 *The Outliner set to Libraries*

This view shows all of the libraries that are linked into the current BLEND file. **Relative** links will begin with a "//" symbol, the double forward slash. If you see these in front of all of your library path names, then you've done things correctly. If, however, you see ones that begin with a single "/" followed immediately by path information or a drive letter like "C:\", you have absolute links to a library.

Remember that using relative links will preserve your ability to access your shot files and their libraries if you move or copy the production onto another computer or if you are trying to use them over a networked drive.

Finding and Fixing Broken Links

There may come a time in your production when you open a shot file only to see that some, or maybe all, of your linked objects are missing. To make sure that is what's going on, check the Blender console. If you see something like Figure 6.31, then your links are broken.

Figure 6.31 *The Blender console reporting failed links*

Don't panic. This can almost certainly be fixed. There are a number of reasons that your links might be broken, and each has its own remedy. These only apply to libraries that are linked with relative paths.

> **WARNING**
> When attempting to fix broken links, do not save any of the shot files you have opened. Saving a file with a broken link can result in losing the link, and possibly other local data, entirely, making it unrepairable. Of course, if you are fixing the original library files themselves, any changes you make will have to be saved. But avoid saving any file that reports broken links.

- If only a single link out of many in your file is broken, then the culprit lies with the original library file. First, examine the supposed path in the Outliner. Look on your disk for the file. It is possible that the library file has either been moved to another directory or that the filename has been changed. In either case, simply move the file back to its original location or restore its original filename, both of which can be obtained from the Outliner in Library view. If the path and filename are correct, you will need to look inside the Library file. Most likely, the name of the original object has been changed. You need to change it back to its original name to restore the link.

- If some, but not all, of your links are broken, then files have been moved or renamed. If all of the links were to the same file, check to make sure that file's name and path appear as they do in the Outliner.

- If all of the links in a file are broken, there could be a number of reasons. First, has the shot file been moved from its original directory? If it is not in the same position in the directory structure relative to the libraries as it was when the links were made, it will fail. To fix this, simply move the file back to its original directory. If that is not the case, then it is almost certain that somewhere along the way a directory has been renamed or moved. This will cause all links to fail. You must restore the original directory structure for the links to function again.

- In addition to the information available in the Outliner and the console, you can also have Blender generate a report on any missing links. In the main File menu, there is an entry for External Data that has a number of options. From that menu, choose **Report Missing Files**. With this command, Blender generates a text file with a list of any missing links that can be viewed directly in a Text Editor window.

It's pretty obvious from the troubleshooting advice given here that maintaining file and directory names, as well as their locations, is of primary importance when dealing with libraries and linking, and that changing them, either accidentally or on purpose, will result in problems. The organized directory structure suggested in Chapter 3 is an attempt to minimize your need to move things around when you've begun to work. Of course, you might run into a situation where you need to move a file. If it's a shot file that contains lots of links, it turns out that this is not so hard to do.

Moving a Shot File and Maintaining Its Links

If you want to move a shot file to another part of the overall directory structure of your project, use the **File > External Data** menu to select **Make All Paths Absolute**. Then save the file and quit Blender.

It's true that so far all we have talked about is how splendid relative paths are for your project, and now we're saying to change all paths in your shot file to absolute ones. Don't worry. They'll only be that way for a moment.

Move the shot file where you wish, restart Blender and open the file. Because you used absolute disk paths, Blender still knows exactly where to look to find the links, keeping them alive. Now, use the other path command from the menu: **Make All Paths Relative**, which will rebuild all the paths as relative and make your whole project portable once again.

Moving an Asset File

Don't do this. Seriously. Just don't.

Obviously, if you've not linked any of the library file's assets into scenes in other files, this isn't a problem. However, when you move or rename the file, there is no way to determine for sure which scenes have linked to assets from it. You will only be able to tell when you open those files and find the links broken. Unfortunately, the process of opening a file with links, and especially proxy objects, can cause irreparable damage to the links, meaning that even the **Recover Missing Links** tool in the **External Data** menu item will not fix things. The files will be relinked, but the damage to the proxy will already be done. If you do have to move or rename an asset file, though, here are some suggestions to help you out.

Situation: You've moved the original asset file then linked those assets into other scenes from the new location. **Solution**: Create a duplicate of the file and return the duplicate to the original location using the technique previously described if the asset file itself contains any live links.

Situation: You've moved or renamed the original asset file and for some reason cannot or will not duplicate the file into the original path. **Solution**: You will have to locate any assets in the shot file that are linked to the missing file and delete them (the Outliner can be helpful for this). Then you will need to relink them from the **Shift–F1** dialog, as though they were brand new links. If you used proxies before, you will need to create new ones. After you have all of the assets linked back in, you use the Ipo window to reattach the original animation Ipos to the appropriate objects. If you were rigorous about naming Ipos as they were created, this will be easy. However, it will be more likely that you will need to go through a trial and error process to find the correct Ipos for each linked object.

Finally, you can directly change a library's path in the **Library** view of the **Outliner** by **Ctrl-LMB** clicking on the path name itself. This changes the path into a text entry field, allowing you to type a completely new path, or fix one that has changed. Note that this only works to fix a broken path before the asset file changes location. Simply opening a BLEND file with a broken link, typing the correct one, and re-saving will not work.

Or, to put it more simply, don't move or rename your asset files once you've linked to them.

Summary

Libraries and links are the technical bedrock of a consistent large scale animation project. Each asset in the project (characters, sets, props) is created in its own BLEND file, which acts as a library to which other files can link.

Depending on your needs, there are different ways to link and use these library assets. For an animation's sets and other static objects, it is sufficient to link them in as an entire scene, then use that scene as a set in the Scene buttons. Assets that require only object-level animation can be linked either directly and animated by making a proxy, or by adding them to a group, linking that group into the scene and assigning an Empty to use it as a dupligroup. For character animation work, all of the elements of the character, including the rig and controls, are linked at once, and a proxy is created for the controlling armature.

Library and link information can be viewed in the Outliner, in the console when the file loads, or with the Report Missing Files tool in the External Data submenu of the File menu. It is important to maintain your original filenames and relative paths when you begin linking to your library assets.

The Peach Perspective

On asset management: Can you imagine doing a project of the size of BBB without a nicely functioning asset linking system like Blender has?

Nathan: Well . . . "nicely functioning" might be giving it a bit too much credit. It's certainly not perfect and has its share of bugs and annoyances that we ran into (and ripped our hair out over). But it did get the job done. But to answer the question: Yes, I can imagine it. However, it wouldn't be pretty. For example, if I updated a rig with a bug fix, it would have to be manually replaced in all of the scenes. Not pretty at all, and lots of unnecessary work, not to mention the increased storage usage.

Rough Sets, Blocking, and an Animatic

Objectives

- Creating rough sets
- Building your template scene file
- Matching camera angles and character blocking to the storyboards
- Additional detail: reusing cameras, moving cameras, moving characters
- Creating an animatic

Inbox

- The ability to create models in Blender
- Character models—these do not have to be rigged or completed
- Completed storyboards (Chapter 4)
- A knowledge of linking assets (Chapter 6)

Creating Rough Sets

At this point, you have character models, a story reel, and not much else. It is time to start bringing the pieces together. Your characters need a meeting place, and that place is going to be a rough set. If your final set will be very simple, there is no need to create a rough version at this early stage. Just build your final set and skip this section. If you're wondering why you would want to create a rough set, well, it comes back to time. Sets, like any other aspect of an animation project, could occupy an infinite amount of your time. If it came to choosing between having a crummy, half-baked animation appearing on a beautiful detailed set, or a wonderfully crafted animation taking place on a minimalist set, which would it be?

Hopefully, it won't come down that, but you never know. It might. Our goal is to get to the animation phase as quickly as is practically possible so that occupies the majority of your time. Later on, you can spend any time you have left enhancing your sets or getting outside help with them.

During the story development and storyboarding process, you have probably developed a decent sense of the physical space in which the story takes place. Actually, this is one of the reasons for acting out the story and creating the storyboards in the first place.

It will probably help before you begin working in 3D to sketch an overhead map of the set either on paper or in a digital painting program. Figure 7.1 shows an initial sketch of the set for *The Beast*. The first thing you may notice is that this configuration does not make for a realistic house. It consists of a single L-shaped open area, divided into three sections: a living room, kitchen, and dining room. No bedrooms, no exterior doors, and more importantly, no bathrooms! Maybe that's why the Beast has such issues.

Figure 7.1 *An initial sketch of the set*

The point is that a set for an animation is more like a set for a television show or movie than it is an analog of real life. The requirements for living in a place are completely different from the requirements of staging and filming a production in one. Of course, because our sets are digital, we can easily do things such as remove a ceiling or making a wall or piece of furniture transparent to get the shot we are after, so the stylization of the set does not have to be as extreme as that of a physical production.

Preparing the File for the Rough Set

To begin your rough set, create a new BLEND file. Just as if working with multiple characters, it is important to maintain the same physical scale across all of your files. So use the **Shift-F1 Append** command to import one of your characters into the file. There's no need to bother with linking because you'll be removing this character when you have the scale established.

If you are working with an exterior, the obvious starting point is to add a plane for the ground and scale it past the bounds of where the set objects will sit. The easiest way to begin an interior set is to trace the floor plan.

You can do this by adding a plane for any square or rectangular portion of the floor, then extruding edges

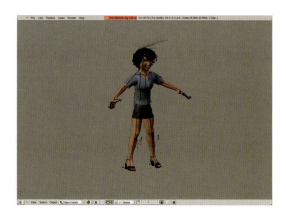

Figure 7.2 *An empty BLEND file with a character mesh appended*

to fit the final plan. Figure 7.3 shows the floor plan for the set of *The Beast*.

At this point in the production, you don't even need walls or a ceiling unless your characters will be making contact with them. The rough set is all about boundaries. The floor is necessary because your characters and props will (probably) be making constant contact with it, and you need it for a reference. Any other items you add will be there for that same purpose: as a reference for contact or position. No frames are going to be rendered with this rough set, so the shading of any of its objects and their exact contours and construction are mostly irrelevant. All that matters is that when you put the final high-resolution sets in place, your characters and props are already set to react to any surfaces they coincide with.

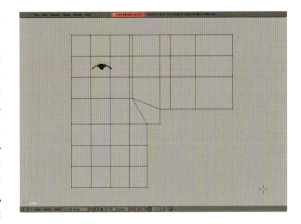

Figure 7.3 *The floor plan for the set of* The Beast

As you can see in Figure 7.4, the rough set for *The Beast* consists of a floor, a bunch of cubes, and a very simple representation of a couch. For an outdoor scene, you can get wild and crazy and create trees from cubes and icospheres, as in Figure 7.5.

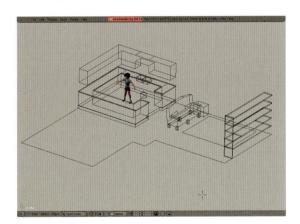

Figure 7.4 *The rough set for* The Beast

Figure 7.5 *An outdoor set featuring several primitive trees*

For a little additional visual feedback while you animate, you can assign simple materials to your set pieces. Only the main and specular colors, and the amount of specularity, will make a difference in the 3D view, so you can ignore any other settings (Figure 7.6). Figure 7.7 shows the Beast's home with basic materials so that the rough set has some color.

Unlike other elements of the production, it's not even necessary to **Ctrl-A Apply** rotation and scaling to any of these set objects. This entire construction will be replaced throughout the course of the coming chapters. Speaking of placeholders, you can remove the character that you added for scale.

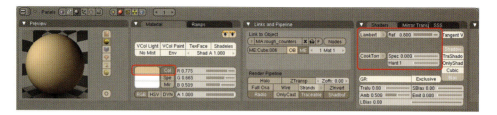

Figure 7.6 *A basic material for coloring the set in the OpenGL 3D view*

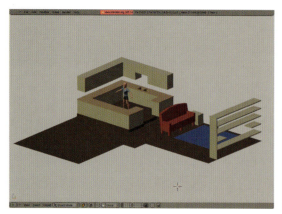

Figure 7.7 The Beast's *rough set, colorized*

Figure 7.8 *Naming the scene for later use*

The only thing that you should do after the rough set is finished is to name the scene something appropriate such as "roughset" with the **Scenes** drop-down menu on the main header as in Figure 7.8. Then save it as "roughset.blend" in your sets folder.

If you have several sets, then your scene and file names should reflect that with proper descriptions. Your goal is to be able to link these rough sets into your working files as entire scenes, and use them as sets in the Scene buttons, as shown in Chapter 6.

Why Use a Different File for Each Camera Angle?

It may seem like needless complication to create a new BLEND file for each camera angle in your animation. During the course of the production, though, you will see that it grants you significantly more freedom in both animation and direction. Consider the following problems you can run into when working with a single, monolithic BLEND file for your animation.

- Composition: When switching between two camera angles, the framing is not exactly what you want. The obvious solution is to tweak the positioning of the characters for each angle. When edited together, such a shift will not be noticeable to the viewer but will enhance the composition of both shots. With a single file, you have to perform keyframing sleight of hand to make the characters jump into their positions for each shot, probably causing

motion blur problems. If each angle is its own file, you simply adjust the characters as needed for each shot.

- Bad animation: There is a bit of animation you are displeased with or for some other reason would like to replace. If your character has a 2-minute long stream of animation in your single file production, you have to make sure that removing or replacing the bad animation doesn't mess with the good animation and maintains proper transitions. If your animation is broken up into smaller portions, each with its own file, this once again becomes easy to solve. Replacing the animation for a discreet shot does not endanger any of the work done on other shots.

- Render management: You are ready to render your animation. Whether you are using a render farm or just your home workstation, having to babysit your single BLEND file along the way can be a pain. For each camera angle, you have to make sure that the proper camera is selected, the right frame range is designated, and the right combination of sets, props, characters, lighting, and render options are used. Each time you want to render a different angle, you have to reevaluate and possibly reset all of these. If you need to go back and rerender a particular shot, you have to make sure you set things up just like the first time. When each shot is its own file, all of the optimizations and render settings for that shot are permanently saved in the file. All you have to do is open it and render, or send that file as is to the render farm.

Building Your Template Scene File

Each shot (different camera angle) in your production will eventually have its own BLEND file. While each of those files will have an optimized population of characters, sets, and props, they will all be traceable back to the master file for the scene.

The *template scene file* is a BLEND file that contains links to all of the sets, props, and characters that are in a scene, as well as all of the different cameras that will be used throughout. It will act as a baseline for most of the shot-by-shot files that you will create later. If there is more than one scene in your animation, each scene will have its own template file.

To create the template scene file, start with an empty BLEND. Save it with an appropriate name so that relative path linking will work. In *The Beast*, it was called, "beast_scene_template.blend".

Use **Shift–F1** and navigate to the file containing your rough set. Make sure that **Relative Paths** and **Link** are enabled, and find the Scene (not the objects!) that contains the set. Figure 7.9 shows the rough set selected from the Scene section of the BLEND file. When you link the set scene, Blender will not show any noticeable difference in the 3D view, but rest assured, your scene is there.

Figure 7.9 *Linking the rough set*

In the **Scene buttons** (F10), choose the "roughset" scene as a set, using the control in Figure 7.10.

If you have any props you want to bring in at this point, link them in either as groups for use with dupligroups and Empties as explained in the previous chapter, or directly, in which case you must use **Ctrl-Alt-P** to create proxies that are capable of moving. Position the props at their starting points (Figure 7.11).

At this point, you are ready to add your characters to the template. Unless you have worked ahead, your characters are not yet ready for animation. They are basic meshes, possibly untextured. You will not be animating the characters now—just moving them around like chess pieces, so this is okay. The fully animatable versions of the characters will replace them later.

Because you will be moving them around at the object level only, it makes sense to bring the characters in as dupligroups. In you character files, select all the parts of the character that you have so far and create an appropriately named group for them. Link that group into your template scene file just like a prop, create an Empty, and set it to use that character's group in the **Anim Settings** panel of the **Object buttons**, as in Figure 7.12.

When all of your characters are linked into the template file, it's time to find out how good your visualization skills have been.

Matching Camera Angles to Storyboards

You're about to start adding cameras to this template file and matching real 3D camera

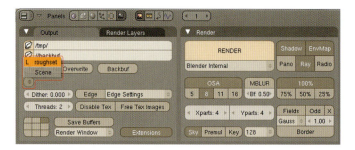

Figure 7.10 *Using the super-secret set menu*

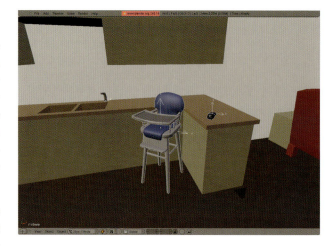

Figure 7.11 The Beast's *rough set with some crucial props in place*

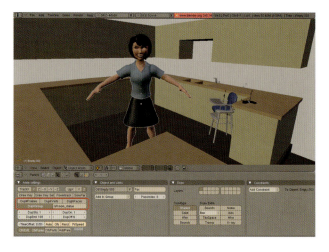

Figure 7.12 *A character brought in as a dupligroup*

framing to your storyboards. If you have a dual-monitor system available, this is a great time to start using it. The procedure is to add a camera to the scene, bring up a storyboard, and try to match the framing of the actual shot to the storyboard illustration. With a two-monitor setup, it's easy to bring up the story reel in the secondary monitor and work with your 3D scene in full frame on the primary monitor. If that's not an option, you can configure Blender on a single monitor such as in Figure 7.13.

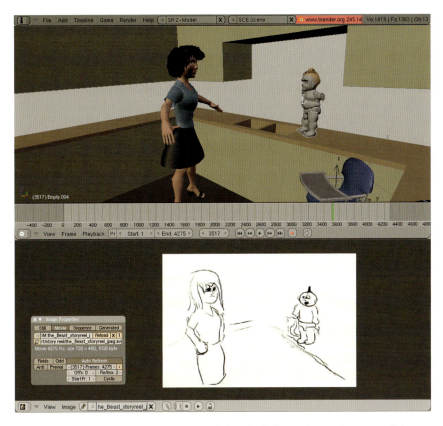

Figure 7.13 *Half the screen is used to display the story reel, and the other half is used to match camera and character positioning*

In this case, make sure to use the **Movie** and **Auto Refresh** buttons on the **Image Properties** panel, as shown in Figure 7.14. Regardless of exactly how you configure your screens, you will need at least one 3D view, a Timeline window to scrub through the animation, and an Image Editor window to display the story reel. You could also use a Sequencer window for this, but you would need to add a Movie strip and set the Sequencer to preview mode. I find it easier to load the movie as an image in an Image Editor window, as presented in the figure.

Advance the current frame to reach the first storyboard in the story reel. Add a camera to the scene and change the camera's name to "shot01" in the **N-key Properties panel**. You will be naming both your cameras

and your Blender scenes this way so that it will be easy to tell at a glance later if you are working with the intended camera and scene. In a single scene production, you can simply use the "shot01", "shot02" notation. For animations that have more than one scene, you can expand that to "sc01.shot01", "sc01.shot02", with the first number designating the scene and the second designating the shot. Of course, you are free to use any naming scheme you care to, as long as it will be clear what is what if you revisit the project a year from now.

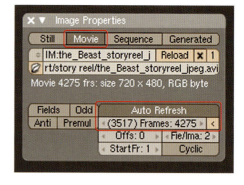

Figure 7.14 *The image properties panel set so that the story reel displays properly in the Image/UV Editor window*

Select the camera and adjust its position to your first best guess of where it will show the shot that you see in the first storyboard. Use **Ctrl–Numpad-0** to enter the camera view and use the translation and rotation tools to do your best to match the shot to your illustration. One rotation method you may not be familiar with is the "Trackball" style that is triggered by pressing the **R** key twice. Try it from the camera view with the camera selected. I've found that this is a much more intuitive "true to life" way of aiming the camera than the standard rotation tools. Also, don't ignore the **Lens** value on the **Camera** panel of the **Edit buttons**. It defaults to 35, which is almost certainly more wide angled than what you have drawn in your storyboards.

If you have not used this control on your cameras before, a higher value equates to a greater zoom in a physical camera and lessens the effects of perspective. Lower values are the equivalent of zooming out, with very low values (around 20 and below) giving a wide-angle lens, almost a fish-eye effect.

Of course, you are welcome to use a more traditional "multiview" when adjusting the camera, with front, side, top, and camera views filling a divided workspace. The trackball method explained here is certainly worth your time to try, though.

NOTE

When working in a camera view, you may want to enable the **Passepartout** option in the **Camera** panel of the **Edit buttons** and set its **Alpha** value to around **0.5**. Passepartout darkens the area outside of the camera's view so you can get a better visualization of what your shot will look like, as in Figure 7.15. Be careful not to set the Alpha value the whole way to 1.0, though, because you won't be able to select the camera to adjust it while in a camera view.

Figure 7.15 *A camera view with Passepartout enabled and set to 0.5*

This is when you will find out how well you visualized the 3D space in which your animation takes place. You may find that no matter what you do, you just can't match in 3D space what you drew in your storyboards. Figures 7.16 through 7.21 show several storyboards from *The Beast* and their corresponding framing. Some obviously worked out better than others.

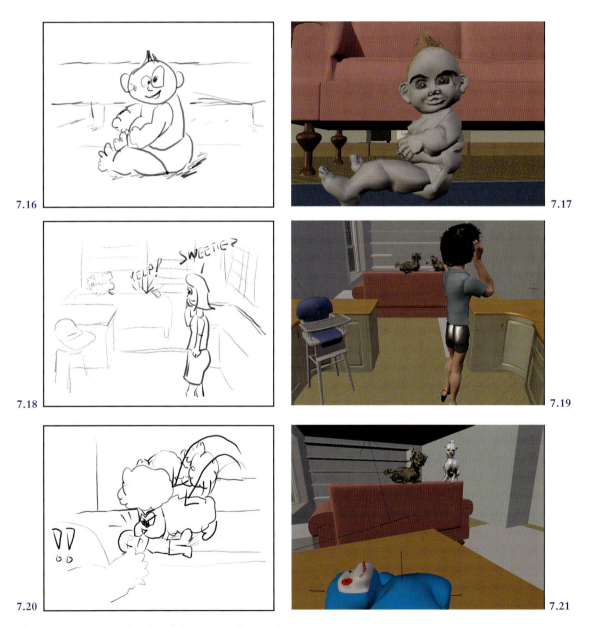

Figure 7.16–7.21 *Storyboards and their corresponding 3D framing*

When you have a discrepancy between the two, you need to ask yourself if the difference will cause a material change in the staging or action that needs to take place in the shot. If not, adjust the camera to compose that shot as well as you can and move on. If the difference really will affect the way the shot plays out, you need to consider if it is, in fact, the right camera angle to use. It is possible that you may need to rethink the action in the shot. If you do, you may have to go back to the storyboards and rework them a bit, armed with your greater knowledge of the physical aspects of the scene.

> **NOTE**
>
> Even though the chapter on storyboarding is behind you, that does not mean that the storyboards, or any other part of production that has been worked on up to this point, is really finished. Many phases of animation production are iterative, meaning that what you do at a later stage may cause you to go back and rework something you thought you had set in stone before. Don't be afraid to do this. It's perfectly normal.

In addition to adding and naming a camera, there is one more organizational tool that will help you during the production. If you have a **Timeline** window showing, you can add a **Marker** at the current frame with the **M** key. Timeline markers are just visual placeholders in the timeline that can be named and help you to identify different sections of an animation. With the mouse over a Timeline window, press the **M** key. A little yellow triangle appears at the bottom of the timeline on the current frame, as in Figure 7.22. Press **Ctrl-M** to bring up a pop-up menu that will let you name the marker. Call it whatever you called the camera, which in this case is "shot01". The name displays in the Timeline windows, as well as in other timeline-based windows like the Ipo editor and Action editor.

Figure 7.22 *A named marker in the Timeline window*

Placing Your Characters

With a camera in place, you can move your characters into frame. Of course, without the ability to pose them, you won't be able to match your storyboards exactly, but you will at least be able to tell if the general positioning will work. Select and transform your characters until they work with the framing presented in your storyboards. Because you will potentially be changing these with each different camera angle, you should set rotation and location keyframes for the characters.

...nimation to your files, albeit in a primitive fashion.

23 *The Record button on a timeline window*

Figure 7.24 *Removing the Ipo of an unintentionally animated object*

...while animating, and you don't accidentally lose a careful placement because you forget to set a key), it can lead to a surprise or two if you forget that it's on.

From time to time, there will be objects that are not supposed to move, like a camera or a lamp. The problem arises when you adjust the positioning of otherwise static objects while autokeyframing is enabled, then readjust them again on a different frame. Although you didn't intend it to, you've just animated the object. This is easily fixed by finding the frame on which the object sits at its intended location and unlinking its animation Ipo, as in Figure 7.24.

The other related issue it can cause is seen when you adjust the positioning of an object, but no matter how many times you do it, it keeps reverting to its old transformation on a frame change. If this happens, the odds are that at some point, a keyframe was accidentally set for the object. Once again, removing the Ipo from the object fixes the problem.

You can also access Automatic Keyframing from the **Edit Methods** section of the **User Preferences** window, along with a number of powerful options, shown in Figure 7.25. We'll discuss these other options (Available, Needed, and Use Visual Keying) in Chapter 11.

Figure 7.25 *Autokeying enabled in a user preferences window*

Press the **I** key and choose **LocRot** from the pop-up menu as shown in Figure 7.26. This sets a key for the character's location and rotation on the current frame. Before you proceed to other storyboards, camera angles, and character positions, you need to make an adjustment to the way that Blender interpolates keyframes. If you were to proceed through your story reel setting positions and keys for your placeholder characters, they would slide from key to key, producing an ugly animation. At this stage, we are just interested in matching the static shots of the storyboards, so it would be beneficial to have the characters just snap into position at the beginning of each different storyboard.

With a character selected, locate the **Object Ipo** in an **Ipo window**, as in Figure 7.27. Using the **A** key, select all of the Ipo curves in the window. Then, from the **Curve** menu on the window header, select **Interpolation Mode** and choose **Constant**. This option can also be chosen by simply pressing the **T** key in the Ipo window's workspace and selecting **Constant** from the pop-up menu.

In case you are not familiar with animation curves, the Ipo window is a visual representation of the changing values of an object's attributes, including (but not limited to) location, rotation, and scale. Each curved line in the window tracks a different attribute and is color coded to match its description

Figure 7.26 *The Insert Keyframe pop-up menu*

Figure 7.27 *Setting Interpolation to Constant*

on the right side of the window. The curves can be selected and edited just like a mesh in the 3D view, with the **Tab** key, to fine tune animation timing. How your objects move between the keyframes you have set is decided here.

The Interpolation type you choose determines how the object acts between the keyframes. The default, called Bezier, produces smooth transitions between keyframes, beginning and ending slowly with a more constant rate of change in the middle. The Linear interpolation type changes the value at a uniform rate, producing abrupt stops and starts in motion. The Constant type that we are using here signals that there will be no interpolation between the keyframes at all. The value of the previous keyframe is held intact until another keyframe is encountered, at which point the new value is used.

If you are working along, you can hold off on changing your characters' curves to Constant interpolation just so you can easily see the difference in effect when you do.

Proceeding Through the Story Reel

With your first camera created, the shot composed, and characters positioned and keyed, you can move on through the story reel. Find the next frame on which the camera angle changes. Add a new camera, name it, and begin the process again. As you work through the rest of the story reel, you will develop a series of named cameras that correspond to timeline markers and character positions that will allow you to visualize your storyboards in 3D for the first time. Depending on how many camera angles there are in your animation, you may end up with something that looks like Figure 7.28.

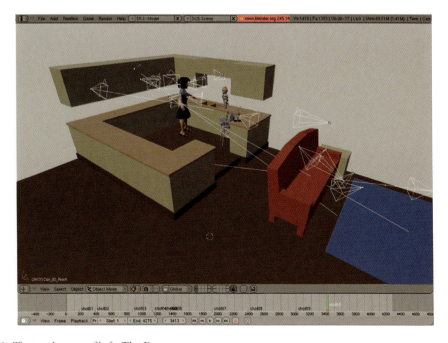

Figure 7.28 *The template scene file for* The Beast

Special Case: Reusing Cameras

It may be that a certain camera is used more than once in your animation. In fact, it's possible that you could have only one or two cameras for the entire production. When that is the case, you need a way to keep track of which bit of action is shot from which camera because creating a series of identical cameras with different names every time the perspective changes would be pointless.

> **NOTE**
> Even if you have such a camera setup, it is still a good idea to break your shots into separate files for all of the reasons mentioned before.

For a situation in which you have significantly fewer cameras than shots, it can be useful to label the cameras with letters such as "CameraA", "CameraB", or descriptions such as "Long" or "MomCloseup." When you create your timeline markers, you simply expand the name to include the shot number and the camera name, as seen in Figure 7.29.

Figure 7.29 *Markers named with shot numbers and their corresponding recurring cameras*

Additional Detail: Moving Cameras, Moving Characters

There are many situations in which your camera will move. You may have drawn these into the storyboards with camera directions. Whether or not you did, you can put them into place now.

Once again, it's a matter of following your storyboards as you play through the story reel and setting keys on your camera instead of your characters. Figures 7.30 through 7.35 are a series of storyboards in which a camera showing the Beast's point of view looks back and forth between the two dogs sitting on the back of the couch. In the final animation, this was given a more realistic motion, but at this stage of the production, it was done with a simple series of rotations and keyframes. Depending on your taste, you can leave the Ipo curves for any camera motion in the default bezier mode for smooth movement or set them to Constant as you did with the characters.

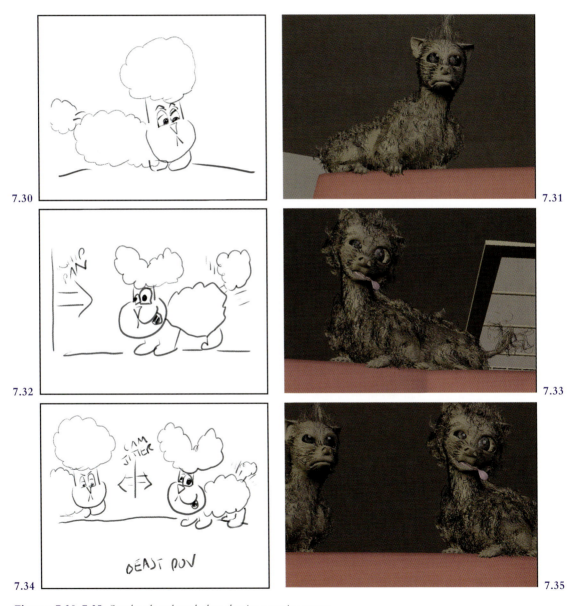

7.30 7.31 7.32 7.33 7.34 7.35

Figures 7.30–7.35 *Storyboards and rough shots showing a moving camera*

In the previous section, you only placed the characters once per shot. There is no real reason to restrict yourself like this, though. There may be a number of contiguous storyboards all from the same camera angle in which your characters move about. If that is the case, feel free to adjust the character positioning on a board-by-board basis. You can put even more positions in between if you feel that it helps to show the action. Don't put too much time into it, though, because these are still just placeholders for the real animation that is yet to come.

Creating an Animatic

An *animatic* is a bridge step between the storyboards and the final animation. The template scene file (of files) you just created is the basis of an animatic. If everything proceeded pretty much according to your storyboards, you don't really have to create one. However, the longer and more complex your animation is, the better an idea it becomes, just to ensure that all of your assets are in place before moving on.

The shot matching for *The Beast* was close enough to the storyboards and the action was clear enough that I did not create an animatic for the project. If you would like to, though, here is a good way to proceed.

Replacing Storyboards in the Story Reel

Your goal is to replace the storyboards in the story reel with more accurate representations of the final project. To do this, you will be working within the template scene file. For shots in which there is no camera movement and little character action, it is as simple as advancing the frame counter to the appropriate shot and creating an image file from the appropriate camera's perspective.

Locate the shot in the timeline by using the markers you created, and set the current frame counter to place yourself at the beginning of the shot. Select the camera in the 3D view and press **Ctrl-Numpad-0** to force the view from that camera. If you have not used it before, there is a quick preview button on all 3D window headers that sends the OpenGL preview of the camera's view to the Render window, allowing you to save it like a render. Figure 7.36 shows the button highlighted, with the OpenGL preview in the Render window.

These "renders" are saved by pressing **F3**, just like any regular render. You can save them into a subfolder of your storyreel folder called animatic, or, in the case of *The Beast*, quickies.

Back in your main story reel file, import these new images into the Video Sequence Editor and place them above the storyboard image strips that they will replace. Leave the storyboards where they are—you may want them there for reference later, and it costs almost nothing in terms of file size and processing time. Figure 7.37 shows two OpenGL shots superseding their storyboards in the story reel file.

For sections with camera movement, you can either export several still shots that correspond to the storyboard breakdown, or, if you're feeling fancier, export the whole range of frames in an animation.

Once again, the preview render header button comes into play. First, though, choose an animation codec that is appropriate to your system (FFmpeg, QuickTime, AVI), and then set a filename as you did when creating the animation file for the story reel. If you have a larger hard drive with plenty of space, you can simply choose AVI JPEG, which is one of Blender's internally supported animation formats. It does not produce the

Figure 7.36 *Sending the contents of the 3D view to the Render window*

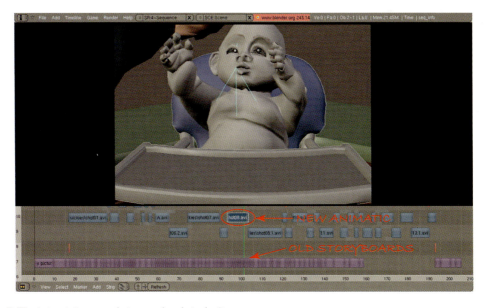

Figure 7.37 *Animatic images replacing storyboards in the Sequencer*

smallest files, and other animation or video programs may have trouble reading it, but any version of Blender on any platform will happily see and read the file, and the quality is more than good enough for an animatic.

In the **Animation** panel of the **Scene buttons**, set the frame range for the preview render to match the range designated by the shot markers in the timeline (Figure 7.38). Hold down the **Control** key and click the header Preview Render button (again, Figure 7.36). Blender will pipe the OpenGL 3D view to the render window as an animation and save it with the format and filename you specified.

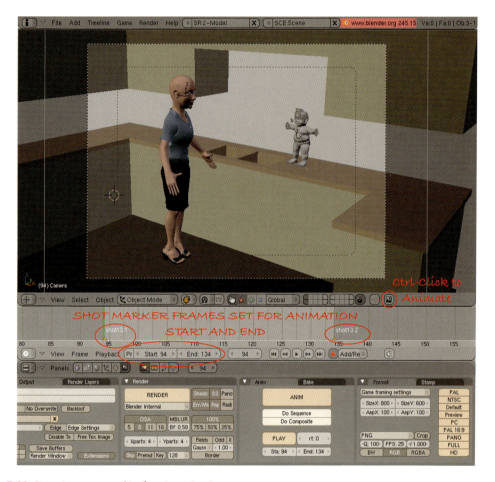

Figure 7.38 *Preparing to export a bit of preview animation*

In the story reel file, you can add this new bit of animation above the storyboards.

At this point, you can regenerate your story reel animation if you like. If you are going to do so, it's a good idea to give it a different name (such as "storyreel_animatic") than the original storyboards-only animation, so that when your project is done, you will have a progression of files to look back on. It's not a necessity, but it's

nice when you're finished to see how far you've come. Of course, you don't have to export the animation at all. Pressing **Alt-A** directly within Blender will play the animation for you live from the Sequencer.

Summary

Using your storyboards and a physical sketch as a guide, you create rough sets with primitive objects to give your characters references for their actions during animation. A template file is created that will serve as the basis for all the shots in the scene. The template scene file contains the rough sets linked in as whole scenes and any props and characters that are available linked in as dupligroups.

Cameras are added and synchronized with the story reel, while markers are placed in the timeline to help with future organization. The character models are moved around to roughly follow the storyboarded action.

Finally, preview images are made from the new cameras that correspond to the original storyboards. These images and any animated camera movements are put in place in the master story reel file to create an animatic.

Outbox

- A rough set file for each set in your production
- A template scene file that contains a link to both the rough sets and character meshes, as well as local assets for each camera in the production
- An animatic-enhanced version of the story reel

Good Sound

Objectives

- Finding decent equipment and environments
- Making the recording
- Some sound processing basics
- Previewing the recorded sound

Inbox

- A script
- People to perform the lines

Finding Decent Equipment and Environments

Although you won't be adding ambient sounds such as footsteps, crashes, and background noise until after animation is finished, you need to have any dialog recorded before you begin. While those other types of sounds are fairly easy to synchronize to your animation, the reverse is true for the spoken word. Any variance from the rhythms of natural speech are easily discernible by the viewer, so you are constrained to using speech in a mostly unaltered format. It is much simpler, then, to animate to already recorded dialog than to try to have your voice actors match what they say to characters whose mouth movements and facial expressions were done without guidelines. In fact, doing the latter would be nearly impossible!

Neither you nor I are professional sound engineers, so we're not going to be able to get beautifully reproduced studio quality dialog. Fortunately, it is possible to get "good enough" sound for your production with only a little effort and investment.

What to Use

There are four levels of equipment quality and configuration to choose from. You should obviously choose the highest level of quality that your production and resources will comfortably support.

The lowest level of quality is a simple PC microphone connected to the microphone input of your computer. Depending on how picky you are prepared to be (or not), the sound gathered from this setup may be good enough. Although I have heard some surprisingly "not bad" recordings done with a simple PC mic, most likely it will produce a fairly noisy, low quality result.

The next step up would be to purchase or borrow some lower end "phantom power" microphone equipment. These microphones are significantly better in sensitivity and quality than the ones that plug directly into your PC, but they require an external power source. Usually a powered mic will first plug into the power source (often a powered mixer), then into the line input source on your computer's sound card. Due to other projects I have worked on, I already owned a powered microphone and power source, which you can see in Figure 8.1. The microphone at the bottom left is an MXL brand condenser mic, and the power source/mixing board on the right is the Behringer Eurorack UB1002. Both were obtained for less than $150 total. They are not truly professional quality, but they are not entirely out of bounds regarding cost.

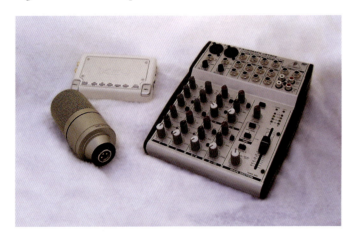

Figure 8.1 *The recording equipment used on* The Beast

The next level of quality would be obtained by not recording directly into the computer. Depending on the sensitivity of the microphone you use, the sounds of the computer's fan and electrical interference from the power supply can introduce additional noise into the recorded signal. Using a quiet laptop can counter the sound problem, and obtaining an external sound card such as the Audigy 2 NX from Creative Labs can eliminate electrical interference. Once again, due to other projects, I already owned a direct digital recorder that can be used without a computer. Figure 8.1 shows the device in the upper left, called the iKEY, which can be obtained for around $80 online. This device takes analog audio inputs and saves them in WAV or MP3 formats directly to an attached USB device such as a USB memory stick or hard drive. There are certainly more expensive digital recorders that perform the same job, but I found this device to be a good mix of price and performance.

The highest level of quality, and one in which you are not likely to invest, is the true top-of-the-line recording equipment: Sennheiser and Shure microphones, Allen & Heath mixers, and Sony and Yamaha digital recorders. This equipment costs thousands of dollars and will almost certainly outstrip your meager recording skills in its ability to produce great sounding dialog.

Borrowing Better Equipment Than You Can Buy

Here's a hint for finding a great resource for audio knowledge and equipment without spending a cent: Do you know someone in a band? You almost certainly do. Band members traditionally spend ridiculous amounts of money on audio equipment and equally ridiculous amounts of time learning the arcane ins and outs of high-end recording and sound reproduction. Ask the band what they recommend and if you can have an hour with their recording equipment. If you can appeal to their audio geek sensibilities, they will not rest until you have the cleanest, best recording possible.

Another resource to consider is that of local churches. Many churches have invested tens of thousands of dollars in audio and recording equipment. If you are a member of that church, they might let you use it just by asking. Churches of which you are not a member or don't attend could be persuaded to let you use their facilities for a small donation.

Where to Record

The location and portability of the recording equipment at your disposal may determine your recording environment. If you'll be using your desktop computer and a direct microphone, then you'll be recording in your computer room. Because the point of your project is to produce a short animation and not learn every aspect of audio engineering, you should try to make your dialog recording as "live" as possible. This means that if a bit of dialog takes place in a kitchen as in *The Beast*, you should try to actually record in a kitchen. Nothing that you and your amateur audio skills can do to a pristine studio sound will result in anything as realistic as actually recording on location.

Of course, you will need to minimize nondialog sounds when recording. Put the dog outside. Ask the neighbors to save their very vocal fight for another day. If you live near a busy street or highway, you'll have to wait until a low traffic time. If the people you live with and your voice talent can stand it, the early morning hours (3:00–5:00 a.m.) are a great time to do this sort of thing. The ambient sounds of daily life will be at a minimum. One last thing to do before recording is to unplug (not just turn off) any electrical equipment in the area. Refrigerators, televisions, and all sorts of appliances make noise that we generally filter out as we go about our daily lives, but that will appear as annoying background noise when put through a sensitive microphone. If your actors will be reading from a script, beware of the sound of turning pages. Actors should also be careful if they are sitting on squeaky chairs or standing on a creaky floor. One last source of unintentional noise is fluorescent lighting. Turn it off if there is another source of light.

Making the Recording

To make proper use of them, your sound files are going to have to be as organized as the other assets in your production. The easiest way to keep track of what dialog is in which file is to take notes with paper and pencil. Here are some guidelines for recording your dialog:

- Do several readings of any piece of dialog.
- Multiple readings can be recorded into the same sound file with a small bit of silence before and after each one. This will make it easy to listen to the different readings when you are trying to decide which to use.

- In a single reading, group any phrases or lines that naturally occur together in speech. You don't want your voice actor to have to break what would normally be several sentences delivered together into several separate takes. The lines will lack the transitions that are found in natural speech.
- If you have portions of dialog where characters are speaking simultaneously, try recording them both at once and individually. You can decide later which sounds better. Of course, if you are using high end equipment with multiple microphones in a studio setting, the studio people will rig up something snazzy so each actor can hear the other on their high-end headphones allowing them to act "together," but be recorded separately. If you have the resources, good sound isolation, a multitrack recorder, and long enough cables, you can do the same thing at home, but it's really a step above what most home users will be able to accomplish.
- Consider the physical situation of the character when the lines are delivered. If the character is crouching or hunched over, make your actor do the same. Record them a few times in a natural pose, while trying to make their voice sound like they are hunched, and a few times under the actual circumstances. If your character is supposed to be winded, have them just act like it a few times, then have them run in place for a minute and deliver their lines. If your character is saying something when they walk into a wall, once again, have them pretend first, then give them a firm (but loving!) shove on another take to gently simulate the impact. If your character is being eaten by a bear, it is advisable not to have your actor actually eaten by a bear, regardless of the level of realism that might obtain.
- In addition to reading the different lines of dialog into separate files, try using one overall take in which all the actors cluster around the mic (or mics) and do their interactions "live." What you could lose in sound quality by not having everyone speaking directly into a mic might be made up for with the group dynamic and better interplay between the actors.

NOTE
When we use the term "actors," we really mean whomever you have decided to record for your dialog. You don't need to go inquiring at the Screen Actors Guild, or, even worse, your local community theater group. Most likely you will be able to find "actors" of sufficient talent from among your friends and family. Who knows—your own voice might be appropriate for any number of your characters. Of course, if you really want to be nice, you can advertise in your local craigslist "GIGS: Talent" section and throw some starving actor or actress a bone.

The Goal of the Recording Session

The goal of the recording session is to walk away with a set of sound files that represent several different readings of each spoken line of your script. The sound signal that is recorded on the files should include minimal background noise and be as strong as possible without clipping. *Clipping* is when the sound source (in this case, the actor) is so loud that it overloads some portion of the recording equipment, making that particular portion of the recording useless.

To get a strong signal without clipping, you need to make sure that your actors are the optimum distance from the microphone (Figure 8.2). This will vary from mic to mic and will possibly be included as part of the instructions that came with your microphone.

One source of clipping is the introduction of "plosives" in the dialog. Plosives refer to the small blast of air that is produced when you make a "p" sound, or, to a lesser degree, "t" and "b" sounds. The air hits the microphone and is the equivalent of someone smacking the thing, producing a pop in the recording and often, a clip. The simplest way to mitigate plosives is with a screen, as shown in Figure 8.3. Screens are cheap, but you don't even have to purchase one. A simple plovise screen can be constructed from a 5″–6″ loop of metal coat hanger covered with two layers of nylon stocking and clamped to the microphone stand between the mic and the actor.

With your actor the proper distance from the mic and plosives taken care of, you just need to set the proper recording levels. If you are using a noncomputer recording device, it will almost certainly have a "clipping" indicator. The iKEY that I used has a simple red LED to indicate clipping. If you are recording directly to your computer, the recording software that you are using, one example of which we'll see in a moment, should also have a clipping indicator. Basically, you want to have your actors speak into the microphone, just as they will when recording, while you keep turning up the recording volume. Turn up the input volume until the clipping indicator begins to trip. When that happens, it means that you've gone a little too far. Back off on the input volume. Have your actor read through the lines again (just the louder ones if there are a lot) and pull the input volume back until you no longer see the clipping indicator.

Figure 8.2 *The voice talent on the mic*

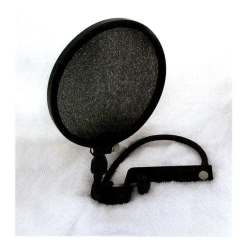

Figure 8.3 *A screen for avoiding plosive clipping*

Some Sound Processing Basics

If you already have and know how to use a sound processing program, you can skip this section. However, those of you who do not are welcome to download and install Audacity, an open source, completely free sound processing program that runs on Windows, OS X, and Linux-based computers. Audacity is available at `http://audacity.sourceforge.net/` and is included on the disc that comes with this book.

Recording with Audacity is as simple as running the program and pressing the large "Record" button that is shown in Figure 8.4. It uses the familiar icons for play, pause, stop, and record. One of Audacity's features that

is immediately useful is a live input level indicator. By clicking once in the meter area designated in Figure 8.5, you can see how much sound is coming through your microphones. If the bar reaches the end of the meter, you're clipping. The level for your chosen input (microphone, line in) can be conveniently set to the right of the input meter.

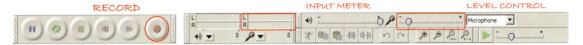

Figure 8.4 *Audacity's main controls* **Figure 8.5** *The input meter and microphone level controls*

To record a take, press the record button, have everyone stay silent for a couple of seconds, then have your actors speak their lines. When they are finished, wait a second or two again and press the stop button. The pauses are there to give Audacity's built-in noise reduction filter something to work with later.

A recording that looks something like Figure 8.6 is what you are aiming for. It shows a solid input level with no clipping. Figure 8.7 shows a recording made with too little input. Notice how the waveform is smaller and barely reaches a third of the way toward the outer edges of available volume space. The audio tools can amplify it, but it's better to start with a stronger signal. Turn up the input level and try another take. Figure 8.8 shows clipping in the indicated areas. This take is trash. Turn down the input levels and try it again. Depending on what equipment you are using, there might be several places along the way that you can adjust the levels: mic inputs, mixing board outputs and mix controls, and computer or digital capture inputs.

Figure 8.6 *A good audio take*

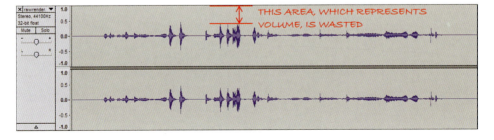

Figure 8.7 *Input levels are set too low*

The clipping on the left side of Figure 8.8 is probably due to the computer's input level being too high. The clipping on the right is more likely to have occurred in the equipment before the sound even got to the computer. The more complex your setup, the more places that clipping can be introduced and the more you'll need to know about your equipment to prevent it. This is another situation where having an experienced audio geek on your side will really work to your benefit.

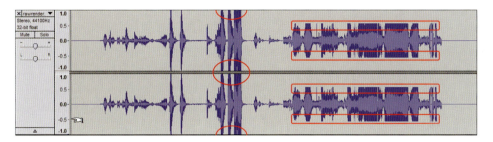

Figure 8.8 *Input levels are too high and clipping results*

When you have recorded a take, save it using the **Export** item from the **File** menu. Put the sound into your sound folder, giving it an appropriate name such as "mother_line_05.wav". The default uncompressed format is the WAV format, which is the one you should use. After the take is saved, click on the **X** in the upper left corner of the audio track to close it, as in Figure 8.9.

If you leave the track up when you record your next sound clip, it will play in the background, causing problems. Of course, you can always use the **Play** button before you save and close the track to make sure that you got what you wanted from the actor. If you like, you can monitor the performance through a set of headphones.

Figure 8.9 *Closing an audio track*

> **NOTE**
> There is a setting in the **Audio I/O** section of Audacity's **Preferences** that prevents already-recorded clips from playing while you record new ones. Just disable the **Play other tracks while recording new one** check box.

Whether you use direct-to-computer recording with Audacity or not, at some point you will have the raw files of several takes and different readings of your dialog. Make a backup copy of these files before proceeding.

Removing Noise and Adjusting Levels

Open one of your recorded sound files in Audacity. Using the left mouse button, click and drag in the flat area at the beginning of the sound, as in Figure 8.10. This is the area of quiet that you hopefully left at the beginning of each of your recordings. With this area selected, choose **Noise Removal** from the **Effect** menu. The **Noise Removal** dialog appears, with two steps, each of which are shown in Figure 8.11. Choose **Get Noise Profile**. This option examines the area of "quiet" that you selected previously. The dialog disappears, returning you to the sound file.

Figure 8.10 *Selecting the quiet area at the beginning of the sound file*

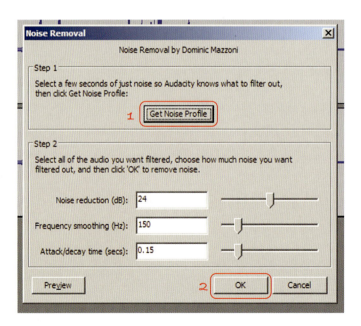

Figure 8.11 *The Noise Removal dialog*

Use **Ctrl-A** or double-click anywhere within the sound clip to select the entire piece for processing. Reselect **Noise Removal** from the **Effect** menu. This time, simply click **OK** to start the removal process.

Depending on the length of the sound file, it may take a few seconds. After the filter is done, listen to the processed sound. Too much noise removal can add a muted, tinny cast to it, making the recording seem to come from underwater. If you hear something like this, **Undo** the filter, then run it again, this time reducing the **Noise Reduction (db)** value. Do this until you have a good balance between background noise removal and foreground sound quality.

> **NOTE**
> "Background noise" in this context refers to the constant low level of noise that we mentally remove from our own hearing every day: the electrical and mechanical hum of nearby appliances. The **Noise Removal** filter was not meant to remove occasional background sounds like someone closing a door or dropping a book. When your take is interrupted by something like that, the filter will not help you. You will need to rerecord the take.

The other simple trick you can do to your sound file is to run it through a **compression** filter. Compression amplifies softer parts of the sound and reduces the volume of louder portions, giving a more even dynamic range. You may or may not prefer the effects of compression, so be sure to play your sound a couple of times both before and after you use the filter for comparison.

To run the sound through the compression filter, double-click the sound to select the entire thing and choose **Compressor** from the **Effect** menu. Although there are a number of options and settings available, accept the default by pressing **OK**.

When the file sounds good to you, choose the **Export** command again to resave the WAV file. (Choosing **Save** in Audacity creates an Audacity project file, not a playable sound file.)

> **NOTE**
> If you want to know more about editing and sweetening your sound, there are a multitude of Audacity tutorials available on the Internet. Some other simple Audacity filters that are fun to play with and can enhance your sound are **Bass Boost, Echo,** and **Change Pitch**.

With background noise removed and the dynamic range compressed, your dialog tracks are ready to use.

Previewing the Recorded Sound

The odds are that you don't have the professional equipment available to properly preview your sound files before using them. If you do . . . well, lucky you. For the rest of us, here is a low-tech way of getting an idea if your recording session has you at least in the right ballpark.

1. Using the CD burning software that came with your computer, burn an audio CD of both the raw and noise reduced/compressed sound files. It may be a good time to take notes because it will be helpful to know which is which when you are listening.
2. Play the burned audio CD in a DVD player that is attached to a television set. Most DVD players are capable of using standard audio CDs.
3. Listen to the CD through whatever speakers you normally use to watch television. Whether it is just your television's built-in speakers or a full-scale digital receiver system doesn't matter. The point of doing this is that you are used to hearing dialog played through this system. It provides a good reference for what your own recorded dialog sounds like when piped through the same equipment.

Does it sound like what you are used to hearing? Worse? Better? You may notice things when listening to the recordings in this way that you didn't notice when playing it through your computer's speakers or headphones. Depending on how it sounds, you may want to go back and record and process the dialog again. In fact, it would probably be a good idea to do a few tests with your recording pipeline before you bring in the voice talent. Actors can be touchy, and you don't want a strike on your hands.

Summary

When recording the final dialog for your animation, you should try to get the best equipment your resources will allow. Sound should be recorded in as "clean" of an audio environment as you can find. Dialog is recorded in different ways and with different readings of each line so that you can choose the take that works best in the final production. When the recordings have been made, basic digital processing can enhance the raw sound files.

Outbox

- A series of sound files, one for each line or naturally grouped series of lines in the script

The Peach Perspective
On voices and sound: Knowing the complexity and depth of animation and the visual arts, how important do you think it is for animators to attempt to "let go" of the sound portion of their project and let someone with real audio experience help out?

Sacha: Since an animator has his own work to worry about, I'm sure it would be no problem for this person not to think about the audio part. Especially when it's in the hands of a professional. In that case it's even a blessing, cause you know it's in good hands. The director just needs to make sure everyone shares his vision.

Rigging and Skinning

Objectives

- An iterative method for rigging, skinning, and testing
- A practical example
- Testing your rig
- A final example of fixing a rigging problem
- A checklist for preparing rigged characters for life as a library

Inbox

Coming into this chapter, you need:

- Completed character models
- A working knowledge of armature creation
- A story reel and a good idea of the motions your characters will achieve

An Iterative Method for Rigging, Skinning, and Testing

Rigging and skinning is the art of adding controls to your characters so they can be posed and animated according to the needs of your project. The rigging/skinning combination is probably the most technically demanding, and is often the most frustrating step in the entire process of creating a short animation. Some people are rigging geniuses. Most likely, you are not, and neither am I. That's okay, though. We're going to introduce some simple steps and concepts in rigging and skinning that will allow your characters to be flexible to different situations, as well as to introduce refinements as you go that won't destroy all of your previous work.

You don't have to create your rig from scratch. There are a number of great ones freely available for you to use in your own projects. Even if you plan to take advantage of someone else's genius, you will need to know

your way around both rigging and skinning if you want to successfully integrate such a complex piece of technology into your work.

A complete rig consists of three parts: controls, deformers, and helpers. Of these three, only the controls will be visible when you begin to animate.

Control Structures

The ideal control structure for a character is one whose tools are obvious, easy to use, and that produce intuitive results. Depending on your personal preference and the needs of your project, your animation controls might be anything from plain old armature bones (like my own rig in Figure 9.1), to finely crafted mesh object stand-ins that help you to remember what each control can accomplish at a glance ("Maloyo," Figure 9.2). During animation, the controls are what you will be selecting, manipulating, and keyframing. Efficiency is paramount because you will be searching for the smallest amount of effective controls that allow you to pose the character to the level of detail you need.

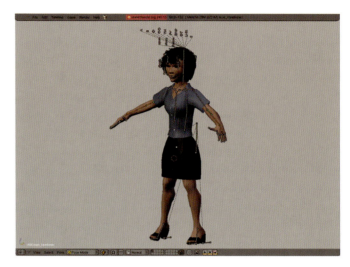

Figure 9.1 *The control structure for the mom. It's bare bones because that's the way I like it*

When animating with Blender, all of a character's controls should consist of bones in a single armature. This is because Blender's Action Editor, where character animation is generally done, will only show animation information for one object at a time. If the controls for your character are spread across several objects or armatures, you will not be able to perform some very necessary tasks (selection, alignment, scaling) on them as a group. Blender's armature is the only type of compound object that allows several subobjects (bones) to be animated at once, making it the only option for characters that require more than a single control. Also, when using

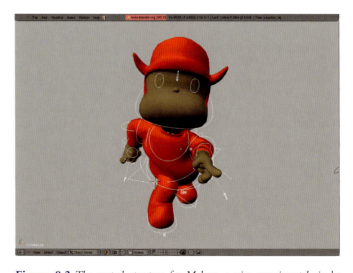

Figure 9.2 *The control structure for Maloyo, a nice experimental rig by Claudio Andaur*

libraries and linking with your characters, the proxy creation process is touchy enough that multiple control objects for the same character (e.g., a character with controls spread across two separate armatures) may or may not survive the proxy creation process, potentially rendering your rig useless for linking.

Obviously, control structures will vary in complexity, based on the animation needs of the character. Different levels of complexity may even appear in the same rig and can be shown separately by placing them on different bone layers within their armature. Blender provides 16 layers for bones in each armature for organizational purposes, as well as the ability to group bones for easy selection and visualization.

You can spend a lot of time creating custom-shaped controls for your rigs and really cleaning up their functionality. This, however, is another potential time-sink for your project. Make sure that the amount of time you spend on a rig makes sense with the amount of time the character will spend on screen. Obviously, your main character (or characters) should get significantly more love from your rigging skills than incidental or background characters.

As you can see from the disparity between the mother's rig and the Maloyo rig, there are also varying levels of "fanciness" you can build into your rig. If you are going to be the only animator and your project is of limited scope, it makes sense to keep things basic. However, if you are going to be handing off your animation files to other team members or think you may be taking long breaks during the project, you'll want to spend the time to make the controls more user friendly and accessible.

Deformers

The controls that are used when animating must be translated into motion and deformation of the character model. There are a number of ways to deform mesh objects in Blender, only some of which we will deal with: direct Armature deformation, lattices, and mesh cages. None of these, however, will be directly visible or accessible by the animator when the full character is linked into a scene.

In *The Beast*, both the Beast and the mother use a combination of mesh cages and vertex group deformation, while the dogs use cage deformers exclusively. The Beast's ragged toy uses vertex groups and a lattice. We'll examine each of these methods and their usefulness in an animation project.

Helpers

While some of the functionality of your rig might be contained in the controls themselves, anything but the simplest of rigs will require some sort of structure between the control elements and the deformers. These are the helpers, and they will not be seen by the animator under normal conditions. You can think of them as the "inner workings" of the rig. Blender provides 16 layers for bones in each armature, so, unless you are creating the ultimate all-purpose rig, you should be able to manage with a couple of layers for controls, some for deformers and some for intermediate bones.

General Rigging and Skinning Work Flow

Before we begin to analyze a rig and look at specific techniques, let's run down a general work flow for developing and testing a multilayered rig.

1. Build the basic structure. This is the stage where you construct the first part of the armature, adding bones to follow the contours of the character. Even though some of these (such as leg bones as we'll learn later) are really "helpers," it's okay and even necessary to include them at this point. Figure 9.3 shows the first stage of construction of the mother's rig.

At this stage, you will set up basic parenting relationships so that unconnected parts of the rig move properly. For example, arms and legs that don't have a direct connection to the trunk of the body should be made children of bones in the spine or hips so that everything moves together.

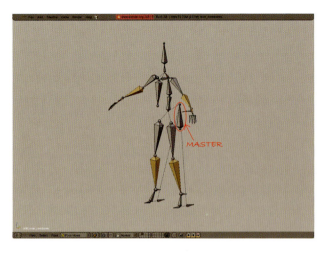

Figure 9.3 *The first stage of the mother's rig*

WARNING

Before you begin adding constraints to your armature, you need to remember to apply/remove any transformations from the object. Enter object mode and use **Ctrl-A** to apply any rotations or scaling, and clear any translations with **Alt-G**. Binding the armature to your deformers and character meshes in a transformed state can have unpredictably (but almost always) bad effects. Do it now, before it's too late!

If you're going to use inverse kinematics (IK) on any of the limbs, add it now, before the first round of animation testing. The last thing to add is a "master" bone, which is indicated in Figure 9.3. A master bone is the ultimate parent of everything in the armature. For the most part, you will not be moving your characters at the object level. Even initial placement will be done through bone level animation. So you need a convenient way to move the entire character at once. Any bone that is not a child of another bone in your rig will need to be made the child of the master bone. Figure 9.4 highlights the bones in the mother rig that are the direct child of the master bone. In this rig, all of

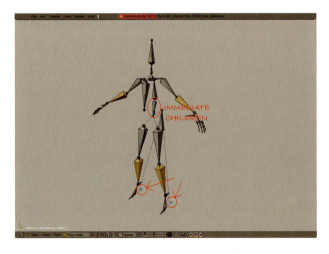

Figure 9.4 *The master bone and its immediate children*

the bones of the arm and head are connected through the spine, so they do not need a direct parent connection to the master.

If you move the master bone and parts of your armature are left behind, those parts need to become children of the master.

2. Test the basic rig and make adjustments. A good way to test the rig at this point is to set the armature to the **B-Bone** visualization on the **Armature** panel of the **Edit buttons**, as in Figure 9.5. In B-Bone mode, you can adjust the size of the bone visualization without affecting the bone length by using the **Alt-S** hotkey combination. Using this tool, you can adjust the B-Bones to approximate the proportions of your character, as in Figure 9.6, allowing you to test your rig with a slightly more "character-like" look before bothering with deformation and mesh binding.

Figure 9.5 *Choosing B-Bone from the Armature panel*

First, manipulate the control bones to see how the rig responds. That will mostly consist of moving the limbs and manipulating the head and spine. Then, keyframe some simple actions. You don't have to go crazy and create beautiful animation, but you should have your character perform some raw motions that are representative of what they will do in the final production. If the character doesn't do what you want at this stage, there is no sense in proceeding any further. You'll need to achieve a basic level of functionality before you move on. In the next section, we'll analyze the mother rig and discuss some specific techniques and the results they can produce. You can save the keyframed actions you create for later rounds of testing, if you like.

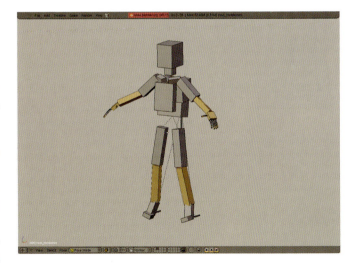

Figure 9.6 *The mother's rig with an Alt-S adjusted B-Bone visualization*

3. When you've gotten your basic rig built, move any helper bones that have been added onto a separate bone layer so you are only left with the controls. This includes bones that are in the middle of true IK chains, like most leg bones. They will never be directly manipulated during animation and their presence on the screen adds clutter. At this point, you choose your deformation methods and use them to bind the mesh to the controls. We'll examine the specifics of the different methods later.

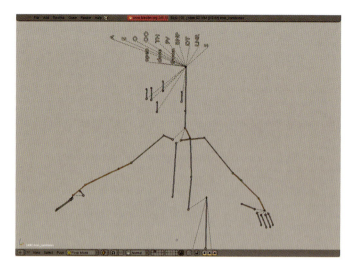

Figure 9.7 *The upper half of the mother's rig switched to Stick mode, showing some custom shapes*

4. Test the deformation. Switch the B-Bones to **Stick** mode, as in Figure 9.7, to declutter the display, or to **Shape** mode if you are using custom bone shapes. The words above the head in Figure 9.7 are custom bone shapes. Enable the **X-Ray** option so the armature controls will show through the character mesh. Start once again by manipulating the controls to see how the bound character reacts. If you have saved actions from a previous round of testing, bring them out and see how the mesh acts. In a later section, there is specific advice for testing your rig.

5. Refine the deformation. Now you go back and fix problems with the deformation, either by adjusting the binding parameters and methods or changing the structure of helper bones.

This is where the "iteration" kicks in. The approach now becomes a cycle of testing and adjustment, going back through the steps until you have something that performs reasonably well. The important thing is to make sure that you can manipulate the controls easily and that the character mesh reacts in a predictable, controllable way. Even if the deformers aren't perfect at this point, it's okay. Using this method allows you to refine the helpers and deformers throughout the course of your production. As long as you don't change the actual controllers, which are the only bones that will receive keyframes, you won't have to redo your animation every time you make an alteration.

Building the Rig in Layers

There are several reasons to build your rig in discreet steps and sections as presented here. First, it provides a clean interface during animation. There will be quite enough going on when you are keyframing your characters' motion that you won't be able to afford any clutter. Second, it allows you to refine both the deformers and the helpers throughout your production, even after you have begun animation.

Let's take a look at the controls, helpers, and deformers for the mother character from *The Beast* while we discuss some rigging practices.

A Practical Example

Figure 9.8 shows the controls for the Beast's mother, without the mesh. The controls for a character need to be created with a few things in mind. First, the controls should fit what the character will be doing. Second, when animation has commenced and keyframes have been created, the control structure cannot be changed. Here are some guidelines to follow when creating your rig and how they apply to the mother.

Inverse Kinematics/Forward Kinematics

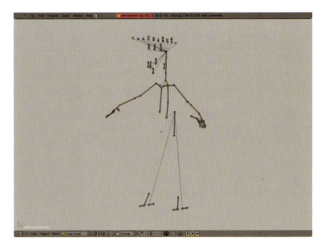

Figure 9.8 *The controls for the mother*

By default, armatures are created using forward kinematics (FK), with several options for implementing inverse kinematics (IK). IK is most useful when the end of a bone chain will be bearing weight. Technically, IK is used when the end of a limb is required to have a fixed-point in space, while the remainder of the limb is moving. This can be a foot on the ground, a hand on a countertop, or a paw holding onto a tree limb. Obviously, most characters will use this for their feet and legs. There are some exceptions, of course. In the case of the Beast himself, the legs and feet use forward kinematics because he spends a lot of time sitting, or with his feet in the air. Also note that the "weight-bearing" rule only applies to the tips of bone chains, not the roots. Even though a sitting character's weight is supported by the base of its spine, that bone is usually a root of a chain, not a tip, so IK is not appropriate. Unlike the Beast, the mother spends all of her time standing, so IK is appropriate for use on her legs.

If you examine Figure 9.8, you will notice that the leg bones themselves are not visible. That is because the animator does not directly interact with them. Bones that are part of an IK chain are not directly manipulable in any useful fashion. Figure 9.9 shows the leg bones, which fall under the helper category because they translate the controls from Figure 9.8 into deformation. The legs and feet are rigged with a standard method called the *reverse foot*, which is shown in Figure 9.10. The reverse foot allows you to control the position and rotation of the foot, as well as the extension of the ball of the foot and toes, while having the leg react

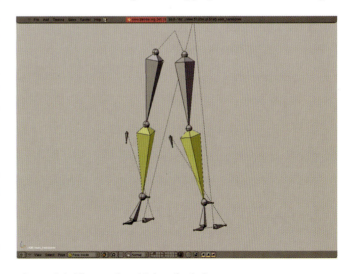

Figure 9.9 *The controls and helpers for the legs*

to it naturally, all with only three controls. Because they are weight-bearing limbs, the legs are rigged with inverse kinematics.

In the reverse foot rig, the bone that extends through the majority of the foot (FOOT in Figure 9.10) begins at the base of the toe bone and ends at the base of the lower leg bone. Both the toe bone and this reverse foot bone are offset children of the LEG CONTROL bone. All translations and rotations around the Y- and Z-axis have been locked so that a user cannot directly manipulate the bones. Movement of the foot is accomplished by translating and rotating the LEG CONTROL bone so that both children (the foot and toe) move together. The nice thing about the reverse foot, though, is that you can still rotate the FOOT bone along the X-axis, letting you raise the heel off the ground, while keeping the toe bone anchored, as in Figure 9.11.

Extruded from the end of the foot bone is an ankle bone (ANKLE in Figure 9.10), which acts as the target of the leg's IK chain. And so, moving the LEG CONTROL moves FOOT, which in turn moves ANKLE, which drives the IK chain of the legs. To the animator, though, it's as simple as manipulating the LEG CONTROL bone. The rest of the action is hidden.

The toe bone has freedom to rotate along the X-axis, just like the foot bone, so that the toes can be curled in either direction.

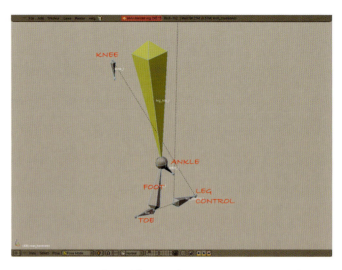

Figure 9.10 *Lower leg and foot controls, demonstrating the "reverse foot" rig*

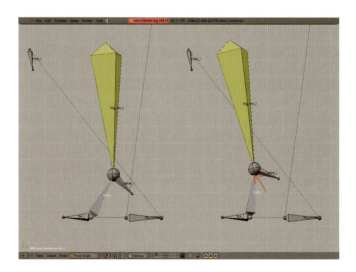

Figure 9.11 *You can rotate the foot bone to raise the heel without affecting the toe placement*

NOTE

Consider how much of a rig you need. Even though the mother's toes are individually visible, they will never move independently. A bone structure for each toe would be overkill, so a single control is used and the toes are treated as a part of the shoe for animation purposes. The Beast's toes are sometimes posed expressively, more like a hand, so each toe gets its own control in that case.

For the leg to follow the rotations of the ankle (and thus the rotations of the foot and LEG CONTROL), an additional helper bone is used. A KNEE bone is added, in front of the knee, as in Figure 9.10. The knee bone is set as the child of the LEG CONTROL bone and as the Pole Target of the leg's IK chain. When an IK bone has a Pole Target, it always attempts to orient toward it. Figure 9.12 shows how moving the LEG CONTROL moves the knee bone, which keeps the IK legs rotated along with the foot.

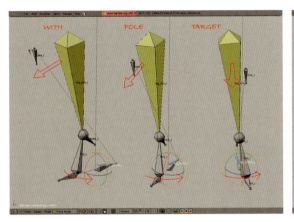 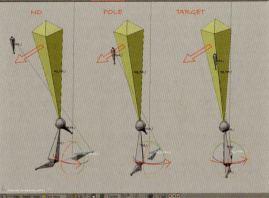

Figure 9.12 *A pole target keeps an IK constrained object oriented properly. Note how without a pole target, the IK chain fails to rotate with the controls*

Shortcut: Adding Constraints with Hotkeys

The fastest and most accurate way to add a constraint when rigging is through the use of hotkeys: **Ctrl-I** for IK chains and **Ctrl-Alt-C** for the other types. When you select two bones, two objects, or a bone and an object in sequence and use either of these hotkeys, a constraint is added to the active selection (the last item selected), targeting the other item (the first one selected). When using **Ctrl-Alt-C**, you will be presented with a pop-up menu showing all of the available constraint options, as in Figure 9.13. The only thing to keep in mind when using the hotkeys to set constraints is that the order of selection can seem unintuitive for many users. It would make sense to select an object to constrain, followed by its target, when the actual behavior is the opposite. Just remember that Blender always operates on the last object selected, the active object, and it's that object you want to constrain.

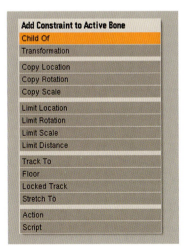

Figure 9.13 *The constraints hotkey menu*

The great thing about using the hotkeys to generate constraints is that the targeting information is entered for you in the constraints panel, eliminating typos and having to look up object names. This is especially useful when your target is a bone because you would otherwise have to type in both the name of the armature and the bone.

Blender also lets you use a different IK mode to generate poses on limbs and structures that are not part of an actual IK chain. In this mode, the character's bones will move according to IK principles during direct manipulation and posing. That is where the effect ends, though. Under normal IK conditions, you move and keyframe only the IK controller bone while the rest of the chain follows it. Interpolations between keyframes are done on the controller bone, and the IK chain is recalculated for each frame. When using the special pose-only IK tools, normal keyframes are required on all bones in the chain to record the pose, and interpolation between poses is done based on normal FK rotations—not according to IK rules.

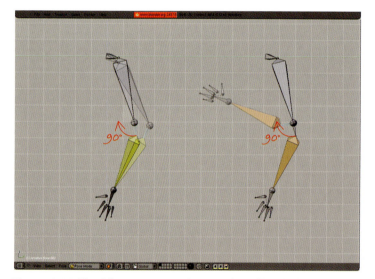

Figure 9.14 *The difference in rotating bones in the middle of different kinds of bone chains*

So using the pose-only IK tools, you get the intuitive posing capabilities of IK but retain the ability to rotate and adjust bones within the bone chain for the fine-tuning provided with FK. Figure 9.14 shows two bones chains. The one on the left is rigged with standard IK; the one on the right, pose-only IK. Rotating the middle bone in the chain has little to no useful effect on the IK chain, while it produces the standard rotation behavior on the other chain.

In Blender, this pose-only type of constraint is called *Targetless IK*. An IK constraint is applied to a bone, but a target is not assigned. If you add the IK constraint from the **Constraints** panel in the **Edit buttons**, making it targetless is as simple as not entering a target. The constraint name field becomes red, and the bone itself becomes orange (normal IK constrained bones are yellow). If you are using the **Ctrl-I** hotkey to create the IK chain, select only the bone (remember, you're going for "targetless" IK, so you don't need to select a target bone) and choose **Without Target** from the pop-up menu. Figure 9.15 shows both the pop-up menu and the constraints panel for targetless IK.

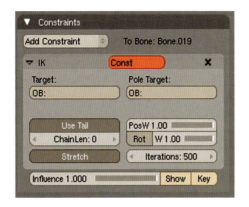

Figure 9.15 *Setting up targetless IK*

> **NOTE**
>
> If you are going to use **targetless IK** for your rig, it is strongly suggested that you enable **Automatic Keyframing**, as discussed in Chapter 7. Because each bone in the chain needs to receive a keyframe to retain the pose you created, yet you only have a single bone selected for transformation, without automatic keyframing you would have to create a pose, then select every bone that had changed and manually set a keyframe. With automatic keyframing enabled, any bones that transform as a result of the targetless IK move will receive a keyframe.

> **NOTE**
>
> While targetless IK is useful for quickly positioning limbs by grabbing the end bone in the chain, remember that, unlike targeted IK, the tip will not stay in place if the root or any other bone in the chain is transformed.

Regardless of the type of IK you use, all bones in an IK chain have a set of locks and limits available to them to make the resulting IK solution more realistic. Figure 9.16 shows the **Armature Bones** panel that is displayed when a bone that is part of an IK chain is selected in the 3D view.

To get a sense of how these work and why they are useful, let's take a look at the mother's collarbone. In Figure 9.17, the collarbone (called clav_l) is selected and has a different type of construction around its tip, forming a sort of umbrella. Normally, a bone is given 360 degrees of freedom. This shape represents the restricted range

Figure 9.16 *The IK restriction options*

137

of motion that is possible for this bone. Notice the red and blue axis lines on the shape that correspond to X- and Z-axes, respectively. These restrictions are set in the **Armature Bones** panel. Figure 9.18 shows the settings for the mother's collarbone.

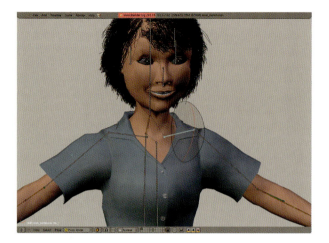

Figure 9.17 *The left collarbone, with restriction visualization*

Figure 9.18 *The control panel for the left collarbone*

The top row of buttons (**Lock X Rot**, etc.) completely prevent rotation around that axis. A collarbone should never roll or rotate along its own length, so Y-axis rotation was locked. I also wanted a very limited range of motion along the other two axes, so the **Limit** buttons were enabled for X- and Z-axis rotation. How much

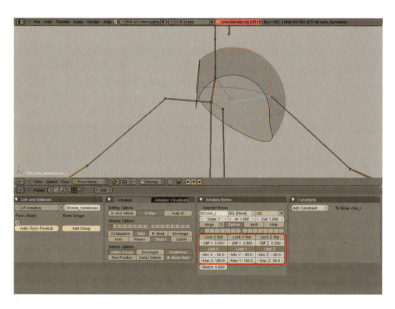

Figure 9.19 *Several limit umbrellas*

to limit? Well, that depends entirely on your situation. Think about what should be physically possible for the joint in question. If you are working with human (or humanoid) characters, move your own body and carefully observe how your joints rotate: Along which axes do they never move, where do they stop, where can they not go? As you adjust the minimum and maximum values for each limit, the umbrella changes its shape to match the settings, giving you visual feedback for your choices. Figure 9.19 shows several different lock and limit setups with their corresponding umbrellas.

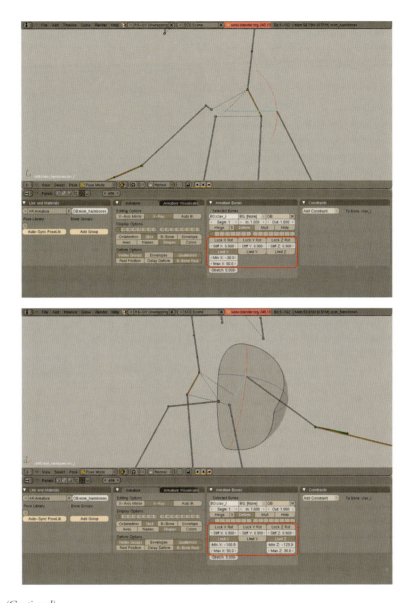

Figure 9.19 *(Continued)*

Each axis can also be assigned a degree of "stiffness." In this context, stiffness is the amount of resistance a joint puts up before it begins to move. For the mother's collarbones, I only wanted them to move when the rest of the arm was completely extended, so I assigned the X- and Z-axes a very high value of stiffness: 0.9. The highest level of stiffness is 0.99, and the lowest is 0, which is the default. Working with stiffness on IK joints has a bit of an artistic voodoo to it because stiffness values for one joint can affect the way that stiffness works with other joints in the chain. The most reliable method for making use of it is to apply it to the

single bone in the chain that would most benefit from it, seeing how that affects the chain's overall motion and proceeding from there. If you want to get this deep into the IK system, it's best to only change one thing at a time, experiment, then go back and readjust.

In the end, the only way to tell if your settings produce the desired results are to attempt to place the character into different poses. Carefully constructed limits and locks in an IK chain will dramatically increase the realism of your rig and reduce the time it takes you to make your poses look good. On the other hand, bad settings here can ruin an otherwise good rig. Remember, you want your rig to work for you. You don't want to have to fight it every step of the way.

The last IK parameter we'll discuss for now is called **Chain Length**. The **Chain Length** property is found on the constraint itself in the **Constraints** panel, as seen in Figure 9.20. **Chain Length** tells the IK solver how far up the bone chain to continue its effects. A length of 1 will only affect the constrained bone itself. A length of 2 affects the constrained bone and the next one up the chain. The IK solution will go as far as the highest bone in the entire parent—child hierarchy if you let it, including the master bone! Chain lengths need to be adjusted carefully so that the effects of your IK solver don't extend too far.

New IK constraints are created with the chain length set to 0. The 0 length signals that the IK effect should extend as far up the chain as possible. Unless you have an animation death wish, the first thing you should do when you create a new IK constraint is to change the chain length to something reasonable. It is usually best to stop the influence of IK on the last connected bone of your chain.

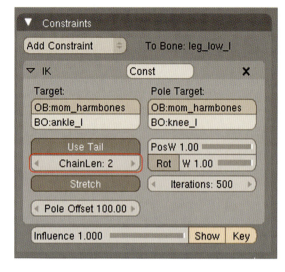

Figure 9.20 *The Chain Length parameter of an IK constraint*

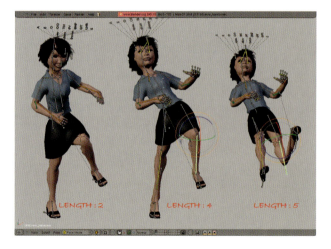

Figure 9.21 *This shows the mother rig with three different values for chain lengths of the leg IK chain. Obviously, some settings are better than others*

When multiple IK chains affect the same bones, the result can be pleasing when manipulating and posing, but it can cause problems if not managed carefully during keyframed animation. For example, if both leg chains in the mother rig are allowed to affect the base of the spine, moving a single foot will affect the positioning of the entire rig, including the other leg. Unless you are generating some extreme motion, it's probably better to keep IK effects isolated to their own limbs.

Auto IK

If you find that targetless IK works well for you, there is another option that takes targetless IK even further. Figure 9.22 shows the **Auto IK** option on the **Armature** panel in the **Edit buttons**. Enabling **Auto IK** for an armature causes any bone that you select and translate to act as though it has a targetless IK constraint attached to it. Any bone that you grab functions with pose-only IK. This means that you can manipulate all of your controls with the intuitive posing ability of IK without having to prethink where you would like to place your targetless IK constraints. **Auto IK** does not affect your ability to rotate bones normally with the **R** key. The only bones that are not affected by **Auto IK** are bones that are part of a genuine, targeted IK chain.

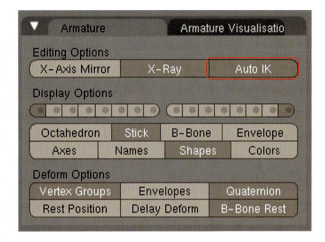

Figure 9.22 *The Auto IK button on the Armature panel*

All of the limit, lock, and stiffness settings that were added to any bones with other IK methods carry over when Auto IK is in use. Unfortunately, Blender does not allow you to set these parameters for bones that are not part of an actual IK chain. If you would like to use Auto IK and still take advantage of the lock/limit/stiffness controls, there is a way to work around this.

To do so, you add a targetless IK constraint to the end of a chain within which you would like to set those parameters (once again, it's **Ctrl-I**, followed by **Without Target**). The IK limitation buttons will then appear for all bones within that chain. When you have them as you like, remove the IK constraint from the end of the chain. Even though the controls disappear, the settings stay with the bone for use in Auto IK.

Another Rigging Example: The Fingers

The mother's fingers (as well as the Beast's fingers and toes) are a good example of the kind of approach you will need to take when creating controls and helpers. Physically, fingers are complex, and the fact that there are five on each hand makes it a tough subject for animators. What is needed, then, is a fairly simple set of controls that can drive the more complex structure of fingers.

In Figure 9.23, you can see both the control and helper bones for the mother's fingers. Each finger is controlled by a single bone. When the controller is scaled, the finger curls. When it is rotated, the finger rotates. This is accomplished with the following technique:

- An IK chain is created, with a bone for each segment of the finger.
- The bone inside the finger tip (A) is given the IK constraint, which is targeted to the bone that extends past the finger tip (B).
- This IK target is the connected child of the controller bone (C).

So when the controller bone is scaled down with the **S** key, the IK target is drawn toward the hand, curling the finger's IK chain. Likewise, rotating the control bone changes the location of the IK target, which in turn makes the finger rotate. To make the finger chain work properly, IK locks have been placed on the bones to prevent them from rotating along the X-axis. When animating, all except the controller bones are hidden on bone layer 16. The controllers remain visible.

Binding the Rig to the Mesh

The traditional way of achieving high quality deformations for character animation in Blender is the use of vertex groups and weight

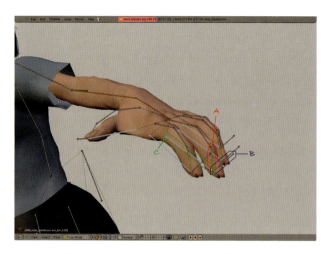

Figure 9.23 *A close-up of the mother's hand rig. The control bones that are visible when animating are selected*

painting. That technique is still valid and useful, but a new addition to Blender's deformation arsenal called the *Mesh Deformer* has made great deformations even easier to achieve. The mother uses both the armature/ vertex group and Mesh Deformer techniques, so we'll examine both.

If you would like to practice the techniques in this section, a file called "deform_practice.blend" has been included on the disc that accompanies this book. It contains the character mesh of the mother, the control armature, and the mesh deformer cage.

To Deform or Not?

Not every bone in your armature should be used to actually deform the mesh via vertex groups or to drive the other styles of deformers. The **Deform** option on a bone's **Armature Bones** panel signals to Blender whether the bone should be used or not. In general, bones that follow the actual structure of the character will be used for deformation. Bones that only act as targets for IK chains or intermediate helper bones are rarely used for deformation. All bones are created with **Deform** enabled by default, so you will have to turn it off for each bone you don't want to include.

The mother's rig is shown again in Figure 9.24, with all bones made visible. In this illustration,

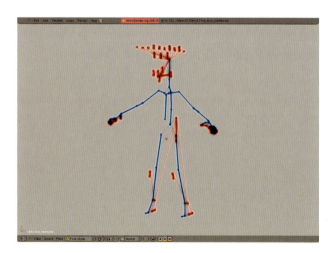

Figure 9.24 *Blue represents bones that will be used for deformation; red represents nondeforming bones*

bones that are set to deform are highlighted in blue, while bones for which deform is disabled are tinted red. Notice how the deform bones generally follow the structure of the character. Also notice that "off character" bones, such as the master bone, the main foot and finger controllers, and the knee IK pole targets are not to be used for deformation.

You can toggle the **Deform** option a bone at a time while you create your armature if you are thinking ahead. If you haven't done so, though, you can simply select all of the bones for which you wish to disable deformation, press **Shift–W**, and select **Deform** from the Toggle Setting pop-up menu, as shown in Figure 9.25.

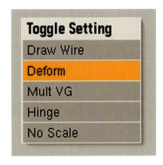

Figure 9.25 *The Toggle Setting menu*

The Armature Modifier and Vertex Groups

The latest release of Blender has a greatly enhanced algorithm for generating vertex groups from bones called *Heat Weighting*. Before you actually attach the armature to the character, it is worth ensuring once again that both your character meshes and your armature have neither rotations nor scaling with **Ctrl–A**. Then, with the character model selected, add an **Armature** modifier from the **Modifiers** panel. Enter the name of the control armature in the **Ob:** field.

> **NOTE**
> There are a few shortcuts for entering names into fields like this. You can begin typing the name and press the **Tab** key to have Blender attempt to automatically complete it. Also, you can hover the mouse over the armature's name field in either the **Object buttons** or the **N-key pop-up panel** and press **Ctrl-C** to copy, then hover over the **Ob:** field in the **Modifiers** panel and **Ctrl-V** to paste it.

Figure 9.26 shows the configuration of settings for this type of deformation. Both **Vert. Group** (to use vertex groups for deformation) and **Quaternion** (to give better deformation on twisting chains) should be enabled. **Envelopes**, a simpler but less precise method of deformation, should be disabled.

If you've worked with Blender and vertex group deformation before, you may be tempted to set the control armature as the object parent of the character mesh. Do not do this. You may decide later that you want to incorporate other methods of deformation into the rig, and not all methods play nicely with object-level motion.

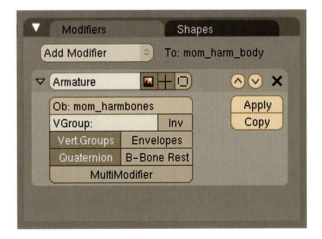

Figure 9.26 *The Armature modifier*

You'll be moving your character only at bone-level during animation anyway, so this will not present a problem.

If you enter pose mode and manipulate the armature at this point, the mesh will not move. You still need to create vertex groups in the character mesh that correspond to the bone names in the armature. In the "old days," Blender used a nearest-neighbor style search when automatically creating vertex groups for deformation. The new heat-based weighting produces excellent results and makes a much better starting point for your work.

First, select the armature and make sure that you are in pose mode. If you have any helper bones that are on a hidden layer, show them. Before vertex group creation, confirm your Deform settings for your bones so that you don't accidentally create deforming vertex groups for bones that should not be included.

Then use the **A** key to select all of the bones in the armature.

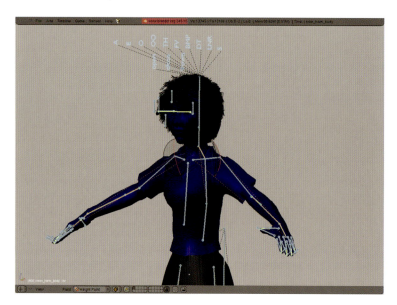

Figure 9.27 *The mesh in Weight Paint mode with all bones selected*

Holding down the **Shift** key, right mouse button select the character mesh. The armature itself will turn bright pink (or white depending on what UI theme you are using), as though you have left pose mode.

Press **Ctrl-Tab**, and the character mesh will enter **Weight Paint** mode (the mesh will turn dark blue). You will notice that the armature appears to be back in Pose Mode. This is a special selection state in Blender (a mesh selected, along with multiple bones in an armature in pose mode) that can only be achieved by performing these exact steps. All of the bones should still be selected. Figure 9.27 shows this state.

Figure 9.28 *The Weight mode specials menu*

Use the **W** key to bring up the **Specials** menu, and choose **Apply Bone Heat Weights to Vertex Groups**, as shown in Figure 9.28. Nothing will appear to change in the 3D view, although Blender might seem to stall for a few seconds, depending on the complexity of your mesh and how many

bones are in your armature. If you right mouse button select any of the bones now, you will see their influence visualized on the mesh. In this mode, only a single bone can be selected and visualized at a time. Figure 9.29 shows a sample.

You can test your deformation directly in this mode. Just right mouse button select a bone and manipulate it as you normally would. Note that the manipulator widget will not appear in this mode, and attempting to use mouse gestures will actually paint on the mesh, so you will have to use the standard G/S/R keys for manipulation.

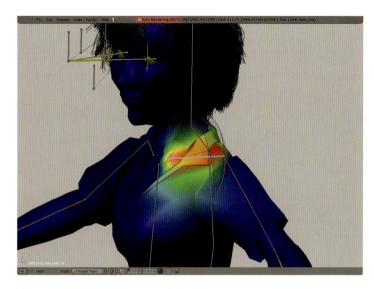

Figure 9.29 *The collarbone selected, displaying its weights on the mesh*

All of this earns you a starting point. The first thing to do is to grab the master bone and move your character away from the origin as one whole piece. It should all move. If parts of the mesh have been missed in the vertex group creation process, you will see something like Figure 9.30. The spikes are undeformed parts of the mesh. The solution to this problem is to select the bone you think should influence those vertices and paint some additional weight onto the mesh in the offending locations. You can even do this with the character showing the bad deformation like Figure 9.30. The Figure is in object mode to show the detail; weight painting will only work

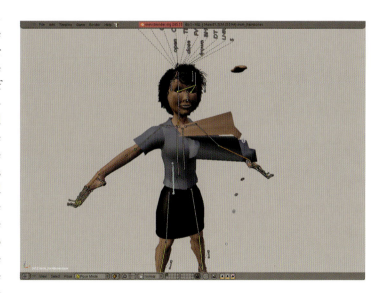

Figure 9.30 *Some vertices have been missed during vertex group creation*

in Weight Paint mode. As you paint the vertices, you will see them snap into place.

Actually, the rest of the vertex group process is similar to this. Manipulate the rig. See how the mesh responds. Using the weight painting palette, shown in Figure 9.31, add and remove weight to portions of the mesh.

To get out of Weight Painting mode, press **Ctrl–Tab** again. If you need to adjust the weights at any time, you can reselect the mesh and use **Ctrl–Tab**, selecting different bones to show their influence on the mesh.

Of course, armature modifiers, weight painting, and vertex groups aren't the only way to deform your mesh. Before you spend a whole day creating and refining vertex weights, let's take a look at the Mesh Deform modifier, which can make the job much easier.

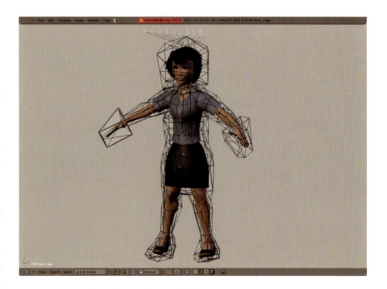

Figure 9.31 *The Paint panel in the Edit buttons*

The Mesh Deform Modifier

Figure 9.32 shows a cage surrounding both the mother mesh and the control armature. This cage is a regular mesh object, composed of triangles (not quads!) and fully enclosed (no holes). Every face of the character mesh is inside of it. This simple mesh, just over 300 vertices, acts as a controllable deformer for the high resolution character mesh. Pixar created the technique, and, after the release of their paper on the subject in 2007 (they call it *harmonic coordinates*), one of the Blender developers (Brecht van Lommel) implemented it for our animating pleasure. If you are looking for very sharp bends and creases in your deformations, this may not be the method you want to use due to its smooth nature. On the other hand, if you will be deforming things such as a chubby baby or a furry dog, this method is ideal.

Figure 9.32 *The mother with a mesh deform cage*

To use it, you create a low resolution cage around your character, such as the one in Figure 9.32, then add a **Mesh Deform** modifier to the character mesh. The name of the deforming cage is entered in the **Ob:** field, just like it was for an Armature deformer. In this case, though, the binding is not done through weight painting, vertex groups, and bones. It is accomplished by pressing the **Bind** button, as shown in Figure 9.33.

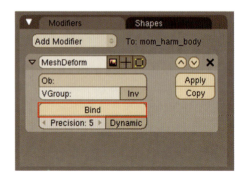

Figure 9.33 *A Mesh Deform modifier*

Depending on the complexity of your character mesh and the polygon count of the cage, it could take several minutes to calculate the binding on a modern computer. When it is done, though, any changes that you make to the cage mesh, whether in Edit mode or through some other mechanism, will be propagated to the character mesh.

But can that be it? Can it be so simple? Yes, it can. There are adjustments to make, but the **Bind** stage does a lot of behind the scenes magic to create great deformations.

Now with the character set to be deformed by the cage, you need to somehow control the cage itself. Obviously, applying an Armature deformer to the cage and setting up heat-based vertex groups as though it were the high resolution character mesh is the way to go. Figure 9.34 shows the relationships between the character, a deforming mesh cage, and the armature. Just to be clear, it works like this: the armature deforms the cage mesh, which then deforms high resolution character

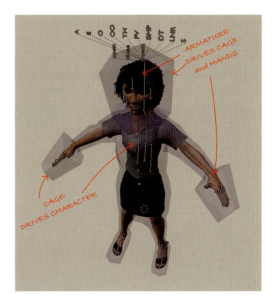

Figure 9.34 *The armature/mesh cage/character mesh relationship*

mesh. The great thing about using a system like this is that it makes it much easier to achieve pleasing deformations that react as you would expect them to than using vertex groups alone.

Here are a few tips for using the mesh deform modifier:

- Make sure to use triangles in the cage mesh (not in your character!). The algorithm that creates the binding and deformation seems to do a better job at maintaining the proper shapes when triangles are involved. If you're used to working with quads in your meshes, just use **Alt-T** in Edit mode to change quads to triangles before binding.
- Try different levels of Precision when binding. Lower levels of precision will cause distortion of the character mesh under less extreme conditions. Sometimes distortion is visible even at higher precision levels when rotating a character through a full 360 degrees. Beware of going too high with the precision value—it can take an extremely long time to complete the process or even cause Blender to stop responding. I was able to get away with a precision level of 6 for both the Beast and the mother.
- If you experience distortion when rotating your character, even with a relatively high Precision value, don't be alarmed. This is, apparently, a weakness in the process that has been acknowledged by Pixar (do *not* call them to complain!). You can minimize the problem by moving the cage away from the character mesh. Be sure to Unbind first. Notice how the mesh cage around the mother's head is significantly further away from the character mesh than in other places on the body. This was done to alleviate distortion during animation.
- When testing the deformation by moving the armature, you may find that a couple of faces of the character mesh are left behind. This is almost always caused by those faces falling slightly outside of the mesh deformer cage. To fix this, **Unbind** the deformer, move the cage a little bit further away from the character at the offending location, and rebind.

- The **Dynamic** button allows the mesh deformer to function properly even if the character mesh itself changes underneath the cage. This will be dealt with in Chapter 10 when we discuss facial animation.
- Any time you want to make an adjustment to the cage mesh without affecting the character mesh, you need to first **Unbind** the cage, using the **Unbind** button on the modifiers panel, make your change, then **Bind** it again. Entering Edit mode and making changes to a bound cage will cause the character mesh to deform under it. Of course, this suggests that, like any other modifier, the **Mesh Deform** modifier can be used as a modeling tool! Major distortions or alterations can be applied to a character by editing its Mesh modifier cage and clicking the **Apply** button on the modifier to make the deformation permanent.

From here, you refine the way that the armature bones drive the mesh deformer in exactly the same fashion as you worked with the armature and the main character mesh. Weight paint mode, select a bone, adjust the weighting, test, repeat.

When eventually animating, you don't need to see or directly interact with the cage under normal circumstances. In *The Beast*, deform cages are sent to a hidden layer to keep them out of the way. If you examined the mother's library file, you may have noticed that her cage appears in transparent purple. Even with the cage showing, you can see both the character and the structure of the cage at the same time. If you want to accomplish this effect, apply a material to your mesh cage, even though it will never render, set its Alpha fairly low (0.15), and enable the **Transp** setting in the **Draw** panel of the **Object buttons**.

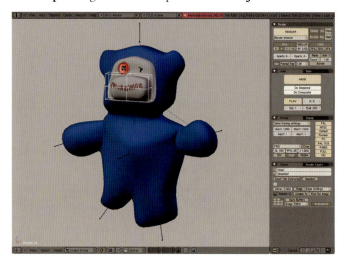

Figure 9.34A *The Beast's favorite toy, with a lattice on its muzzle*

Lattices

In some ways, a Lattice modifier is a functional opposite of the Mesh Deform modifier. While the Mesh Deform modifier is strictly bound to a mesh, and any movement of the cage mesh will move the character along with it, a Lattice deformer sits in place and only deforms portions of the character that happen to pass within it. Figures 9.35–9.38 show a simple sphere with a lattice deformer applied to it. As the sphere passes through the lattice object itself, you can see how it warps within the shape of the lattice.

9.35

9.36

9.37

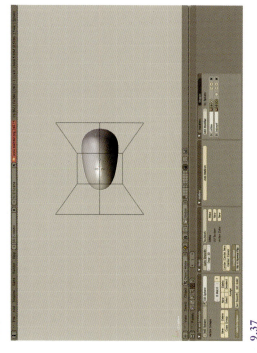

9.38

Figures 9.35–38 *A sphere passing through a distorting lattice*

Whenever you need to have a shape or character bend or twist overall, a **Lattice modifier** is the way to go. In the case of the Beast's toy, I was having a difficult time getting the mouth stitching to deform without passing inside the muzzle with the normal vertex group/armature deformation that the rest of the prop used.

To use a **Lattice modifier**, you must first add a Lattice object to your scene. This is just another object type from the main **Spacebar Add** menu, shown in Figure 9.39. A lattice in its default state looks like a mesh cube. You fit the lattice to your character by transforming it in Object mode, not Edit mode. So, through translation, rotation, and scaling, you get your lattice to enclose the portion of your object that it needs to affect. In the case of the Beast's toy, the lattice has been transformed to envelope the muzzle. In Figure 9.40, you can see object-level transform properties of the lattice.

Figure 9.39 *Adding a Lattice to a scene*

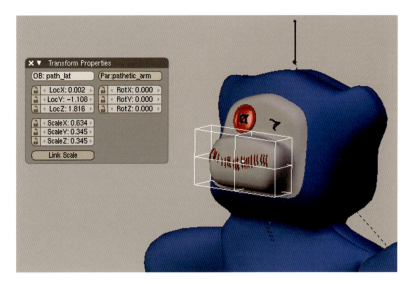

Figure 9.40 *The lattice object that deforms the toy's mouth stitching*

Notice that in Figure 9.40, the lattice has three sets of vertices along both the Y- and Z-axes, but only two sets along the X-axis. The resolution of a lattice is controlled on the **Lattice** panel of the **Edit buttons**, shown in Figure 9.41. As with anything else in 3D, don't use more than you need. The toy's muzzle would only be bending and stretching from top to bottom and side to side, so one extra level of resolution was added along those axes.

> **NOTE**
> Lattices use a separate coordinate system: U, V, and W. The [uvw] system comes from the roots of lattice mathematics. There is little to no practical distinction to the artist, though.

An Armature modifier was added to the lattice itself so that the bone movements of the toy would affect it along with the main body. Creating vertex groups on a lattice is less convenient than creating them on a mesh object, which is one other reason to keep the resolution count of the lattice as low as possible. To create vertex groups for armature-based animation of a lattice, it is necessary to enter Edit mode on the lattice, select the lattice vertices you wish to move, and manually create and assign them to a vertex group in the **Links and Materials** panel of the **Edit buttons**. Figure 9.42 shows a vertex group created for the **head** bone.

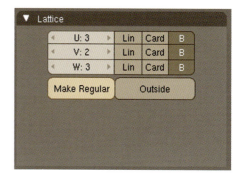

Figure 9.41 *The Lattice panel, showing the simple settings for the toy's mouth lattice*

In this example, the top and middle portion of the lattice move along with the bones for the top of the head, while the bottom and middle are bound via vertex group to the neck bone. The final effect, shown in Figure 9.43, is that the stitching is deformed smoothly as the lattice deforms, producing a nicer effect than simple vertex group/armature deformation.

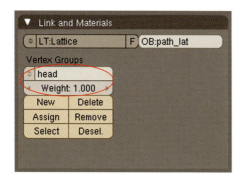

Figure 9.42 *A lattice vertex group that will move with the "head" bone*

Figure 9.43 *The Beast's toy severely deformed, with the lattice keeping the stitching in place*

Combining Different Deformation Methods with Vertex Groups

While the Beast's dogs only use Mesh Deform modifiers, both the Beast and his mother required something more complex. To use only a Mesh Deform modifier for them, the finger and toe animation would have needed a cage almost as articulated as the fingers themselves. Notice, in Figure 9.44, how the mother's hands have only a large, very simple structure around them. While the rest of the character is deformed by a mesh deformer, we want to use regular Armature modifier deformation on the hands and fingers the whole way up to the elbow.

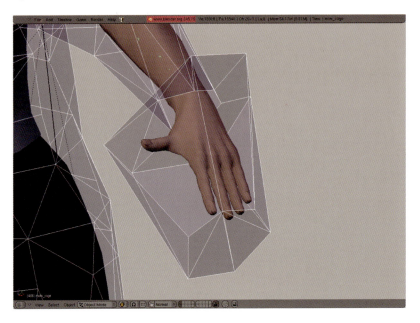

Figure 9.44 *The mother's left hand contained within a simple cage*

Figure 9.45 shows a part of the mother's modifier stack. A **Mesh Deform** modifier is first, followed by an **Armature** modifier. The Mesh Deform modifier appears without any remarkable settings, exactly as you have configured it in the previous section. However, the Armature modifier makes use of a number of settings we have yet to examine.

The **MultiModifier** button tells the modifier that instead of using the previous modifier's result as its starting point, it should use the original mesh, then blend the result of the previous modifier with the current one using the specified vertex group. In this example, it means that the Armature modifier comes

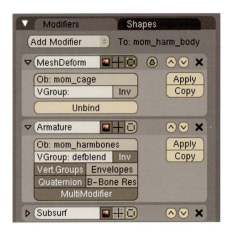

Figure 9.45 *The modifier stack for the mother's deformation*

152

up with its own deformation solution for the whole mesh, then blends that with the Mesh Deform modifier's result based on the **defblend** vertex group. Figure 9.46 shows the **defblend** vertex group in Weight Paint mode.

> **NOTE**
>
> In this example, the **defblend** vertex group has been painted so that the heaviest weight (the highest value: 1) is on the lower arms and hands. This is actually the opposite of what we want because the highest weight is used for the first modifier's result, and the lowest weight is used for the second result. Blender allows you to easily toggle this behavior, though, with the **Inv** button that appears beside the **Group:** field. Enabling **Inv** switches this relationship so that a weight of 1 signals the second modifier's result, and a weight of 0 signals the first. So why did I paint it backwards to begin with? The vertex group was originally created for something else, and worked well enough for this that I didn't bother to change it.

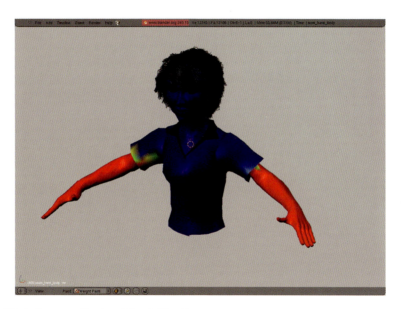

Figure 9.46 *The Weight Paint visualization of the "defblend" vertex group*

Of course, if the deformations produced by both modifiers are radically different, there will be distortion or very poor deformation within the transition areas. For that reason, it is to your advantage to try to make sure that the areas of the mesh where a transition occurs from one modifier's result to the other have a high degree of congruency between the two methods of deformation.

For now, you are limited to using the MultiModifier tool with the Armature deformer. If you want to use multiple modifiers for deformation without the MultiModifier tool, you can still do so by carefully using vertex groups to control the effects of each modifier in the stack, but achieving a pleasing, smoothly blended result is significantly more difficult. For now, it is best to use the modifier stack as shown in this section.

Testing Your Rig

When the rig is created and deformers are set up, you need to test the entire contraption. The best way to do it is to pick the most demanding scene from your story reel and put your character through its paces. Actions to watch out for that will show shortcomings in your rig are as follows:

- Any time a character (or a part of a character) rotates more than 180 degrees from its initial position, or even worse, past 360 degrees: Think a backflip or a character pacing around in a circle. Sometimes joints and bones will "flip" or "pop" at those points, creating bad breaks in animation. These kinds of problems can be identified early on, even during the B-Bone visualization stages before a mesh is attached. If you are only finding these problems after you've carefully bound and weighted your high resolution character mesh, you probably should have done more "real life" testing with keyframed animation sooner. Usually these problems stem from using Tracking constraints incorrectly or from inadequately restricted IK joints.

- Limbs that move very close to the body: This will show deformation problems because limbs or clothing might intersect with each other at the nearest limits of what the rig can handle. Of course, if these intersections don't occur where the camera will see them, you can put fixing them on your list of things that may be nice to get to some day. Another problem when limbs move close to the body is that the body actually pulls away from the approaching limb. Figure 9.47 shows this effect. In cases like this, you will need to work on the deformations. Almost certainly, arm or shoulder bones are influencing vertices that control (either directly or indirectly) the parts of the body that are moving incorrectly. Eliminate their influence on those portions of the body in Weight Paint mode.

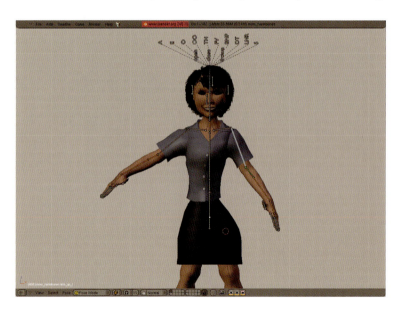

Figure 9.47 *An arm moving close to the body, causing the ribcage to shrink*

- Limbs or bone chains that extend toward their outer limits: While problems generated by stretching a rig beyond its capacity are generally solved by animating carefully so that it simply doesn't happen, limbs and joints will sometimes pop into a reversed position at extremities. This is just one of the limits of the IK solving process. When the chain is fully extended, the bones "lock" into place until the IK target comes back within reach of the chain. Your only friend here is knowing the limits of your rig and animating appropriately.

A Final Example of Fixing a Rigging Problem

While the problems you encounter during rigging are too numerous to mention in a single chapter (or even a single volume of a book), I would like to present you with one problem that I ran into and show how I fixed it. This is very typical of the kinds of things you will run into, and the framework for finding a solution should be instructive.

In one of the shots of *The Beast*, the mother kneels on the ground to pick up the little fellow. In her kneeling position (okay, technically it's a squat, but she's a dignified lady, so I won't say she was doing that), the stomach area deforms poorly, reducing her front-to-back depth to something like a few inches in real scale. The effect is highlighted in Figure 9.48. Test renders confirmed that it would indeed be visible in the final product. I needed a way to prevent the stomach from collapsing like that when she bends at the middle.

One of the rigger's best friends when solving problems like this is the **StretchTo** constraint. "Stretchy bones," as I call them, are great at adding structure to a rig. Usually their root is placed wherever you would like to anchor the deformation, and the tip is placed on a controlling bone. In this case, a new bone was added with its root near the front of the lower abdomen, about where a belt buckle would be. The tip of the bone was placed at the tip of the sternum. Figure 9.49 shows the new bone in place. Notice that, as I was attempting to solidify the structure of the abdomen, the bone approximates the location of the abdominal muscles.

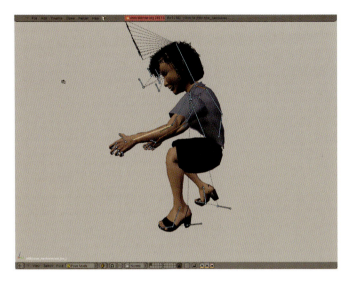

Figure 9.48 *The mother kneeling*

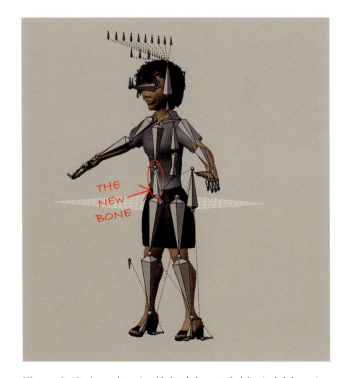

Figure 9.49 *A new bone is added to help control abdominal deformations*

155

Back in Pose mode, this bone is assigned a **StretchTo** constraint, with the sternum bone as the target. As constraints automatically target bone roots, and we want it to point to the tip of the sternum bone, we have to adjust the **Head/Tail** parameter in the constraint. **Head/Tail** is a new rigging feature that lets certain constraints target any point along a bone instead of just the root (the **tail**). For the mother's new stomach bone, this has been changed to a value of 1.0, which is the tip (**head)** of the sternum bone. The new bone is made an unconnected child of the base of the spine so that it forms a "solid" area between the roots of the two bones.

Now when the armature is manipulated, the root of the new bone moves in conjunction with the spine, while the bone itself stretches, squashes, and otherwise contorts itself to follow the sternum bone. We have created a stretchable structure that approximates the abdominal muscles. Figures 9.50–9.52 show the final construction along with the StretchTo constraint panel.

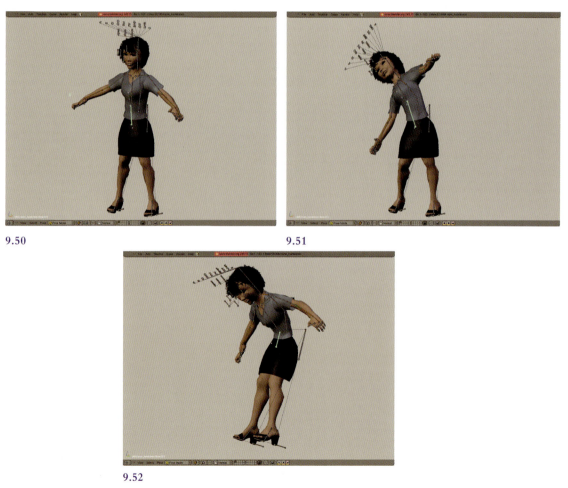

9.50

9.51

9.52

Figures 9.50–9.52 *The stretching abdominal bone*

156

A trip to the cage that is used as the mother's Mesh Deform modifier, followed by Weight Paint mode and recalculating both the sternum and new abdominal bone's heat-based weights (**W** key) gives a much more pleasing result. Notice the increased depth of the abdomen in Figure 9.53 that results from the addition of the stretchy bone.

If you want increased structural integrity, you could add even more stretchy bones to simulate the oblique muscles, back muscles, etc. In fact, before the addition of the Mesh Deform modifier, both the mother and the Beast's deformations were entirely rigged with stretchy bones just

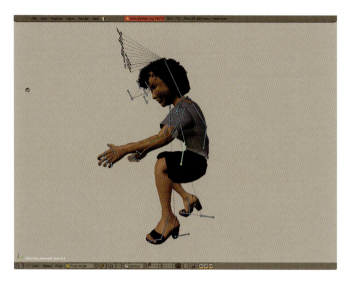

Figure 9.53 *The problem fixed*

like this one! Techniques like the one just shown still apply, but with the advent of Mesh Deform, their effectiveness is drastically increased.

This example also shows the value of separating your controls from your deformers. Adding a bone and changing the deformation weights didn't result in surprises—only a better outcome. If we had needed to change the controller bone to change the deformation, it could have affected portions of the armature that were already keyframed.

A Checklist for Preparing Rigged Characters for Life as a Library

Before you hit **Save** and close your character's master file for the last time (Oh, who are we kidding? You'll be back in here many times over the course of the rest of the animation. Many, many times.), there are some things to confirm that will make your life easier when animation begins. It's worth checking each of these items for every character in your project before linking them into a single production file:

- All meshes that are part of a character have rotations of 0 and scales of 1. If not, use **Ctrl-A** to apply them. You should have done this long ago (you were warned!), and applying errant rotations and scaling now might cause unpredictable problems, resulting in your having to rebind/skin your model to the deformers, move items that may have "jumped," etc.
- Your control armature has rotations and translations of 0 and scales of 1. Same thing here as the previous item, although this one can be even worse to remedy if you've ignored the copious warnings so far.
- Your bones are organized consistently, with bones that will not be used for controls sent to hidden bone layers. It can be helpful to use the same bone layers across all of your characters so that main controls are on layer 1, fingers and toes are on layer 2, hidden helpers on layer 16, etc. This will make it easier to keep track of things throughout your project.

- Select your armature, enter pose mode, grab the master bone, and translate the whole thing. The entire character should move at once, without distortion. If parts are left behind, check their modifier setup to ensure that they have deformers available that are somehow attached to the controls. If the character deforms bizarrely, you may have parented either the armature, mesh deform cage, or lattice directly to the character mesh. You can try **Alt-P** to break the relationship and hope for the best.
- Name all of your objects appropriately. A good scheme for naming objects related to a character is to begin with an abbreviation of the character's name, followed by an underscore and an abbreviation of the particular portion of the character setup. Figure 9.54 shows the mother with the names of the different objects showing. This makes it very easy to identify which objects you need to select when linking the character into a scene, as well as which objects belong to which character in the Outliner.

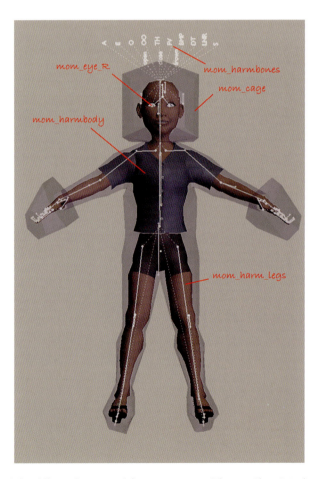

Figure 9.54 *The mother, with her different objects named for easy recognition. The term "harm" in the naming scheme refers to "harmonic deformation," another name for the mesh deformer*

Summary

Rigging and skinning is the most technically demanding task in the short animation process, even if you choose to use someone else's rigs. An effective rig consists of three sections: controls, deformers, and helpers. A rig's controls should be simple but provide intuitive freedom for animation. When building a rig, it is best to work in stages, testing along the way. First, a bare bones rig is created. Then the rig is cleaned up and bound to the character mesh. Animation testing proceeds from there with further refinements as problem areas are identified.

Weight-bearing extremities will probably be rigged with inverse kinematics. Other portions of characters may be rigged with other tools, including both targetless and automatic IK. Areas of high but compact functionality, such as feet and fingers, will require more complicated solutions than other areas of the rig.

The controls will deform the character through the use of modifiers: Armature, Mesh Deform, and Lattice. Armature modifiers work through the creation of vertex groups on the character mesh, which are directly driven by the corresponding bones in the control armature. Lattices provide a limited ability to warp and smoothly bend portions of a character. The Mesh Deform modifier provides a flexible method for smoothly deforming high resolution characters while retaining the ease of driving a low resolution mesh. The results of these modifiers can be combined in the modifier stack for a fully controllable character.

Outbox

- BLEND files that are ready to be used as character libraries in scene files
- A headache

The Peach Perspective

On rigging: Do you think you would rig a character differently if you knew that you were going to be the only animator using it, i.e., a one-man project? How do you change your approach when you know a whole team will be using your controls?

Nathan: Well, I'm no expert on this, honestly. *Big Buck Bunny* was my first time doing any really serious character rigging. But yes, I do things differently. Namely, when I'm rigging only for myself, I only have to please myself. When I'm rigging for others, I have to at least *try* to please them as well, even if I sometimes disagree with what they want. I suspect the rigs for *BBB* would have been somewhat simpler if I had only been rigging for myself. There's a bit of bloat that comes with trying to please everyone.

Facial Motion and Controls

Objectives

- Blender's method for controlling facial expressions
- Creating a library of shapes
- Constructing shape controls
- Rigging and controlling eyes

Inbox

Coming into this chapter, you need:

- A rigged character model
- A good idea of the range of emotion and dialog for your character
- A working knowledge of Blender's Shape Key system

Blender's Method for Controlling Facial Expressions

Facial expressions and animation are crucial to a finished character animation project. When working with facial animation in Blender, you have the deformation tools that were already presented in the previous chapter: armature/vertex group, mesh cage, and lattice. However, none of those alone can provide you with the flexibility and fine control that you need to create emotive facial expressions. Blender's system for directly creating, storing, and animating different shapes and deformations of a mesh is called *Shape Keys*.

> **NOTE**
> Everything in this chapter can also be applied to situations other than facial expressions. Any detailed and exact mesh deformation can be handled with the tools presented here. For example, picture an alien character whose ribs become significantly more and less prominent as it breathes. Blending between the exactly modeled shapes of a smooth torso and a torso with ribs protruding is a perfect job for this technique.

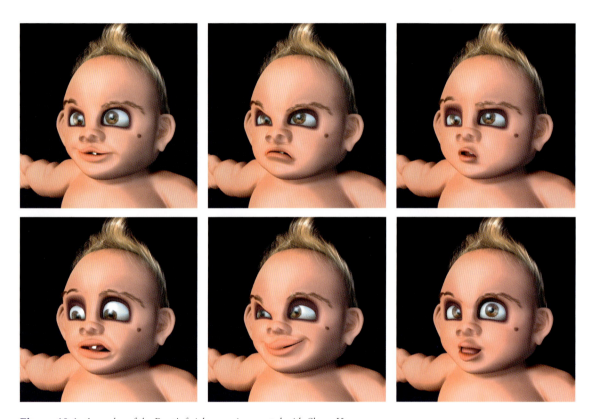

Figure 10.1 *A number of the Beast's facial expressions created with Shape Keys*

Figure 10.1 shows several of the Beast's expressions, each of which was created from the basic Beast mesh. Shape keys are technically simple to create:

- Enable Shape Keys for your mesh by clicking the **Add Shape Key** button on the **Shapes** panel of the **Edit** buttons. The first time it is pressed, this button creates a saved shape called "Basis," which is simply

the original shape of the mesh. Figure 10.2 shows the result of pressing **Add Shape Key** for the first time.

- Create and name a new shape by clicking **Add Shape Key** again, assigning a name to it in the title field. Nothing changes in the 3D view because any new shapes added in this way begin their lives as duplicates of the previously selected shape. In Figure 10.3, a new shape key has been added and named "smile."

- Directly alter the mesh, using either the standard transform tools in Edit mode or the Sculpt tools. Whatever changes you make to the mesh are used for the currently selected shape. In the case of Figure 10.4, the expression seen in the 3D view has been created and automatically stored under the "smile" shape.

That's it! You can continue to add, name, and construct shape keys until the needs of your animation are met.

You may recall from the previous chapter that only a single animation control structure can effectively be shown in Blender while animating. For that reason, it makes sense to build the controls for these shapes directly into the armature object that will be driving the animation for the rest of the character.

Figure 10.5 shows the Beast with his controlling armature. The bones floating in front of the face control shape keys that allow

Figure 10.2 *Enabling Shape Keys by creating the "Basis" shape*

Figure 10.3 *A new shape key has been created and named "smile"*

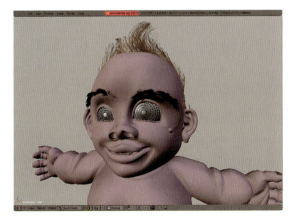

Figure 10.4 *The mesh is altered in either Edit or Sculpt mode*

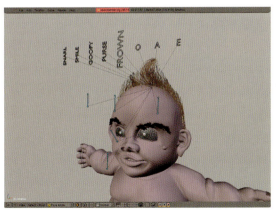

Figure 10.5 *The Beast with his controls*

the Beast to squint, close and open his eyes, furrow his brow, and wrinkle and flare his nose. The controls above his head, which are represented by words and letters, affect the shape of his mouth so that he can smile, scowl, and make silly baby sounds when he's not abusing the dog. These bones are linked to shape keys so that keyframing the bones along with all of the other bone-based controls produces facial animation. In Figures 10.6–10.8, you can see several complete expressions from the Beast superimposed with the controls that produced them. We'll take a look at how to build these controls a bit later.

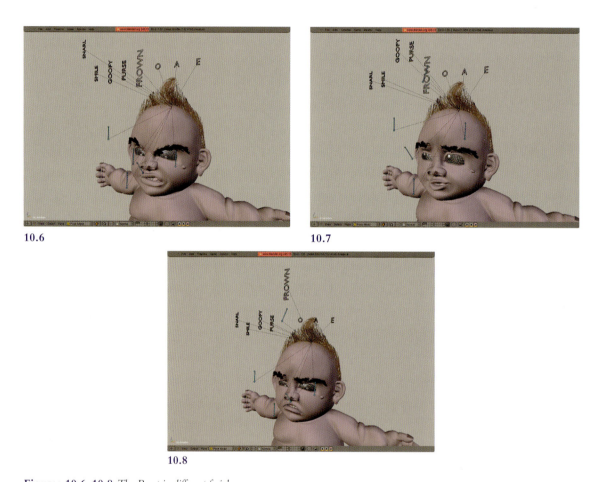

10.6

10.7

10.8

Figures 10.6–10.8 *The Beast in different facial poses*

Creating a Library of Shapes

Before you begin to consider creating and binding the controls for your facial expressions, you need to decide which shapes your character will need. Once again, an examination of your story reel will assist you in whittling down the candidates. Create a list of the expressions your character makes. Also consider your script.

If your character has any appreciable amount of dialog, you will most likely need a full range of mouth shapes to properly lip sync to the vocal track. On the other hand, if your character will only be "gooing" and "gaa-ing" like the Beast, you can get away with a smaller set of shapes.

Different Ways to Construct Expressions

There are two different approaches to creating shape keys for expressions. The first, creating individual movements or "expression fragments" (raised left eyebrow, raised right eyebrow, wrinkled nose, etc.), is easier to do but will produce less predictable, and therefore probably less realistic, overall expressions. The second method—creating a full expression (angry face, happy face) and breaking it up into component movements—is more work but gives you significantly better control over the final result. The following instructions apply to the faces of human characters, but you can easily adapt the methodology to whatever type of character you are using.

Expression Fragments

Creating shapes for individual movements is simple. Add, name, and edit new shape keys for each of the following:

- Left eye, with the brow both raised and lowered. When editing the shape for each of these, keep in mind that the upper portion of the cheek generally moves with opposing motion to the brow. When the eyebrows move up, the lower eyelid and upper cheek move down.
- Right eyebrow, the same as the left.
- The midbrow (the space between the eyebrows), both raised and lowered; for additional control, you can create rotations of the midbrow, both clockwise and counterclockwise. A rotation control is good for lopsided, twisted eyebrow poses.
- Nostrils flared and contracted.
- Nose wrinkled. For additional control, create separate shapes for the left and right.
- A smile divided into left and right halves.
- A frown divided into left and right halves.
- The mouth opened with the jaw dropped.

When you are done, you will have a fairly long list of shapes that will look something like Figure 10.9. The shapes can be browsed and viewed either by selecting them from the drop-down menu in the **Shapes** panel or using the forward and backward arrows to either side of the shape's name.

Later, we'll see how to link these fragments to controls and mix and match them to create full facial expressions.

Figure 10.9 *The list of saved shapes for the Beast*

Splitting Expressions

Another way to approach the creation of facial expressions is to make a fully-formed expression in one shape, then use vertex grouping to split that shape into segments for greater flexibility and control. The advantage of this method is that you can be very artistic in the creation of individual expressions: anger, shock, glee, and disgust. The downside is that the procedure is technically more difficult, the controls are more complex, and you will have many more shapes to manage.

The first thing you do is to create the shapes for your overall expressions. The next section explains some good ways to do that. Analyze your storyboards to see the range of emotions expressed by your character. Obviously, if your character spends the entire animation grinning like a lunatic, there is no need to create a sad expression.

At this point, you could simply attach a controller for the entire expression and be done with it, and, if your character isn't going to be front and center, that might be good enough. The problem is that real people (and other creatures, real or not) do not move all of the parts of their face at once when they, for example, change from smiling to frowning. First, the brows fall, followed by the corners of the eyes and eventually by a relaxation of the mouth's smiling muscles and a tensing of the muscles that generate a frown. If your character does those things all at once, and all at the same rate, it looks robotic. The solution is to use vertex groups to split each of these full expression shapes into component parts for individual control.

Figure 10.10 shows one suggestion for a way to divide the face into control zones. The vertices in each of these zones will become named vertex groups. In Figure 10.11, the Beast is in Edit mode and the vertices that make up Zone 1, the right

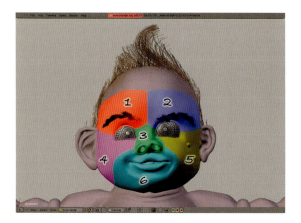

Figure 10.10 *The Beast's face divided into control zones*

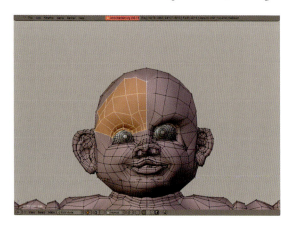

Figure 10.11 *Zone 1 selected in Edit mode*

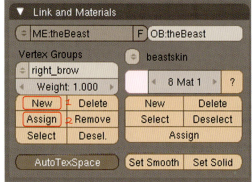

Figure 10.12 *A new vertex group has been created and assigned for "right_brow"*

eyebrow, have been selected. With that selection made, click the **New** button in the **Vertex Groups** section of the **Links and Materials** panel of the **Edit buttons**, shown in Figure 10.12. Give the vertex group a descriptive name (such as "right_brow"), and then click the **Assign** button to actually assign the selected vertices to the newly created group.

> **NOTE**
> Before you enter Edit mode to make your selection, make sure that the **Shapes** panel is set to the "Basis" key. Remember that any time you enter Edit mode, you are editing and selecting based on the currently visible shape. While you could technically build your vertex groups with the mesh set to any shape, you will probably get a better result when working with the "Basis" shape.

Create vertex groups in this way for each of the control zones. Unlike working with weight groups and the armature deform modifier, you need to be very careful how these vertex groups overlap. Shape keys are **additive**, meaning that two shape keys applied to the same area of the mesh will not blend together—they will reinforce one another. For example, if you were to create vertex groups for both the left and right brow areas and have them share a common seam, the vertices along that seam will receive twice the amount of shape keying than they ought to if you were to apply both shape keys at once. Those vertices would be moved completely by the one shape control, and then moved again by the second control, producing something not very natural, such as in Figure 10.13.

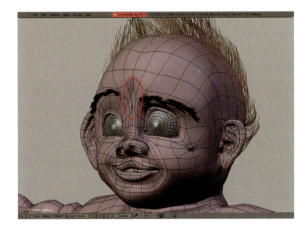

Figure 10.13 *The row of vertices between the brows is receiving shape information from both the left and right brow shapes*

To fix this, you simply reselect only the seam vertices and change their weights to **0.5** in the **Vertex Groups** tools. To do this, bring up each group in the panel that the seam vertices are a part of, change the **Weight** control to **0.5**, and click **Assign**. Figure 10.14 shows the border vertices of the right eyebrow group being set to a weight of 0.5. The weighting on a vertex across all groups needs to add up to **1.0**, indicating that it will use a total of 100% of the deformation from all shapes combined. In the case of the border between the brows, 0.5 works because there are only two vertex groups affecting those vertices (and $0.5 + 0.5 = 1.0$). If you have a vertex that is shared by four groups, you would need to give it a weight of 0.25 in each group.

In reality, though, the notion of discreet, nonoverlapping zones like this will not produce very good results. When a person moves their right eyebrow, some motion is seen in the surrounding areas. There is no clear delineation of a stopping point. Something more complex is called for. Figure 10.15 shows the brows as fading, overlapping zones. This is more difficult to accomplish because you will have to set very carefully the weighting to make sure that the

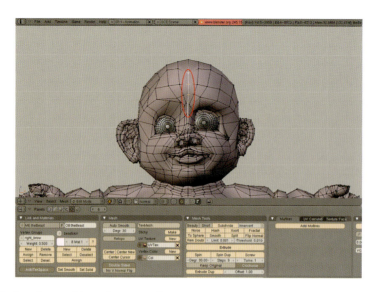

Figure 10.14 *Setting a lower weight on the seam vertices*

influences of all vertex groups add up to 1.0 on any particular vertex. Figures 10.15–10.16 show two overlapping vertex groups, with the weighting each vertex would need to create a proper and smooth transition.

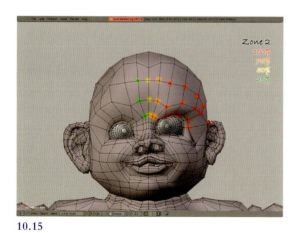

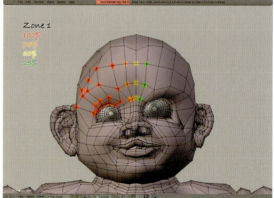

10.15

10.16

Figures 10.15–10.16 *Smoothly blended vertex groups*

This points out another strength of the technique mentioned in Chapter 5 of working with a relatively low resolution master mesh to which subsurfacing is applied at render time. It is far easier to deal with problems like this when there are only, say, 10 vertices to weight by hand, as opposed to working with a high resolution mesh, which would involve hundreds or thousands of vertices.

The good news is that when you have the face broken into zones, the same set of vertex groups will be used on all of the master expression shapes.

Splitting the expressions themselves is easy in comparison.

In Object mode, bring up the character's overall expression on the **Shapes** panel. The 3D view shows the new shape (Figure 10.17). Enter the name of one of the zoning vertex groups into the **Vgroup** field. The 3D view now shows the deformation affecting only the area within the selected vertex group (Figure 10.18). Finally, press the **Add Shape Key** button. A new shape is created that is identical to the current state of the

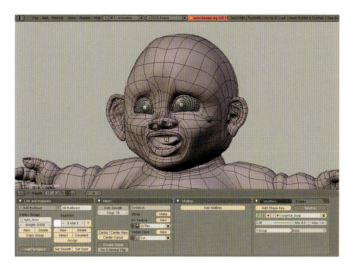

Figure 10.17 *A full expression*

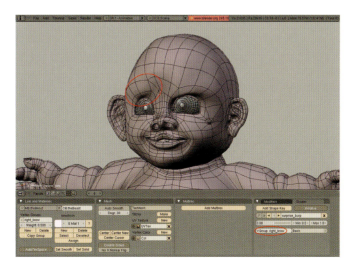

Figure 10.18 *The expression masked with a vertex group*

169

mesh, that is, the vertex group-masked original shape but without the vertex group mentioned in the panel. In effect, the vertex group has been "applied" to the original shape and used to create a new shape key. Figure 10.19 shows the result of this. Note that there is no vertex group attached to this new shape. Name the new shape something useful, like a combination of the overall expression and the zone ("burp_brow_r").

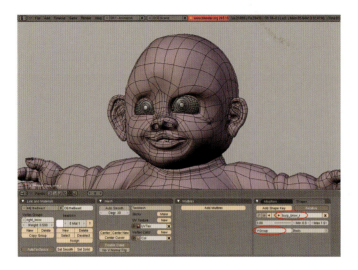

Figure 10.19 *A new shape is created from the masked original*

Continue through each of your master expressions, building a library of named expression components.

Tips for Creating the Shapes

To create these shapes, either the fragments from the first method or the overall expressions from the second, you can use both the regular mesh editing and sculpting tools. I have found that using the sculpting Grab brush is an intuitive way to alter the shape of your characters' faces. When sculpting shapes on an already-completed model, it feels very much like working with clay. If you have not used the sculpt tools before, it's as simple as choosing **Sculpt** mode from a 3D view header and bringing up the **N-key properties** panel to show the tools. Figure 10.20 shows the mode pop-up. Figures 10.21–10.22 show the sculpting Grab brush used to widely open the Beast's left eye. The sculpting Grab tool works by left mouse button clicking and dragging on the model.

Figure 10.20 *Selecting Sculpt mode*

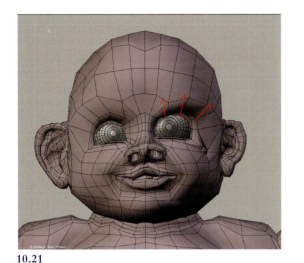

10.21

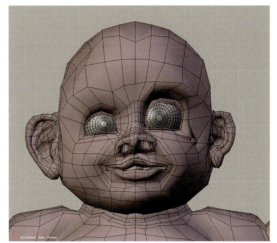

10.22

Figures 10.21–10.22 *Sculpting the Beast's left eye open*

NOTE

When using the sculpt tools on a mesh that has differ-ent shape keys, you will need to "lock" the shape before beginning. In fact, Blender will warn you and not allow you to sculpt if you do not. In the **Shapes** panel, select the shape on which you would like to sculpt, and enable the "Pin" icon on the left of the shape controls. This is shown in Figure 10.23.

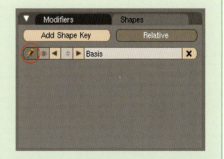

Figure 10.23 *Locking a shape to enable it for sculpting*

Use caution when working around the eyes so the eyelids of your model don't pull away from the eyeballs, leav-ing an unsightly gap. If your mesh has overlapping or nested structures such as teeth or a tongue, you will not necessarily want to have those affected by the sculpt tools (teeth don't flex and bend as you move your lips). There is a way to prevent them from being affected by the sculpting tools, but it is a bit of a work-around.

- With the "Basis" key selected in the **Shapes** panel, enter Edit mode on the mesh.
- Make a selection of everything that will *not* be rigid (everything that you want to remain "sculptable"). You do this either by directly selecting all of the nonrigid vertices or by selecting just the teeth, horns, etc., then using the **Select Swap** command from the 3D view **W-key Specials** menu.
- Using the Vertex Group tools, create and name a new vertex group called "sculptable" and assign the selected vertices to it.

- Returning to the **Shapes** panel, find the shape name into which you wish to sculpt and enter the "sculptable" vertex group into the **Vgroup** field. This prevents the shape from affecting the rigid parts of mesh, and, because you are sculpting directly into the shape key, it also prevents the sculpt tools from moving any of the vertices that are not in the group.

When you are finished sculpting, remember to unlock the shape by disabling the pin icon.

In addition to the sculpting tools, you can also work on your shapes with the standard Edit mode tools. Particularly helpful will be the **Proportional Editing** transformation (**O** key) so that any edits you make will remain smoothed with the rest of the mesh.

Edit mode will be most useful when making edits that involve rotating the mesh, such as curling the edges of the lips upward in a smile or rotating the jaw downward for an open mouth key. Figure 10.24 shows the mother's jaw being rotated open with a pivot point set where the hinge of the jaw would be. It can also be handy to save certain selections, like a loop of edges around the mouth, into vertex groups. They can be called up any time you need to; for example, to widen the mouth in an expression: Select the mouth loop vertex group and scale along the X-axis.

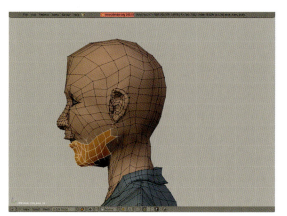 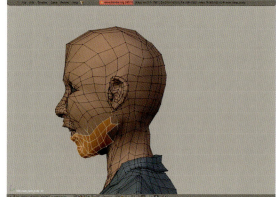

Figure 10.24 *Using Edit mode to create a "mouth open" shape*

NOTE

When you begin to control your shapes, you will find that you can have them extrapolate past the original deformation into an even more extreme shape. While this is useful, it can lead to some artifacts and less than ideal exaggerated states. For that reason, try to create your shapes with some of that exaggeration already built in. If you make your shapes in an already "beyond the norm" fashion, you can always choose to use the shape at less than full strength for a more traditional effect, while retaining the ability to go even further and still have a nicely formed expression.

Mouth Shapes for Lip Syncing

A quick search of the Internet will reveal that everyone has their own ideas about how many mouth shapes you need to effectively lip sync your character to your dialog. In the end, it comes down to the same thing as so many other details of your animation: the style. If the style is simple and cartoony, you can probably make do with only a few shapes for lip sync (open mouth, closed mouth, wide mouth, and "oooo" lips). The more realistic your animation becomes, the more closely you will have to match the shapes that would actually be needed to make the sounds coming from your character's mouths.

Creating shapes for lip syncing works exactly like making any other kind of expressions, although you will probably not want to divide them into separate left and right components.

Figures 10.25 and 10.26 show the mouth shapes for both the Beast and the mother characters, along with the sounds that they are capable of representing.

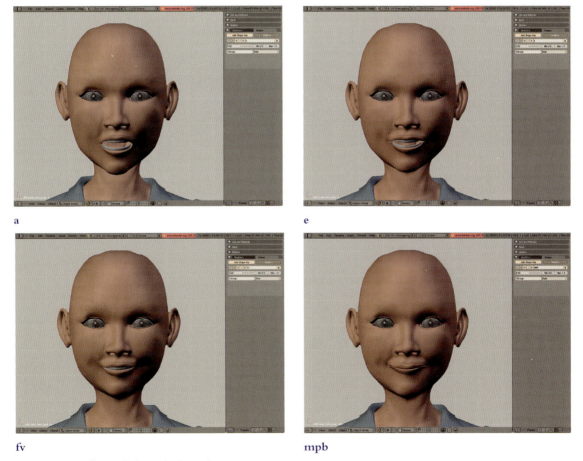

a

e

fv

mpb

Figure 10.25 *The mouth shapes for the mother*

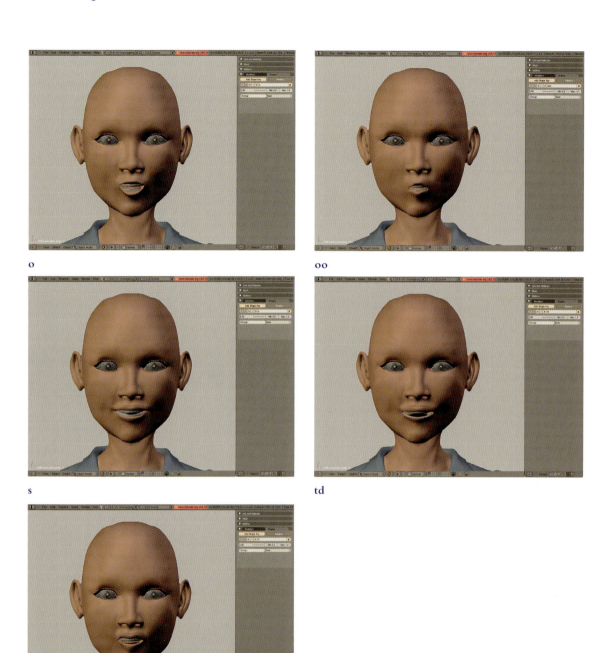

o

oo

s

td

th

Figure 10.25 *(Continued)*

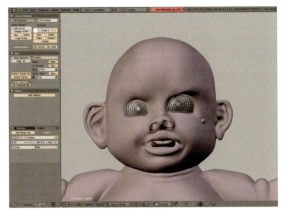

aaa

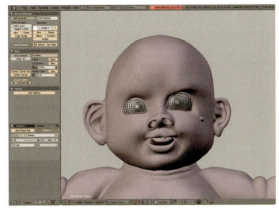

eee

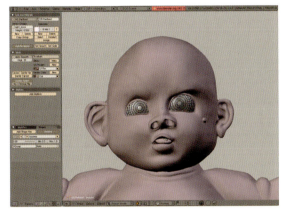

ooo

Figure 10.26 *The mouth shapes for the Beast*

Constructing Shape Controls

For ease of use during animation, the best controls for your shapes are bones within the main control armature for your character. The controls can be visualized as normal bones or represented as custom shapes to ease the animation process even further. Figure 10.27 shows all of the facial controls bones for the Beast. Eye, brow, and nose controls are plain bones, while the mouth controls arrayed above the head use custom bone shapes. How you structure the controls of your character is mostly a matter of personal preference, so we will look at how the Beast's controls are set up to give you some insight into the process.

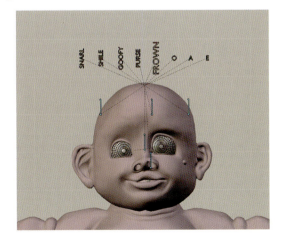

Figure 10.27 *Both plain and mesh-shaped bones can be used for controllers*

Here is the basic work flow for binding a shape to a control:

- You will need two windows available at once: a **3D View** with the character's mesh object selected and an **Ipo Editor** set to **Shapes** and with the **N-key Properties Panel** showing. Such a configuration is shown in Figure 10.28.

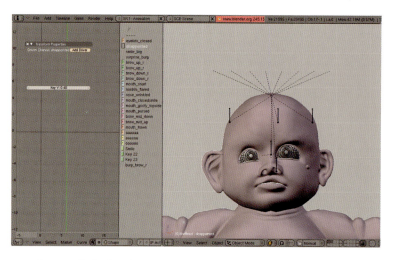

Figure 10.28 *A screen configuration for binding shapes to controls*

- On the right hand side of the **Ipo Editor**, left mouse button select the name of the shape you would like to bind to a controller (Figure 10.29).

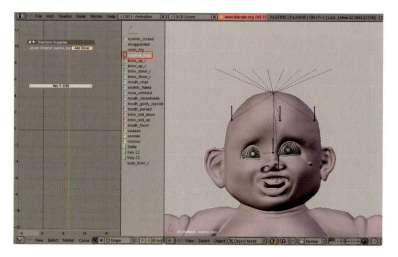

Figure 10.29 *Selecting the shape to bind*

176

- Click the **Add Driver** button in the **Ipo Editor's Transform Properties** panel.
- Enter the name of the character's control armature in the **OB:** field that appears (Figure 10.30).
- Change the setting on the right side of the panel from **Object** to **Pose**.
- Enter the name of the bone that will act as the animation controller for the shape into the new **BO:** field that appears (Figure 10.31).

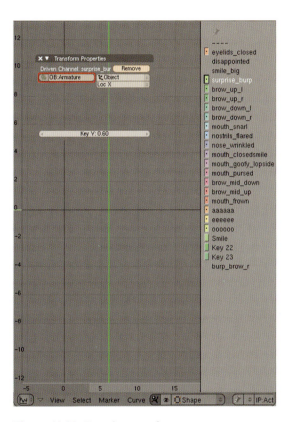

Figure 10.30 *Enter the name of armature* **Figure 10.31** *Enter the name of the controlling bone*

- Now you have to decide which aspect of the bone will control the shape: rotation, location, or scale? In the example, **Loc Y** has been chosen, meaning that vertical motion of the bone will control the shape. It's best to choose something that makes sense to you when deciding which type of transformation to use. If the shape twists the nose to one side or another, you will probably want to choose a rotation along an axis that corresponds to the actual motion. For shapes that make cheeks puff out, you may want to choose a scaling transformation. Technically it doesn't have to relate, but it will certainly make the controls more intuitive.
- With the mouse over the **Ipo Editor**, press the **I-key** and accept the **Default one-to-one mapping** from the **Insert Curve** menu that pops up (Figure 10.32).

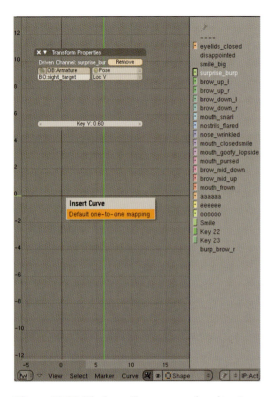

Figure 10.32 *The Insert Curve menu and resulting Ipo curve*

the same controller so that moving it up and down would produce the entire range of shapes. Figure 10.35 shows how this would work.

This establishes the most basic functionality of the system. Figure 10.33 shows the Beast at 0%, 50%, and 100% of an overall surprise/burp face shape, controlled by a vertical motion of the indicated bone. In Figure 10.34, each of the face controls is labeled to show what kind of motions control which shapes.

To make things more complicated from a setup standpoint but much more intuitive from the animator's point of view, you can and should attach different shapes to the same controller. For example, you will almost certainly have "eyebrow up" and "eyebrow down" shapes of some kind. It would be useful to attach both of them to

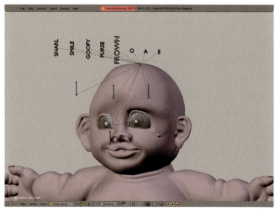

0%

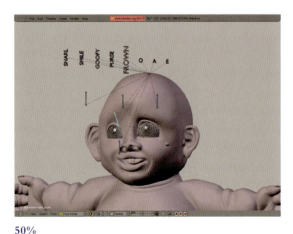

50%

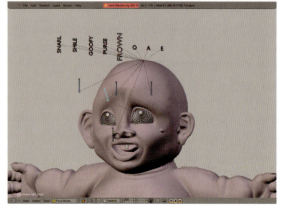

100%

Figure 10.33 *The Beast with various levels of the surprise/burp shape*

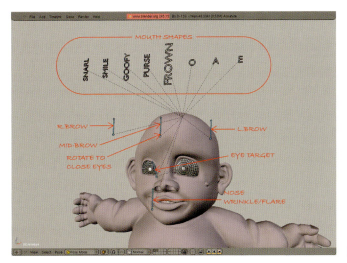

Figure 10.34 *The Beast's facial controls, labeled*

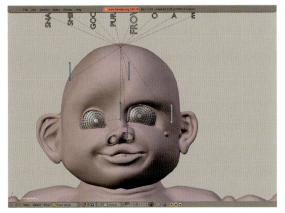

down

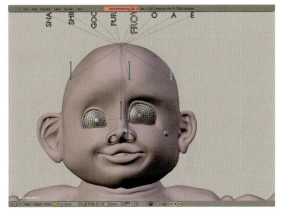

rest

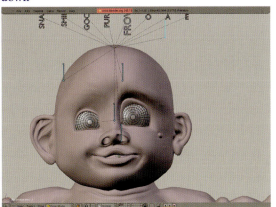

up

Figure 10.35 *An eyebrow controller set to work with two different shapes*

Before you rig this, let's take a closer look at the **Ipo Editor** for one of these bound controls. Figure 10.36 shows how the shape strength maps to the bone position in the curve Editor. The X-axis (horizontal) represents the value of the bone. The Y-axis (vertical) is the strength of the shape (0.0–1.0 is 0%–100%). So, with this default line for the control, the bone's chosen value (**Location Y** in the example) runs between 0.0 and 1.0, mapping to 0% to 100% of shape strength. This relationship can be altered so that moving the bone in the opposite direction triggers a different shape.

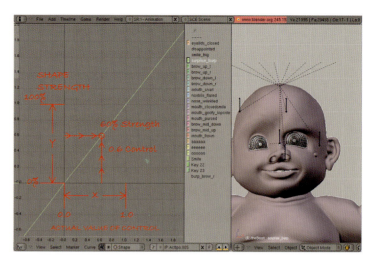

Figure 10.36 *The default mapping explained*

Notice how the line that extends past the (0,0) and (1,1) points into infinity. This means that the further you move the control in either direction, the more pronounced the shape will become, and that is exactly the effect we see in Figure 10.37. If this shape is the only one that will be attached to the control, this might be desirable, so that you can really exaggerate the expression from time to time. Otherwise, the effect can be stopped by setting the curve's **Extend** mode to **Constant**. To do this, select the curve, then choose **Extend Mode > Constant** from the **Curve** menu on the **Ipo Editor**'s header. In addition, you will want to set the driver's **Interpolation mode** to **Linear** from the same **Curve** header menu. When generat-

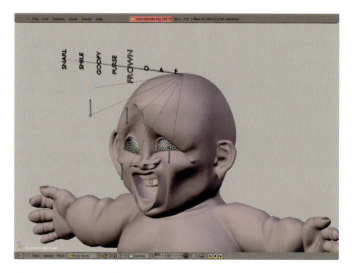

Figure 10.37 *The "distressed/burp" expression applied way too heavily. Poor little guy*

ing keyframes for the controllers, Bezier interpolation will already be present in the animation Ipos, so leaving it as Bezier in the driver would multiply the "ease in/ease out" effect.

If we want a different expression to be controlled by moving that same bone in the opposite direction, we're going to have to create a curve where the X-axis, which represents the bone value, goes from 0.0 to −1.0,

and the Y-axis, which is the shape strength, goes from 0.0 to 1.0 over the same distance. Figure 10.38 shows what this looks like. To bind a second shape to a control, then, is as simple as following the previous instructions for the new shape but editing the created curve afterward. Curves are edited just like meshes in the 3D view—by using the **Tab key** to enter Edit mode, right mouse button selecting individual vertices and moving them around. And, just like the 3D view, you can enter precise values for vertex locations right in the properties panel.

To break it down, when you have used the **I-key** to create the default mapping line, select it with the **RMB**. Use the **Tab** key to enter Edit mode. Right mouse button select the upper right hand vertex of the line, which should be at (1,1) in the editor. On the **Transform Properties** panel, change the **Vertex X** field from **1.0** to **−1.0**. Change the extrapolation type to **Constant**. Done.

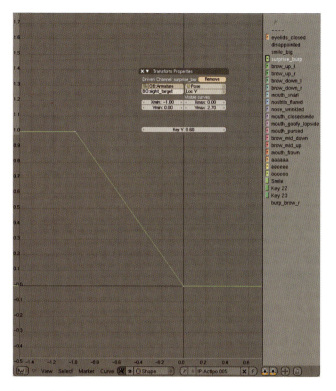

Figure 10.38 *A curve for mapping a shape to reverse motion of a bone*

> **NOTE**
> When working with rotations for your controls, you need to keep in mind a little idiosyncrasy of Blender's curve editor. Rotations appear there divided by 10. Weird but true. So, if you want your shape to engage over a 180 degree rotation, you cannot use 0.0 through 180.0 on the X-axis. Instead, you must use **0.0** through **18.0**.

The control now functions as shown back in Figure 10.35. Moving it vertically between 0 and 1 units will engage the "brow_up" shape, while moving it between 0 and −1 will engage "brow_down."

As you may be guessing, setting up controls like this for any large number of shapes can be tedious, and you would be correct. It is tedious. But it must be done to give a decent level of intuitive control over expressions when you begin to animate.

Here are a couple of final tips for creating these kinds of controls:

- Make sure to parent these control bones to your main head bone so that they are always available when looking at your character's face. Don't worry that the parented motion will activate the shapes. It won't. These control drivers read the bone's local movement, relative to its parent.
- Consider locking bone transformations in the 3D View's Transform Properties panel for motions that were not used in the controls. In other words, if your control bone only engages a shape along the X-axis of motion, lock Y- and Z-axis motion as well as rotation on the panel.
- If you have two shapes for the same control zone that you would like to be able to blend, consider attaching them to one control along different axes. For example, that way you can get 65% of one shape and 50% of another by moving the control over 0.65 units and up 0.5 units.
- If you have more than two shapes for the same control zone, you will have to set up a "mixing board" situation like the mouth and sound controls above the Beast's head.
- You can extend the Ipo curve line past the (0,0) and (1,1) points to get more than 100% or less than 0% of a shape.

In Chapters 11 and 12 (animation and lip sync), we'll revisit the facial control tools with some practical advice on how to actually use them.

> **NOTE**
> There is nothing to stop you from using direct armature manipulation of the mesh for facial control. In fact, some animators and riggers find it useful to move a character's jaw with a bone, as opposed to shape keying. Entire facial rigs have been constructed using nothing but bones and an Armature modifier.

Rigging and Controlling Eyes

There are several ways to rig and control eyes in Blender, but all of them involve keeping the eyes as two distinct objects, not part of the overall character mesh.

Spherical Eyes

For eyeballs that will be nearly spherical and will not squash, stretch, or otherwise deform oddly, the solution is bone-level parenting. Figure 10.39 shows this method.

- Position and rotate the eye to something that looks good as a rest position. An actual camera-view render is appropriate at this point because an

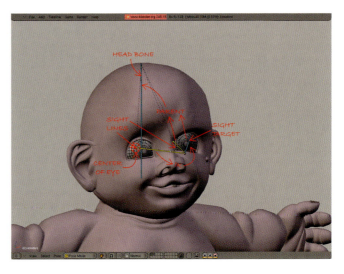

Figure 10.39 *How to rig eyes that follow a target*

alignment that might look good in the orthogonal view of the 3D window could look cross-eyed or cock-eyed from a perspective render.

- Apply any transformations to the eye objects with **Ctrl-A**.
- Create a new bone called something like "sight_target" in the character's control armature midway between the eyes and standing about a foot away from the character's face in the scale of your model.
- Using the snap tools (**Shift–S** in the 3D view), create a new bone that begins at the center of an eye and ends at the base of the "sight_target" bone. Call it "sight_line_R" (or "_L").
- In Edit mode on the armature, make the "sight_line" and "sight_target" bones children of the main head bone so that they move with the rest of the head.
- In Pose mode, add an IK constraint to this "sight_line" bone, setting "sight_target" as its target. Make sure to set the IK chain length to **1** or moving the eye controller will cause your entire character rig to go crazy. At this point, moving the "sight_target" bone in pose mode should have the two "sight_line" bones (one for each eye) follow it.
- Return the "sight_target" to its rest position (**Alt-G**, **Alt-R**).
- Right mouse button select an eye, then **Shift** right mouse button select the corresponding "sight_line" bone.
- Press **Ctrl-P** to create a parent/child relationship and choose **Bone** from the menu that pops up. This ties the eyeball as a whole object directly to that bone. Repeat the procedure for the other eye or as many times as your character has eyes.
- Moving the "sight_target" will now move the eyes.

When animating with this system, it is easy to control the character's gaze. Under normal circumstances, the sight target will move with the head, causing the eyes to move along with it. Moving the target closer to the face makes the character go cross-eyed, while moving it away makes the character appear to gaze into the distance. It is also simple to use a CopyLocation constraint on the sight target to fix the character's focus to a specific object or location.

Flattened, Squashed or Otherwise Nonspherical Eyes

Many more stylized or cartoonish characters will require eyes that, due to the design of the character, cannot be spherical. Figure 10.40 shows a fish character with eyes that are obviously nonspherical. In this example, there is no way to rotate the eye around the X-axis without having it protrude horribly from the character. The challenge is to create an object for the eye that can somehow rotate within an ellipsoid eye socket.

Unfortunately, there is no such object. You can fake it, though, with the steps

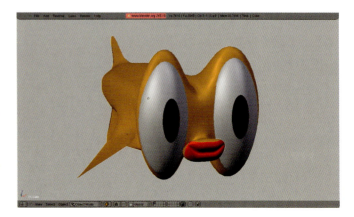

Figure 10.40 *Note the vertically stretched eyes*

previously presented and the creative use of a Lattice object.

When creating oddly shaped eyes, it is best to create them as normal spheres and position them in the nonstandard socket. In Figure 10.41, a spherical eye has been placed where the properly shaped eye should go, even though it obviously does not fit.

Even though the eye doesn't fit, you proceed with rigging as in the previous example.

When you have the eyes rotating to follow the sight target, it's time to squash them!

Add a lattice object, scaling and transforming it so that its outer boundaries closely match those of the eyeball. A configuration like the one in Figure 10.42 will work. Bind the lattice to the eye by adding a **Lattice modifier** to the eyeball. Then alter the lattice in Edit mode until the shape of the eyeball conforms to the shape of the eye socket. Figure 10.43 shows the result.

The final step is to make the lattice a child of the same bone (probably the main head bone) that the sight target and sight line are children of.

Now when you move the sight target, the eyes "rotate" but within the confines of the deformed shape. Even more control can be enjoyed by making the Lattice affect a vertex group around the eye of the main mesh. This way the Lattice itself can be animated for a nice squash and stretch effect on both the eyeball and eyelids together. It's lattice-based eye-squishing magic!

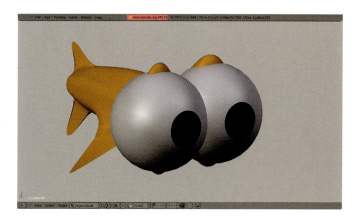

Figure 10.41 *Placing the round eye in the oval eye socket*

Figure 10.42 *An eyeball with an undeformed lattice surrounding it*

Figure 10.43 *The lattice is deformed, and along with it, the eye*

Summary

Any of the standard deformation methods will work for creating facial expressions, but one of the best ways to approach them is to individually create the expressions with the use of **Shape Keys** and to bind the various shapes to bone controls for animation. The shapes are attached to the controls through the use of **Drivers** in the **Ipo window**. Using this system, you can construct a set of facial expression controls tailored specifically to the needs of your character.

Eyes present a special case and can be easily rigged and controlled with the use of a target bone, IK sight lines and, for nonspherical eyes, lattices.

Outbox

- A character model with a set of controls for facial expressions, including eyes

Animation

Objectives

- Creation of per-shot working files from the scene template
- Animation basics
- Animating in Blender
- A practical example
- Fine tuning your animation
- Production techniques

Inbox

Coming into this chapter, you need:

- Fully rigged character models
- Storyboards and a story reel
- A scene template file

Creation of Per-Shot Working Files from the Scene Template

Here you are.

You've worked through preproduction and actually followed the plan. It's time to animate. The big show.

Oh, wait. There is one more thing you need to do before you begin to animate.

Find your scene template file you created back in Chapter 7. If you'll recall, this file contains links to all of your characters, your rough set, and the cameras for each of your shots. Choose the shot that you will animate

first, create a duplicate of the template scene file, and name it "shot01.blend", obviously substituting the shot number you are actually working on.

Animation Order

When you are beginning the animation phase of your project, the temptation may be to attack your hardest or most spectacular shot first. Unless you are seasoned veteran, you should probably start with something a little less ambitious. Your goal is to find a relatively short shot that can be reanimated later on without too much trouble. When you set the final keyframe on your last shot, you will almost certainly be at a different place as an animator than when you began the project. If you've chosen your opening shot or the big action sequence for your first one to animate, it will have a significantly different look from the shots animated later on.

In *The Beast*, I animated straight through from shot 1 to shot 13, which was a mistake. When I was finished with main animation, the later shots were much better than the first one. Because both the opening and closing shots have the greatest impact on the viewers' memory in the final production, I couldn't let that stand. So weeks after animation was completed, I found myself reanimating the opening shot.

You do not want to do this.

Choose some fairly short, insignificant shots for your initial forays. Try to pick one with only a single character and minimal to no prop interaction. If the animation isn't that good, well, the shot should be relatively insignificant. If you don't have time to redo it, it won't be the end of the world. If you have an extra day or two, though, and the shot isn't very long, you may have a chance to revisit it, bringing it up to the standard of the rest of the production.

Take a look at the story reel and storyboards for this shot. Eliminate any characters and cameras from the file that will not appear. If you're the nervous type, you can simply move unneeded characters, props, and cameras to an unused, hidden layer. Once again, you are encouraged to use the same layering scheme across all of your shot files so that if you put unused assets on layer 19 in this first file, you should continue using layer 19 for that purpose throughout the production.

Figure 11.1 shows a good starting configuration for animation work. The Action Editor window is where you will see and adjust your animation keyframes along the timeline. It will also be swapped out occasionally with an Ipo window for fine-tuning timing for certain types of actions. An Outliner window sits to the left of the main animation window and provides convenient access to library and object information. Along the bottom, you find a buttons window, and a little 3D window set to a camera view. A Timeline window for scrubbing and toggling Automatic Keyframing completes the screen.

As you work, you will also find it beneficial to use the **Shift-Spacebar** hotkey to toggle the main 3D view into and out of full screen mode. I have found that as I work, I tend to work on full poses with the 3D view maximized like this, dropping back into the normal screen view to deal with timing, adjustments, and keyframes.

So, no more fooling around. It's time to animate.

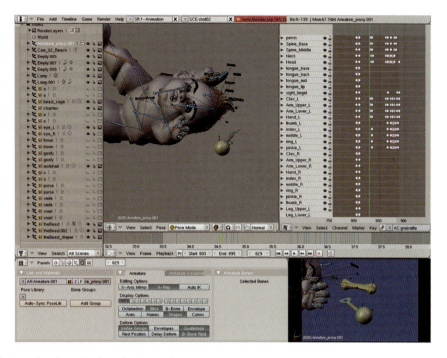

Figure 11.1 *A good configuration for animation work*

Animation Basics

Okay, I lied. It's not quite time to animate. Going into it, there are a couple of things you should know.

This book is not meant to be a stand-in for a good education in the basics of character animation. Entire tomes have been penned by master animators of which you are encouraged to avail yourself. If you're the diligent sort who already has that covered, or if you're the type who hasn't but figures you'll just plow straight ahead anyway, here is the briefest rundown of what you need to keep in mind while animating.

Computer animation is a combination of puppetry, engineering, and acting. It is a performance. And, just like an actor's performance in a movie or on the stage, the goal is not to exactly mimic reality. The goal is to present a believable character whose actions tell a story. Because the performances in animation (especially in CG) are engineered or constructed, a set of guidelines has grown up around the industry that can help to push those performances toward believability.

Consider a very basic scenario: A character holds a ball in the middle of a field. The character throws the ball.

In its simplest form, an animation of this would consist simply of the arm moving from one position to another and the ball flying away. That, of course, would be terribly boring (Figure 11.2).

Anticipation and follow through. With the throwing motion starting and ending exactly as seen in the figures, this would be horrible and very mechanical. Well, he *is* a beast. However, no one, not even a robot,

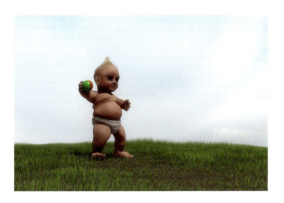
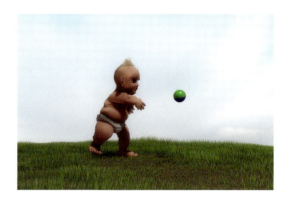

Figure 11.2 *The Beast in a two-frame throw*

should move like this. To make it a little better, you must add **anticipation** and **follow through**. An action almost never starts and ends with the main application of force. There is usually some sort of anticipatory action and a follow through (Figure 11.3). The anticipation image has the beast leaning backward, really cocking his arm and raising his forward foot off the ground. The follow through pose shows how his body has continued to move even after the ball has left his hand.

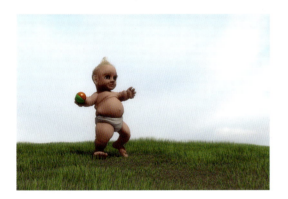
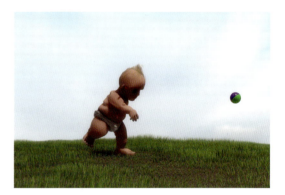

Figure 11.3 *Anticipation and follow through added to the action*

That's a little better. Follow through is not constrained to just the main action, though. A character's tail, hair, or tentacles can also exhibit follow through. A body absorbing the shock of a landing will show the results of hitting the ground throughout its structure if it's animated carefully.

Timing. The next thing to consider is timing. How long would this action take in reality? How long would the anticipation take? You don't have to stick with the real world here, and you can even change timing to emphasize your action. To build suspense, for example, you could have the anticipation pose take longer than it really would, then have the throw occur in a flurry of motion.

Squash and stretch. When the ball leaves the Beast's hand, it has so far been perfectly round in the illustrations. Perhaps, though, it would be more dynamic if you could see the motion even in one of these still frames.

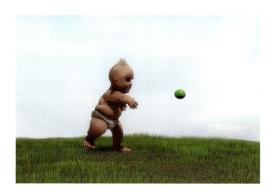

Figure 11.4 *I thought this thing was supposed to be rigid!*

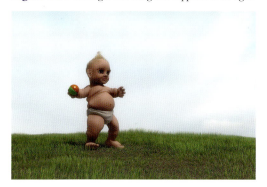

Figure 11.5 *The leg has begun to move before the arm holding the ball*

Applying **squash** and **stretch** to the model of the ball can do this. Figure 11.4 shows the final frame again but with the ball stretched slightly to show its motion.

Squash and stretch will apply to anything you are animating that moves at a high velocity or encounters some kind of barrier. The degree to which it applies will depend on the level of stylization of your project. Clearly, characters with a high degree of realism will neither squash nor stretch much. It wouldn't be believable.

Overlap. When living things move, their limbs, though coordinated, do not move in perfect sync. During the Beast's throwing motion, the leg begins to move before the arms (Figure 11.5). Making sure that the motions of a character occur in the proper sequence and not all at once is called **overlap**.

Symmetry. A local journalist was watching the Beast throw the ball and asked if he would pose for a picture for the local paper. Figure 11.6 demonstrates **symmetry**. Notice how much more natural he looks when things are not symmetrical. Avoid creating symmetrical poses and having otherwise symmetrical actions (e.g., both hands reaching for a ball), begin and end on the same frame.

Exaggeration. The Beast has learned that through his exposure in the local paper, a talent scout has discovered him, and he will soon be playing for the Pittsburgh Toddlewackers. His triumphant pose in Figure 11.7 is **exaggerated** to convey his mood. A viewer should be able to determine a character's mood, thoughts, and actions without any dialog. Too much exaggeration will cause your animation to lose believability, but none at all will make it feel boring.

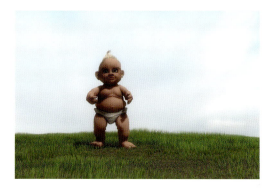

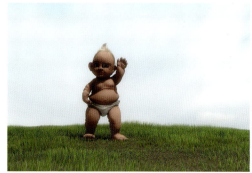

Figure 11.6 *Avoid completely symmetrical poses*

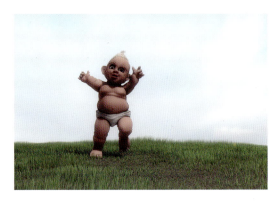

Figure 11.7 *I'm the man!*

There are, of course, other tips and guidelines for good animation, but if you begin with these in mind (anticipation, timing, follow through, overlap, exaggeration, squash and stretch, and symmetry), you will at least have something that doesn't look terrible your first time out. We'll look at a couple more of the basics that are useful for evaluating and refining your animation work but only after we've worked with Blender's animation tools.

Animating in Blender

Using the template scene file as discussed earlier in this chapter, create a file for the first shot you have chosen to animate. Find the timeline markers that you added way back during Chapter 7 while blocking and set the Start and End animation frames for the shot.

If you haven't already done so, select the control armatures of the characters in the shot, and press **Ctrl-Alt-P** to create animation proxies for each of them. With those armatures selected, make sure that they are set to **X-Ray** in the Edit buttons so that the control armature will show through the model, even in solid display modes. Figure 11.8 shows a configuration that I used while animating *The Beast*.

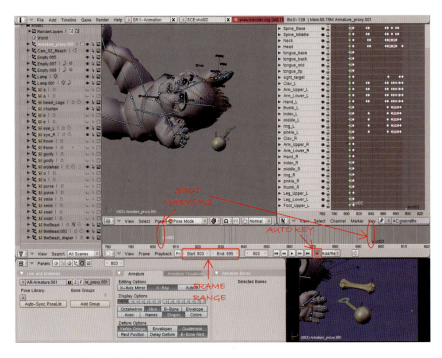

Figure 11.8 *An animation workspace from The Beast*

On the Timeline window, enable the automatic keyframing "record" button. You're going to be setting hundreds of keyframes. If you're using Auto or Targetless IK, some of the keys will be on bones that you didn't even know needed keys, and it would ruin your animation to forget to key them by hand. Set the current frame marker to about 10 frames before the beginning of the shot in the timeline.

Place the armature into Pose mode with **Ctrl-Tab** and build your initial pose. If you've followed the instructions in the rest of this book, your character will almost certainly begin its life at the origin (0,0,0), unrotated. This will probably not be ideal for a starting point for your shot. You can try to move the entire armature into a good starting position in Object mode, but depending on how your character is rigged, this may or may not wreak havoc with the model. Your best bet is to create your character's initial position entirely in pose mode. Use the character's master bone in pose mode to position things properly before moving on to pose-level refinements.

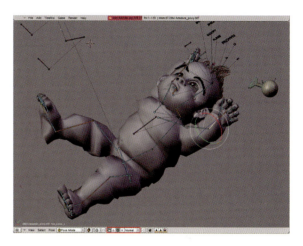

When building a pose, it is often useful to toggle the 3D workspace into full screen view with **Shift-Spacebar** or **Ctrl-Down Arrow**, then back again after you are finished. Doing so gives you much more screen real estate for refining your pose, as shown in Figure 11.9. Also in that figure, you will notice that the transform manipulator has been enabled. It has been set to show only rotations and to work with **Normal** space on the window header. The rotation manipulator in Normal mode is invaluable for creating poses because it provides one-click access to rotations around each of a bone's local axes.

Figure 11.9 *Animating with the 3D workspace maximized*

Working in the Action Editor

As you create poses, automatic keyframing will add keys as they are needed. These keys appear as blocks in the Action Editor, where they can be moved along the timeline. Figure 11.10 shows the Action Editor for a shot from *The Beast*. Selected keyframes are yellow. Unselected keyframes are white. Keys can be selected for manipulation through many of the normal Blender selection methods: right mouse button, **B** key border select, and the **A** key for select/deselect all. There are also several selection methods that are unique to the Action Editor.

Figure 11.10 *The Action Editor full of keyframes*

Selecting all of the keys on a single frame. Often you will need to move all keys on a single frame forward or backward in time to adjust the timing of a specific pose or action. To select all of the keys that fall on the current frame marker, press **Shift-K**. Simply pressing the **K** key looks at any keys that are currently selected and selects any additional keys that share a frame with the original selection. These selection methods are also available under the **Select** menu of the Action Editor's header.

Selecting all keys between two timeline markers. If you need to accurately grab an entire time slice of an animation, you can select two triangular timeline markers at the bottom of the Action Editor, then press **Ctrl-K**. This selects all keyframes between the markers.

Selecting all of the keys ahead of or behind a certain frame. Many times you will need to take an entire portion of your animation and shift it in time either to make room for an additional pose or to make a certain transition happen more quickly. To do so, place the current frame marker into the area of time you would like to expand or collapse. Then, **Alt-right mouse button** click to either side of the current frame marker. This action selects all keys on the "clicked" side of the marker, allowing you to easily transform everything in the Action Editor. Figure 11.11 shows the result of **Alt-right mouse button** clicking to the right of the current frame marker.

Selected keys may also be deleted, as you would guess, by pressing the **X** key.

An armature can have dozens of bones that receive keyframes. The Action Editor can quickly become littered with just as many channels, making it look like a jumble of names and white and yellow blocks. To make things easier on you, Action Editor channels can be rearranged, grouped, and hidden.

Figure 11.11 *All frames ahead of the frame marker are now selected*

Figure 11.12 *Channel groups can help to keep the Action Editor sane*

Figure 11.12 shows the Beast's armature with bone groups created and arranged for maximum efficiency. Bones that will often be manipulated and keyed together, such as the arms and legs, can be placed into groups. Doing so is as easy as using the left mouse button to click on the bone channel names in the Action Editor,

using **Shift-left mouse button** to build the selection, and pressing **Ctrl-Shift-G** to create a channel group. The new group's name can be changed by hovering the mouse over the existing group name, pressing the **N** key (which is the generic "properties" key command throughout Blender), and typing a new name into the pop-up that appears. Figure 11.13 shows a name being assigned to a new bone channel group.

When groups are created, they can be rearranged by left mouse button selecting the group header and using **Shift-PageUp** and **Shift-PageDown** to shuffle them. Individual channels that are not part of any groups can also be arranged like this, but Groups will always sit above nongrouped channels.

Figure 11.13 **N** *key panel for naming groups*

Channel groups can be used to conveniently select several bones at once. When animating, you will find that you need to set a key on, for example, all of the arm bones on a particular frame. **Ctrl-Shift-right mouse button** clicking on a Group name in the Action Editor selects all of that Group's bones in the 3D view.

Finally, Groups can be collapsed and expanded by clicking on the triangle to the left of their name. Putting the bone channels for each limb into their own groups, facial controls into another, and "miscellaneous" bones into yet another group can really clean up the Action Editor for you, making your job as an animator much easier. Figure 11.14 demonstrates an Action Editor that is only showing the bones for the right arm. All other groups are collapsed.

With all that under your belt, we return to animation where you have created an initial pose. How to proceed? There are several methods, each having strengths and weaknesses.

Figure 11.14 *A decluttered Action Editor*

Straight Ahead Animation

The "Straight Ahead" method is used heavily in the stop motion animation industry. Each pose and motion is built in full detail, going forward in the timeline. In the case of the Beast throwing the ball from the previous section, straight ahead animation would require you to first create a full pose in the anticipation phase. Then you would create a pose midway between anticipation and the start of the throw, building in the proper **overlap**

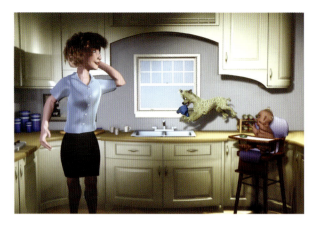

Figure 11.15 *The mean dog runs away with the Beast's toy*

so that, perhaps, the leg has moved more than the arm. Next, you build a pose showing the actual start of the throw, proceeding through the entire action creating fully formed poses.

Straight Ahead animation tends to produce a looser feel because the actions and poses are not necessarily planned in advance. You will certainly have an end goal in mind for your character, but how the action of the character develops toward that goal depends on the spontaneity of the animation. In *The Beast*, the dog's leaping escape across the countertops with the Beast's stuffed animal was animated in a straight ahead fashion (Figure 11.15).

Straight ahead animation is great for fast action that needs to feel dynamic.

Pose to Pose Animation

For shots with lots of acting where a character has a carefully planned series of actions from the storyboards, the pose to pose method is more appropriate. Using this approach, the major poses are created first along the timeline. After they work well and the entire shot is blocked in, adjustments are made to timing, while anticipation, follow through, and secondary actions are added.

The great advantage of pose to pose animation is that it is very controlled. Your actors do what you want them to do, exactly when you want them to do it. This means that complex interactions between different characters are manageable, and you will not have trouble sticking to your story reel frame count and timeline. With straight ahead animation, it is easy to animate too much (or too little) to fit your initial timing estimates.

Another point in favor of the pose to pose method, especially when working with or for someone else, is that the key poses can be created, approved, and discussed before you take the time to really refine things. If it's not what your collaborator or supervisor is looking for, you can rework the poses or overall timing without having to throw away too much work. We'll talk about refining your animation in the next section, but let's take a quick look at how to block in pose to pose work.

When your initial pose is created, use the **A** key to select all of the channels in the Action Editor. To do this, hover the cursor over the channel names on the left side of the window when you press the **A** key. Otherwise, you will select the keyframes, which you don't want to do. With all of the channels selected, press **Shift-T** and select **Constant** from the menu that pops up. Figure 11.16 shows the pop-up, with all Action channels selected.

Figure 11.16 *Setting Interpolation to Constant*

This functionality is also available from the **Interpolation Mode** section of the **Key** menu on the Action Editor header.

In **Constant** mode, poses do not blend from one to the next. Instead, they snap into existence on their exact keyframe, holding the pose until the next key is encountered in the timeline. By setting poses in constant mode, you get something between the "chess pieces" animatic you created before and a full blown animation. Also, because you are only working with the key poses and not anticipation/overlap/etc., the Action Editor stays relatively clean. This makes it much easier to adjust the timing of the main poses before the Action Editor acquires the lovely (pronounced "messy") look that the full animation process will give it. Figures 11.17 and 11.18 show the difference.

Figure 11.17 *The Action Editor at the first stage of pose to pose animation*

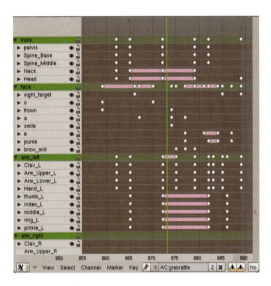

Figure 11.18 *The Action Editor full of keyframes from a refined animation*

After getting things to look right in Constant interpolation mode, you "release" the animation into normal Bezier interpolation and begin to add anticipation, overlap, follow through, and secondary motion and to adjust the timing of the interpolations.

A Practical Example

For the vast majority of *The Beast*, I used a hybrid approach. I found the straight ahead method to be too loose, while pose to pose was rather restrictive. What I had arrived at by the end of production, and what I will demonstrate here, was a straight ahead approach to create the main poses, followed by a pose to pose style review and refinement.

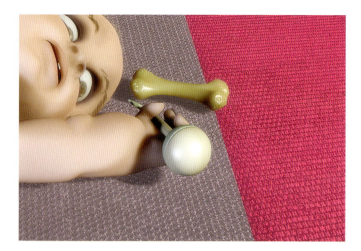

Figure 11.19 *The Beast grabbing the rattle*

Let's look at shot 2 of *The Beast*. Figure 11.19 shows a final production frame, with the Beast, two toys, and a carpet and floor as the background. The action in the shot calls for the Beast to slide toward the toys on the floor, then to scoop up the rattle.

When beginning this shot, I knew that it would proceed directly from shot 1, so instead of going all the way back to the master template scene file, I created a duplicate of the already animated shot01. blend. This produced a better starting point than the raw scene template file because the only character in shot 2,

the Beast, was already positioned near where he needed to be. Of course, I had to bring in the correct camera for shot 2 from the scene template file (**Shift-F1-Append**), and change the animation frame range.

As you can see in Figure 11.20, the framing for this shot does not work exactly with the endpoint of the animation from the previous shot. No problem though, as you can see in Figure 11.21. The positioning has been changed so that everything comes together just like the storyboard. When shot 1 and shot 2 are cut together in final editing, these minor differences in positioning will not be noticed, but the shots will have more compositional strength. This is one of the best reasons to break your shots up into different files. If we were trying to do the Beast's drop, fall, and grab all in one long piece of animation with several cameras capturing it in one file, we would not be able to optimize the framing of each shot nearly so easily.

An initial pose is set several frames before the beginning of the animation start frame. Automatic keyframing has been enabled. Figure 11.21 shows this starting point.

Figure 11.20 *The endpoint of animation from shot 1*

Figure 11.21 *The endpoint adjusted for optimum framing*

Acting the motion out several times myself (yes, I got on the floor and squirmed toward a goal, and no, this is not an appropriate place for an illustration), I saw that I would first glance at the object, slide a bit, then scoop up the toy with another little slide. That meant I had to have the Beast sight in on his target, squirm, then squirm and grab.

Using the **Up Arrow** key, I advanced 20 frames to create the glancing pose. Timing will be adjusted after all of the main poses are created, so it's not that crucial how many frames you advance between poses when working like this. However, in my "on the floor" practice session, I did try to figure out how long in seconds each bit was going to take as a general guideline.

On this frame, I created a new pose with the Beast tilting his head backward to see the toy and his hand moving up into the air a bit. Normally I wait until a later stage to work in any facial animation, but because the direction of the eyes is important for a "glance" pose to work, I also posed the eyes. Figure 11.22 shows this pose.

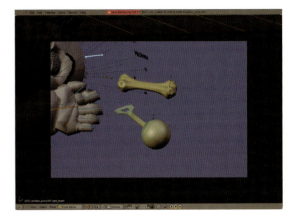

Figure 11.22 *The next pose*

Advancing 20 more frames, I created the "slide" pose after he has moved across the floor a bit (Figure 11.23).

Next he'll be grabbing the toy, and I know I'm going to need some serious anticipation for that movement. I may as well build it directly into a pose. Advancing 20 frames, I created a pose with the hand drawn back, winding up for the big grab. Of course, there is also movement in the rest of the body. When a pose focuses on a change in one part of the body, you need to be careful that the rest of the character doesn't simply freeze. You don't need to have them

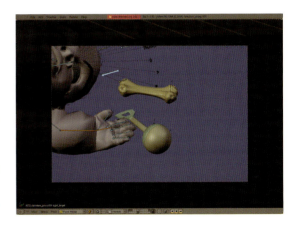

Figure 11.23 *After the first squirm*

doing a tap dance in the background, but a careful observation of your own movements—again, you are your own best reference—will show how your body moves subtly, even away from the main action. Figure 11.24 shows this anticipatory pose.

Twenty frames ahead I built the pose at the end of the grab motion. The Beast's hand is now passing through the rattle, which we'll fix later. Note that the whole body has moved.

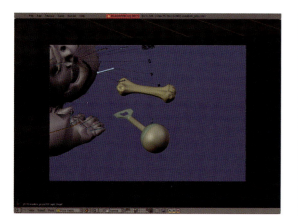 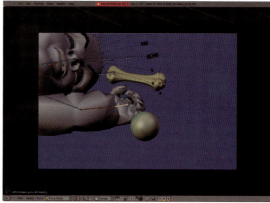

Figure 11.24 *Ready to strike!* **Figure 11.25** *The big grab*

Finally, he finishes the motion by drawing his hand up to view the rattle. In the final edit, this upward motion will not be seen in its entirety. There is a camera cut to the next shot, a close-up of his face, which splits the hand raising action. It is important, though, to animate the motion fully so that the edit looks natural.

Each of these poses was created by maximizing the 3D view and dropping both the character mesh and control armature into local mode with the number pad "/" key. Doing so not only gives you more screen space to work in, but it also clears out visual clutter and makes your system respond more quickly. Sometimes the full screen window was quickly set to the camera view (number pad 0) to see how things would look from that perspective.

> **NOTE**
> Remember to include any squash and stretch that is a part of your character rig in your posing. It's easy to build the tools to do this and then forget to use them as you are working on stationary poses. Each pose should convey the dynamic of the moment, and if squash and stretch are going to be a part of your character, including it from the beginning will help to convey that.

With the initial poses created (in a straight ahead fashion), I adjusted the timing and overlap. When working with timing, it is crucial to receive real-time feedback. Regardless of how well you optimize your meshes and backgrounds, any preview you get from the 3D view in Blender will be inferior for this purpose. The easiest way to get a real-time preview of your animation is to:

- Set the output format to **AVI Jpeg**.
- **Ctrl-left mouse button** click on the "OpenGL Render" icon on a camera view's 3D header.
- When it is done "rendering," press the **Play** button on the **Anim** panel of the Render buttons (**Ctrl-F11** also works).

Your animation will loop in a render window in real time.

Making such a loop at this stage of the animation shows a series of smoothly sliding poses evenly spaced in time. Clearly, this isn't what we're looking for.

Here's one way to work with the timing of motion in Blender.

Timing

If you watch people or animals, you will see that unless they are performing some kind of repetitive activity, such as walking or stirring a pot, their motions are brief and often quick. Spend some time around people (You're into computers and 3D like me, I know. It's sometimes hard to associate with normal people. But do it. It's worth it!) and watch how they move. If you're very lazy or agoraphobic, turn on the television for half an hour. Although the final product will depend heavily on the level of stylization you have chosen and your actual subject matter (Human beings? Sixteen-winged organic thermos creatures?) human motion will be your observational core.

From observation, I determined that the amount of time between the initial pose and the glance pose would be about 1 second (24 frames in my production). However, the actual movement would take only about half a second. So the initial pose must hold for about 12 frames then fall into the glance pose. To make this happen, you select any Action channels that received keyframes in the glance pose and place the current frame marker a couple of frames after the initial pose, as in Figure 11.26. Then, with the cursor over the Action Editor, press the **I** key to insert a keyframe and choose **Only Selected Channels** from the pop-up menu that appears. The result is Figure 11.27. This creates new keyframes that represent the interpolated pose just a few frames into the blend between the two poses.

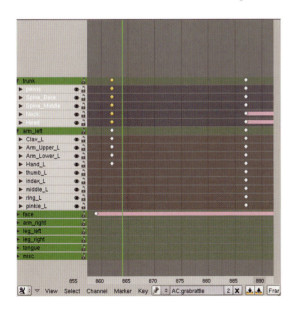

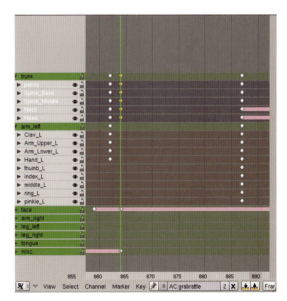

Figure 11.26 *The current frame marker is advanced slightly from the first pose*

Figure 11.27 *New keys are added*

You select only these new keyframes (**B** key border selection works well here), and move them forward in time until you actually want the motion to begin. In this case, that starting point is 12 frames before the second pose. The overall effect of doing this is that your character holds the previous pose for the proper amount of time, and then shifts into its new pose at the appropriate rate. The hold, though, isn't completely stationary. This technique allows a little motion to occur during the hold, giving it a bit of life.

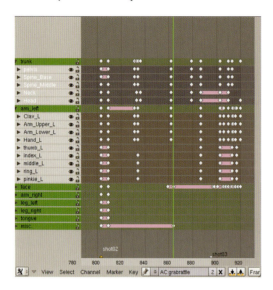

Figure 11.28 *Timing for the shot has been adjusted*

Use **Ctrl-left mouse button** on the OpenGL preview button, then play the animation back to see the new timing in place.

As you work on timing, just remember that the amount of time between the key poses is not necessarily the amount of time it should take to transition from one pose to another. If you spend some time observing your own regular motions and the motions of others, you will notice that most motions you perform—grabbing something, turning your head, leaning over—take only a second or less. Obviously certain actions such as stretching or other actions done in a deliberately slow fashion will take longer.

After the timing is adjusted so that the real-time preview looks fairly natural, you can start on overlap, anticipation, follow through, and secondary motion.

In Figure 11.28, the timing for the shot has been adjusted. Notice that the keys now seem to come in sets instead of single columns. The sets represent the actual transition times between poses, while the longer gaps between the sets represent times when there is only a tiny bit of motion to keep things alive.

Overlap

When the Beast finally grabs at the rattle, it all happens at once. Real life does not happen that way. The solution is to introduce **overlap** into the shot. Through observation of the actual motion (me on the floor again), I determined that the arm and shoulder should start to actually reach out slightly after the whole body motion begins, with the grab continuing for a short while past the end of the body motion. With the timing keys set correctly, this is easy to accomplish.

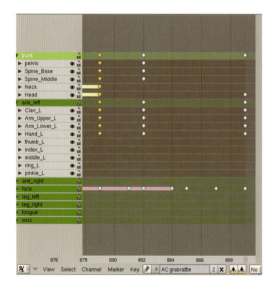

Figure 11.29 *All of the keys are in sync*

Figure 11.29 shows the set of keys that represent the beginning and ending of the overall motion. The keys for the arm bones are selected. In Figure 11.30, the arm keys

have been shifted a couple of frames to the right (forward in time) so that their motion begins slightly after the overall body motion. Finally, Figure 11.31 shows the end keys for the arm bones moved even further beyond the end of the body motion. The result is that the body begins to move, followed shortly by the start of arm and shoulder motion. After that, the body motion slows and ceases, followed by the end of arm motion. Not only are they not moving at the same time, but, because we changed the interval between the start and end keys, they are moving at slightly different rates as well. This variance produces a much more natural look.

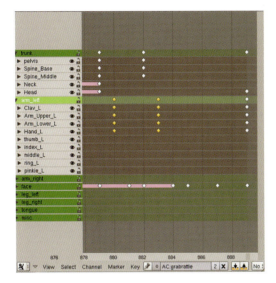

Figure 11.30 *The arm keys are offset*

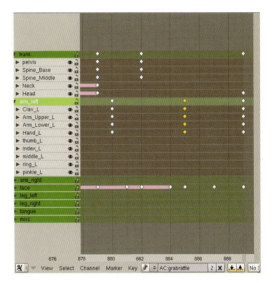

Figure 11.31 *The ending arm keys are further offset*

Now here's where time and resources come in. If you really wanted to, you could go back and add overlap and offsets for every joint in the motion. The shoulder would move one frame before the upper arm, which would move one frame before the lower arm. You can get as detailed as you like with it, depending only on the amount of time you have to devote to the shot. Of course, the way that you structure the overlap will go a long way toward showing where the force of the action is generated and focused.

Think about an arm, waving goodbye. The force begins in the shoulder and moves outward to the hand. Whereas someone who is holding firmly onto, say, Bigfoot's tail would show a completely different chain of motive force. Bigfoot would shake his enormous behind, moving first the hand, then the arm, the shoulder, and beyond. How you decide to offset the keys could very much enhance the effect.

A corollary to this notion is that overlap must be created with deliberation. Don't simply say, "Well, this shot needs overlap!" and start offsetting keys randomly. The result will be sloppy, random animation that lacks a sense of force. Think about what moves first, where, why, and how it affects other body parts around it.

Also note that you are in no way constrained to simply pushing keys around in the Action Editor to create overlap. If you are being even more careful in your animation, you can offset the keys as demonstrated here, then further refine the poses on those offset frames to truly optimize the motion.

Anticipation and Follow Through

As shown earlier in this example, these two can be built in from the beginning. You don't have to do so, but you will probably find that as you continue to animate you will start to think of these sorts of things ahead of time, giving you an opportunity to create a stronger launching point for the rest of your work. You may be tempted to try little tricks to save time by creating follow through and anticipation keys by extracting points from within the interpolation of the main action, but I advise you to avoid it. Both anticipation and follow through are valuable cues to your audience in that what's happening is believable and dynamic, and each deserves its own carefully crafted pose.

In the case of the Beast grabbing the rattle, the follow through to the main motion is that the hand comes up toward his face, and his head inclines toward his hand. Each motion is keyed and given the same respect regarding timing and overlap as a "normal" pose.

Once again, generating and watching a real-time preview will be the only reliable way to tell if what you are doing is really working.

Fine Tuning Your Animation

After you've really worked on the basics of a shot's animation, it's time to take a step back. Seeing the previews of the same actions over and over again can quickly destroy your ability to objectively evaluate what you're looking at.

There will be physical problems to deal with. A good example is the arm motion of the Beast in the rattle grabbing shot. When he finally really goes for it, the interpolated motion of the arm between keyframes actually carries the arm down into the floor. This sort of physical intersection that cannot happen in real life is one of the sorts of things you will have to watch out for. Figure 11.32 shows the bottom of the arm dipping into the carpet.

The best way to fix something like this is to simply position the frame marker in the middle of motion during which the two objects intersect and make an adjustment. In Figure 11.33, the arm has been moved up and a

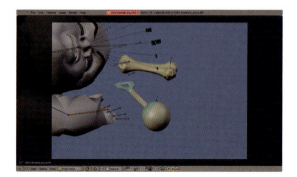

Figure 11.32 *The arm passing through the floor*

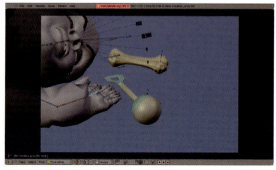

Figure 11.33 *The arm, moved up and keyed*

new set of keys has been added in the middle of the motion. This is not always enough to fix the problem. Sometimes you may need to key motion on each frame to force a body part to do exactly what you want.

Analyzing Motion with Arcs

Most vertebrate creatures move in arcs. It is a direct consequence of having a skeleton with joints. It will not always occur this way in every action of every animation, but it happens frequently enough that checking the paths your character's bones follow for arcs can improve your animation.

Shot 7, in which we see a full body view of the mother walking across the kitchen and kneeling to find the Beast, was difficult to animate. I went through several completely different attempts with different approaches. When I finally had something I was basically satisfied with (although I'm still not wild about the final result), I needed to further refine the motion.

Figure 11.34 shows what happened when I selected the main pelvis bone and enabled the **Calculate Paths** functionality. The sharp peak in the bone's path indicates a quickly reversing motion—a possible problem point. Bone paths are found on the **Armature Visualization** panel (Figure 11.35) of the Edit buttons when an armature is selected and in Pose mode. Selecting a bone (or bones) in the 3D view, then pressing the **Calculate Paths** button draws the path that the root of the bone follows throughout the course of the animation. Alternately, you can enable the **Bone-Head Path** button to track the head of the bone instead of the root.

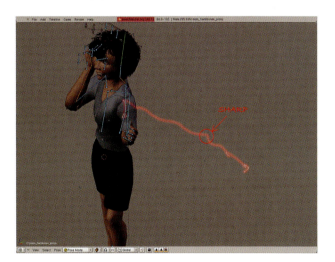

Figure 11.34 *A jagged path indicates possibly jerky, less than natural motion*

Figure 11.35 *The bone path options on the Armature Visualization panel*

An easier way to access this functionality is through the **W-key Specials** menu in the 3D view. Paths can be removed from the 3D view by selecting the appropriate bones and choosing **Clear Paths**, either from the panel or the **W** key pop-up menu.

As you move the frame marker in the timeline, you can watch your character move along the path in the 3D view. Frames are indicated on the path in the 3D view by little white dots. Advance the character to the

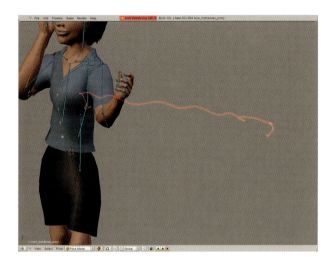

Figure 11.36 *The bone's path is smoothed, which produces better animation*

jagged part of the path and adjust its position to what you think will produce a smoother curve. Set a key on that frame. Of course, if automatic keyframing is still on, you won't have to worry about doing this. Then select the bone in question and use the **Calculate Paths** command again to redraw the path. Hopefully you will get a smoother curve, like the one in Figure 11.36. Notice how the path curves gently up and down to follow the up and down motion of the pelvis during the walk and how it forms little loops near the ends where turning and kneeling actions happen.

When you adjust motion like this, make sure that nothing bad has happened to other pieces of animation "nearby" in the timeline. For example, a slight move may make a foot that was supposed to be locked to the floor slide or make a part of the character's body pass through a solid object.

Facial Expressions

While you are perfectly welcome to add facial expressions during the main animation phase, I have found that I like to wait until the animation is more refined. Things can change when working in overlap, anticipation and follow through that alter the feeling of the overall performance, giving you a slightly different set of cues for the facial expressions.

Proper timing and overlap are certainly necessary when working with the face, although using anticipation and follow through are inappropriate except for the most exaggerated expressions. Anticipation and follow through are such necessary tools in bodily animation because they simulate the physical momentum of having a body. There is not a lot of mass and momentum involved in typical movements of the face.

The best tool for animating facial expressions well is simply careful observation. Watch the video. Keep a mirror beside your workstation. Observe the order in which the different areas of the face move when changing expressions.

Generally, expressions are led by the eyes. Knowing this, you could signal deceit in a character by, for example, moving the mouth into a smile first, followed by the eyes.

"Automatic" Motion: Breathing and Blinking

Depending on how you have built your rig, a simple breathing effect can often be achieved by slightly scaling a chest control bone. As long as nothing is going on that will alter your character's breathing pattern in

a shot (speaking, breaking into a run), you can keyframe a simple shrink and grow of the bone. Selecting that bone's channel in the Action Editor, as in Figure 11.37, and changing its **Extend Mode** to **Cyclic** in the **Key** menu on the header will cause the animation in that channel to repeat indefinitely throughout the timeline. This technique was used to make the dogs breathe and pant throughout *The Beast*.

When keying a repeating breathing pattern like this, make sure to observe some real-life breathing patterns first. Humans generally breathe with a fairly slow inhale, pause for an instant at peak "inflation," perform a brief exhale, then have a longer pause while at rest. Remember to keep the breathing subtle. You usually do not notice others breathing around you, and neither should you notice it in your animation. It should just be one more small clue that what's going on in the screen is believable.

Figure 11.37 *Setting the chest bone's breath keys to Cyclic Extend mode*

If you are working with lip sync (Chapter 12) or something that will obviously impact the breathing pattern during a shot, you will have to animate the breathing by hand, as opposed to the cyclic method described here.

Blinking is something that humans and many animals do on a more or less involuntary basis. It is not so in animation. While letting long stretches of time pass without blinking will definitely create an unnatural feeling, just assigning blinks at regular or even random intervals will not help either. Where you place your blinks will have a great effect on both the believability of the animation and on your character's ability to properly convey their emotional state.

A character should blink when:

- Their eyes look in an entirely different direction
- They move their head rapidly
- They change their mind or emotional state
- They are trying to hold back tears

Depending on the situation and the character, blinks will vary in length. A hyper character might do a full blink over the course of only three frames. This is very fast. A character that is trying to exude a calming effect on others would have a more leisurely blink, perhaps taking four frames to close and six or more to open. Just like adjusting timing during main animation, real-time previewing is your best friend here.

Remember that in real life, a blink is almost always a way of lubricating the eyes, but in animation a blink is a signal to the viewer. Don't waste it.

Production Techniques

There are a number of things you will certainly want to have your characters do that will be more easily accomplished with a little explanation: picking things up, holding onto stationary objects, and walking.

Pick it Up

Picking up and releasing objects in Blender has become very simple with the addition of the **Child Of** constraint. The constraint works like a normal Parent Child command but with a significantly greater degree of control.

In the shot of the Beast picking up the rattle, here is how you implement the constraint.

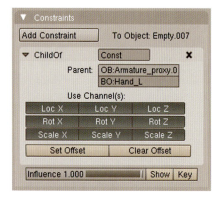

Figure 11.38 *The Child of constraint panel*

Advance to the frame where the hand will actually lift the rattle. On that frame, apply a **Child Of** constraint to the rattle, entering the armature and appropriate hand bone name in the panel, as in Figure 11.38.

When you do this, the rattle will disappear. Press the **Set Offset** button on the constraint panel to tell the constraint to use the current transformation as the basis of the parent/child relationship. The constrained object, in this case the rattle, jumps back to its original position. Moving the arm shows that the rattle follows perfectly, as though it were a standard parent/child connection.

The great thing about doing this by a constraint, though, is that you can animate the influence of the effect. Return the frame counter to the frame in which the hand actually picks up the rattle. On the constraint panel, click the **Key** button beside the **Influence** slider. This sets a key for full (1.0) influence on the current frame. Move backward one frame, set the **Influence** slider to 0.0, and press the **Key** button again. This tells Blender to not use the result of the constraint on this or any previous frames.

Figure 11.39 *The Ipo Editor view of a constraint's keyed influence*

If you look at an Ipo Editor window and change the view to **Constraint** on the header, you will see a curve that looks like Figure 11.39. What this means is that up until frame 882 in the example, the constraint has 0.0 influence, so the rattle stays in its initial position on the floor. However, on frame 883, the constraint influence jumps to 1.0, meaning that it now follows the transformation of the hand bone as though it has been grabbed by the Beast.

Simply reversing this process (keying influence from 1.0 to 0.0) will cause your character to release something from its grasp. Of course, this would cause the object to jump back to its previous, unconstrained position. So before the constraint

influence is keyed to 0.0, you will need to set a keyframe on the object, using the **VisualLocRot** keying method. Then when the influence of the constraint disappears, the object will remain in place.

Obviously, this technique is useful even if your character is not lifting something. Anything that will be stuck to your character temporarily—a cat with claws dug in, a cup balanced on her head, or a fork stuck in his cheek—can use this same technique.

> **NOTE**
>
> The production files for *The Beast* that are included on the disc do not use the Child Of constraint. At the time of the production, the constraint did not function properly due to several bugs. It is working properly now.

Hold On!

When animating, you may want to have your character hold on to some stationary object or set piece. If you remember back in the chapter on rigging, this is one of the situations where you would want to use a traditional targeted IK solution (weight-bearing bone chains should use full IK). Even if your arms are not rigged with full IK, you can still make it work.

Blender allows you to attach localized constraints to a proxied armature so that you can build nice little constraint networks that are specific to your shot without altering the master asset file.

In *The Beast*, shot 11.2 required the Beast to brace himself by holding onto the kitchen windowsill. In the shot file, the targetless IK constraint that already existed on the right hand bone was simply altered in the local file to target an Empty that was added at the appropriate location on the windowsill. Figure 11.40 shows the hand on the sill. Note the hand bone's yellow color, which indicates that it is using properly targeted IK.

This functionality makes Blender's rigging system even more flexible because you can safely build your rig to function well (and simply) for 95% of your shots, trusting that you can rig a "minisolution" in the one or two shots that require something more complex.

If you are adding entirely new constraints to a bone, and it has existing constraints from the master asset file, the new constraints will always appear after the "master" constraints. Should you need to override the master constraints, you can simply set their influence to 0.0 and recreate them as local versions to rearrange and deal with as you like.

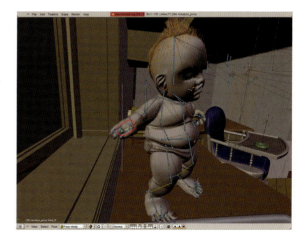

Figure 11.40 *You can alter constraints on a proxy for individual shots*

This technique will work for any constraint type. It isn't limited to IK, so you have almost complete rigging freedom on a case-by-case basis throughout your production.

Walk This Way

If you've done preliminary work in animation and followed the beginner tutorials, you've no doubt created a walk cycle at some point. For example, characters that will be running for a long distance and not hold the main focus of a shot will no doubt be fine with the traditional walk cycle methods. However, when your main characters need to walk and move around as the central action in a shot, the walk (or run, or leap, or shamble) should be done by hand.

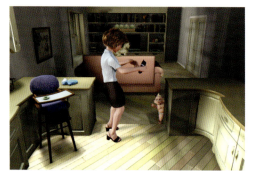

Figure 11.41 *Shot 7 for* The Beast

Shot 7 of *The Beast*, which shows both dogs, the mother, and the baby, has the mother turning around in place, walking to get a better view of the living room, and kneeling to find the Beast. Figure 11.41 shows a frame of the shot.

I went through several complete attempts at animating her turn and walk before I struck on a method that worked. I will present you with my failures, so that you can avoid them. The first time I tried, I did the performance with straight ahead animation. The result was like something from a horror movie. The mother's walk, especially in the skirt, should have been very controlled, but the straight ahead attempt had her careering and flinching all over the place. Instead of trying to refine that, I moved on to another technique.

For the second take, I decided to modify a method I had used to generate automatic walking in my BlenderPeople crowd simulation script. The technique involves keyframing pelvis and foot controllers along the motion path that I intended her to follow, but all together, much like the chess piece shuffling of the animatic. Then I went back to the beginning of the sequence and strategically added holds along the paths the feet were already following. As a final pass, I adjusted the position of the pelvis and torso so that it was always midway between the feet. The result of that experiment was something that, while much better than the previous attempt, lacked life. It walked like a Cylon.

I realized by obsessively watching the real-time preview of the animation that the problem was that I had been attempting to make the feet drive the motion. When people walk, their motion is led by their center of gravity, somewhere in the abdomen. The feet and legs just do their thing automatically, based on balance feedback.

So I got the bright idea to lock the legs in place and animate only the torso and deliberate arm movements first so that the motivation would come from the correct place, then go back and fill in the feet and legs later. I was gratified to see that Shawn Kelly of AnimationMentor.com discussed much the same technique in his recently released free Tips and Tricks eBook download, which I recommend that you read.

To use this method, you first apply a temporary **Child Of** constraint to the foot controllers so that they follow the rest of the body around (remember to use **Set Offset** to fix the initial **Child Of** position). You could opt

not to do this, but the sight of your character's legs warping and stretching across the room as you animate the rest of the body might throw you off a bit (Figure 11.42). Figure 11.43 shows the mother's pelvis and arms keyframed throughout the rest of the motion, with the feet following along due to the **Child Of** constraint. It's okay that they pass through the floor when she "kneels" down—you'll fix it later when you animate the feet.

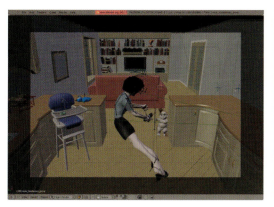 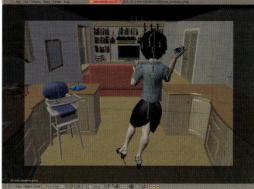

Figure 11.42 *Working with the upper body with and without the Child Of constraint*

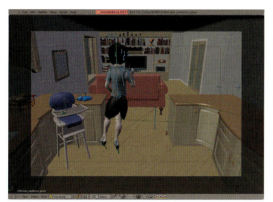 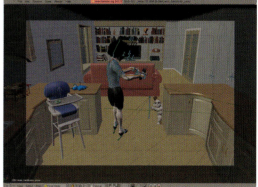

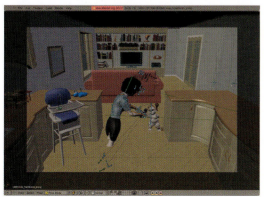

Figure 11.43 *The rest of the keyed body motion with the feet following*

With the feet locked to the rest of the body, you create the motion of the torso. When walking about, the torso really does lead the legs, so taking care of it first makes sense. For the arms, you can ignore the standard opposing swing that develops while walking, only setting keys for them if they have some kind of deliberate motion like a wave or a reach. You'll create the opposing swing after you key the legs.

If it helps, you can focus a camera view so that only the upper body is seen. That will help you to evaluate how the legless walk looks. Don't forget to show your main torso bone's path to really smooth and fine tune the motion.

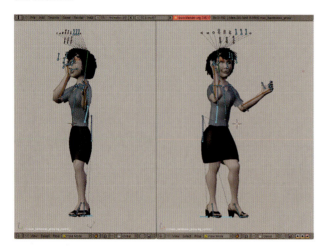

Figure 11.44 *A good way to start the feet*

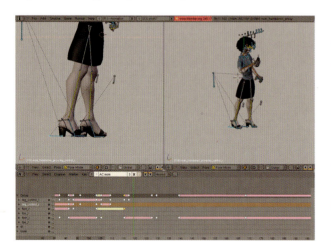

Figure 11.45 *The rear leg past its IK chain limit*

When you have the body motion worked out, return to the beginning of the animation.

Remove the **Child Of** constraints on the foot controls to release the legs and feet. Now that the body has been properly keyed and timed, you step through the walk a frame at a time, keying the feet and legs in a straight ahead fashion. Before you begin, though, you should alter the initial foot pose so that the feet straddle the center line of the torso, aligned with the starting direction of the walk. You should also drop the torso a little bit. Figure 11.44 shows such an initial pose.

Using the right arrow key, advance the frame counter until the back leg straightens and "pops" or separates due to overextension of the IK chain (Figure 11.45). This means you have gone too far. Go back two frames and set a key on the bone that lifts the heel off the ground. Advance two frames, lift the heel (rotate the foot bone, not the main leg controller), and set a key. The IK pop should be gone, but the leg will be close to fully extended (Figure 11.46). On that same frame, set a LocRot key for the main foot controller.

Keep advancing the frame until the torso is directly over the front leg. Don't worry that the rear leg is beyond its reach and has begun to stretch or poorly deform. If you've worked with stationary walk cycles before, this will be the "passing" part of the walk. Bring the rear leg up beside the front leg, raised from the ground (Figure 11.47). Also, clear the rotation from the foot bone that had been used to raise the heel and set a Rotation key.

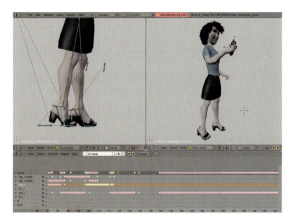

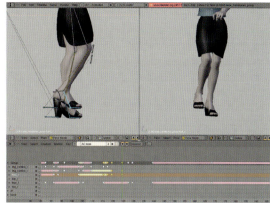

Figure 11.46 *Back two frames from the IK pop, the heel is raised*

Figure 11.47 *The leg is brought forward for the passing pose*

Now advance the frame until the formerly front leg hits full extension and "pops" or separates. Move backward two frames. Set a key on the "heel raise" bone of that leg, just like you previously did with the other leg. On this same frame, pull the formerly rear leg forward so that it is almost at full extension, rotated so only the heel is touching the ground (Figure 11.48). The foot should be oriented in the direction of the walk. Drop the pelvis a bit. Advancing two frames, you fully plant the rest of the foot by rotating the leg controller (Figure 11.49).

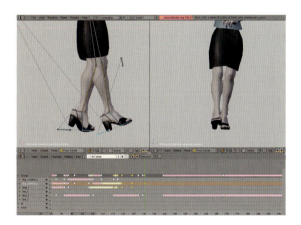

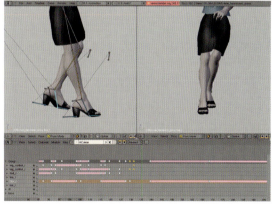

Figure 11.48 *The receding leg now raises its heel, and the proceeding leg plants its heel*

Figure 11.49 *The proceeding leg fully plants the foot*

And repeat. Easy!

Okay, this is actually kind of difficult to get right, and you will probably need to pace around the room for a while, observing exactly what your legs and feet do while you walk. Of course, if this all proves to be too hard, you can always alter the shot to only show your character from the waist up! Actually, this technique, like many others, becomes easier when you get used to it.

When the main walk is done, you will need to go back and refine the animation, adding opposing arm swing and all of the secondary motion that normally accompanies a standard walk. Make sure as you tweak things that you don't damage the nice path you created for the main line of the torso's motion. This is also one place where a separate controller for hip rotation can be useful, allowing you to key the rotation of the hips without affecting the rest of the pose for a more realistic walk.

A Final Note

Although it is difficult, animation should be fun. It is a strange mix of acting, puppetry, art, and engineering. The principles and techniques presented in this chapter seem like a lot of information to absorb, and, in fact, they are. You will find, though, that as you progress as an animator, these things become second nature to you. That is the goal—to embed these methods and ideas so deeply into your understanding of the subject that implementing them is no longer mechanical, but intuitive. When that begins to happen, you will be able to extract more believable and resonant performances from your characters.

Summary

When it's time to actually start animating, you create working animation files from the scene template file. Using the principles of animation and Blender's animation tools, you keyframe the motion of your characters. One way to do this is to create key poses, then adjust their intervals for proper timing. Overlap, anticipation, and follow through are added. The animation is fine tuned by analyzing motion paths and through real-time previews.

Outbox

A series of files, one for each shot in your production, that contain finished character animation.

The Peach Perspective

On animation: What's the most unexpected thing that you discovered about the actual character animation process during the production of BBB?

Nathan: The most unexpected thing about animating for *BBB* was the whole director thing. I'm used to classroom-style critiques, where it's all about the quality of animation, but the artistic control is still yours. So having animation rejected not because of quality concerns, but because it didn't fit the director's vision, was a totally new experience that took quite a bit of getting used to.

Sacha: Defining both the characters and the animation style was extremely hard. There are many possibilities for a style of toony animation, and every animator had different ideas and visions about this. When not having enough time to predefine this, it can make things very hard during production. The same goes for the character definition in a way. A certain evil character can look evil in a lot of different ways, so the danger of having a character look too different every time is always present. Again, it's time that could solve this, which we didn't have in most cases.

Lip Sync

Objectives

- Adding audio strips to shot files
- Creating the sync
- Mixing and exporting sound for the final edit

Inbox

Coming into this chapter, you need:

- Shot files with character animation
- Audio files with dialog

Adding Audio Strips to Shot Files

With character animation mostly finished on a shot, you can add sound and lip syncing. For actions within your shot that will emphasize or be affected by the specific beats of dialog, you may want to wait until lip sync is finished to add them. However, if you created a decent rough soundtrack at the story reel stage, you may have already blocked and animated such actions, in which case you can adjust their timing to match the final dialog track at this point. For example, the mother's hand and arm motions when she sees the Beast in shot 7 ("Oh there you are!") were animated prior to the finished dialog track and lip sync, then tweaked to fit the final voice work during lip sync (Figures 12.1 and 12.2).

To begin the process of lip syncing, open the shot file that will contain the dialog. On the **Sequencer** panel of the **Sound Block** buttons, which are part of the **Scene Buttons** context, adjust the sound settings to match those in Figure 12.3. Make sure that the frequency is set to **44.1 kHz**, which is most likely the frequency that your raw sound files were saved at. Enable the **Sync** and **Scrub** buttons too. **Sync** forces

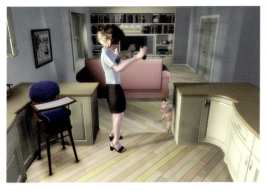

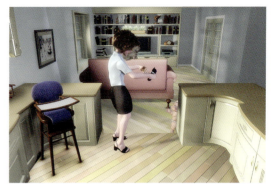

12.1　　　　　　　　　　　　　　　　　　**12.2**

Figures 12.1–12.2 *"Oh there you are!"*

Blender to play **Alt-A** animation in real time, even if it means skipping frames. **Scrub** lets you drag the frame marker in any timeline window (Timeline, Action Editor, Sequencer, etc.) and hear the relevant portion of audio while you do. This is an essential feature for lip syncing.

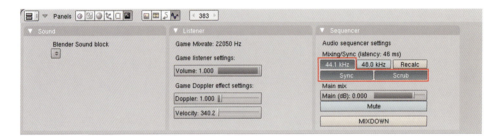

Figure 12.3 *The Sound Block buttons prepared for lip syncing*

To lip sync, you will need to have a work screen with a Sequence Editor, a 3D View, and an Action Editor. Figure 12.4 shows such a configuration. In the Sequence Editor window, use the **Spacebar** or **Shift-A** to add a new **Audio (RAM)** strip. If you have several takes of a piece of dialog all in one audio file as suggested in Chapter 8, you will need to select the take you want to use now, cropping the rest of the takes out. If you remember from the creation of the story reel, sequence strips can be cropped by individually selecting and moving the end arrows on the strip.

A good way to place the dialog strip is to scrub in your Action Editor window to the point in the animation where the lip sync needs to begin. When you reach it, press the **M** key to create a timeline marker. The marker also appears in the Sequence Editor window. Using this, you can zoom into the Sequence Editor window to get a good look at the waveform of the audio and position it properly relative to the new marker. In Figure 12.5, you can see how the start of the audio coincides with the timeline marker.

Left mouse button drag in the Sequence Editor within the area of the audio strip. You should hear it play, albeit in a slightly choppy fashion. This is called "scrubbing." Scrubbing playback may be vastly improved

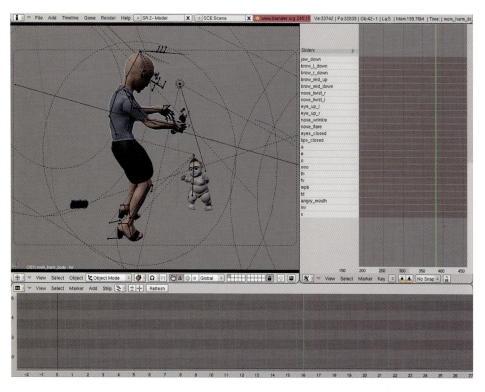

Figure 12.4 *A good configuration for lip syncing*

Figure 12.5 *Matching the audio strip with the animation*

by turning off subsurf on the character mesh and simplifying the scene by hiding other objects that aren't required for lip sync. If you don't hear anything, trying pressing **Alt-A**, the "Play Animation" command. On some systems, a bug prevents audio scrubbing until the audio is played in this fashion.

Creating the Sync

Set your 3D window to a good view of your character's face and expression controls. If you need to drop into local view mode with **Numpad-/** to declutter the display, do that now. Select all of the mouth controls on the armature and set an initial key by pressing the **I** key (Figure 12.6).

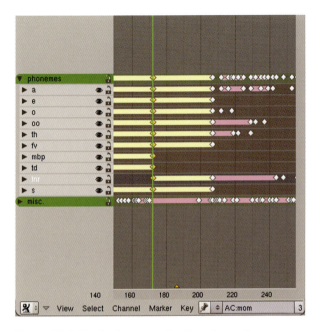

Figure 12.6 *Baseline keys are set for all mouth controls*

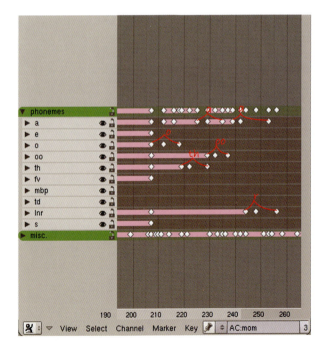

Figure 12.7 *The keys for "Oh there you are"*

Scrub over the first part of the audio, back and forth, so that you can identify the sound that is being made. When you've figured out the correct mouth shape to begin with according to the animation controls you've developed, place the current frame marker at the very beginning of the sound (not the audio strip, but the sound itself).

Every time you use a mouth control, you will have to set at least three keys. The first key will be in the "closed" or "off" position. The second key will be in the middle of the voice sound that control represents, in the "on" position. Remember that the control does not have to be the whole way "on." You will have to use your judgment regarding the exact sound of the audio clip, the volume of the voice, and the emotional state of the character at the time. The third and final key will be a return to the "off" position.

Another good guideline is to begin the mouth movement two frames before that bit of sound actually starts. This gives a bit of anticipation to the action, and, as humans preform words before the sound actually comes out of their mouths, it is more in line with reality.

Take a look at the key set for the mouth movements of the line of dialog introduced earlier (Figure 12.7). Notice that the actual sequence of mouth keys are, overlapping, **o-th-a-oo-a-r**. If you key every single letter in the script, you will produce an animation that is extremely overacted. It will look like your character is wildly enunciating every single syllable to pass an English as a second language test. Instead, listen carefully to the dialog as spoken. Try to hear it not as words but as the actual raw sounds. When we speak, our mouths actually take a lot of shortcuts, and it will benefit your animation to take note of it.

While lip syncing would benefit from a real-time preview played with the audio in place, this

is not conveniently available in Blender. You will have to settle for making sure that **Sync** is turned on in the Scene buttons and pressing **Alt-A** in the 3D view, as mentioned in the setup part of this chapter. To get a better playback frame rate, disable or minimize any subsurfacing modifiers and disable hair and fur particles, if your characters have them.

Basically, you will continue to scrub back and forth through the dialog, setting off-on-off keys from the different sounds as they occur. Pay attention to how the mouth shapes blend from one to another. You won't always get what you expect. Due to the nature of shape keys, two overlapping key sets might cause the mouth to open too far at one point or for the jaw to move inappropriately. When this happens, you will need to adjust the timing of the "off" keys so that more or less of a particular shape is used on the frames in question. There may also be cases where a particular mouth control works better than the one you think you need to use to get a certain mouth shape. In other words, your "e" shape may work better during a certain transition than the "a" shape, even though your character is technically making an "a" type of sound.

When your lip sync animation is finished, you may want to review the overall animation for the shot again. Some actions, such as blinking, breathing, finger pointing, or other hand motions might work better if they are coordinated exactly with the dialog track. It is worth it to make one more round of full, real-time preview to make sure that all of the layers of animation fall together naturally.

Mixing and Exporting Sound for the Final Edit

Whether you have several sound clips for a particular shot or just one, you will need to mix and export them into a single sound file that will match the exact frame length of the animation for the final edit.

Using the **Gain** control in the **Filter** panel of the **Sequencer buttons** as shown in Figure 12.8, you can increase or decrease the overall volume of the selected audio strip. Although you processed your audio before you brought it into Blender, you may find that you need to make adjustments if one strip is noticeably louder or softer than the others.

Figure 12.8 *Gain controls the volume of an audio strip*

If you need to get fancy and have portions of the audio increase or decrease in volume so they blend properly with overlapping sounds, you can use the Ipo editor to get exacting control over the volume of the sound. To do this, you need to show the Sequence Editor, a buttons window, and the Ipo Editor at the same time, like Figure 12.9.

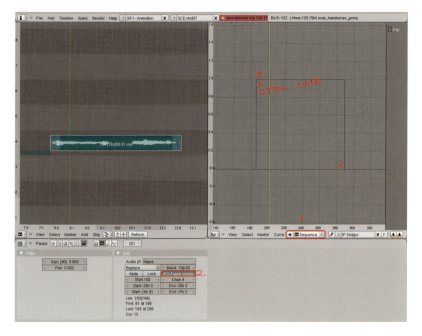

Figure 12.9 *Preparing to add a volume Ipo curve*

With the audio strip selected:

1. Set the Ipo Editor to view **Sequence** curves.
2. Click the **Ipo Frame Locked** button on the **Edit** panel of the **Sequence buttons**. This displays a small outline in the Ipo Editor that represents the area of the audio strip.
3. Hold down the **Ctrl** key while left mouse button clicking in the Ipo Editor. This creates key points and a curve in the editor. The **Y-axis** controls the volume, with 1.0 being the normal, unaffected volume and 0.0 being complete silence. Figure 12.10 demonstrates the volume changing from full (1.0) to nothing (0.0) over the course of the strip.

One last technique you can use is to alter the **Pan** value in the **Filter** panel of the **Sequence** buttons. **Pan** shifts

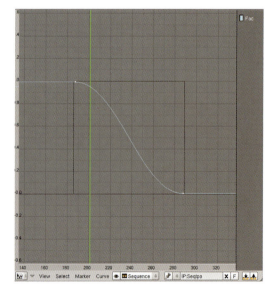

Figure 12.10 *An Ipo curve for fading volume*

the sound to the left and right of the stereo space. Setting **Pan** to −1.0 plays the sound entirely in the left channel, with only silence in the right; 1.0 puts the entire sound in the right channel; 0.0, the default, is balanced. Although this value cannot be animated, it can add another level of realism to your final project. For example, if a character is speaking from off screen to the left, you could adjust the **Pan** value for the audio strip of his dialog to something like −0.75 so it seems that the sound is coming almost entirely from the left.

> **NOTE**
>
> If you plan to use the **Pan** value, you should be sure to do so consistently. Having sound carefully placed into the stereo space for an entire animation, but forgetting to do so in one shot, would be a bit jarring for the viewer.

When you are satisfied with the way your audio strips sound, you need to export them. This is done with the **Mixdown** button that is found in the **Sequencer** panel of the **Sound Block** buttons (Figure 12.11). Pressing **Mixdown** creates a single, uncompressed audio file and saves it in whatever directory you have designated for animations in the **Output** panel of the **Render** buttons. The filename begins with whatever name is specified in the same **Output** panel and includes the frame range as well. For example, if no filename is specified in the panel and the animation frame range is from 125 to 840, the filename would simply be 0125_840.wav. Locate this file and move it into a shot-specific subfolder of your sound asset folder.

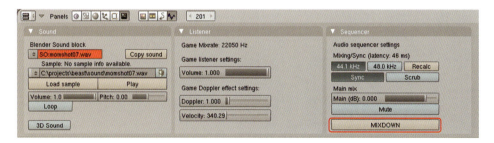

Figure 12.11 *Mixdown*

Because the mixed audio file uses the same animation frame range as the final renders for the shots, it makes it easy to match them with the corresponding shot file during final editing.

Summary

Lip syncing in Blender is accomplished by adding audio strips of dialog to the Sequence Editor in each of your shot files. Initial keys are created, followed by sets of off-on-off keys for each of the sounds you hear as

you scrub through the timeline. Finally, you adjust the relative volumes of the different audio strips to achieve a balanced result and mix the entire range of sounds down to a single file for later use.

Outbox

- Finished character animation in your shot files, including lip synced mouth movements
- An audio file of the mixed dialog for each shot

Final Sets and Backgrounds

Objectives

- Work flow
- Quality versus render time
- Geometry
- Materials
- Lighting
- Getting help

Inbox

Coming into this chapter, you need:

- A rough set file

Work Flow

Even though this book presents the production phase of animation in a linear fashion, it does not have to be so. As was mentioned before, the fact that there is so much to do on a project like this can be seen as a strength as opposed to an obstacle. If you are feeling burned out after doing nothing but animation for 3 days, there is no reason that you can't take a break and work on the final sets. Or take a day to record and play with voice work.

It's important to remember, though, that hard core animators never quit. Ever. They just go crazy after a few months and melt into a puddle of coffee and keyframes. The lesson? Don't be a hard core animator.

Break up the schedule. Take a day off, even. But if you find yourself becoming bored, remember that there are a lot of very interesting and engaging things to do within the scope of your project. You can almost certainly find something fresh to work on.

With that point about sanity and flexibility behind us, it's back into the maelstrom...

Quality versus Render Time

How much quality should your final renders have? As much as possible.

How long should your renders be? As short as possible.

Obviously, the answers to these two questions are at odds with each other. While your renders, eventually, will have to take *some* nonzero amount of time to produce, there is no reason to gratuitously jack up the render times with foolish choices. Before we talk about final sets and props, materials, and lighting, we should look at some of the basic principles that will help to keep your render times as short as possible.

Once again, it is worth pointing out that 10 seconds saved on a 3 minute render time spread over 2,000 frames (which equals just over 1 minute of animation) will save 5 and one-half hours of total rendering time. And that's if you get everything right on the first shot! During production of *The Beast*, the render farm was returning about one frame every 4 minutes on certain shots that could only be marginally optimized, but sometimes as quickly as one every 30 seconds. Following some simple rules can make a huge difference.

Your goal during the creation of the final sets, including materials and lighting, is to obtain the look that fits the style of your animation while keeping render times to a minimum.

Geometry

Following the same rules as character design and development, the geometry of final sets and props should be created at an appropriate level of detail with respect to how it will appear on screen. Items that will only take up a few pixels on screen probably shouldn't be allocated 4 hours of modeling time. Set pieces that appear mostly in the background but once or twice in close-ups should probably either have separate versions created or should be made following the character design suggestion: a good base shell with a subsurface modifier. This makes it simple to raise the subsurfacing level and consequent edge detail as needed.

As you build your final set, keep in mind that you probably have a limited amount of time in which to finish your production. If it is ever a question of spending time on geometry, materials, or lighting, definitely sacrifice the geometry. Many beginners intuitively choose the opposite, dumping all of their time into creating a set of exacting geometric detail under the assumption that materials and lighting are easy. The opposite is true. Good materials and lighting are the bedrock of a great render and are far from simple. In fact, getting the lighting correct is both essential and time consuming.

Matching the Rough Set

Remember that, although your final set geometry does not need to conform exactly to the specifications of the rough sets, it is crucial that at any point where the characters interact with the set (the floor, a chair, a wall that is leaned upon), the final set needs to be identical. Most likely, you will have already animated some or all of your shots

before you reach this point in the production process. If the final sets change in any material way from the rough sets where the characters interact with them, you will have to go back and adjust your animation to compensate.

Figure 13.1 shows the rough set from *The Beast* side by side with the final set. The points of contact between characters and set are the floors, the couch, the Beast's high chair, and the kitchen windowsill. Animation was done completely with the rough sets in place, so at those locations, the final sets had to match identically. As you can see in the illustration, the placement of structural and major elements is almost identical. To create the full set, a duplicate was made of the rough set file, and new geometry was created directly on top of the old to ensure congruence.

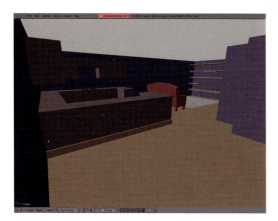 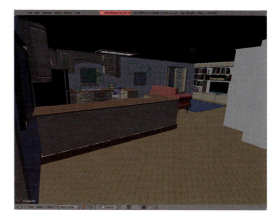

Figure 13.1 *The rough and finished sets*

In one instance, I messed up, causing me to have to retool some of the animation. When animating the opening scenes with the Beast on the floor, I had forgotten when creating the rough set to add adequate depth for the carpet. When I switched to the final set, which included the carpet, I found that the character was passing through the floor rather frequently. Fortunately, a move and rekey of the Beast's master bone upward on the Z-axis fixed the problem, although I had to adjust several shot files this way.

Movable Objects and Construction

If you examine the file "fullset.blend" in the sets folder of the production directory on the disc, you will see that many objects in the final set are linked dupligroups attached to Empties. In theory, you could build your entire set this way. However, I chose to create structural elements—the floors, walls, ceilings, and cabinetry— all directly within the set file. Having done physical construction work before, this just seemed the natural way to approach it, and it worked out very well. Anything that was going to be "bolted down" existed as live geometry in the set file. Everything else, including furniture, would come in as a linked dupligroup for easy manipulation. In Figure 13.2, local elements are on the left, with linked dupligroups on the right.

> **NOTE**
> The procedure for building dupligroup assets and linking them into your files is covered in Chapter 6.

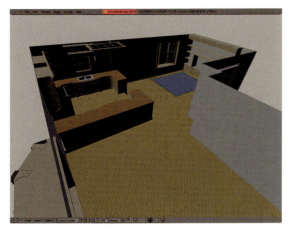

Figure 13.2 *Local and linked assets in the main set*

If you are working with outdoor scenes, you will certainly want to employ the dupligroup method as well, especially for high-polygon assets such as trees that will most likely be duplicated across the face of the set. Trying to do that with live geometry would cause a prohibitive increase in the file size and RAM usage. Any time you work with such a set, your system will slow to a crawl. Even with linked assets, you will have to come up with a few tricks to render such a scene without blowing through the top of your system's RAM limit. As you will see later in this chapter, there are a number of ways to deal with these sorts of problems.

Materials

No raytracing. Seriously.

That simple rule goes a long way. Yes, there will be times, such as a point-of-view shot through your character's bifocals, when you absolutely need to use raytracing to achieve believability in your scene. Barring that, though, just forget it.

The three material properties that will cost the most render time and which you should use only with consideration are:

Raytracing, of Course

This applies to both ray mirror and ray transparency, found on the **Mirror Transp** tab. Ray-based transparency produces perfect reflections and is necessary only for true mirrors. It can be faked almost everywhere else. Allow me to introduce you to the **FakeRef** texture. It's not an actual texture type, but I use it so frequently that I gave it its own name. Figure 13.3 shows the texture buttons, with a **Blend** texture selected and the **colorband** set. The colorband is the key. This colorband, when mapped to an object's **Refl** space (instead of **Orco** or **UV**) and blended properly with the base color, produces a passable reflection effect, as in Figure 13.4. The material settings for the Beast's phony corneas are in Figure 13.5.

Figure 13.3 *Setting up a fake reflectance texture*

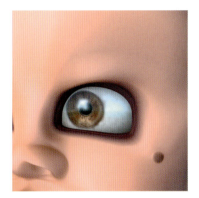

Figure 13.4 *The Beast's eyes, with and without the fake reflectance blend*

Figure 13.5 *The material settings for fake reflection*

For most items that reflect their surroundings in a subtle way, this will more than suffice in an animation. The idea was adapted from the way that fantasy painter Boris Vallejo stated that he paints chrome and other highly polished metals. His theory is that our own experience with high gloss metal is mostly restricted to cars, and that is the context in which our eye most easily recognizes it. Therefore, he paints all of his chromes with a "reflectance map" based on a roadway: black on the bottom for the road, then greens or tans for midground, a faded tone for the horizon, light blue to darker for the sky, and sometimes capped at the top with a bright band for the sun.

Before you use ray mirror or even an environment map—which does six minirenders of the object's surroundings—try the fake reflectance blend texture. Far fewer items need to have accurate reflections than you might think.

Be aware that this technique does not work with perfectly flat surfaces such as a mirror, and it only has limited success when a surface only curves around a single axis, such as a perfectly cylindrical glass. If you want

a slightly more realistic look, you can always find or take a digital picture of a scene that approximates the locale of the shot, blur it, then use it as an image texture with **Refl** mapping.

When it comes to refraction, less is more and none is best. While adding true raytraced refraction to transparent objects can add a startling bit of reality to still images, unless the refracting surface is the main subject of your animation, no one is going to miss it. Try your scene without refraction, using only **Ztransp** for your Alpha, and see how it turns out. Show it in motion to someone. If you like, render a small test with ray refraction turned on to show alongside it. You will probably find that it doesn't make any difference to your viewer, even though it made a large difference in your render times.

Subsurface Scattering

While Blender's subsurface scattering render is very fast for the high quality it generates, you need to be aware of how it can affect the overall render time on a typical short animation project. Each material that uses subsurface scattering gets it own render pass, regardless of whether the object is seen in the final render or not. Once again, each of these renders is fairly quick, but that time can begin to stretch if there are many shadow casting lamps or if Ambient Occlusion is used.

As an example, in the Beast's kitchen each of the dishes on the shelves and the cups and saucers on the counter used subsurface scattering to achieve a nice thin porcelain look. It looked fine, but I found that in many shots I was watching the SSS pass render, only to have the dishes obscured by the cabinetry. In the end, I just removed SSS from the material, and the eventual production renders did not suffer because of it. It probably only saved five or six seconds per frame, but the kitchen appeared in over 3000 frames. I'd say it was worth it. Figure 13.6 shows the dishes both with and without subsurface scattering. Even though it looked great in the "beauty renders" I did when making the dishes, it actually doesn't matter that much with everything else around it.

Figure 13.6 *Doing the dishes. Can you tell which stacks used SSS and which didn't? Neither could I.*

Of course, subsurface scattering is crucial to getting the proper look for living creatures, especially anyone whose skin is showing. And, as those are probably going to be your characters and the heart of your story, they are certainly worth the bit of extra time that SSS will cost.

Full OSA

Full OSA is not one of the options you'll be tempted to overuse. It is mostly implemented when a texture that is attached to a material has details that produce an unsightly pattern, either in stills or during animation. Figure 13.7 shows the texture for most of the fabrics in *The Beast* (the skirt, couch, and carpet). When applied to something like the couch and rendered under normal circumstances, the repetitive nature of the texture image can produce ugly renders, even at the highest Scene buttons' OSA settings. The reason is that the tricks that are used to "shrink" the texture to properly map it onto the model and then sample it for render can produce inconsistent results. Toggling **Full OSA** uses a much stronger but slower sampling algorithm. In Figure 13.8 you can see the difference between the couch rendered with Full OSA (time: 3:10) and without it (time: 2:06).

Figure 13.7 *The base texture for* The Beast's *fabrics*

How do you know when to use **Full OSA** on a material? When your renders show an uneven, choppy pattern in a reduced tex-

Figure 13.8 *Full OSA versus regular sampling*

ture that should have a fairly uniform look. Also, you may notice it when animating an object whose texture seems to "crawl" from frame to frame. Although it takes significantly longer to render (50% longer in the preceding case!), **Full OSA** is the only real solution to this problem, short of entirely changing the texture itself.

Before moving on to lighting, let's touch on a few notes for materials that can raise the believability of your objects:

- Turn down the saturation. Few objects in real life have highly saturated colors. Instead of using the RGB sliders to generate your colors within Blender, switch to the HSV (hue, saturation, and value) controls on the **Material** panel. You don't want your entire animation to appear drab, but it is much easier to "turn up" the color in postproduction if you need to and maintain a good dynamic range than it is to remove oversaturation without damaging the visual quality of the shot. Slightly reducing the saturation of most objects will also allow you to give your main characters additional visual punch by saturating them a bit more.

- Turn down, or turn off, specularity. Take a look at your immediate surroundings and observe how many things have a noticeable specular highlight, compared to how many have them in your scene. Specularity is a default in Blender's materials, so it shows up much more often than it is needed. If you have a material that you think shows no, or almost no, specularity, try setting the **Spec** value very low, like 0.1, and the **Hard** value as low as 10, so that a very weak specular highlight, only a hint really, will spread over a large area.

- Even if you plan to use simple procedural textures on your objects, take a minute to create UV maps. Blender has one of the easiest, highest quality UV mapping systems of any 3D package, making it possible to create decent UV mapping for background objects within seconds. Procedural textures, if set to use UV space, will appear as surface texturing, instead of having the "carved out" look that they often do.
- Watch the scale of your texturing. Unless you plan to use **Full OSA** as mentioned previously, a texture whose scale is too small can produce a noise-like effect when rendered for animation.

Lighting

It will be hard enough to get really good lighting on your characters and sets by themselves. To try to light them both at once will probably result in failure, or at least in running out of time before you've arrived at a good solution. As you will be working with animation, there are some lighting techniques that will just take too much time to render, so lighting skills and tools that you may have picked up when working on still images will not necessarily help you. Of course, the principles of what looks good—the artistic side—remain the same.

Good illumination will help to describe surfaces, showing their shape. It should also give a sense of depth (where depth exists) and draw attention to the important points of the scene. When lighting sets, then, that are a background to your characters and the story, you must keep in mind that the set is (usually) not the most important element of the shot. This is not to say that you should make your sets boring or light them poorly, but that they should not be in a competition with your characters for visual dominance.

What Not to Use

Continuing the hard line expressed in the materials section: no raytracing. So, no ray shadows, and especially no soft ray shadows, or ray shadows with area lamps. They make beautiful renders but take way too long. Console yourself with the fact that most "big budget" animation projects, including feature films, eschew raytracing and opt for buffered shadows.

Also proscribed will be raycast Ambient Occlusion. This is the standard AO method that has been around for several Blender versions and provides either a great "overcast day" look when used by itself or a good realistic baseline for most other renders.

In shots in your production where the camera does not move and your set can be replaced in whole or in part by a background image (which we'll discuss in Chapter 15), and you will only be rendering the set once for the entire shot, you actually can use these techniques. The problem arises if you light your set with these "high cost" tools for a shot with a stationary camera but use faster lighting tools for other shots. You will have a very hard time maintaining a consistent look across the differing shots.

Here's a little mental script you can use as you struggle through the first stages of raytracing withdrawl:

Bad you: Oh come on. Let me just use ray shadows on my area lamp.
Good you: No. Absolutely not. We have a deadline to meet.
Bad you: Give me a break. See how easy this is? Come on!
Good you: It'll take forever, and soft sampled shadows can crawl across different frames!
Bad you: I think you're just scared. You can't **handle** raytracing. It's too awesome for you.
Good you: I think you need some help.

Lighting Exterior Shots

The easiest way to light an outdoor scene is to enable Ambient Occlusion with the Sky Texture option, throw in a sun lamp, and turn on ray shadows.

Are red lights flashing and sirens going off in your head? They should be. The AO + sun lamp method is not going to work for animation.

Fortunately, there is a new nonray-based ambient occlusion method available. One of the downsides of the original ray-based AO, besides its lack of speed, is that even at maximum quality, it is not completely smooth, giving a slight grain to every surface it touches. This grain is different on every frame and could produce a noisy effect when animated. That made it unusable on everything but the highest (slowest) quality settings. Although the new **Approximate** method of Ambient Occlusion takes more tweaking to get right than the ray based variety, which is pretty much "fire and forget," the results are relatively quick, smooth, and produce consistent renders across frames. Figure 13.9 shows both AO methods used on the Beast with no other lighting.

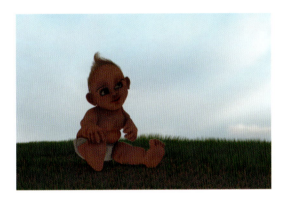

Figure 13.9 *The Beast in the field with both raycast AO (24:70) on the highest quality level and approximate AO (0:42)*

The options for Approximate Ambient Occlusion (AAO) are a bit obscure, so let's examine how to use them to fix problems you may encounter with the default values. Figure 13.10 shows the default values on the **Amb Occ** panel of the **World buttons**.

In Figure 13.11, notice how the areas that have been darkened by AAO seem unusually dark. This is one of the downsides of AAO—areas that have faces pointing in the same direction will tend to reinforce the occlusion effect. To fix this, there are two methods: raising the **Passes** value, which attempts to cull duplicate faces from the solution before rendering, and raising the **Correction** value, which simply tries to reduce

Figure 13.10 *Approximate Ambient Occlusion defaults*

Figure 13.11 *An out-of-the-box render using AAO*

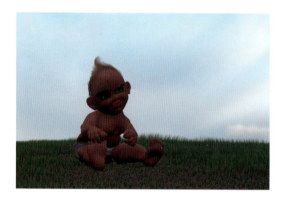

Figure 13.12 *Passes set to 2 to fix overocclusion*

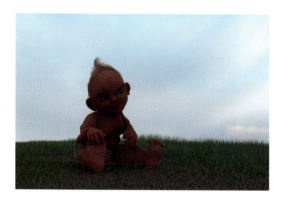

Figure 13.13 *Correction set to 1.0 to fix overocclusion*

the darkness of the final result. Figures 13.12 and 13.13 show both methods used to fix the problem from 13.11. Personally, I have achieved more visually pleasing results with the **Correction** tool. I turn it up to 1.0, the maximum, and work it down from there until it gives the look I'm after.

Remember when working with AAO and looking at these examples that it is meant to be a basis for the rest of your lighting scheme, so it will look dark to begin with.

AAO rendering speed can be greatly increased by increasing the Error value. It begins at 0.250, but can be set as high as 10.0. Basically, the error value represents how tolerant AAO is going to be of nonoptimal conditions within the solution or how lazy it will be about fixing bad stuff. As you can see in Figure 13.14, a value of 10.0 means that it is very, very lazy. You will have to experiment with the setting for your own shots, but I have found that a value of even 0.5 produces a result mostly indistinguishable from lower values but with a significant increase in speed.

Falloff functions much the same way as it does in raycast AO. It is an adjustment from 0.0 to 10.0 that determines how quickly a shadow fades out as it moves away from the face that casts it. A value of 0.0 gives you the default render from 13.13, while maxing it out at 10.0 produces short shadows that fade quickly, as in Figure 13.15.

Figure 13.14 *Error cranked up to 10…. It's a good thing it doesn't go all the way to 11!*

Likewise, the **Energy** control functions exactly like it does for raycast AO, increasing and decreasing the overall brightness of the result.

Finally, try enabling the **Pixel Cache** option, which can dramatically speed up AAO rendering. Be aware that it is an even further shortcut in the rendering process and may produce undesired results. The best advice, though, is to get your AAO settings as you like them, do a test render (possibly even a test animation), then enable **Pixel Cache** and rerender for comparison. If everything still looks good, then go with it!

Figure 13.15 *Falloff set to its highest and tightest value*

> **NOTE**
> You can choose to use the **Sky** option with AAO to let the sky's color affect the solution. Unlike raycast AO, AAO does not take the **Real** sky option into account, so any colors you specify in the Horizon and Zenith color blocks of the World buttons will be used as a simple up/down blend, not as a true color horizon.

Most outdoor scenes will include direct lighting from the sun as well. The simplest way to accomplish this sort of unidirectional light is to use a **Sun Lamp** (remember—no ray shadows!). Figure 13.16 shows the outdoor test scene that was previously described rendered with a single Sun Lamp added.

Of course, you will need to include shadows. The best way to do this in a controllable fashion is to duplicate the Sun Lamp and change the new lamp to a Spot Lamp, set to **Only Shadow**. Settings for the Spot Lamp used to produce Figure 13.17 are in Figure 13.18. If you set the lamp's **SpotBl** (Spot Blur) to 1.0, the shadows will fade out nicely around the edges of the lamp, allowing you to use several lamps beside each other to shadow large areas if the need arises. Be careful when using multiple shadow-casting spot lamps, though, that the same object is not overlapped by the coverage areas of multiple spots. This would produce multiple cast shadows and look bad. For some shots, you may need to carefully manage the layering of spot lamps and objects to avoid these sorts of problems.

When setting up lighting for an outdoor scene, Approximate Ambient Occlusion creates your base. Direct illumination is

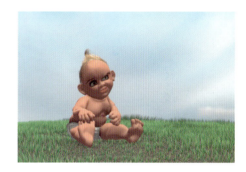

Figure 13.16 *A Sun Lamp added*

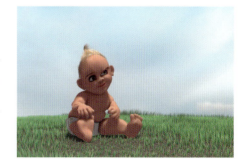

Figure 13.17 *A Shadow Only spot lamp is added*

233

Figure 13.18 *Shadow Only spot settings*

provided by a Sun Lamp, and direct shadows are provided by a shadow-only Spot Lamp. The deepest shadows, then, will be found anywhere the spot-cast shadow and AAO shadowing coincide. A midtone area will be created where the spot-cast shadow falls, but AAO provides full illumination. Finally, the brightest areas will be places where AAO creates the most light, faces point toward the Sun Lamp, and no shadows from the Spot Lamp fall. Adjusting the outdoor lighting, then, becomes a process of tweaking the AAO settings to the range of light present in shadow areas, the Sun Lamp energy and color for the proper amount of direct illumination, and the shadow only Spot Lamp's energy and shadowbuffer settings for the correct intensity and sharpness of direct shadows.

Lighting Interior Shots

Interior shots are significantly more difficult to light believably than exteriors. Many of us (especially computer people) spend an inordinate amount of time indoors and have a well-developed sense of the subtle shading and radiance effects of interior lighting. The best advice to give about working with interiors is to approach it as though you are a retail store designer. Take a trip to your local mall or shopping center, walk through some of the more upscale places (as long as security doesn't tail your silly artistic self), and observe the way that the store is given a very natural look even though there is probably no natural light whatsoever.

If you've even been on stage in live theater, or, less likely but even better, been on a sound stage for film or television production, you will notice the gigantic array of lights that are needed to produce a natural effect. You will be doing the same thing in 3D.

Figure 13.19 shows the large array of spot lamps that were used to create a decent base for interior lighting in *The Beast*. Each of the lamps in this configuration is a Spot Lamp with very low energy, a relatively small shadowbuffer, and high shadow blur. As you can see from the render in Figure 13.20, it gives an "okay" interior Ambient Occlusion effect.

Figure 13.19 *The lamp arrays for set lighting on* The Beast

More low intensity lamps were clustered outside of windows to provide extra diffused brightness coming from those areas. Figure 13.21 shows those lamps. Note how several overlapping lamps are used so that the light seems to diffuse in a more natural pattern further from the windows. Figure 13.19A is an additional detail of only the lamps associated with the living room area. You can see that each wall has four or five overlapping lamps to simulate light diffusing from that wall.

In Figure 13.22, you can see the interior with the clustered "window" lamps added to the base shading.

Figure 13.19A *The living room base lamps*

Areas in the render that still remain too dark can be brightened with low intensity regular omni Lamps with **Sphere** falloff enabled and carefully adjusted. This only needs to be done on a shot-by-shot basis.

In the actual shots, additional lamps are added on an as-needed basis for direct illumination. Why not use the fast Approximate Ambient Occlusion like the exterior shots? Unfortunately, the AAO algorithm did not like the long, thin faces that were used for many of the architectural elements of my set, such as the cabinet bevels, floorboards, and crown

Figure 13.20 *An interior render with no additional lighting*

Figure 13.21 *The lamps for adding diffuse window lighting*

Figure 13.22 *The window lighting added to the base shading*

molding, producing bad results even at very low and slow levels of error tolerance. It is worth a try in your own production to test AAO for the interior shots. It may be that there are no ugly artifacts present, but remember that it will be an all or nothing proposition. Using AAO on only some of your shots, but not on others, will produce an uneven finished product.

An examination of the set file for *The Beast* will show the final part of this interior lighting technique. While the walls, ceiling, and floor are capable

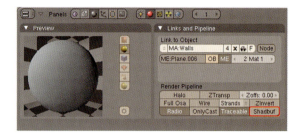

Figure 13.23 *Turning off cast shadows for the walls, ceiling, and floor*

of receiving shadows, they cannot cast them. This is set by turning off the **Shadbuf** button in the **Links and Pipeline** panel of the **Material buttons**, as shown in Figure 13.23. This allows the light from the surrounding lamps to pass through the walls on its way into the set, as though the light were reflecting from the wall itself. Notice how the size of the selected lamps in Figures 13.21 and 13.22 roughly matches the dimensions of the outside edges of the wall and ceiling so that a good simulation of reflected interior light occurs.

Another way to accomplish this effect is to allow the normal shadow casting properties of the walls, etc., but to carefully set the Clipping distance of the shadowbuffer calculation so that it begins only inside the walls. Because I wanted to make all the lamps instances of the same base lamp object for ease of overall energy adjustment, and the clipping method requires fine tuning of each lamp individually, I decided not to use this technique.

Layering

As you construct your final sets, you should keep in mind that often the camera will not see the whole thing at once. Work through your storyboards and story reel with an eye toward which portions of the set will be seen in which shots. Because one of the goals of set design is to minimize render times, it is a good idea to break your set up into layers. Figure 13.24 shows three different layers of the set from *The Beast*. While

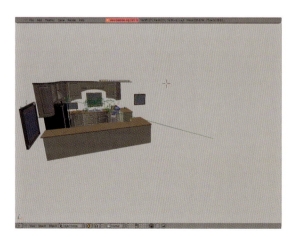
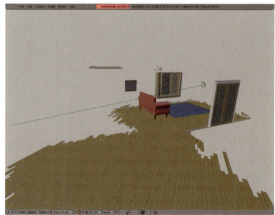

Figure 13.24 *The different layer breaks of* The Beast's *set (walls, ceiling, and lamps have been removed for clarity)*

 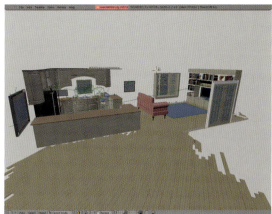

Figure 13.24 *(Continued)*

there are some elements and objects that appear on more than one of the layers, major geometry is arranged so that when it does not appear in a shot, it can easily be disabled on the layer buttons. In Figure 13.25, you can see one of the camera views of a shot from later in the project. Notice how only one set layer out of three is enabled because the others were not needed for this view.

If you are going to use this method, you will also want to put the lamps that illuminate each specific portion of the set on

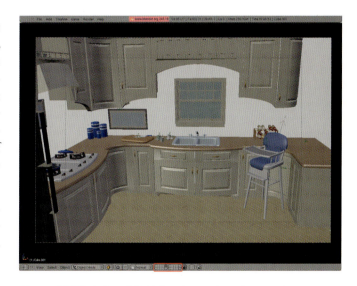

Figure 13.25 *A view of the kitchen that requires only one set layer*

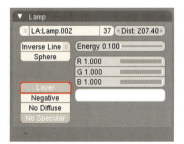

Figure 13.26 *The Layer lamp setting restricts the lamp's effects to objects on its own layer*

the same layer as the objects. In fact, it can be useful to also change those lamps to only affect objects on their own layer by using the **Layer** setting in the **Lamp buttons**, shown in Figure 13.26. This means that the lamps will not affect your characters, but it is usually best to light them independently anyway. Also, if your characters will have hair or fur using Blender's strand particles, the calculation times for shadowbuffers on a very high number of interior lamps can be quite large.

Another thing to consider, especially for outdoor scenes, are distance breaks. Most likely, you will not be rendering an entire foreground-to-horizon environment in live 3D for every frame of your animation. Unless the camera is spinning wildly, it would be completely unnecessary. If you will be using a statically rendered distant background, you will need some way to blend that into the foreground. The easiest way to do so is with distance breaks. Consider the image in Figures 13.27 and 13.28. They demonstrate how the entire shot can be seen as a series of overlapping layers. The point is that between two of those layers, you will need to change from live geometry to a prerendered (or painted) still image. Having some sort of physical break line, like a cresting hillside, will give you an excellent place to make the transition.

Figure 13.27 *A rendered outdoor scene*

Figure 13.28 *The different production layers*

You aren't required to have a physical breakpoint, and you won't always be able to have to one, but a line of trees, a building, or a hillside can make your job during the compositing stage much easier. The actual creation and integration of background images for your shots will be covered in Chapter 15, Rendering and Compositing.

Getting Help

This is a good time to discuss getting help with your project. We've encouraged you previously to solicit feedback on your story ideas, storyboards, and story reel, but that sort of help can come from anyone with eyes and, at the least, a half a brain. If you have committed to developing the story and characters either by yourself or with a small group, the finalization of sets and props is an excellent opportunity to open the project up to a larger pool of help. You don't have to, but at this point in the production, going from character animation to modeling books on a shelf can feel like a bit of a letdown. It can also take a while. Fortunately, the modular structure of your sets and object files (linked assets) makes it easy for you to farm out these sorts of duties.

The mechanics of doing so are simple. For modeling help, you request one BLEND file per object. As you receive BLEND files, you place them in your models directory, or perhaps a subdirectory called **contributed**,

and open them for inspection. Make sure that any texture images have been packed and that the artist has obeyed any rules you've given (like no raytracing!). Select all of the objects in the file, excluding any lamps or cameras the artist had used for testing, add them to an appropriately named Group, then save and close the file. The asset can be linked into your set or shot files as a dupligroup and scaled and placed accordingly.

Having artists work on materials is even easier. Just send them your single-object asset file, have them apply textures and materials, and return it. As long as they haven't altered the geometry in any way, you can drop that returned file into place in your models directory, replacing the original, and that object will now be textured throughout your production.

Of course, dealing with people is neither simple nor mechanical. Here are some guidelines to follow when asking for help:

- Before you begin asking for general help in web forums, try to find some people who are familiar with Blender and whose artwork style seems to fit with your project. You will have a much greater success rate by personally contacting such artists with details about your project and exactly what you need, rather than making an online cattle call. It will help to include a little bit about yourself, how much time you already have in the project, and perhaps a few bits of teaser artwork into the request.

- When someone expresses interest, show them some more of the artwork you already have finished, as well as a little of the animation. This will help them to decide if your project is something they want to devote their time to. Not every project fits every artist.

- If someone is interested, give them a small assignment or two to see how they do. You will not only be considering how their finished products actually look, but in how well they can stick to a stated time frame. If they say, "I can do it in two days," do they really come through in two days? Obviously you cannot be a slave driver about it, but it's good to gage how much time the person has available.

- Don't ask for too much. Remember that you've decided to put your sanity on the line by producing a short animation, but no one else has. Don't be demanding. No one is going to die if someone ditches on adding textures and materials to your picnic table model.

- When giving an assignment, be clear about it. Provide reference images or artwork (web links are fine), as well as a clear description of what you are looking for. Do not say, "Just make whatever you want." Indicate any restrictions you might have (no raytracing, no blue, whatever). For quality and completeness, ask them to use the PNG format for texture images and to Pack them into the BLEND.

- If you have one available, provide your stable of modelers and shaders with an FTP site where they can receive and load jobs. While these sorts of transfers can be done by email, packed files might become quite large.

- As your project progresses, share as much of it with your helpers as you can. It's nice to feel as if you're on the inside of something cool.

- You will receive files that are not exactly what you had hoped for. Before rejecting them outright or asking for revisions, there are a few things to consider. First, how long will it take you to bring the work into line with your original idea? It might be simpler just to make a few changes than to go back to your artist for a revision. Second, could this idea work better than your own? Try it and see. If the work simply doesn't fit your project, be diplomatic. Examine your original request—it may have been unclear.

- Credit. Make absolutely sure that you credit anyone who helped in the final production. Before the final edit, send the credit list around to everyone who helped so that they can check the spelling of their own name.

Here is a sample message you could send to someone who you have identified as a potential helper on your production.

```
Hi DarkStarr02 -

I noticed some of your great artwork in the blenderartists forum gallery and
thought you might like to take a look at my current project. I've been working
on a short animation for the last 4 months. Most of the animation is finished,
and I'm starting to create the details of the sets. I was wondering if you would
be interested in modeling and texturing a few objects that would appear in the
finished production? I really think your style fits well with my animation and
hope you can help.

You can see some of the already finished artwork and animation here:
http://www.super_awesome_animation.com/secret/

Thanks!

super_awesome_animation_dude
```

Also, be sure to include your real name and main email address, so you feel less like someone who they just met on the Internet, even though you are.

Summary

Like many other aspects of the short animation process, final set and prop creation is a continuation of the balancing act between resources and results. The sets themselves are created from a combination of local geometry and linked assets. When adding materials to your objects, care should be taken to avoid features that can cause render times to drastically increase. Sets should be lit independently of the characters. Outdoor scenes can be effectively lit for animation with Approximate Ambient Occlusion, a Sun Lamp, and shadow only Spot Lamps. Interior scenes can also benefit from AAO, but they may require more complex setups to mimic the subtle reflected light we are used to seeing inside. Sets and lighting are broken into layers to facilitate both rendering and background blending during compositing.

Outbox

Leaving this chapter, you should have:

- Finished set and prop files, fully lit, with materials for all objects
- The set elements broken into layers for exclusion from shots

The Peach Perspective

On set lighting: How crucial was the implementation of Approximate Ambient Occlusion to the lighting schemes of your sets? Please take a crazy, wild guess at how much time it saved the set and lighting designs.

Andy: I would go to the extent of saying that, without AAO the movie would not have been possible. It really helped us a lot and saved us approximately 75% overall. All of our scenes either were in bright daylight or in deep forest. The main problem with these settings is that it's always hard to fill them up with a general environmental (bounce or fill lights in that matter) light scheme. Sure, you can use Sun or even Hemi lights in Blender, but that way you also lose a lot of depth and detail. The crucial feature for AAO was that it produced very subtle contact shadows. These are absolutely vital (for example) to connect a character to an environment or vice versa. So in many cases we ended up using Spot lights for the main and bounce light sources, and AAO for the fill. In nearly all the cases, the AAO was rendered out as a separate Render Layer to get more control over the depth and color of the contact shadows.

When using localized light sources such as spots on animated characters the problem is to deal with the terminator lines (the area where shadow meets light). If there are too many lights (=too many terminators), things tend to look very busy, especially in the face area where your main focus is. As a lighting artist, it's your goal to support the animation! So in reducing the Spots on characters and replacing them with AAO, the characters were a lot more expressive and had more appeal.

Simulation

Objectives

- Blender's simulators
- Fluids
- Cloth
- Rigid bodies
- Particles
- Strands—hair and fur
- Soft bodies
- Linking issues with simulators

Blender's Simulators

Blender has a number of simulators available for your animation needs. These simulators can produce accurate results that add a high degree of believability to your animations. While it is simple to configure the simulators to make impressive demonstrations, integrating them successfully into a larger animation project can be extremely difficult. So in addition to looking at a short example of each type of simulation, we'll also take a look at integration issues and when it may be better to just skip the simulation altogether.

Fluids

Here's the three-step tutorial on creating fluid simulations in Blender:

1. With the default cube selected, choose **Enable** and **Domain** from the **Fluid** panel of the **Physics buttons** (Figure 14.1).
2. Add a small sphere inside of the default cube and choose **Enable** and **Fluid** for it (Figure 14.2).
3. Reselect the original cube and press the **Bake** button (Figure 14.3). The bake might take some time, so don't assume Blender has crashed or stalled. Watch the progress bar in the main header.

Figure 14.1 *Enabling an object as the overall domain of the simulation*

Figure 14.2 *Adding and enabling an object for the starting position of the fluid*

Very simple, right? The domain object becomes the actual fluid, and the original bounds of the domain become the extent of the simulation. The other options are just as easy too. Setting an object to **Obstacle** does exactly what you'd think—it uses the object as a solid obstacle that the fluid will not penetrate. Objects set to **Inflow** and **Outflow** add and remove fluid from a simulation at a constant rate, like a spigot or a drain, respectively.

Blender's fluid simulator is impressive, but in reality it is better suited to creating stills than animations at this point. The problem is one of resolution and time. There are a number of very cool demonstration videos

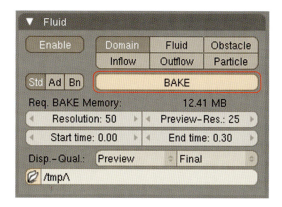

Figure 14.3 *Pressing Bake starts the simulation*

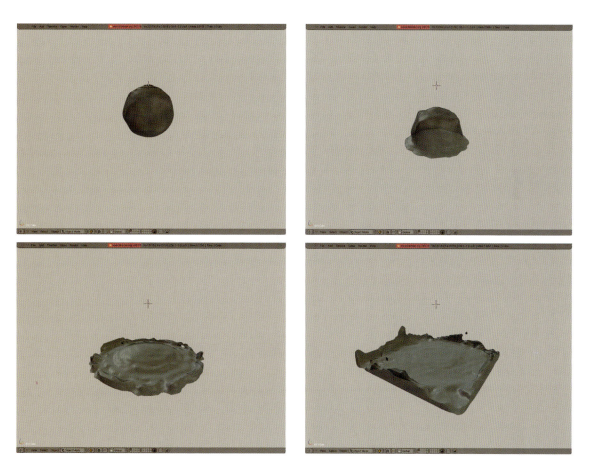

Figure 14.4 *Taste the splashification!*

245

of the fluid simulator available on the Internet, and most of those were created with a sort of "let's see what we can do" attitude. While this is great for testing and for doing technical demos, it doesn't really fit into the production pipeline very well. When producing an animation, you will be looking for a very specific effect and probably an exact behavior from the simulation.

In *The Beast*, the original plan was to use the fluid simulator for the shots where the Beast fires the sink sprayer. After several attempts with the simulator and a couple of consultations with some people who are much more experienced with it than me, it was decided that a true simulation would not be possible. A workaround was found, which will be explained later. First, though, let's look at what criteria can help you to decide whether or not a true simulation will be appropriate.

- Detail: This is the controlling factor. You need to be able to put enough detail in the simulation that it looks realistic. For example, if you are simulating a glass of water tipping over, but there is not enough detail, the liquid will appear thick, like a heavy syrup. Increasing detail rapidly leads to drastic increases in both calculation time and RAM usage.
- Overall size: As the real-world size of the simulation increases, so do the RAM and time requirements to maintain the same level of detail. The size of the simulation encompasses the entire area that fluids may be. So if you have a splash that flies away from an impact point, the entire area that is covered by the splash must also be a part of the simulation or the splash will seem to hit an invisible boundary.

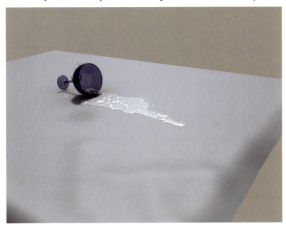

Consider a fairly small fluid situation. A character has knocked over a glass, spilling its contents onto the table. For some reason that makes sense in your story, spill is a major story point—a very dramatic moment. You decide to show the glass falling and the water spilling in slow motion with a fluid simulation. As a test, I've made such a simulation. You can see the result in Figure 14.5. The setup for creating this simulation can be seen in Figure 14.6. The domain (the area in which the simulation takes place) has to cover everywhere the fluid might splash or flow, meaning that it is much bigger

Figure 14.5 *A spilled glass, before the liquid "soaks into" the tablecloth*

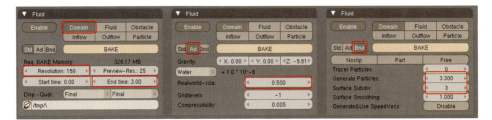

Figure 14.6 *The liquid settings for this simulation*

(0.5 meters) than just the area of the glass. Also, due to the trial and error nature of creating a good simulation, this particular setup took over 2 hours to get just right, let alone the 4 hours the final solution took to compute on a quad core system. Working with simulations is much like setting up a physical stunt or effect on a movie set: You can set up the initial conditions, but it may take hours or days of tweaking and fooling around to get the exact effect your are looking for.

That's not bad for something that will be central to a dramatic moment in an animation, and you have a whole team of technicians devoted to tweaking and running the simulation at your disposal. However, that means it probably won't be appropriate for anything less important. Also, the results, even at a relatively high resolution, are less than stellar as you can see in the image.

In the case of the sink sprayer in *The Beast*, the domain turns out to be almost the entire area of the kitchen. Domains are perfect cubes, so the shortest distance it could occupy is the line from the sprayer to the mom, which is at least 3 feet. However, the water has to end up on the ground and splash up and away from her, meaning that the domain must extend even further: from a foot above her head down to the floor. Now the domain is over 2 meters square. To achieve enough detail just to see the fluid coming out of the nozzle requires a resolution setting of over 250. This will require 1.47 GB of RAM and starts to come back at over a half-hour per frame during calculation. So even to see anything, let alone get a decent result, is already beyond the capabilities of my systems.

It's surprising how quickly the feasibility of using a true simulation disappears.

So if you have a small controlled situation, or something on a larger scale where "anything goes" and the detail does not have to be too high, the fluid simulator can work well. However, if you're doing something more ambitious, you will have to look elsewhere.

If you do choose to use a simulation, integrating it into your animation shot is not that difficult. It's best if it is done directly within the shot file with all local objects, just to avoid any incompatibilities that might be lurking between the fluid simulator and linked objects. Any animation that needs to interact with the fluids should be done before the simulation so that the fluid can react to the moving obstacle. The fluid simulator does not recognize deformation animation, so you will have to come up with another solution if your character needs to splash or otherwise affect the fluid.

The best way to do this is to create a dummy object or two and keyframe them to match the motion of your character. In Figure 14.7, you can see the Beast holding his hand under a fluid simulation. As the Beast moves his hand, the simulation reacts appropriately. To accomplish this, the Beast's arm mesh

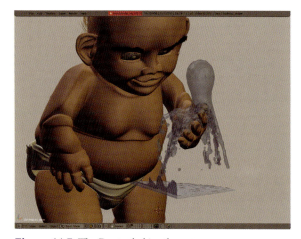

Figure 14.7 *The Beast splashing the water*

was duplicated and animated at the object level to mimic the character level motion. Figure 14.8 shows the dummy object that was used to drive the fluid simulation as an **Obstacle**.

Figure 14.8 *The dummy object used as an obstacle*

The simulation itself is stored in a directory that is designated at the bottom of the Domain object's **Fluid Simulation** panel, as shown in Figure 14.9. When you hit the **Bake** button, Blender creates a file for each frame of the simulation and places it in the specified directory. So, if you plan to move your BLEND files to another computer or a render farm for rendering, you will need to make sure that those files go along for the ride and that the path is relative. We'll talk more about collecting files like this for rendering in Chapter 15, Rendering and Compositing.

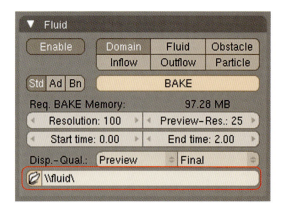

Figure 14.9 *Setting the path for the simulation files*

Common Methods of Faking Water and Fluids

To create a large-scale water effect, like a river or ocean, you can use a combination of the Wave modifier and texturing. For things such as fountains and sprays, particle systems work well.

Figure 14.10 shows a small portion of ocean made from a subdivided plane mesh, two wave modifiers, and a material. The wave modifiers provide the larger scale waves and swells for the water, while the textures on the material create the smaller details. The Wave modifier settings are shown in Figure 14.11. The material and textures are shown in Figure 14.12.

The river image in Figure 14.13 was also created from a base mesh, a wave modifier,

Figure 14.10 *An example of an ocean*

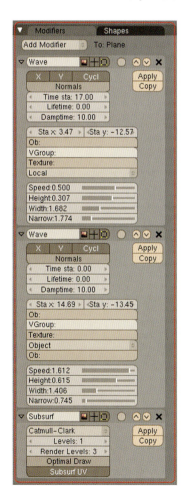

Figure 14.11 *Two wave modifiers*

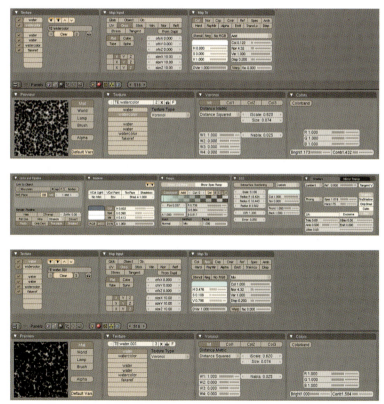

Figure 14.12 *Material and textures for ocean details*

and a very simple material that mapped an outdoor image to the reflection vector.

If you want to use this technique with animation, the best way is to set the different mapping spaces of the textures to an Empty object. That Empty can be animated and in turn control the motion and development of the textures. The Wave modifier is automatically animated—you only have to worry about adjusting the speed of the animation for a believable effect.

Let's look at the Beast's spray gun assault for another fluid-faking technique. Figure 14.14 shows a still from shot 13. This is the shot for which the true fluid simulation was grossly inappropriate. For initial visualization, I used a simple particle system with a circle mesh for an emitter. The emitter is the child of the sprayer, so the emitter follows its motion. Figure 14.15 shows the basic motion settings for the particle system. To build the simulation with proper deflection, the mother's mesh is enabled as a deflector in the master asset file. The simulation is created and cached, then the mother's mesh is reverted to its original state.

Figure 14.13 *A river scene*

Figure 14.14 *The Beast hosing down his mother*

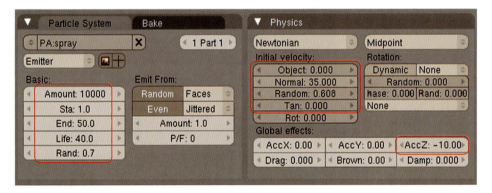

Figure 14.15 *The particle settings*

When you have a particle system that moves in the way you want it to (particle systems are covered later in this chapter), you need to decide how to visualize it. There are two basic ways to fake water with particles. The first is to use **Metaballs**, which are objects that when moved close enough to one another merge into a single surface. Figure 14.16 shows a sequence of images of several metaballs moving closer together and merging. When a particle system is visualized with metaballs, the effect can be similar to water. Figure 14.17 shows a particle system using metaballs. The **Visualization** panel is shown in Figure 14.18.

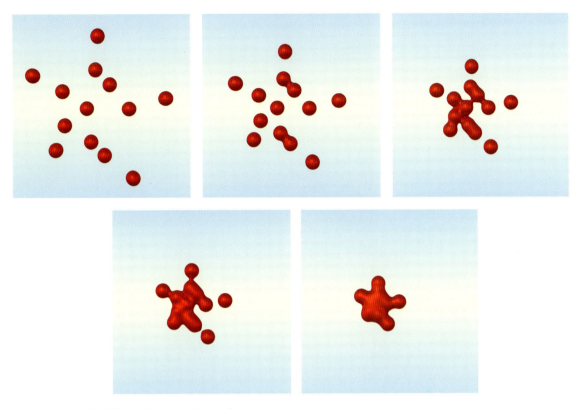

Figure 14.16 *Metaballs merging into a single surface*

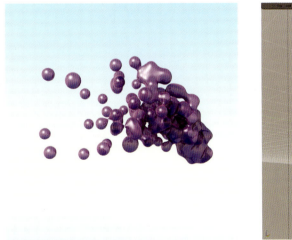

Figure 14.17 *Particles viewed as a metaball object*

Animating with Blender

While metaballs can gener-
ate some fairly believable liquid
effects, they have some drawbacks.
Dealing with metaball proper-
ties and sizes can be very touchy,
and you can spend a lot of trial-
and-error time getting the merge
thresholds just right. The other
problem is that when employed
with any significant amount of
particles (above 3000 on my test
system), the surface calculations
take so long that it makes them
nearly unusable. Other problems
in visualization of particles as

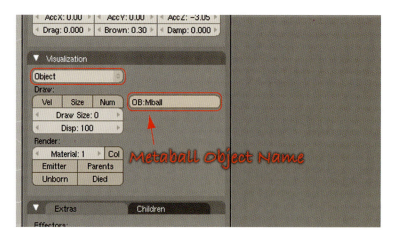

Figure 14.18 *The visualization settings for using metaballs*

metaballs seem to pop-up from time to time as well, suggesting that that portion of Blender may still have a few bugs.

This was the problem I ran into in *The Beast*. While metaballs would have produced a more believable liquid effect, they simply took too long to calculate. This would not have been a deal breaker if the calculations were only done once for the final render. The real problem is the inordinate amount of time it took to test things and get them to behave properly.

Instead I decided to use a simple icosphere for the particle visualization. The sphere uses a transparent mate-rial that fades out toward its outer edges and uses the fake reflection texture discussed in the previous chapter. In conjunction with motion blur, it gives a passable effect when animated. A shot from the final scene can be seen in Figure 14.19.

Figure 14.19 *Particle spray visualized as icospheres*

Cloth

New in Blender 2.46 is an actual cloth simulator. Previous to its introduction, the Soft Body simulator was used for cloth, but the results were less than stellar. Much like the fluid simulator, a basic cloth simulation is easy to set up but tough to tweak for a specific effect in a production environment.

For a basic demonstration of Blender's cloth simulator, take a look at Figure 14.20. It shows a blanket draped over the Beast's couch. The blanket was created as a sub-divided plane, then "dropped" onto the couch with the simulator. Because Cloth appears as a modifier in the mesh modifiers panel, the **Apply** button was clicked on the modifier to make the shape permanent.

Figure 14.20 *A blanket draped realistically on the couch*

Building a cloth simulation is as simple as creating the cloth object itself and designating obstacles. A cloth object, like the blanket in the example, has the **Enable** button set on the **Cloth** panel in the **Physics buttons**, as shown in Figure 14.21. For basics, you can choose one of the preset material types from the **Material Preset** drop down. These preset values won't be perfect, but they can provide you with a good starting point for your own simulations.

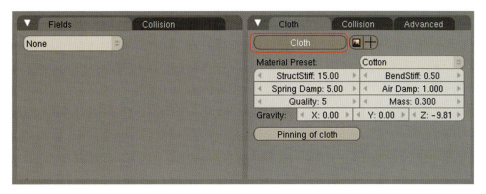

Figure 14.21 *Enabling cloth in the Physics buttons*

To create your own very simple cloth simulation, add a 32 × 32 **Grid** mesh object above the default cube from a clean BLEND file, as in Figure 14.22. You may have to scale it and move it up a bit to match the figure. Enable **Cloth** on the **Cloth** panel, and choose **Cotton** from the presets menu, resulting in Figure 14.23. On the **Collision** panel, set both the **Enable Collisions** and **Enable Selfcollisions** buttons so that the cloth will react to obstacles and not pass through itself as it deforms. Select the default Cube and enable **Collision** in the **Collision** panel, as shown in Figure 14.24. This indicates to the cloth simulator that the cube should be used as an obstacle. Now select the cloth object again and, in the **Cloth Collision** panel shown in Figure 14.25, set the frame range for the simulation. Press the **Bake** button. After baking completes, you can press **Alt-A** to watch the simulation, several frames of which can be found in Figure 14.26.

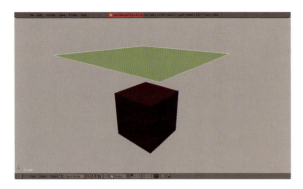

Figure 14.22 *A Grid object added for cloth*

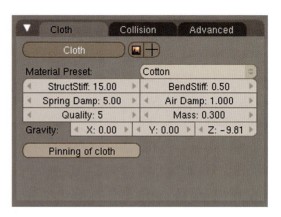

Figure 14.23 *The Cotton cloth preset*

Figure 14.24 *Making the cube a deflection object*

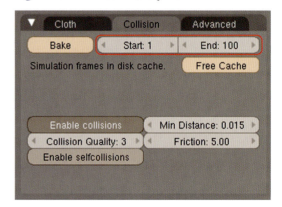

Figure 14.25 *Setting the frame range*

The most likely uses for cloth in an animation production will be for clothing and environmental effects such as curtains. In *The Beast*, I originally intended to use the cloth simulation for the mother's skirt. However, some shortcomings in the system prevented me from being able to do so. The problem was that certain shots began their animation on frame 1, with the character already in a pose. The cloth simulation did not have time to "settle down" before the action started, leading to the skirt flapping around like crazy, or simply causing a bad result. At the end of this section, we'll look at what I actually did for the mother's clothes.

To successfully integrate a cloth simulation into a shot, you will need to create your animation in a very specific fashion. For clothing, your character should begin with a "rest pose" on frame 1 and develop to a starting pose on frame 100. Your rendering and action won't really commence until this artificial starting frame (100). This will let the cloth begin in its native position as well and have 100 frames to make its way to a good starting solution. Also, if your character rigging method permits it, you should move your character and clothing as close to their starting positions as possible with object-level animation. Due to the way that Blender deals with cloth solutions, there are some special steps you will need to take when using cloth with linked assets. They can be found at the end of this chapter in the section called *Linking Issues with Simulators*.

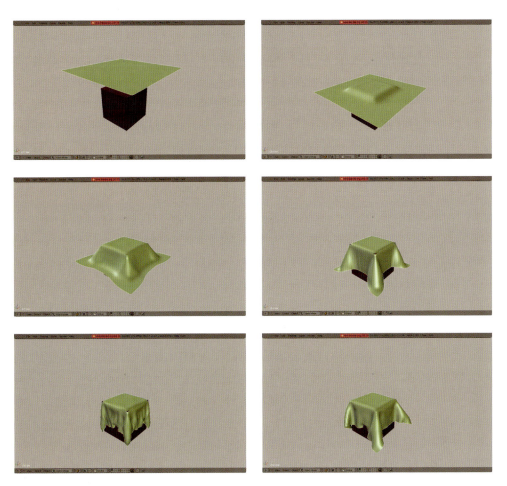

Figure 14.26 *The cloth simulation in action*

Cloth Pinning

In the case of a curtain or something like a shirt, there will be certain portions of the cloth that will not follow the simulation. The top of a curtain where it attaches to the curtain rod will remain stationary, even if the wind blows the rest of the fabric. On a character's shirt, you may want the collar and perhaps the area tucked into the pants to move exactly with the underlying body and not deform as part of the simulation. These portions of the cloth act as anchors for the rest of the simulation.

This is accomplished by "pinning" portions of the cloth through vertex groups. Revisiting the very simple example from above, a vertex group can be created for one entire edge of the grid. The **Pinning of Cloth** option is enabled on the **Cloth** panel, and this vertex group is selected, as in Figure 14.27. Running the simulation then produces the result in Figure 14.28.

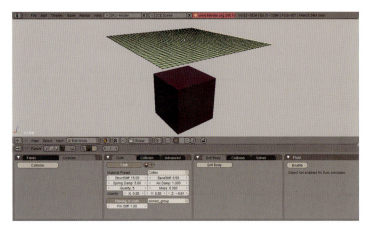

Figure 14.27 *Adding a vertex group for cloth pinning*

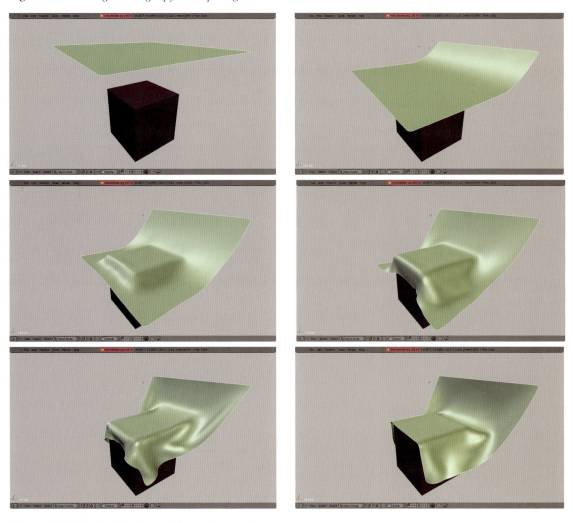

Figure 14.28 *The cloth simulation with one edge pinned*

When you use a cloth simulation on a character for clothing, there will be instances when the cloth collision does not work as well as you would like, causing the character's underlying body to show through. In Figure 14.29, the Beast's body is showing through a tank top he decided to wear to protect his delicate skin from the blazing sun. The solution to this problem is to assign any "covered" areas of the skin with another material that has been made completely nonreactive to rendering. Figure 14.30 shows such a material. The key parts are **Alpha=0.0**, **Ztransp**, and **Shadeless**, with **Traceable** and **Shadbuf** disabled, which make it completely unreactive to light, shadows, or rendering. This way, even if a portion of the body accidentally pokes through the clothing slightly, it will not render.

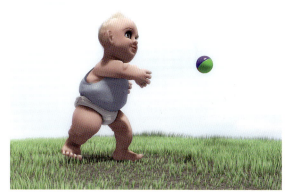

Figure 14.29 *The Beast's body showing through his shirt in the interface, but not in the render*

Figure 14.30 *A material for bodies*

A cloth simulation will not necessarily be the best solution for your character. Like other physical simulations, it can be tough to manage and to force it to do exactly what your shot requires. If you've been working with a cloth simulation and find that it just will not "behave," you will have to simply model the clothing and deform it as a part of the body. With the failure of the cloth simulation for the mother's skirt in *The Beast*, this was the method that was used throughout the production. The clothing was simply a part of the character, deforming with the regular rigging tools. Fortunately, the use of the Mesh Deform modifier gives significantly better results for prewrinkled clothing like the Beast's diaper than previous methods.

Cloth simulation generates cache files, much like the fluid simulator, that must "follow" the file if it is moved to a different computer or directory for rendering. Once again, we'll look at that in Chapter 15: Rendering and Compositing.

Rigid Bodies

Certain situations arise in an animation that are just too difficult to animate realistically by hand. Imagine a closet full of sports equipment emptying itself into a room, or two hundred bricks falling onto a character's head. Even simpler, think of a rubber ball thrown into a kitchen, bouncing and spinning until it finally comes to rest. Any of these things could be animated by hand, but the physical movements are so exact that to mimic their behavior realistically with keyframing would take ages.

Figure 14.31 *Canisters on the edge of disaster*

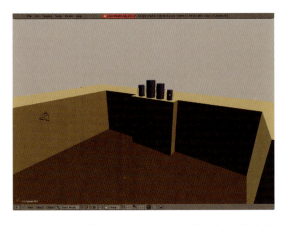

Figure 14.32 *The low resolution set for the rigid body simulation*

In these cases, a Rigid Body simulation is called for. Setting up such a simulation is a little more difficult than using the Fluid or Cloth simulators, but the results are usually more predictable and easier to integrate into your finished animation.

Figure 14.31 shows a series of canisters sitting near the edge of the kitchen counter from the Beast's kitchen set. If we wanted the Beast or the dog to run by and knock the canisters off so that they fell, collided, and clattered on the ground realistically, a rigid body simulation would be the perfect way to do so.

Unless you have worked with games or Rigid Bodies before, you have probably not ventured into the **Logic** context of the buttons window. First, you need to construct a low resolution proxy scene that contains simple objects representing everything that will interact within the simulation. The physics system works much better with lower polygon objects than with the more detailed levels of geometry than you are probably using for your production. In this case, the canisters will be represented by cylinders, the counter by a scaled cube, and the ground by a plane. We'll just use an icosphere to initiate the collisions. This original setup is shown in Figure 14.32.

Each item in the simulation must be initialized for the physics engine by enabling its **Actor** button in the **Logic** buttons, shown in Figure 14.33. Below the

Actor button, you will also need to enable the **Bounds** button and choose the closest shape to that of your object in the drop-down that appears. The normal options are: box, sphere, cylinder, and cone. This tells the simulation how best to calculate collisions involving your objects. For stationary objects, (your set), these settings are sufficient.

Figure 14.33 *Enabling objects as Actors and setting their Bounds*

For objects that will move—in this case, the canisters—you need to enable both the **Dynamic** and **Rigid Body** buttons to the right of the **Actor** button. Figure 14.34 shows the settings for the canisters. **Dynamic** tells the simulator that the object should be affected by things such as gravity and move when struck by other objects. The **Rigid Body** setting allows the object to tumble and roll realistically. The **Bounds** object that most closely matches their shapes is obviously the **Cylinder**.

Figure 14.34 *Preparing objects for rigid body motion*

At any point you can test your simulation by hovering the mouse over the 3D view and pressing the **P** key. This command starts the physics engine and will continue it until you press the **Esc** key. Of course, pressing the **P** key at this point won't do very much. Well, it shouldn't.

It's possible that if you are following along with this setup that activating the physics engine will cause the canisters to rapidly fly away, as though from an explosion. If that happens, it just means that the objects were considered to be in a state of collision at the very beginning of the physics simulation. To fix the problem,

try using a different shape for **Bounds** that more closely approximates the shape of your object. You can also try to decrease the **Radius** control to make the physics engine think that the object is smaller than it really is.

Another thing that might happen is that the canisters may initially bump upward a bit or fall a little to land on the counter. This is because the tolerances on the boundaries of the objects in the physics engine might not be exactly the same as the real mesh boundaries, causing the canisters to think they are a little above the counter, in which case they need to fall onto it, or even slightly inside the counter and in need of a slight vertical push. In either case, a slight adjustment to either the counter object or the canisters themselves will fix the problem. It is easy and quick to test any new positioning with the **P** key.

So if you can hit the **P** key and not have everything go crazy, it's time to add the object that will knock the canisters off the counter. In a real animation situation, you would synchronize this object to the actual character who is doing the damage: the dog, the Beast, or whoever else may be wandering by. The driving motion is done in the normal way, by setting a starting and ending keyframe. Figure 14.35 shows the start and endpoints of the sphere in this example, set on frame 1 and frame 31. Then, enable the colliding object in the **Logic** buttons as an **Actor**, and assign it an appropriate **Bounds** type.

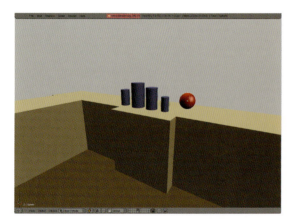

Figure 14.35 *The sphere keyframed to move across the canisters*

That's all you need to do. There are several ways to capture the resulting physics simulation, but the simplest is to put the mouse over the 3D view and press the **Ctrl-Alt-Shift-P** key combination. Blender will think for a moment (or longer, if things are really complex), then return control to you. During that time, it will have calculated the physics simulation for the frame range specified in the animation buttons and created motion Ipos for any objects that were flagged as **Dynamic** in the **Logic** buttons. The resulting animation can be played, as any other animation, with **Alt-A**.

If the simulation isn't to your liking, simply reposition the items or rekey the driving object and press **Ctrl-Alt-Shift-P** again. A new solution is calculated and stored in the objects' Ipos. You can also play around with individual object settings like **Mass** and **Damping**, which will affect the way that the objects interact with each other. The physics engine understands things such as momentum and density, so lighter, smaller objects slamming into larger, heavier ones will generate the appropriate response and *vice versa*.

When you are happy with the simulation, there are a couple of different ways to integrate it back into your main shot. Perhaps the easiest way is to have created the simulation directly within the shot file that requires it, but contained on a normally unused and hidden layer. In this way, the real high resolution objects can be made children of the corresponding objects in the simulation. As long as the starting positions of the low-resolution stand-ins and the high-resolution geometry are close enough, this is all you have to do. With the simulation layer hidden, the high resolution geometry will move along with the lower resolution simulation objects, giving you believable physics with very little effort.

Several frames of a completed simulation are shown in Figure 14.36.

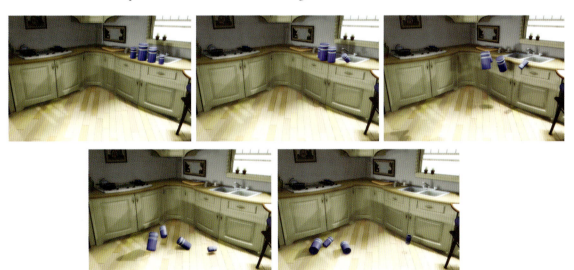

Figure 14.36 *The canisters go flying*

The simulation may end up with items falling a bit into the ground, or, in this case the floor, but that is easily fixed. As the simulation has been recorded into Ipos, all of the Ipo editing skills you have acquired in Blender apply. For example, if the simulation causes one of the canisters to end up passing through the floor a bit, a

trip to the Ipo Editor and an upward move of the Z position Ipo curve will remedy the situation, as shown in Figure 14.37.

As the rigid body simulation is baked directly into animation Ipos, there is no need to collect any external files for rendering. The solution is entirely portable without any additional effort on your part.

Figure 14.37 *Moving the Z-position curve up*

Particles

Particle systems are a large enough topic that they can't be covered in a single chapter, let alone a tiny section of a single chapter. With all of the great new functionality found in the particle system overhaul that Blender received in version 2.46, the situation is even "worse." For that reason, we'll just go over the two main uses of particle systems in animation production: fire/smoke, and what I call, "Bits o' Stuff." The **Strand** aspect of Blender's particle systems—which includes hair, fur, and grass—is found in the next section.

Fire and Smoke

Let's pretend for a moment that instead of ending peacefully, the battle between the Beast and the dog had escalated even further, resulting in a small statuette being hurled through the TV screen. The desired effect is the one seen in Figure 14.38: a television with a large hole in the center, coughing up smoke. The key to this

sort of particle effect, as well as to fire and "magic spar-kle" effects, lies almost entirely in the materials. The basic motion of the particle system is simple: a small emitter object with **Normal** velocity activated, a slight positive **AccZ** force value so that the smoke rises, and a bit of **Brownian** motion to give it some swirl. A typical configuration can be found in Figure 14.39.

The particle's native material mode is called a **Halo**, and a setup for making smoke is shown in Figure 14.40. The deviation from the default settings that are necessary to achieve a smoke effect are:

Figure 14.38 *The Beast is in real trouble now*

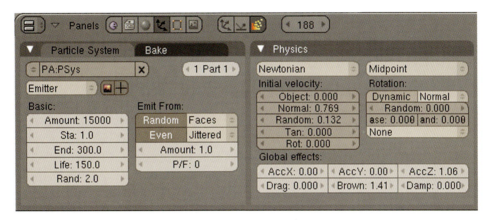

Figure 14.39 *Motion settings for smoke particles*

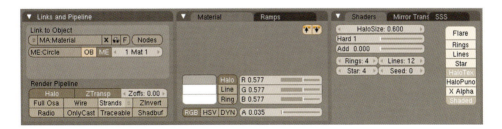

Figure 14.40 *The material settings for a smoking television*

Halo enabled.
Alpha set to around 0.035, with **Ztransp** enabled.
HaloSize set to 0.600 (this will vary based on the scale of your scene).

Hard, which controls the softness and fuzziness of the particle, is set to the minimum of 1, making the particles as diffuse as possible.

Add, which tells the particles whether nor not to add their shading to one another as a kind of light, is set to 0.0. For luminous particles such as those for fire or magic, this would be increased.

Shaded is enabled so that the particles are affected by lamps in the scene instead of generating their own illumination.

HaloTex is also activated so that the particle will use a texture from the Texture buttons.

The best way to get the hang of these settings is to open up the test file, called "smoking_tv.blend," push them around one at a time, and render to see the results.

The texture is a simple **Blend** type that moves from black to gray. Figure 14.41 shows the texture settings.

Figure 14.41 *A texture for smoke*

Figure 14.42 *A simple change to the texture alters the look*

By altering the texture colors, you can easily turn this nice gray electrical smoke into the black and orange horror of a petroleum fire, shown in Figure 14.42.

The real trick to creating a believable smoke effect is to properly balance particle number, halo size, hardness, and alpha. As you add raw numbers of particles, you will need to reduce alpha. Raising the hardness value will add a more defined edge and more apparent detail to the smoke, but you would also need to raise the number of particles to compensate. So a thick smoke like the one seen in this example would require a large number of particles, with a low alpha and relatively small halo size. A vague mistiness, like bits of fog rolling across a battlefield, would perhaps require a lower number of particles with a large halo size and very low alpha value.

Figure 14.43 shows that a fire has actually erupted in the TV. Another particle system is added, with significantly fewer particles. Once again, the motion itself is simple, and it is the materials that do the heavy lifting. The main difference in a fire-type material is the disabling of the **Shaded** option and raising the **Add** value. Flame and other radiant effects do not depend on external lighting, and in fact they generate their own light. The material settings for the basic flames are shown in Figure 14.44.

One last technique that enhances such effects is to animate the **Alpha** of the particles. When a material is attached to a particle system, any animation that is done to the material values between frames 1 and 100 affect individual particles across the entirety of their lives. In other words, regardless of the actual frame numbers of the life of a particle, whether it is from frame 5 to 20, 1 to 999, or 623 to 10,597, the material animation from frames 1 to 100 will be mapped across that range.

So to make flame particles fade out along the course of their life, an **Alpha** key at your starting value, 0.200 for

Figure 14.43 *The TV's on fire! Save yourselves!*

Figure 14.44 *Material settings for the flames*

example, would be set on Frame 1, and another **Alpha** key would be created with a value of 0.0 (completely transparent) on Frame 100.

NOTE

To set keys for material (and other buttons-based) values, hover the mouse over the relevant buttons window and press the **I** key. A small keying menu will appear from which you can choose the property you wish to key. Not all values are keyable, but it is worth a press of the **I** key to find out if the one that you need is available.

Finally, you can add another particle system with only a few upward-gliding particles to represent sparks. The halo material includes several special effects: Rings, Lines, and Stars. Figure 14.45 shows each of these, which can be used for magic, sparkles, and other specialty effects. For the sparks in the television, the **Lines** option has been chosen.

Figure 14.45 *Lines, Rings, and Stars*

Figure 14.46 *The television on fire, smoking, with sparks*

Figure 14.47 *Look out below!*

Bits o' Stuff

One other great use for particles are to simulate "Bits o' Stuff." These bits could be the flotsam and jetsam found in deep ocean water, pollen wafting through shafts of sunlight in a forest, or even the pieces of a shattered flowerpot.

In *The Beast*, particle systems were used to create the shattering flowerpots from shot 10. Let's look at one of them to see how it was accomplished.

Figure 14.47 shows Penelope, the mean dog, cowering as the Beast pelts her with little flowerpots. First, a pot was modeled in its own asset file and prepared for dupligroup linking in other shots. Then the pot was appended directly into the shot file as a local asset. The shattering process involves some "mesh abuse," so it's best to work on it locally. Figure 14.48 shows the kitchen as a set, with the flowerpot brought in as a local object. The pot was keyframed to fly straight at, and through, the wall. You can see a time lapse of the pot's animation in Figure 14.49.

Next, a particle system was added to the flowerpot, and a relatively low particle count was given. The amount of particles in an effect like this will be the number of pieces the object breaks into. A start and end frame are set only one frame before the pot hits the kitchen wall (frames 131 and 132). Obviously, the particles need to be generated in time to actually hit the wall, but

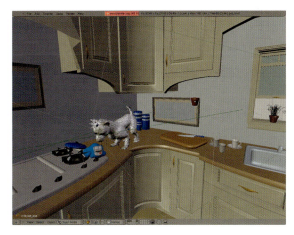

Figure 14.48 *The flowerpot as a prop*　　　　**Figure 14.49** *The flowerpot's trajectory*

starting it too early will cause the pot to begin to break up in midair. A high **Normal** value is given for initial velocity so the pot seems to explode, while some **Object** velocity was added to keep things moving all with the original motion of the pot. An **AccZ** value of -32.00 was provided to simulate acceleration due to gravity. Particle settings for the flowerpot are found in Figure 14.50.

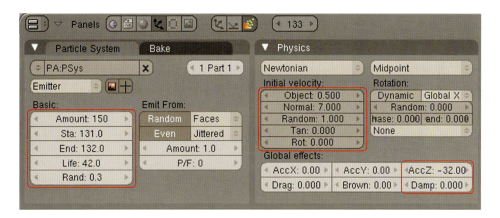

Figure 14.50 *Particle settings for the shattering flowerpot*

Planes are added to represent the walls and counter top, and **Deflection** is enabled in the **Deflection** panel of the **Physics buttons**. Figure 14.51 shows the deflection settings and the plane objects that the particles will react to. The slanted plane is a stand-in for the bad dog so that the pieces of flowerpot don't pass through it after they bounce off the wall.

Playing the animation now shows the pot passing through the wall, but the particle points bounce off and scatter across the countertop. It's time to destroy the actual pot.

Figure 14.51 *Deflection panels and settings for the simulation*

Figure 14.52 shows the pot's **Modifiers** panel. Note the **Particle System** modifier. An **Explode** modifier is added below it, shown in Figure 14.53. The only variation from the default on the modifier is that the **Split Edges** option is enabled because, according to the tooltip, it gives "nicer shrapnel," which is what we're looking for.

Figure 14.52 *The pot's modifiers. Note that the explosion is "points only."*

Figure 14.53 *An Explode modifier is added. The pot now shatters.*

Playing the animation now shows the flowerpot breaking apart. I'm not particularly happy with the way it shatters, though. The explode modifier cuts along existing edges, and all edges in the pot right now are more or less right angles. You can see the result in Figure 14.54. So, in Edit mode, the **Knife** tool is dragged across the model a number of times to produce criss-crossing patterns of faces and edges. This new geometry is shown in Figure 14.55.

Figure 14.54 *The pot shattered along its original edges*

Figure 14.55 *The flowerpot, sliced and diced with the knife tool*

Finally, the explosion looks right (Figure 14.56)! The last step is to completely remove the "particle" aspect so that the actual particles do not render. In the particle settings, the visualization is changed to **None** and the **Render Emitter** button is enabled, as shown in Figure 14.57.

Figure 14.56 *Splat*

Figure 14.57 *Hide the particles and render the pot*

For later shots in which the bits of pot need to be seen on the counter, a duplicate is made of the entire shot 10 BLEND file, and the explode and particle modifiers are applied in the modifiers panel, making their results both static and permanent. The three destroyed pot objects are then extracted into their own asset file for inclusion as a dupligroup in later shots.

Like fluids and cloth, motion particles use a cache file and directory system for storing their result, which will be addressed in Chapter 15.

Strands—Hair and Fur

With the introduction of a useful system for hair and fur in version 2.46, Blender users heaved a massive sigh of relief. No longer did we have to suffer with texture-mapped pieces of hair tiled over our character's head like a bad toupee, nor stew in our envy over Shave and a Haircut, Sasquatch and the like.

Blender's Strand system is most effective when used with **Parent** and **Child** particles. **Parent** strands act as guides: only a relatively small number of them are created and groomed. Figure 14.58 shows the mother's Parent strands.

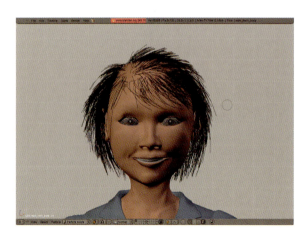

Figure 14.58 *Groomed parent strands*

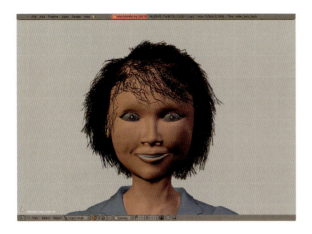

Figure 14.59 *Child strands*

Child strands are what the renderer actually sees and draws. Children are generated at render time (though they can be shown in the 3D view) and can be grown either from the faces of your model based on vertex groups or in a radius around parent strands. Figure 14.59 shows the mother's child strands. Child strands interpolate their characteristics from the parent strands around them.

The best way to use the system is to create and groom Parent strands, then have the renderer grow child strands to fill out the system.

Setting Up and Adding Parent Strands for Grooming

The first thing you need to do is to define your overall hair/fur area with a vertex group. An easy way to do this is to begin with a selection in Edit mode, like Figure 14.60, create a new vertex group, and assign it with a **Weight** of **1.0**. Then, using either **Ctrl-Tab** or the object mode menu on the 3D view header (Ctrl-Tab will not work from Edit mode), enter **Weight Paint mode** and soften the edges of the selection, as in Figure 14.61. This area is where the child strands will eventually grow. In the **Vertex Group** section of the **Particle** buttons' **Extras** panel, set the property to **Density**, and choose the created vertex group in the pop-up menu to the right, as shown in Figure 14.62.

Parent strands can be added in one of two ways. For an even distribution of parents within the growth area, you can just set a particle number in the **Amount** field on the **Particle System** panel, as in Figure 14.63. Change the system type to **Hair** instead of **Emitter**, and give a value to the **Normal** field so that the hair

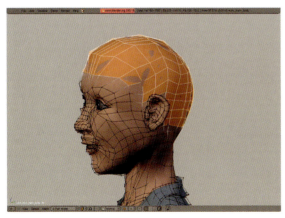

Figure 14.60 *A vertex group for growing hair begins in Edit mode with a selection*

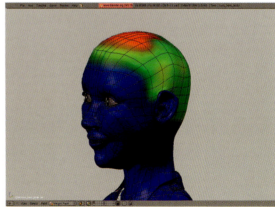

Figure 14.61 *The boundaries of the group are softened in Weight Paint mode*

271

Figure 14.62 *Choosing the vertex group in the particle settings*

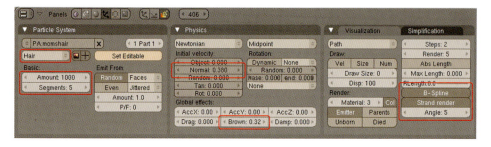

Figure 14.63 *Initial settings for hair*

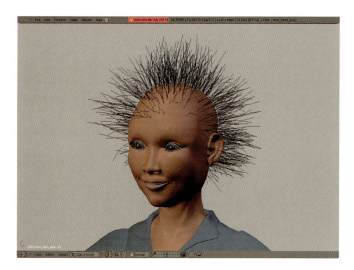

Figure 14.64 *The mother's hair before grooming*

(or fur) actually grows away from the skin. If you have set up a vertex group for the distribution, the hair should only grow from areas of the skin that are included in the group. Fool around with the **Normal**, **AccX/Y/Z**, and other **Physics** panel settings until you get a good starting point for grooming. Basically, you are looking to grow hair that is the correct average length of your final target hair style. If you can "prestyle" it with any of these settings, you'll have less work to do with the grooming tools. You can see the mother's starting point in Figure 14.64.

With hair grown out in this way, click the **Set Editable** button on the main **Particle System** panel. This button freezes all of these initial settings, allowing you to directly edit the strands themselves in the 3D view.

On the 3D header, change the object's mode to **Particle Mode**, and press the **N** key to bring up the tools panel, both of which are shown in Figure 14.65.

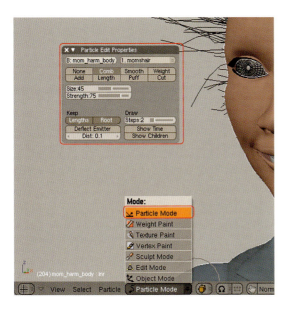

Figure 14.65 *Particle mode and the grooming tools*

Comb will act like a comb or brush when dragged across the strands. **Smooth** straightens them. **Puff** causes the base of the strands to become perpendicular to the skin. **Cut** functions like a precision laser cutting device. **Length** can be used in **Grow** or **Shrink** mode to make hair longer or shorter. And, as in **Sculpt mode**, the **F** key can be used to quickly adjust the size of the on-screen brush while **Shift–F** can be used to interactively adjust brush strength. The other important setting on the panel, **Deflect Emitter**, tries to prevent hair from passing through the emitting surface (usually the skin) while grooming. Keep this enabled unless otherwise noted.

From here, it becomes a fairly tedious process of playing with the tools, alternating between **Comb, Smooth, Puff, Length,** and **Cut** to get just the right style. For learning to do it, there is no substitute for simply playing around with a head full of hair. Here are some best practices for getting started:

- Try a high strength (more than 80) comb for styling, but only use the edges of the brush. This gives a little more control over partial combing than simply setting the brush to a very low strength, like 20.
- On longer hair, comb from the base of the hair outward to the end, directing it where you want it to go along the length of the stroke. This works better than just trying to style the endpoints of the hair.
- If hair becomes stuck inside the mesh (**Deflect Emitter** isn't perfect), it will become jittery and hard to control as you comb it. To fix this, turn off **Deflect Emitter**, comb the hair away from the mesh, then reenable it.
- For fur, use a brush with maximum strength and just lay the fur down against the mesh in the directions you want it to go. Afterward, disable **Deflect Emitter** and use the **Puff** tool until the fur has the correct balance of "poofiness" and "lay down" you are looking for.
- While you groom, constantly view your model from different angles. Just as in in real life, it would be embarrassing to leave hair scraggly or sticking out on the back of the head just because you forgot to check the mirror before leaving for work.

Particle Mode in the 3D view has three different ways of selecting strands to directly move them with the **G** key transform mode or to limit the effects of the grooming tools. Just like the Vertex/Edge/Face selection modes when editing a mesh, these are available on the 3D view header. Figure 14.66 shows the option buttons. The first is called **Path Edit Mode**, which is the default and not useful for direct selection. The

Figure 14.66 *The different strand selection modes*

273

second is **Point Select Mode**, which shows each of the key points on every parent strand. These points are selectable and transformable via the normal Blender methods, although to right mouse button select points, you will need to set the grooming tools to **None**. The last is called **Tip Select Mode**, in which selecting the endpoints of a strand selects the entire strand. The **Limit selection to visible** button is usually enabled because it prevents your selections and grooming tools from going "through" the mesh and selecting and grooming things on, say, the other side of the head. Of course, if you are trying to create a symmetrical hair style, you could turn this option off, letting your grooming tools work on both sides of the head at once in a side view.

Here is an example of how these selection modes can be used to your benefit. Let's say that you only want to adjust the outer ends of your character's hair style. The overall shape is pretty good, but the ends are a little wild. To do this, switch into **Point select mode** and choose **Select Last** from the **Select** menu on the 3D header. This will select the endpoints of all parent strands. Then, choose **Select More** from the same menu (or use **Ctrl-Numpad - +**), to grow the selection one point inward. The result is that only the final segment of each hair is selected. Now, the styling tools will affect only those selected parts, allowing you to nicely groom the wild ends without affecting the underlying structure.

At the beginning of this section, we mentioned that there was a second way to add strands to a model, in addition to setting a number in the **Amount** field. This second way is through the **Add** tool on the particles panel. If you have a model with a fairly sparse configuration of parent strands, but need more control over the children on, say, the character's face, you can use the **Add** tool to add additional parent strands. Be careful when using this because it can add strands very quickly!

The best advice is to set the **Strength** low—between 1 and 5—before proceeding, and to use a small, well-controlled brush. Figure 14.67 shows the results of dragging an **Add** brush across a mesh. It actually "paints" new strands into the particle system. If you do so with the **Interpolate** option enabled, Blender will attempt to add the new strands in such a fashion that they blend in (interpolate!) with the parent strands already in existence.

So it is possible to begin working on a character's hair or fur with a particle **Amount** set to **0**! You start with a completely blank slate and use the **Add** tool to place parent strands precisely and only where you want to have them. If you are going to use this method, you must make sure to set some **Normal** velocity in your particle setup, even though you are not "launching" any particles with the standard tools. Strands created with the **Add** tool will use this as their initial condition. You

Figure 14.67 *That's a nice cut, but I don't think your boss will go for it*

also need to keep track of your **Density** vertex group, so that your added strands will correspond to it. Of course, you could always alter the vertex group afterward, or even wait until the parent strands are added to create it.

Filling it Out with Children

Rendering with only parent strands will produce disappointing, somewhat scary results. Figure 14.68 shows the mother rendered with only parents. Ahem. She might want to wear a hat.

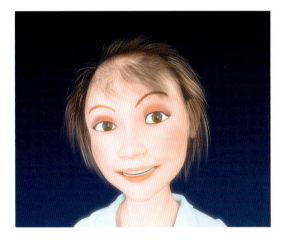

Figure 14.68 *What happened to my hair?*

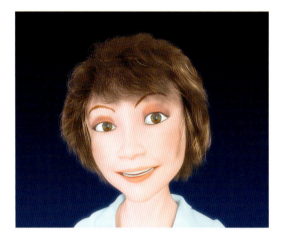

Figure 14.68A *Reference image with children enabled*

Children are enabled on the **Children** panel of the **Particle buttons**. There are two modes of child generation. The first, **Particles**, creates a certain number of children per parent and clusters the created children around each parent strand. In my tests, this was only useful in very limited cases and produced overly clumpy, poor results. The other option for children generation is **Faces**, in which children are created from the faces of the mesh, using the parent strands only as guides, not for placement.

How many children to use? Start small and work your way up. The final number of strands will be equal to the number of parents times the number of children, so keep in mind that actual rendered strands can quickly go through the roof. In *The Beast*, the mother's hair was created with 1,715 parent strands and 25 children each, for a total of 42,875 strands. The body fur of the mean dog (not the curly fur) required 2,502 parents with 30 children each: 75,060 final strands. You can see the mother's Child strand setup in Figure 14.69.

Notice that the **Amount** is set to **4**, while the **Render Amount** is set to **25**. The lower value is what will be

Figure 14.69 *The mother's children*

shown in the 3D view and is used to give you an idea of what your child settings will look. The **Render Amount** value is, obviously, the number of child strands that will be created at render time.

Due to the large number of child parameters, it's not really possible to give an in-depth explanation of each one here. However, we can at least take a brief look at what is available.

> **NOTE**
> All of the child strand options function relative to their parent strand. For example, clumping or curling of child strands will occur toward or around the parent strand that most influences them.

Clump: Causes the ends of strands to clump together at the tip for positive values and at the base for negative values. Tip clumping will give hair or fur a wet look because wet hair tends to gather in just this fashion. Base clumping gives a "hair plug" effect, like a doll's head.

Shape: The shape of the clump. Positive values cause the clump to plump out before gathering. Negative values lead to a slender clump.

Rough1: Strand noise that varies with the strand's starting point.

Rough2: Random roughness that applies across all strands. The **Threshold** value allows you to apply this roughness only to a very few strands. By setting it near 1.0, you can create the effect of a normal hair style with a few stragglers sticking out on their own.

RoughE: Roughness applied to the tips of the hair. This can keep hair from looking completely uniform, as though it has just had the 100-brush-stroke treatment.

The **Kink/Branch** button brings up a completely different part of the interface, shown in Figure 14.70. These tools allow child strands to wrap themselves around their respective parents in four different configurations: a wave, a curl, a radial, and a braid. In *The Beast*, both the dogs' fur and the mother's hair use the curl option to varying degrees. If you are interested in the exact values used in the production, just check out the main asset files included in the **production** directory of the disc that came with this book.

Materials

When using particle systems for effects such as fire and smoke, it is the materials that do the heavy lifting toward believability. Hair and fur are no different. While it is true that you must groom your strands properly to achieve believability with each particular character, good materials can make even a simple fur ball look realistic. A bad material can ruin the illusion of believability on an otherwise well-constructed character. Figure 14.71 demonstrates this effect.

Figure 14.70 *The Kink/Branch options*

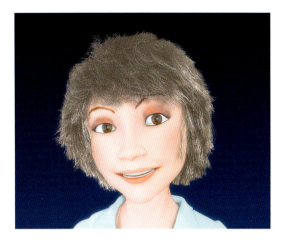
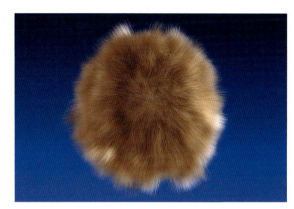

Figure 14.71 *The mother with crummy hair materials, and a ball of fur with effective particle materials*

The two most important components of a good material for fur and hair are the Alpha texture and the Strand settings. Let's start with the Strand settings. Figure 14.72 shows the Strand pop-up menu for the mother's hair material. The key to good hair and fur is to enable **Use Blender Units**. Without this setting, a strand's render size will be measured in pixels, meaning that far away strands will have the same apparent width as near ones. It is a screen space sizing method and will produce poor results. With **Use Blender Units** enabled, strands are given a specific size in real Blender units, and this will be reflected in the renders.

Figure 14.72 *The Strand menu*

After you've chosen **Use Blender Units**, though, what is a good size? Some back-of-the-envelope calculations and a bit of trial and error lead me to a value of around **0.020** Blender units for the thickness of a hair strand. Of course, this value is dependent on the overall scale of the rest of the project and may need to be fine tuned up or down to suit your own needs. Rather than use Strand menu sizing to generate a taper in the hair, I used an Alpha texture, so the Start and End values are the same.

The **Minimum** setting below **Start** and **End** specifies exactly that: the minimum value in Blender units that will be allowed when calculating the strands, regardless of how far away they might be from the camera.

For human hair, those are the relevant strand settings.

Looking at the dog's fur in Figure 14.73, the settings are a bit different. The **Start** size for fur strands is larger, **0.050**, thinning to **0.020** for the **End** value. Note that the **Minimum** value is **0.035**. This means that the **End** will be forced to at least **0.035**. However, this does not produce the same effect as simply setting

the **End** value to **0.035**. Whenever the **Minimum** value is passed, it causes that portion of the strand to be rendered slightly out of focus, giving a "fuzzy" effect. Because the dog was supposed to be "fuzzy," I took advantage of this quirk of the renderer.

The second important part of a hair material is the Alpha texture that will fade the strands along their length. Without such an effect, the hairs appear to be uniform in width, with a boxy tip if you bring the camera close enough. To use a texture for the Alpha value, first turn both the material **Alpha** and **SpecTrans** values down to **0.0**, as shown in Figure 14.74. The **SpecTrans** default of 1.0 allows specular highlights even in areas where a material's alpha is 0, which we do not want here.

Figure 14.73 *The dog's fur Strand panel*

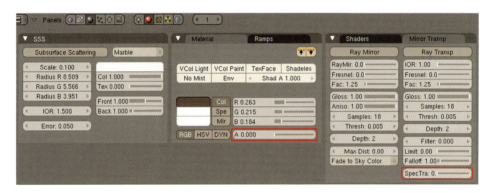

Figure 14.74 *Alpha and SpecTrans reduced to 0*

Figure 14.75 shows the **Blend** texture for the mother's hair. Ignore the colors for a moment and concentrate on the Alpha values noted in the illustration. The left side of the colorband represents the base of the strands, and the right side is the tip. We begin on the left with an Alpha of **0.350**. Having an Alpha of 1 at the base, completely opaque, gives a very hard look to the hair and is undesirable. At about the one-third point, the Alpha raises to **0.539**. At the two-thirds point, it drops to **0.476**, meaning that it stays relatively stable across the middle. Finally, at the tip, it drops to **0.0**, completely transparent. Notice that the Alpha never gets close to 1.0, completely opaque. This takes into account the fact that real hair is fairly transparent, achieving opacity only through the accumulation of many layered strands.

Figure 14.76 shows the mother's hair before and after the inclusion of the Alpha texture. This texture is applied to **Alpha** in the **Map To** material's panel, using **Strand** coordinates in the **Map From** panel.

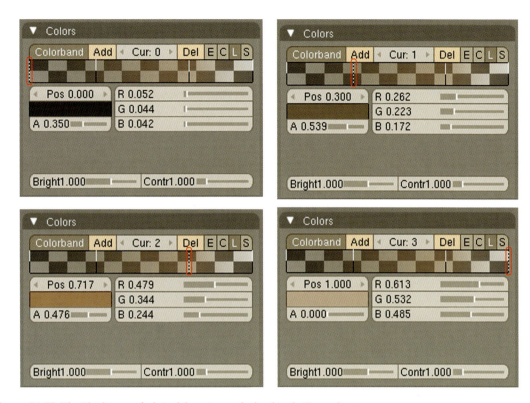

Figure 14.75 *The Blend texture for hair alpha, using a color band in the Texture buttons*

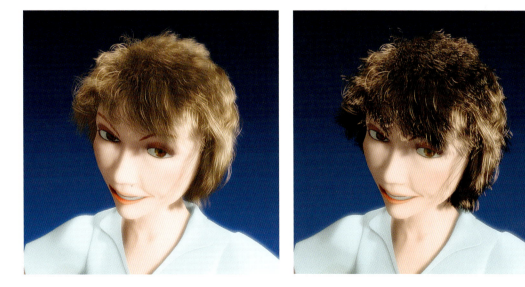

Figure 14.76 *Hair with and without a blending alpha*

Even though you use shadows with almost every object in your scene, you may find the need to disable them for strands. For the mother, shadows are clearly generated in the normal fashion for her hair, which can be seen by examining any shot that the mother appears in. For the dogs' fur, though, the **Shadowbuf** setting in the **Material buttons** had to be disabled. With the high strand count of the dogs' fur, the generated shadow darkened their skin unnecessarily. I was unable to achieve acceptable shading results for the dogs with shadows enabled for their fur.

The actual shaders that you choose, while important, don't have the profound affect that the Strand and Alpha settings will have. The dogs used **Lambert/Phong** for their fur, and the mother used **Lambert/WardIso**. A little translucency was added (**Tralu: 0.22**) so that lamps behind a character's head could still contribute to the strands' illumination.

Both the mother's hair and dogs' fur used a texture mapped to Strand space for their colors. This works exactly the same way as mapping a colorband's **Alpha** to strands. Figure 14.77 shows a wild colorband applied to the mother's hair in this fashion.

In the absence of any colors mapped to Strand space, strands will take their color from their origination point on the mesh. So, if you have applied a texture to the mesh—a UV-mapped image, a procedural texture or even vertex painting—that texture will color the hair that grows from it. Figure 14.78 shows the mean dog sporting leopard-like fur using this technique.

Figure 14.77 *Nice hair, mom*

This suggests a clever technique for carefully controlling the color of strands for special cases. You can independently control the colors of the bases and tips of each strand by creating two separate textures for the mesh, applied in **Orco** or **UV** space, and separating them in the texture stack by a simple white-to-black blend texture mapped to the **Strand** space and used as a **Stencil**. Figure 14.79 shows two different textures applied separately, then stenciled together along the length of the strands. The texture for the strand bases is a black and gold speckling. The tip texture is a white and red. The effect is most obvious in the longer strands on the tail and the top of the head.

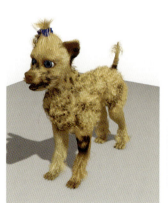

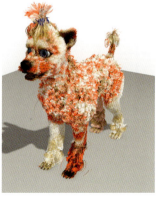

Figure 14.78 *Species confusion*

Figure 14.79 *Blending between two textures along the length of a strand*

Here's one final bit of advice for dealing with strands for hair and fur. When testing your strand, alpha, and shader settings, use the actual lighting you will use in your final shots. Strand shading is very sensitive to lighting conditions, and settings that are fine-tuned under one set of lamps might be completely unsatisfactory under a different set.

Soft Bodies

Blender's Soft Body simulator can be used to give bounce to otherwise rigid mesh objects. It is a flexible system that can be used to generate motion for everything from a snail's rubbery eye stalks to a princess's long, bouncing hair.

Blubber

The primary use of the Soft Body simulator is to create blubber effects. These might be a gelatin cube on a plate, a squishy ball, or the adorable flab on a little baby's belly. I did several tests of the Beast using the Soft Body simulator, and, while it produced nice results, I did not want the additional overhead of dealing with a physics simulation in every shot. The mesh deform modifier produced sufficiently good deformations on the Beast's chubbiness that I didn't feel it was worth the extra effort it would take to simulate it. Let's examine one of those early tests.

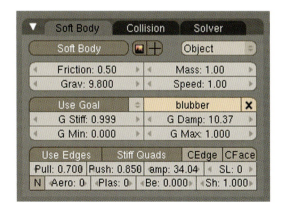

Figure 14.80 *The Beast in weight paint mode, highlighting areas that will receive the soft body treatment.*

Figure 14.80 shows the Beast in weight paint mode. A vertex group has been created and assigned **Weight: 1.0** for the entire mesh. This vertex group will tell the soft body system which portions of the model to affect and which to ignore. Vertices with a weight of **1.0** will not be touched by the system, and ones of weight **0.0** (blue in weight paint) will feel its full effects. So, the entire mesh begins as a **1.0** (red), and lesser values are painted anywhere that the Beast exhibits enough extra love to need the simulation: the belly and sides, the chest and the thighs.

In the **Physics buttons**, **Soft Body** is enabled for the Beast on the **Soft Body** panel, resulting in Figure 14.81. With **Use Goal** enabled, the vertex group created in the previous illustration, called "blubber" is selected. Playing the animation with **Alt–A** shows that the default values for the Soft Body simulator are almost exactly right for this! The effect is subtle and would be hard to see in an

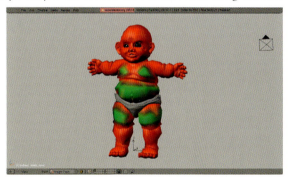

Figure 14.81 *The Soft Body panel*

illustration, so you are encouraged to try the file "the_beast_softbody.blend" on the included disc. Just open the file and press **Alt-A** with the mouse over the 3D view. The first time you do, the frames will step forward more slowly as the simulation is calculated, but afterward it should play back at a reasonable rate.

The keys to fine tuning a simulation like this are usually the Spring values and the Mass. If you were to turn the **Mass** value up from the default of **1.0** to **20.0**, the effect is obvious and can be seen in Figure 14.82. Since the mesh has a greater mass in this simulation, it has more momentum (20 times more in this case!) causing things to go wild.

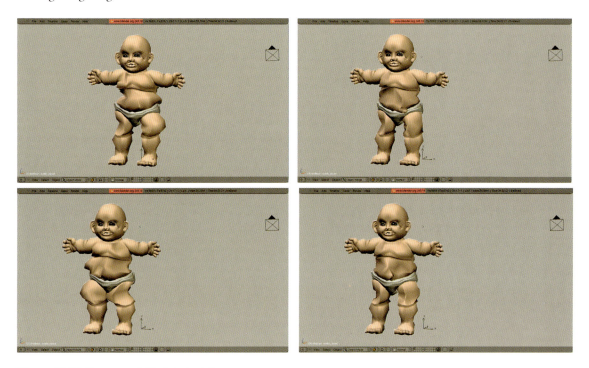

Figure 14.82 *Err . . . wow? That's just weird*

The **Pull** and **Push** values in the cluster of buttons at the bottom of the panel control how strong the "push" and "pull" forces are that will try to get the mesh back into its original shape. The higher the values, the more quickly the mesh will return to its default state, and the less deviation is allowed.

Friction controls how much resistance the air around the object provides as the object moves. Greater values will cause more "wind resistance" as an object moves.

The Soft Body simulator may be used on an entire object simply by not selecting a vertex group in the **Goal** portion of the panel. When used without a vertex group, the entire object is considered a single Soft Body and will react accordingly.

Soft Bodies react to forces and deflection objects just like cloth and particle systems.

Hair

Applying the Soft Body simulator to strand-based hair allows it to bounce and move realistically with the character's animation. In my own experiments, simulation times with collision enabled once you near or pass a thousand strand parents becomes a little too high for the feature to be useful. The problem isn't the final round of calculations before the rendering, but the difficulty in tweaking and tuning such a system. Five minutes to bake a 50 frame simulation is certainly usable, but only if you have an entire day to devote to running the simulation 30 or 40 times while you try to get it right.

If your characters have long hair that is going to be whipping in the wind, flowing, and trying to wrap itself around both the character and its surroundings, you will have to use the collision feature, which will really slow you down. Using collisions in the simulation and enabling the character's mesh as a deflector object will keep the hair on the outside of the character, where it belongs. We'll look at that in a moment.

Fortunately, you can use the Soft Body simulator to give your character's hair and fur enough bounce to really come alive without the need for collision. In the real world, most peoples' hair actually stays relatively in place except under extreme conditions. Since we are just going for some nice secondary motion that will add believability to a shot, this should be quite good enough.

With a finished hair system, like the mother's in Figure 14.83, select that system in the **Soft Body** panel of the **Physics** buttons before enabling the simulation. The pop-up menu to the right of the **Soft Body** button contains entries for the object itself and any particle systems the object may have. In this way, you can enable a separate soft body simulation for each of them if you wish. The panel shown in Figure 14.84 shows the settings that produce a small amount of secondary motion for the mother's hair without collisions or exorbitant calculation time.

Figure 14.83 *The mother's hair system*

Figure 14.84 *Settings for a small amount of soft body motion*

WARNING
Failure to select the particle system in the Soft Body panel will result in a soft body simulation being applied to the emitter mesh!

The **Goal** field has been raised to **1.00** so that the hair always returns to its original style. **G Damp** has been raised to **5.46** from the default of **0.00** to make any bounce settle down more quickly. **Use Edges** has been disabled, which removes the ability for the hair to stretch. Under normal conditions hair does not stretch, so we can eliminate that whole sector of calculations. The main variation that makes the simulation work, though, is reducing the **Mass** field to **0.30**. Hair just doesn't have a lot of mass, and therefore momentum and inertia, so this reduction is key.

The Soft Body **Bake** button is found on the **Collision** panel, which is often tabbed in with the main **Soft Body** panel. Set the frame range for the simulation and press the **Bake** button. Of course, before you begin testing your Soft Body settings, you need to include some kind of motion for your simulation to react to. When testing the settings for the mother's hair, a simple turn of the head over 20 frames was sufficient.

You can examine the file "mom_soft_hair.blend" if you want to see the final effect in motion. Once again, due to time and file management constraints, I decided not to use the soft body simulation for the mother's hair in *The Beast*.

If you really need to have long hair that flies about, wraps around necks and generally makes a dynamic nuisance of itself, you will need to enable collisions and collision detection.

Figure 14.85 shows the **Collision** panel. With the character's mesh object selected, enable **Collision** on this panel. The default settings should be fine. In the Soft Body settings, you will need to reenable **Use Edges**, which is required for collision detection. If you like, you can raise the **Fuzzy** value on the **Soft Body Solver** panel to speed things up a bit. Raising this setting can introduce inaccuracies into the simulation, but it is worth a try for the time it can save.

Figure 14.85 *The Collision panel*

Then set a frame range and press the **Bake** button on the **Collision** panel. Most likely, it will take a lot longer to calculate than before enabling collisions. The only advice for keeping the time in check is to raise the **Fuzzy** value and to try to keep your use of Parent strands to a minimum. The fewer parents that have to be calculated for the simulation, the more quickly it will go, giving you more time to fine tune the results.

When working with Soft Bodies for hair in your animation, it is important to give the simulation some "preroll" time, especially if the shot begins with your character in motion. While it is possible to move animation keys into a negative frame range so that your character hits frame 1 in full motion, Soft Bodies can begin their calculation on frame 1 at the earliest, meaning that they start from a standstill.

Linking Issues with Simulators

As mentioned before, fluids, cloth, particles, and soft bodies all use a caching system to store their solutions. The cache is a folder full of files, created in the same directory as the BLEND file you are using and named "blendcache_" plus the name of your original file.

The major drawback to using these simulators right now is that there is no elegant solution relating to assets and linking. For example, an object with soft body hair that is linked into another BLEND file retains its link to its original cache files. So any simulation work that is done in the original asset file will play just fine on the linked copy. However, you have most likely brought this element into your shot so that you can animate it. As soon as you create a proxy for the character's animation controls and start to move things around locally, the simulation can go crazy.

Creating a local proxy of the character mesh does not work to fix the problem because many of the object's attributes, like simulation settings themselves, are stripped away in the proxy-making process. The only way to create a local simulation, then, is to make the character object local. There are several ways to do this, but the most direct is to click the **Li** icon to the right of the object's name in the **Object buttons** as shown in Figure 14.86. Other portions of the object's data remain linked to the original assets, but the simulation settings are now free for alteration. You can adjust simulation settings and rebake, creating a cache for the local shot file.

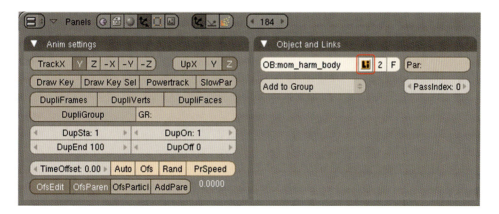

Figure 14.86 *Making your object local*

In doing this, you lose the linked magic of automatic updates for this object. The mesh itself remains linked to the original asset, but many other object properties, such as vertex groups, are held at the object level, so updates to them in the master file will not propagate to the object in this shot. What this means is that simulations of this kind should be done as a last step before final rendering. Hopefully by this point, your characters are set in stone and will not need alterations.

Summary

Blender has a number of physics simulators, all of which can be incorporated into your project. The fluid simulator can produce quite realistic results, but only at very high resolutions and within a limited physical area, constraining its usefulness. Other solutions for fluids are objects animated with a wave modifier and textures, and the use of standard particle systems, either in conjunction with metaballs or a clever use of materials. The cloth simulator is simple to set up, is fast, and produces excellent animation. Blender's rigid body physics system bakes the simulation directly into animation Ipos, making it the most portable of any of the simulators. It is good at simulating objects that must collide, roll, slide, or bounce around believably.

Particle systems can be used for a wide variety of effects, including atmospherics like smoke and fire, and physical systems with high counts of particulate matter like pollen and shattering glass. Particle systems can also be visualized as strands to create hair, fur, and grass. The strands can be styled interactively and have a large number of material and rendering options, which can produce realistic results.

The soft body simulator also has a variety of uses, from creating entire objects that shake and wiggle like gelatin to augmenting character anatomy with secondary motion to giving bounce to strand-based hair.

With the exception of rigid body physics, all of the simulators produce cache files that must be managed properly when dealing with linking and rendering.

Rendering and Compositing

Objectives

- Goals and overview
- Lighting your shot files
- Compositing for better, faster renders
- Getting a good render on your local machine
- Final animation review
- Preparing for render farming
- Setting up and using a render farm
- Checking the final frames
- Staying organized

Inbox

Shot files with finished animation.

Goals and Overview

Great final frames versus *faster render times*. Mutually exclusive goals always make for good fun at parties.

More specifically, your goal as the *art* director of your animation is to produce final frames that help to convey the themes of the story. The images should have a good tonal range, good contrast, and an appropriate color scheme. However, your goal as the *technical* director of the animation is to get the entire job rendered and ready for editing as quickly as possible, with as few technical hurdles, glitches and do-overs as you can manage.

Many beginners in 3D operate under the myth that it is somehow best to have a "pure" render. That retouching and postprocessing are forbidden. Nothing could be further from the truth, and trying to work with an animation project in this fashion will almost certainly make you want to throw yourself down a well. If you are not on board this train already, start right this second to think of compositing, color correction, and postprocessing effects as just another part of the renderer. Compositing and postprocessing are, in fact, integral to solving the conflict between high quality and low render times. Good postprocessing can drastically increase the quality of your final frames while reducing the large amount of work the renderer itself has to do.

Figure 15.1 shows a raw rendered frame from *The Beast* alongside the final composited, postprocessed, color-adjusted frame. The render time of the frame without any compositing effects was 16:51; the composited version was only 4:55. If you multiply the difference out to 4,000 frames and consider that many shots were rerendered due to technical glitches only made visible at that stage, the time savings was significant. In addition to the difference in render times, there are other, more obvious changes as well. The compositing pipeline gives much better control over elements such as shadow density, color, and overall brightness.

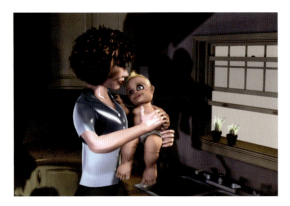

Figure 15.1A *A raw, noncomposite version of a frame*

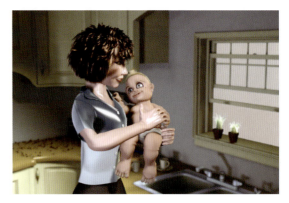

Figure 15.1B *The final frame*

Lighting Your Shot Files

In Chapter 13 you learned about lighting your sets. This was done without regard to your characters and their actions or locations. Now, as you prepare each shot for rendering, you will need to address the direct lighting of your characters. This new lighting can be integrated directly into the lighting solution for the entire shot, or it can be confined to the characters themselves. In the case of a shot like the one in Figure 15.2, the lighting is added to the scene, illuminating both the characters and the set. This is because the characters, the Beast in particular, directly interact with the set within the frame and need to generate shadows that follow the set.

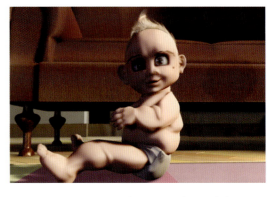

Figure 15.2 *Shot 01, with integrated character lighting*

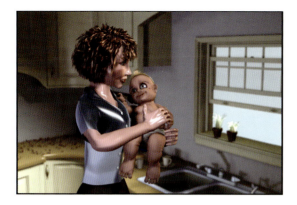

However, in a scene like the one in Figure 15.3, from shot 13.2, the lighting can be confined to the characters because their interaction with the set is both minimal and out of frame. Without the need to see a shadow coming away from the feet, you can truly split the character and set lighting if you wish.

Almost without exception, you will light your characters with **Spot Lamps**. Spots provide fine control of where and how light and shadow are cast. For exterior shots that use the existing set lighting scheme, the set lighting will provide most of the illumination that your character needs. If you need to, you can bolster this with an additional Spot Lamp or two, constrained

Figure 15.3 *Shot 13.2, with character and set lighting separate*

to light only the layer on which the character resides. Figure 15.4 shows the Beast outside in the grass again, first with the default outdoor lighting, then with an additional spot lamp to give some extra definition. The additional spot lamp and its settings can be found in Figure 15.5 and 15.6. Note that the new lamp has shadows enabled but is set to only affect the layer that the Beast is on. This means that the lamp will light him realistically, but not cast a distracting light/shadow pattern on the ground on top of the main light sources.

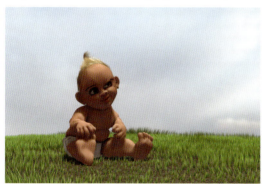

Because of the potential difficulties of using Ambient Occlusion with interior situations, your character lighting will have to be a bit more involved. The multiple spot lamp setup I used in *The Beast* that produced nice interior results for the set would not work with the characters. Due to the high number of buffered shadow spot lamps in the set lighting, the calculation and render times for the characters' strand hair and fur was

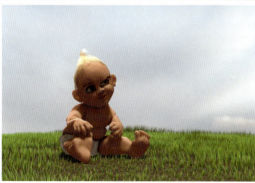

Figure 15.4 *The Beast, outside again*

Figure 15.5 *The shot set up with an additional spot lamp*

Figure 15.6 *The lamp settings*

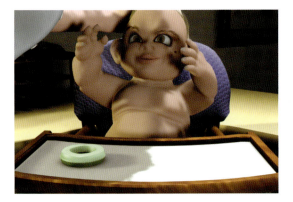

Figure 15.7 *Three key lamps light the characters and set, added with a set "beauty" render*

ridiculous. So I decided to try lighting the characters and set with only a key and fill lamp, which cut render times dramatically, and combining that result with a nice "ambiance" render of the set in the compositor. The result is found in Figure 15.7. We'll take a closer look at compositing that in the next section.

For consistency, these additional lamps can be named (*mom_key, mom_fill, beast_key, etc.*) and Appended to each shot file as you prepare for rendering. While individual shots may require variations to the positioning, intensity, color, and shadow properties of these lamps, this will give you a good starting point and save a lot of time. Of course, you should try to maintain some level of lighting consistency between your shots. Your shots will all be edited together at the end of the project, and it would be jarring to have different camera angles present drastically different lighting schemes, even if those schemes had been individually optimized. You must keep in mind that you are working on a larger project.

Compositing for Better, Faster Renders

You are about to become a "shot detective." You will be looking for any way that you can save render time by separating the animated from the static, the foreground from the background, dealing with them individually, then putting them back together.

Faster Renders

When your characters do not actually touch the set within the frame as in shot 13.2, this is easy. Figure 15.8 shows the characters from the shot, and Figure 15.9 shows the set render. Because the light is fairly ambient in the kitchen, and the strong directional light from the window would cast shadows away from part of the set that is in the frame, there is no need for the characters to cast shadows into the visible portion of the set.

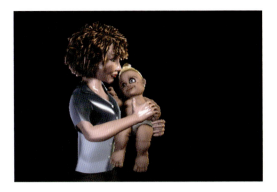

Figure 15.8 *The characters from shot 13.2*

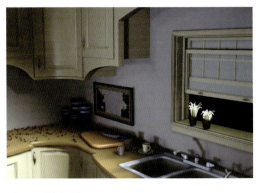

Figure 15.9 *The set*

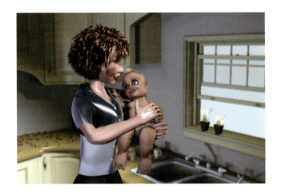

Figure 15.10 *The final composite*

This means that the set can be rendered once and used as a static background for the shot. Only the characters are rendered for each frame. In Figure 15.10, you can see the final composited frame. The nodes network for building this is found in Figure 15.11.

The upper input node, called **characters**, holds the characters themselves. The lower input node does not refer to anything in the scene but is instead an **Image** node. The image used in this node was created by rendering the shot without the characters and saving the result in

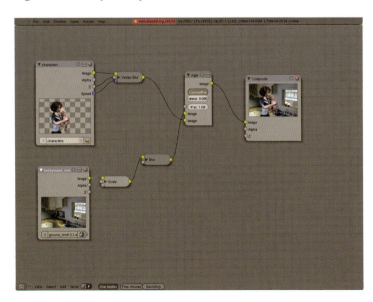

Figure 15.11 *The nodes network for this composite*

OpenEXR format. No tricky compositing or other shenanigans were used. Figure 15.12 shows the screen setup just before rendering the background image. The characters are located on Layer 1, which is disabled. The per-shot lighting that was constructed for the characters is allowed to illuminate the set and is tweaked to give the best render possible for the background image.

Figure 15.12 *Settings for rendering the set for a background image*

> **NOTE**
>
> Rendering a static background for your shots will only work if the camera does not move significantly. If it does, you will need to fully render every element in the shot for every frame. Simple camera tracking (moving side to side) with a distant background can be faked by translating the background image in the compositor with a **Translate** node. Pay attention to well done animation and live action productions. With the exception of the "handheld" look, notice how static the camera is in most recorded entertainment. Not only should you attempt to emulate this same style of camera work for the sake of believability but also for the benefit it gives you at the compositing stage.

Figure 15.13 *The Render Layers panel*

For the final production render of this shot, only the layers with the characters and lamps were enabled, as seen in Figure 15.13. The renderer only has to prepare and render the characters, then blend it with the background image as indicated in the compositor. The resulting frame is saved in OpenEXR format. If this is your first encounter with the **Render Layers** panel, you can get an anatomy lesson in the Render Layers sidebar.

Notice that for the compositing network shown in Figure 15.11, only one extra pass has been enabled for the **characters** Render Layer. The **Vec** pass, which is short for "vector," allows the use of vector-based motion blur in the compositor. Many people believe, after learning the compositor basics, that one must use all of the passes (Spec, Col, Shad, Mir, etc.) to make effective use of the feature. This is not the case. While those separate passes can be useful in certain situations, you will find that most of the time a simple **RGB** curves node applied appropriately will be quite enough to enhance and correct your imagery. Blender's compositor has great depth, but don't feel obliged to use every last inch of it just because it's there.

> **NOTE**
>
> OpenEXR is the preferred format for renders and render elements. Blender renders into a high dynamic range, meaning that the render actually has a much larger gamut of light and shadow than a monitor can properly display ("brighter than white" whites). The OpenEXR format will handle these values properly so that later compositing and color correction will produce significantly better results.

So if you were to build this render/composite tree from scratch you would:

- Choose **Composite Nodes** from the header on a **Node Editor** window and enable **Use Nodes** (Figure 15.14).
- Remove any existing nodes by selecting everything (**A** key) and deleting (**X** key).
- From the **Spacebar** toolbox, **Add** a **Render Layers** node from the **Input** menu (Figure 15.15).
- **Add** an **Image** node from the **Input** menu, click **Load New** on the resulting node, and select the previously saved background image (Figure 15.16). The image brought in through this node must be the same size as the overall rendered image, or the Vector Blur node that we will add late will fail.
- With each input node selected successively, **Add RGB Curves** nodes from the **Color** menu (Figure 15.17).
- With both **RGB Curves** nodes selected, **Add** an **Alpha Over** node from the **Color** menu. Enable **Convert-Premul** on the **Alpha Over** node to properly deal with Alpha edges and transparency (Figure 15.18).

Figure 15.14 *Setting up a Node Editor window*

Figure 15.15 *Adding a Render Layers node*

Figure 15.16 *Adding an Image node and selecting the background image*

Figure 15.17 *RGB curves nodes for fine-tuning color*

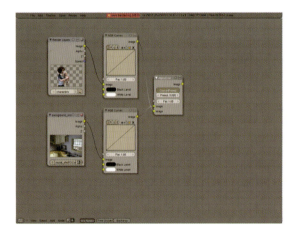

Figure 15.18 *Alpha Over node to combine the input layers*

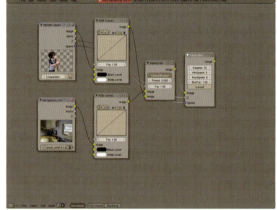

Figure 15.19 *The Vector Blur node for motion blur*

- Add a **Vector Blur** node from the **Filter** menu. Connect the **character** input node's **Z** and **Speed** output sockets to the **Vector Blur** node's input sockets (Figure 15.19).
- Add a **Composite** node from the **Output** menu so that the final vector blurred image is the output. Of course, enabling **Do Composite** in the **Scene buttons** is required so that the **Composite** node is used as the final result of any render commands (Figure 15.20).

When you've rendered once, you can add an **Output > Viewer** node and enable the **Backdrop** option on the **Node Editor** header to show the composite right in the node window. At that point, you can play around with the RGB Curves nodes to visually balance the two input nodes for a more natural composite.

Although this seems like a lengthy description, this is really a very simple node network and will become a matter of a few seconds for you to create and configure when you have worked with the system for a few days.

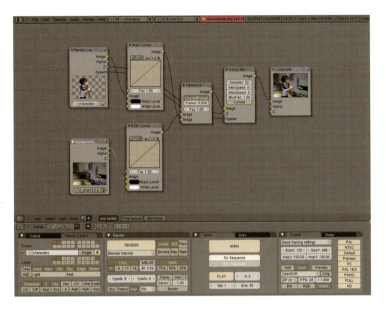

Figure 15.20 *Composite node added, and the renderer set to Do Composite*

The Render Layers Panel

The **Render Layers** panel is the bridge between the renderer and the compositor. It is here that you can create different groups of layers and passes, as well as setting lamp and material overrides and special Alpha options.

Figure 15.21 shows the **Render Layers** panel broken into numbered sections.

1. *Scene Layer buttons:* This is a convenient copy of the main Scene layer buttons, also located on the header of the 3D view. These buttons, like their header-based counterparts, control which objects are considered during render preparations.

2. *RenderLayer drop-down menu:* To avoid confusion, this really should have been called something like "Render Groups," but we go into battle with the terminology that we have. This menu is where you manage groups of render settings that are determined by the controls below. These groups can be selected by name as Input

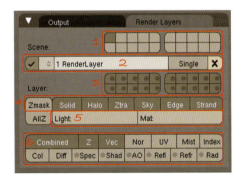

Figure 15.21 *The Render Layers panel*

nodes in the compositor. Each group defined here can be enabled/disabled with the check box on the far left, renamed in the drop-down box, and removed with the "X" control on the far right. Removing one of these defined groups does not affect the scene objects in any way—it just removes the particular grouping of settings created in this panel. The **Single** button causes Blender to ignore all other Render Layers and render only this one.

3. *The RenderLayer Layer buttons (See? The names are getting silly.):* This set of layer buttons controls which of the available, active layers will be included in this particular rendering group. The result of an Input node set to this RenderLayer will be *only* the objects on the layers indicated on this part of the panel. Layers that are activated on this portion, but that are not active on the overall Scene Layer buttons, *will not render.* Even though the RenderLayer settings allow it, the Scene-level Layer buttons have not passed the information for those objects along for render preparations in the first place. This is where things start to get wacky. Active objects in a RenderLayer group will not receive light from lamps that are not on active layers in the same RenderLayer group, regardless of the lamps' particular **Layer** setting in the **Lamp buttons**. However, lamps and objects that are on an active RenderLayer layer can receive shadows from objects that are on inactive layers for this particular render group. Figure 15.22 shows a simple scene consisting of a lamp, a monkey, and a plane. The lamp is on layer 2; the plane on layers 1 and 2; the monkey on layer 1. Figure 15.23 shows the result of a RenderLayer with only layer 1 active. Figure 15.24 shows the result of only activating layer 2. Note that both layers 1 and 2 must be active in the overall Scene buttons to achieve this result.

4. *Render Features:* This controls which portions of the renderer are used. Generally, you will leave this alone unless you specifically need only, say, **Halos** or **Strands** to appear in their own input in the compositor.

5. *Lamp and Material Overrides:* The **Light:** field receives the name of a previously created **Group** of Lamp objects. When a valid group name is entered, only lamps from that group are used when evaluating this RenderLayer. Likewise, when a valid material name is put in the **Mat:** field, that material is used for all objects appearing in the RenderLayer.

Figure 15.22 *A basic scene*

Figure 15.23 *Rendering a RenderLayer using only Layer 1. The lamp is on Layer 2, so the Layer 1 object is not lit*

Figure 15.24 *Rendering a RenderLayer using only Layer 2. Even though the monkey is on the inactive Layer 1, it still casts a shadow*

Figure 15.25 *A RenderLayer node with all passes enabled*

6. *Passes:* Under normal circumstances, the renderer generates an RGB image, which is often accompanied by an Alpha channel. It is possible to access each portion of the render in the compositor, though, by enabling these buttons. The **Combined** image is still generated, but new sockets sprout on the RenderLayer node in the compositor for each enabled pass, as shown in Figure 15.25.

Let's take a look at a more complicated shot from *The Beast*, the time versus quality challenges it presented, and the compositing solution. Figure 15.26 shows a production frame from the first shot of the animation. The frame actually consists of four different elements, which can be seen as the **Inputs** of the compositor in Figure 15.27. They are: the Beast, the mother, the set, and a background image.

As before, there is a statically rendered image for the background and layers for each character. If the characters are going to interact, it makes sense to put them on both the same scene and

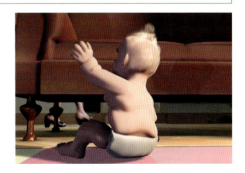

Figure 15.26 *Final composite of shot 01*

render layer. However, if the characters in a shot will fall under different lighting conditions, we should break them out in separate Render Layers so that their color and overall look can be adjusted individually.

What adds a bit of complexity to the shot is the fact the both the Beast and mother are in direct contact with the floor within the rendered frame and cast shadows. If the shadows only fell on the floor, we could add a simple plane object to the characters' layers with a "Shadow Only" material (the **OnlySha** button on the material **Shaders** panel) and composite the faked shadow in with the rest of the piece. However, the Beast's shadow interacts with the couch, so we have to use the real scene geometry.

Figure 15.27 *The simplified node network for the composite (extraneous nodes have been removed)*

That doesn't mean that we have to render the background at full quality for every frame, though. We still generate a high quality background render without the characters, using the setup described for the previous shot. The exception is that we exclude the key lamps, rendering only the ambient shadowbuffered lights that accompany the set. Figures 15.28 and 15.29 show the set without any additional elements and the render to be used as a background.

With the background created on the highest render settings (16× OSA, all lamps available), we are free to render the actual frames with only the keylighting, which will be much faster. We will be rendering the set with only two spot lamps, as opposed to hundreds for each frame.

Figure 15.28 *The set from the camera's perspective. Note that only the raw set lighting is used. Grouped key lamps would be green in the display*

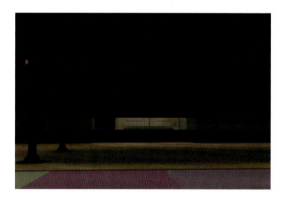

Figure 15.29 *The background render. As you can see, the image is very dark*

Looking at the compositing tree from Figure 15.27 again, you can see that there is a RenderLayer input node called **set**. Figure 15.30 shows the Render Layer panel for this node. Notice the lamp override in the **Light** field. It says **keylamps**. In the scene, the spot lamps that have been created for direct illumination of the Beast and the mother, as well as two hemi lamps for some ambient light, have been added to a Group that has been named **keylamps** (the name doesn't matter as long as it is descriptive enough for you to remember its function). When the **set** Render Layer is used in the compositor, the large number of shadowbuffered spot lamps are ignored, and only the **keylamps** are used. The raw render output from this procedure is seen in Figure 15.31. Going back to the node tree once more, this direct lighting pass of the set is combined with the "ambiance" background that was rendered earlier and brought in through an **Image Input node** with a **Colors > Mix > Add** node, shown in Figure 15.32. Figure 15.33 shows the final result. This makes it fairly simple and quick to control the intensity of the direct lighting and shadows on the set by adjusting the mix value of the **Add** node.

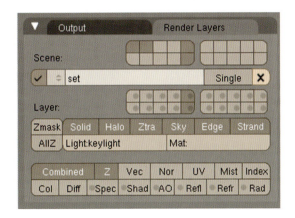

Figure 15.30 *The Render Layer panel for the* set *input node*

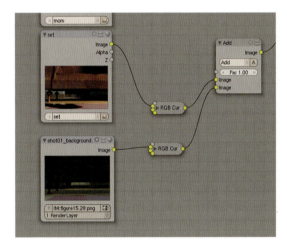

Figure 15.32 *Combining the* set *node with the background image*

Figure 15.31 *The output of the* set *node*

Figure 15.33 *The result of the* Add *node*

299

NOTE

If you remember from the Render Layer panel sidebar, objects that are not on the same layer as a lamp will cast a shadow in a composite but will not receive illumination themselves. So, when working with a setup like the one here, you must make sure that any key lamps are shared across all layers that have objects that will receive light. In this case, it means the lamps in the **keylamps** group should be on layers 1 and 2 for the characters, as well as 5 and 15 for the sets.

Now we must place the characters into the composite. In the previous example, an **Alpha Over** node worked well. Trying that now, though, results in Figure 15.34. The problem is that the mother walks behind a portion of the set where only her feet are seen, after which she disappears completely. We need to obscure the part of her that should be hidden by the set. There are several ways to accomplish this, but the simplest, and the technique used throughout *The Beast*, is to have the set act as an Alpha Mask for the character's Render Layer. This is done

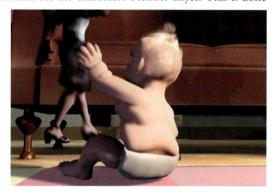

Figure 15.34 *A bad composite, with the mother improperly showing through the couch*

by bringing up the character's Render Layer panel and **Ctrl-left mouse button** clicking in each of the set's layers. Figure 15.35 shows the result in the panel. Instead of activating those scene layers for this particular Render Layer, a black dot is added, indicating to the renderer that objects in those layers should be used to generate Alpha.

When it is rendered, you get the full render but with an Alpha channel properly knocking out anything in the active layers that should be obscured. Now the Alpha Over composite works properly. The raw Render Layer is seen in Figure 15.36; the final composite is in Figure 15.37.

Figure 15.35 *The result of Ctrl-left mouse button clicking on the set layers*

Figure 15.36 *The mother with Alpha knockout*

Let's look at another composite that involves the use of more than one scene. Shot 07 in *The Beast* includes the Beast, the mother, and both dogs. While the scene was renderable on some equipment, other computers (particularly Windows boxes) would crash from time to time due to the high number of strands present. To work around the problem, a duplicate Scene was created inside the Shot 07 BLEND file. To create the new Scene, **ADD NEW** was chosen from the **Scene** drop-down menu on the main header, and **Link ObData** was chosen as the duplication option. This dialog is shown in Figure 15.38. The Scene layer buttons were adjusted on

Figure 15.37 *A good composite*

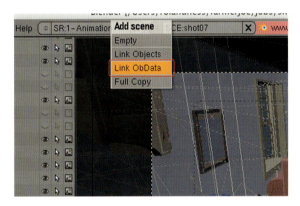

Figure 15.38 *Adding a new Scene with Link ObData*

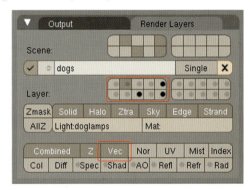

Figure 15.39 *The Render Layer settings for the dogs in the new scene*

this new scene to exclude the Beast and the mother, and the Render Layer changed to provide an Alpha mask for the set (Figure 15.39). This new scene will be identical in every way to the original with the exception of these layer and render settings.

Back in the main Scene, the layer with the dogs is disabled in the scene buttons so they are not even considered. Figure 15.40 shows the compositor, with the dogs brought in by selecting their named Scene and Render Layer in an **Input** node. One of the greatest strengths of the compositor is the ability to bring in elements from not only different

Figure 15.40 *Bringing the dog Scene into the composite of the original Scene*

Render Layers, but from entirely different scenes, which may have entirely different render settings (OSA, Ambient Occlusion, SSS, Ray Tracing, etc.). When working with Render Layers and only one Scene, Blender does a single render, piping the results around as required. But when a second (or third, etc.) Scene is involved, it actually performs entirely separate renders. While this will take longer, it can also allow you to render things that you would not ordinarily be able to render at once due to RAM constraints.

Better Renders

We have already shown how **RGB Curves** nodes are placed after each input node. Let's examine a couple of common uses for an **RGB Curves** node.

Contrast Boost

Figures. 15.41 and 15.42 show a frame from shot 6, both before and after contrast enhancement. In nontechnical terms, a contrast boost involves making the darks a bit darker, the lights a bit lighter, and leaving the middle alone. To translate this into RGB Curves, the top end of the curve, which represents the highlight area, needs to go up (lighter), and the low end of the curve, which represents the shadows, needs to go down (darker). The curve that made the adjustment between the two previous illustrations is shown in Figure 15.43. This is commonly referred to as an "S" curve, or a standard contrast curve.

More contrast will usually make an image more interesting. However, you must be sure not to overdo it. How much is too much? First, you do not want to lose visible detail in either the highlight or shadow range. If you examine the output of the RGB Curves node and the details have disappeared, like Figure 15.44, push the curve back toward a straight line a bit.

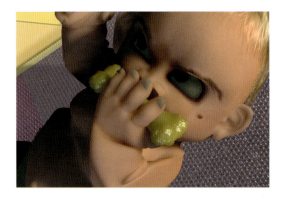

Figure 15.41 *A shot with unaltered contrast*

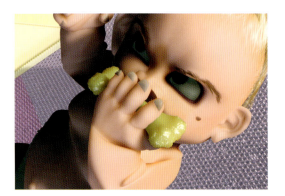

Figure 15.42 *The contrast-enhanced shot*

Figure 15.43 *The contrast "S" curve*

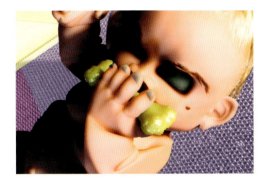

Figure 15.44 *Losing shadow detail from too strong a contrast curve*

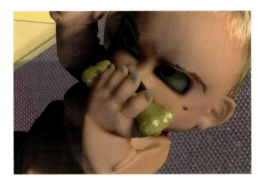

Figure 15.45 *An unadjusted image*

One other thing to be aware of is that the contrast of elements from different Render Layers should work well together. They do not necessarily have to have identical contrast curves, but a stark difference in contrast between objects and characters that are supposed to be a part of single, coherent shot will cause those objects to appear out of place. The goal of the composite should be to get everything to look as though it were really all of one piece.

Midtone Brightness

The adjustment of the brightness of the middle of the RGB curve is also called another name: *Gamma*. Gamma correction can be a very technical thing, and some people will call you bad names if you don't go absolutely Gamma crazy and read everything ever written about it and manage your Gammas from end to end. A very simple but effective layman's resource for adjusting the Gamma of your monitor can be found at `http://www.photoscientia. co.uk/Gamma.htm`.

With your monitor adjusted properly, you can attempt to adjust the midtones of your images as well. Simply add a control point at the dead center of your RGB curve and, most likely, pull it up and to the left. Figs. 15.45 and 15.46 show the difference between a raw and adjusted image, and Figure 15.47 shows the RGB Curve that changed it. Moving the middle point of an image is called *Gamma correction*, and it affects whether an image is weighted toward highlights, toward shadows, or is balanced.

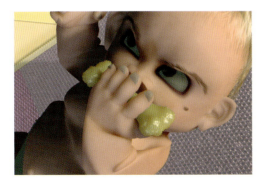

Figure 15.46 *The gamma corrected version*

Figure 15.47 *The RGB Curve for creating this correction*

303

In lieu of the reams of technical explanations, mathematics, and general silliness that it would take to make you an expert in Gamma correction, I will suggest a method that I call "The Optometrist." If you've ever been to the eye doctor and had to get corrective lenses, you will be familiar with the optometrist's technique of finding the exact lenses that you will need. They put one lens in front of your eye, then a different one. They switch back and forth a few times and ask, "One? Or two?" You tell them which looks better. In this way, they go through a number of different corrections until they narrow it down to the best one for you.

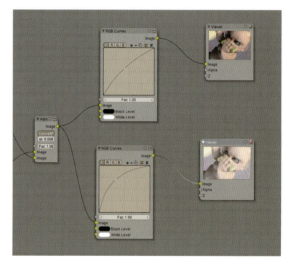

The same technique can be applied to making midtone adjustments to your images. In an RGB Curves node, grab the midpoint and pull it around. Figure 15.48 shows a node tree for performing an "Optometrist" on your image. The **Background** button is enabled so that the active **Viewer** node is displayed there. In this way, you can set two different Gamma curves, one in each RGB Curve node, then switch between the two by clicking on the two viewer nodes. Better? Worse? One, or two? Most likely, you will end up applying a similar adjustment to all of your images, but some experimentation will be beneficial.

Figure 15.48 *The Optometrist node tree (background is not enabled here for illustrative clarity)*

Combining the Techniques

Of course, midtone adjustment can be combined with the contrast curve from the previous section into a single correction curve. Figs. 15.49 and 15.50 show the original image that has been used in these sections and a final brightness and contrast adjusted image. The RGB transformation curve is shown in Figure 15.51.

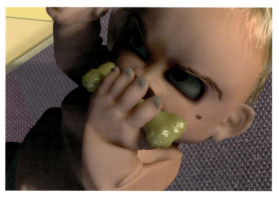

Figure 15.49 *The original image*

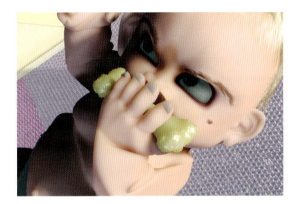

Figure 15.50 *The image adjusted for both contrast and Gamma*

Figure 15.51 *A combined curve*

Figure 15.52 *The R, G, and B buttons for color changes*

You can put these curves immediately after their respective input layers so that you can control each Render Layer element separately, or you can place one right before the final composite so that it works on the finished image. While the second option is easier, you will need to make sure that all of your inputs combine well. If they don't, you will need to adjust them individually so that they look natural together.

Color Adjustment

A final use for the **RGB Curves** node is to change the overall color of images. Figure 15.52 highlights the R, G, and B buttons on the node. Pressing any of those buttons shows the individually adjustable curve for that color channel. By putting a point in the middle of these curves and pulling them around, much like

midtone adjustment in the previous section, you can change the overall color of the image in both subtle and drastic ways. Figures 15.53 through 15.55 show what happens when you move the midpoint for the different color curves.

These controls can be used to fix bad coloring that has crept into a render somewhere along the way, or to subtly enhance the feel of image. For example, they can be used to shift the shadows of a "good" character to a slightly warmer palette of colors and push a "bad" character's shadows a bit cooler.

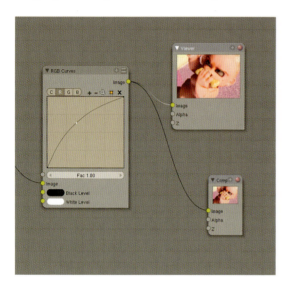

Figure 15.53 *The Red curve: Up casts red, down casts cyan*

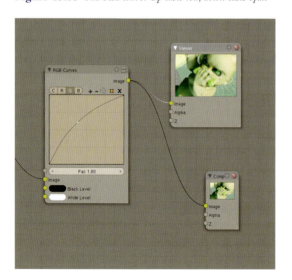

Figure 15.54 *The Green curve: Up casts green, down casts magenta*

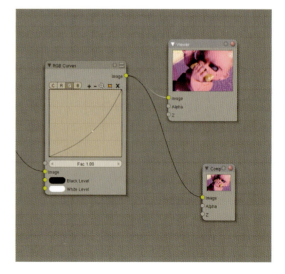

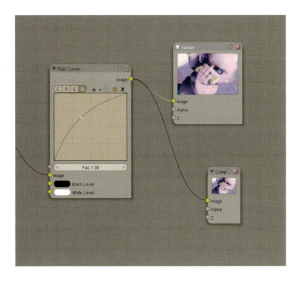

Figure 15.55 *The Blue curve: Up casts blue, down casts yellow*

Motion Blur

Unless you want your final production to look to like clay model stop motion animation or one of the stylized high speed camera action movies like *Gladiator*, you will want to add Motion Blur to your composite. Figures 15.55 and 15.56 show the difference between an action-filled shot with and without motion blur. Due to the nature of our eyes, motion blur is something that we see every day, so much so that we don't usually realize or make note of it. However, when it is not present when it should be, the effect is obvious and reduces the believability of your animation.

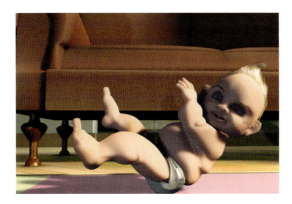

Figure 15.56A *No motion blur*

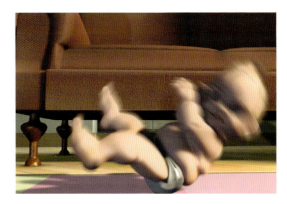

Figure 15.56B *Motion blur*

Fast vector-based motion blur is easy to add in the compositor, and a few changes to the default values will produce excellent results. The **Add > Filter > Vector Blur** node, shown in Figure 15.57, requires three inputs: an image, a Z channel, and a Speed channel. These correspond to the regular RGB (+Alpha), Z and Vec passes in the Render Layers panel. For simple composites, all that is required is to connect the familiar sockets on the **Input** and **Vector Blur** nodes, then send the image output either to a **Composite** node (if it is the last item in the node tree) or to the next input. The example in Figure 15.57 shows this simple configuration.

Figure 15.57 *A basic motion blur setup*

For most cases, you will be able to achieve good results by raising the **Samples** value to 64 and enabling the **Curve** option. **Samples** increases the quality of the blur and can go as high as 256 for objects that are moving very quickly. **Curve** allows the node to generate a curved blur for objects that move in an arc during the course of the frame. Without this option, a ball that is flying in a circle will generate a straight-line blur between its beginning and end points on each frame instead of a proper curve.

The difficulty in using motion blur arises when objects from different Render Layers have motion blur. In those cases, you will need to blur each Render Layer individually. There are two ways to do this. The first method, and the one that produces the best results, is to apply the blur after the element has been combined with the rest of the scene. Figure 15.58 shows this technique. Note how the "mom" Render Layer is added to the background, then blurred, before proceeding to the next. The danger of this method is that a moving object from one Render Layer can blur the already-blurred streak of an object added from an earlier Render Layer.

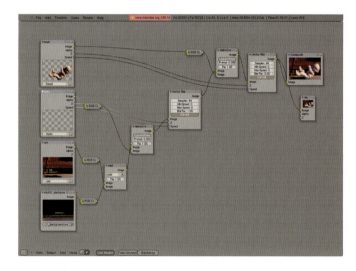

Figure 15.58 *Building up layers of motion blur*

The slightly less desirable way to do this, and one that will prevent the kind of artifacts just mentioned, is to add each Render Layer into the growing composite, then blur them in order of addition. Figure 15.59 shows

a node tree with two different inputs, each vector blurred before being combined with a set image. The problem to watch out for is pixels in the final composite that have gone completely black. This is due to an error between Alpha, compositing, and vector blurring.

This is a tough problem to fix. If possible, consider putting the different elements into the same Render Layer for this shot so that a single vector blur pass can be performed on the final combined image.

Figure 15.59 *Blurring each Render Layer before it is composited*

Getting a Good Render on Your Local Machine

When you have your shot lit and compositing properly, it is time to prepare for production rendering. Here is a list of items to go through before declaring your shot "render ready."

On the **Format** panel (Figure 15.60):

- Double check the render size and frames per second.
- OpenEXR format, with Zbuf and Zip(lossless) options.

On the **Anim** panel (Figure 15.61):

- Do Composite is enabled.
- The correct frame range is set.

On the **Render** panel (Figure 15.62):

- **OSA** is enabled, and the OSA value is set appropriately. Setting 16 is the highest quality, but it can take longer. Do a few tests to see what you can get away with.
- Background options are set to **Key**. This allows Alpha channels to function properly in the compositor.
- Unless you used it for a very good reason, **Ray** should be disabled.

On the **Output** panel (Figure 15.63):

- Enable automatic thread detection if your render computer has more than one processor or processor core. If you don't know, leave it enabled.
- Enable both **Touch** and **No Overwrite**, which is useful later for a "poor man's render farm."
- Set the output path. This is very important! Just like asset paths, this too should be relative. A good scheme is to locate the path for your final renders (probably called *renders* or *frames*) and add the shot name to it as both a directory and part of the file name. A good path would look like: //../renders/shot05/

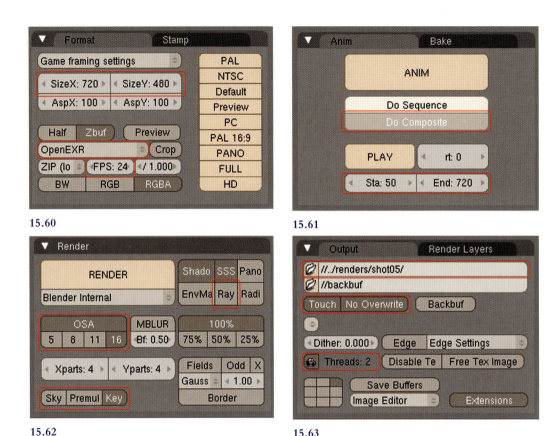

15.60

15.61

15.62

15.63

Figures 15.60–15.63 *The Render settings panels*

- If your shot requires multiscene rendering as discussed in the previous composite example, you will want to turn on the **Save Buffers** option so that each scene's render results and composite tree will be spooled to disk instead of hogging up your system's RAM.

With the render settings prepared, make sure that all asset paths are relative by choosing **File** > **External Data** > **Make All Paths Relative** from the main header menu. Then run a link check on your file by choosing **File** > **External Data** > **Report Missing Files**.

Now . . . the moment of truth. Use the **Render** button to, well, you know . . .

Of course, you've rendered test frames from your shots hundreds of times over the course of your work on this project, but this time it's almost for real. Check the resulting composite image for artifacts: areas of blown out or unexpected colors from a bad composite connection, bodies passing through clothes, people passing through the set, etc.

You should also note any simulations that appear in the shot. Move the frame counter to the middle of the simulation and render a test frame to make sure that things are properly baked. If the entire frame passes a visual inspection at this point, you are almost ready to go.

Final Animation Review

Before you hit the **Anim** button for animation rendering or sending your shot to a render farm, it is worthwhile to do one more round of testing on your animation. You dealt with real-time previews to check your animation and timing in Chapter 12, but there are some details, such as eye movements and blinks, that you will not pick up on an OpenGL preview animation. If you have the time, it is worth performing a final animation review.

> **NOTE**
>
> To perform this review, you will be altering some of the render settings for a quick and dirty render. If you are doing this after you have created your final render and composite settings, make sure that you change everything back to the final production settings and do a full test render before sending things to the render farm. Alternatively, you can **Add** a new **Scene**, using **Link ObData** as before, and create a special set of "test" render settings. Just be sure to switch back to the original scene for final rendering.

To do so, change the output format from OpenEXR to AVI JPEG on the **Format** panel, and disable shadows and SSS on the **Render** panel. If your shot involves characters or set pieces with large numbers of strands, you can disable those as well by disabling their renderability in the objects' respective modifiers panels, as shown in Figure 15.64. Of course, if strands are very important to some aspect of the scene instead of just window dressing, you will need to leave them on. Turn **OSA** down to the minimum or off completely if there are no fine details, like pupils, that matter.

If you really want to get tricky, try changing the **RT** value in the **Anim** panel to **1**. The **RT** control enables super-secret hidden features that might not be ready for a general audience, among other things. Setting it to **1** makes a new panel called **Simplification** come to life, docked with the **Render** panel. This panel, which was created for animation checking on the

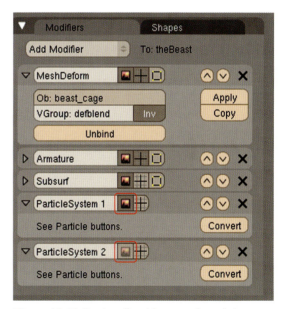

Figure 15.64 *Turning off particle systems for rendering*

Peach project (http://peach.blender.org), is shown in Figure 15.65. It allows you to set maximum levels for shadowbuffer samples and subsurfacing and to set percentage values for overall AO and SSS quality. You can also specify as a percentage the amount of child particles to generate for strand systems.

As you are preparing this for one last review and might want to tweak something here or there, you should also enable **Stamping**, as you did way back in Chapter 4 with the story reel. This will make it easy to identify the frames that might need some extra attention.

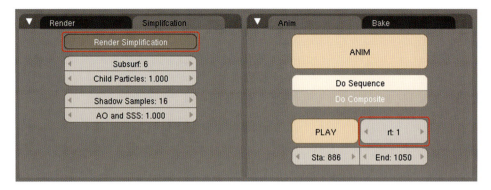

Figure 15.65 *The hidden Simplification panel*

So press **Anim** one last time before the final launch (hopefully) and let Blender make a lower quality version of the shot. Watch the result several times to make sure that you are happy with it, or at least not embarrassed by it. After this, you'll be investing lots of computing time in performing the final render.

Preparing for Render Farming

If you will be performing your renders locally, that is, on the computer on which you've been doing all of your work, there is nothing else you need to do. You've already done test renders to ensure that the renderer will perform properly and all assets will be found and linked correctly. However, if you will be doing your renders somewhere else, say, on an office network that has agreed to let you use their systems in their off hours, you will need to move your project.

Because you followed the organizational advice in Chapter 3, every single piece of your project is within one of the folders in your main project directory. Moving these files now is as easy as copying the entire project directory to the new location. Whether you do it by burning CDs, DVDs, using a Flash device or external hard drive, or over a network with FTP or some other protocol does not matter. The crucial thing is that you maintain the exact directory structure that you had on your original workstation.

At your render location, place this directory structure and all of the accompanying files on a machine that will act as a file server. It doesn't need to be anything fancy—just a computer that has the capability to share directories with others on the network. All of the machines that you will use to render will need to have this project directory mounted for local access. On Windows systems, this will mean using the **Map Network Drive . . .** functionality in the network browser, shown in Figure 15.66. For Mac OS X systems, this involves locating the shared directory through the **Network** panel, which is a bit different for each version of the OS. On Linux computers, you can either attach to the share through Samba or standard Linux file sharing.

On each machine, or **Render Node**, you should run Blender, open one of the shot files over the network, and perform a test render. If you get warnings about assets not being found, your renders show up with image textures missing, or simulations go crazy, then you have done something wrong while recreating the

Figure 15.66 *Mapping a network drive in Windows*

directory structure or failed to use **Relative Paths** at some point. Do a **Report Missing Files** command from the **External Data** menu to see where the problems are.

When you have a good render out of each render node on your network, you are ready to render. Finally!

Setting Up and Using a Render Farm

The most basic way to use Blender as a quick and dirty render farm has been enabled by something you've already done. The **Touch** and **No Overwrite** buttons allow you to load a BLEND file on several different machines at once, press the **Anim** button on each of them, and have the final frames populate the output directory without overlap. The **Touch** setting causes Blender to create an empty file for the finished frame at the beginning of the render instead of at the end. The **No Overwrite** setting requires Blender to look in the output directory before rendering a frame, and, if a file for that frame already exists there, to move on to the next one.

This technique is flexible in that there is no limit to the number of render nodes you can add, and no special preparations are necessary to do so. As long as the computer in question can run Blender and can mount the master project directory as a local drive, it will work.

> **WARNING**
> It is extremely important that all render nodes in your farm are running the same version of Blender. If you are using official versions, this is easy to ensure. However, if you are using computers on different platforms (Windows, OS X, Linux) and Blender's development SVN builds, it may take you some time to get it right. Using different versions of Blender can cause drastic differences in the final renders depending on the feature differences between the versions. Sometimes the same version of Blender, built with different compiling systems, can lead to different render results, especially when strands are involved.

Using **Touch** and **No Overwrite** will work when pressing the **Anim** button in Blender or when using the command line to render. Any BLEND file can be rendered by entering a command into your system's command line utility. Windows users will probably call this the "command" or "DOS" window, OS X users will call it the Terminal, and Linux users should know what I'm talking about already or be forced to turn in their geek membership cards.

A typical command line for rendering is:

```
c:\Program Files\Blender>blender.exe -b r:\projects\beast\shots\shot07.blend -s
50 -e 172 -a
```

The portion that reads "c:\Program Files\Blender" is simply where Blender is located on the hard drive. After that is "blender.exe", which is the actual Blender executable. The "-b" indicates that Blender should be run in "background" mode so that it doesn't start the user interface. Then the full path of the file to be rendered is given. In this case, it is found on drive "r:", which is a network mapped drive of the main project directory on another computer, then within a projects directory, into the "beast" directory, and finally into the "shots" directory where the "shot07.blend" file is located. The frame range is set with the "–s" and "–e" flags. In this example, the frame range is designated from frame 50 through frame 172. Finally, the "–a" flag indicates that Blender should do an animation render.

All other render configurations are taken from the settings already saved into the Blender file: image format and size, compositing, and output file name and path. If the output path is set correctly with a relative path, the rendered files will be created on the main shared drive within your project directory.

Using Render Farm Software: Farmerjoe

If you would like a bit more power, you will need to either purchase time on a commercial render farm or build (or borrow) and manage your own. A fairly simple and powerful tool that I used for rendering *The Beast* is an open source render farm manager called *Farmerjoe*, written by Mitch Hughes. Farmerjoe allows you to use as many computers on a local network as you would like—Windows, Mac, and Linux all at once—control Blender versions from a central location, and track and control render jobs from a simple web interface, all without installing a single thing on the client machines.

> **NOTE**
> The documentation that comes with Farmerjoe has thorough instructions for installation. The instructions in this chapter should suffice for most users, but any difficulties can most likely be cleared up by reading the official installation instructions.

A .ZIP file called "farmerjoe_0.1.3.zip" containing everything you need to run Farmerjoe can be found on the included disc in the farmerjoe directory. The archive should be unzipped into a farmerjoe directory on whichever computer will be the master of the render farm. The actual computing requirements for running the master process of Farmerjoe are modest, so any machine will do. It should, however, be a computer that you can reach with a web browser. For the sake of simplicity, Windows users should unzip the archive into c:\farmerjoe, Linux users into /render if they can, and OS X users into /Volumes/farmerjoe. The contents of the directory will look like Figure 15.67.

Figure 15.67 *The extracted contents of the .ZIP file*

After putting the contents of the .ZIP file into the directory you create, share this directory so that all of your render node computers, (called **slaves** in render farm terminology), can see and mount it as a local drive. Linux and OS X computers should be set up to have proper permissions so that you can both read and write to the share, as well as execute programs from it.

The file Farmerjoe.conf contains the settings that Farmerjoe will use to run the farm. Fresh from the installer, the file looks like this:

```
# Master Server Configuration

port = 2006

master = 192.168.1.10

jobs = jobs
logs = logs

linux_root = /render
linux_blender = /render/bin/linux/blender
linux_composite = /usr/bin/composite

windows_root = r:\farmerjoe
windows_blender = r:\farmerjoe\bin\windows\blender\Blender.exe
windows_composite = composite

osx_root = /Volumes/farmerjoe
osx_blender = /Volumes/farmerjoe/bin/osx/blender/blender.
  app/Contents/MacOS/blender
osx_composite = /usr/local/bin/composite

# Application server Configuration
appserver_port = 2007
```

The only thing you will really need to change here is the master = 192.168.1.10 line, which represents the network IP address of the master computer. Windows users can open a command line terminal and type **ipconfig** to find their IP address. OS X users can look in the main tab of the **Networking** control panel. Linux users can type **ifconfig -a** from a terminal.

You could run the master control program now, but it won't do you any good until you have Blender binaries in the proper place for the slaves to use. For each type of slave computer (Windows, OS X, Linux), you will need the proper Blender binary. Of course, if you will only be using Windows computers, you only need a Windows installation of Blender. The same holds true for the other platforms.

Within the master farmerjoe directory is an already created directory called **bin**. Inside the bin directory are three more: windows, linux, and osx. For Windows, simply dump the contents of the Blender application directory into bin/windows. For Linux, put the contents of the Blender installation into bin/linux. On OS X, Blender is a single application bundle, so just place the lone application into bin/osx.

With the changes to the configuration made and saved and Blender in place, it is time to start the server. From a command line of the master computer, navigate to the main farmerjoe directory. Among other things, there will be several files there: Farmerjoe.exe, Farmerjoe.osx, and Farmerjoe.linux. These little programs are the heart of the render farm and are used to execute all render farm commands and applications. Choose the one appropriate to your master computer's OS, and type the following:

For Windows: farmerjoe.exe --master

For OS X: ./Farmerjoe.osx --master

For Linux: ./Farmerjoe.linux --master

The server will start, and you will see the following text in the terminal:

```
Starting Farmerjoe Master on port 2006
```

```
Now Accepting Connections
```

That terminal is now the host of the render farm. To start the web interface, open a new terminal window and use the same "Farmerjoe.xxx" command as you did for the master, using the flag "-- appserver" instead. On a Windows master, the command would be:

```
Farmerjoe.exe --appserver
```

Some variation of this message will appear:

```
Mon Apr 28 22:43:57 2008: 2772: Farmerjoe Application Server accepting
   connections on port 2007
```

```
Mon Apr 28 22:43:57 2008: 2772: Point your web browser to
   http://yourcomputer:2007
```

At this point, you can fire up a web browser and type that address into the address bar. If you are not in a network setting that has good recognition of host names, though, you will be better off using the master computer's IP address in place of the "yourcomputer" entry. Figure 15.68 shows the Farmerjoe web interface. The top section, labeled **Slaves**, will show all of the computers that are currently available for use by the farm.

The next section, **Jobs**, shows completion information for all of the jobs registered with the farm, both finished and pending, and provides controls for working with them. The lowest section, labeled **Tasks**, provides detailed information about selected jobs, including which slaves rendered which frames and the current status of any individual frame.

Until you get some slaves running and submit a few jobs, though, the screen is pretty plain.

To get a slave ready for rendering, you need to attach to the networked master directory. On a Windows slave, it is recommended that you map the share to

Figure 15.68 *The Farmerjoe web interface*

317

drive **r:**. For Linux machines, you should mount the share at **/render**, with full read, write, and execute permissions. For OS X, try to mount the share at **/Volumes/farmerjoe**, once again with the ability to read, write, and execute. Navigate the command line to that directory and execute the slave OS's specific command:

For Windows: farmerjoe.exe --slave

For OS X: ./Farmerjoe.osx --slave

For Linux: ./Farmerjoe.linux ---slave

Just so everyone knows where they stand, the terminal will display something like:

```
# Welcome 9
```

YOU ARE NOW A SLAVE

And that's it for setting up a slave. You just need to mount the share and execute the "farmerjoe.xyz --slave" command. As long as the Blender binaries have been placed in the proper directories, you are ready to create and submit a job.

While Farmerjoe comes with an integrated Python job submission tool, using it requires you to run an instance of Blender, open the BLEND file in question, run a Python script, make some settings and hit "submit." It also limits you to using certain formats when saving renders, none of which are OpenEXR. Instead, jobs can be submitted from a command line.

Within the master farmerjoe directory, create a new directory called jobs. This jobs directory becomes the base directory for your animation project. All asset directories that we prepared to move in the previous sections go here. So you end up with a directory structure like the one shown in Figure 15.69, each directory populated with the models, textures, and animation shots you have created so far.

Name	▲	Date Modified	Size	Kind
▶	bin	Mar 16, 2008, 8:37 AM	--	Folder
	Farmerjoe.conf	Mar 8, 2008, 3:41 PM	4 KB	Unix Executable File
	Farmerjoe.exe	Oct 30, 2006, 11:43 PM	2.5 MB	Unix Executable File
	Farmerjoe.linux	Oct 27, 2006, 10:18 AM	2.2 MB	Unix Executable File
	Farmerjoe.osx	Oct 30, 2006, 9:35 PM	2.3 MB	Unix Executable File
	Farmerjoe.pl	Jan 19, 2008, 7:02 PM	76 KB	Plain text document
	farmerjoe.state	Today, 8:39 AM	180 KB	Document
	GPL-license.txt	Jul 15, 2006, 9:42 PM	20 KB	Plain text document
▼	jobs	Today, 8:41 AM	--	Folder
▶	models	Apr 22, 2008, 2:43 PM	--	Folder
▶	renders	Mar 22, 2008, 4:33 PM	--	Folder
▶	scenes	Today, 8:41 AM	--	Folder
▶	sets	Apr 22, 2008, 11:42 AM	--	Folder
▶	textures	Apr 9, 2008, 2:59 PM	--	Folder

Figure 15.69 *All of your hard work, ready to be rendered*

So how do you address the render farm? You need to provide it with a JOB file. A JOB file is a little text file that contains very basic information about what the farm needs to do. Some of the information in the file is repetitive because it was supposed to be generated by the integrated Python submission tool. However, it is simple to edit the file to meet our needs. An example JOB file for shot 01 of *The Beast* follows:

```
01>shot01.blend
02>350
03>820
04>1
05>12000
06>scenes
07>shot01.blend
08>720
09>480
10>8
11>8
```

The left hand column simply shows the line numbers of the file for your reference and does not actually appear in the file. Lines 1 and 7 contain the name of the BLEND file to be rendered. Line 6 is the name of the directory within the job directory where the BLEND and JOB files are located. Lines 2 and 3 are the range of frames to render. Lines 8 and 9 are the render resolution, and lines 10 and 11 are the "parts" that tell Blender how many ways to slice up the render as it works.

You create (or copy and modify) the JOB file, place it in the directory with the BLEND file, then head to the command line. When there, type your OS's version of:

```
Farmerjoe.exe --submit scene shot01.job
```

The first parameter "scenes" refers to the directory where the JOB file resides, and the second part of the command is the name of the job file itself: "shot01.job". Note that this is NOT the name of the BLEND file! Pointing Farmerjoe directly to anything except a JOB file during submission will cause it to malfunction.

> **NOTE**
>
> There is one modification you will need to make to your shot files for them to work properly with Farmerjoe. The output path for animation frames that is saved into your BLEND files must end with a directory. Our general instruction in a previous section was to use the name of the shot both in the directory and as a filename prefix, yielding something like //../frames/shot05/shot05. However, Farmerjoe has trouble recognizing prefixes on frame names, so you should instead use an output path that ends with a forward slash like //../frames/shot05/. This means that all generated frames will simply be a number followed by .EXR. As long as the frames always remain within their named directory, this will not cause a problem.

As soon as you hit **Enter** on that last command, the job is submitted to the farm, and the master node begins handing out frames in succession to any available slaves. Figure 15.70 shows the Farmerjoe web interface with a little more going on this time.

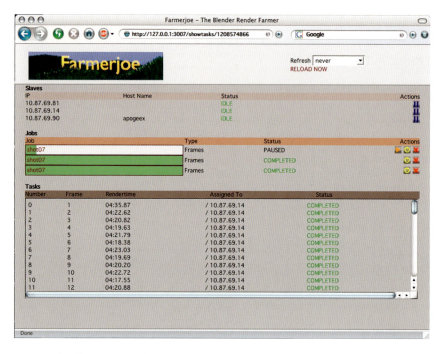

Figure 15.70 *Farmerjoe handling a number of jobs*

> **WARNING**
>
> While using several different OSs and hardware platforms within a render farm can really make the most of your available resources, it may also cause problems. Most elements within Blender's renderer work identically across the different technologies, but the new strand rendering technology is *not* guaranteed to work cross-platform. While some simple strand configurations will work, anything involving the Kink/Branch options can produce drastically different (though individually acceptable) results. An animation compiled from frames produced on different platforms can appear as though any strand items are "alive" as they move around from frame to frame. If in doubt, render the same frame of your animation on several different computers and compare them. If they are not identical, you will have to restrict your rendering only to nodes that matched.

Slave nodes can be paused and resumed with the buttons on the right of the web interface. Likewise, jobs can be paused, reset, or completely deleted with the buttons to their right. Clicking on any job in the **Jobs** list shows a more detailed accounting of its activity in the **Tasks** section.

You might be wondering at this point if all of this is worth it. In fact, it is. I spent about a half a day setting up and configuring Farmerjoe, and that was without the help of this fine book! After a few times, the process of creating a shot directory and loading both the per-shot BLEND file and a master JOB file became little more than repetitive simplicity. I just grabbed the JOB file from the previous shot and changed the filenames and frame ranges.

Running Farmerjoe Remotely

One of the reasons that the command line is emphasized so heavily here is the ease with which it can be used for remote operations. Rendering for *The Beast* was generously donated by Reed & Witting Company, a high end commercial printer located in Pittsburgh, Pennsylvania (`http://www.reed-witting.com`). The resources I was able to use totaled four render cores on Linux machines, four on OS X machines, and eight on Windows boxes. This gave the farm 16 processor cores to work with. Not the mind-boggling strength that Pixar or the big boys use, but it was enough for me.

To operate the farm remotely, an SSH tunnel was created through the firewall, reaching a VNC server that resided on the master machine: an OS X computer. This is probably a bit of advanced networking stuff for the artiste, and you're really not expected to be able to do this yourself. However, any good IT person should be able to set this up for you. VNC is a remote desktop program that allowed me to control the OS X master remotely, as though I were sitting right in front of it. From there, I ran several terminal programs on the OS X computer, starting the master, web application, and a slave. Using both Telnet and SSH, I obtained terminals on all of the slaves that were attached to the same local network as the master and ran their respective slave commands. Of course, if you're getting someone to set up a scheme like this for you, see if you can get the person to script the startup of the different nodes and processes so that you don't have to do any of it by hand.

A second hole was put in the firewall to allow external access to the Farmerjoe web application. FTP access was granted to the farmerjoe directory on the master computer.

In this way, I could FTP my shot and JOB files into place in the master directory from off site, use SSH to access the OS X master to "--submit" jobs, then monitor their progress through the web interface. A couple of final frames were sampled via FTP to make sure that things were rendering correctly, but the full collection of all rendered frames was done on DVD due to the large size and number of the files. The diagram in Figure 15.71 shows the structure.

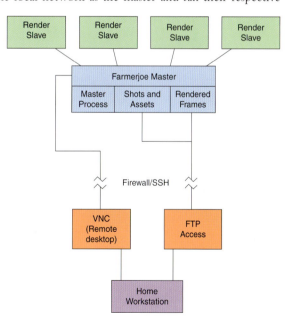

Figure 15.71 *A render farm setup with remote access*

Checking the Final Frames

When each computer in your render farm has delivered at least one frame, you should check a sample from each one to make sure that things are working properly. Because you've been eating, drinking, and sleeping Blender for the past many weeks or months, it makes sense to open and check the OpenEXR frames within one of Blender's image editor windows. If you're on Linux, you can try CinePaint as well. The easiest way to do this in Blender is to add the rendered frames to a Sequencer window as an Image Sequence. Then you can split off a Sequencer preview window and scrub over the timeline to view the frames. Figure 15.72 shows the setup. The nice thing about using the Sequencer in this fashion is that you can simply use the **Do Sequence** button in the **Scene buttons**, set a frame range and appropriate output format, and export the frames as a full animation with the **Anim** button.

Figure 15.72 *The Sequence Editor used as a frame viewer*

If you are reviewing all of the frames for a particular shot, be sure to check them over carefully. The next time you see them will be during editing when you are concentrating on things such as syncing the per-shot sound files to the final edit and creating transitions and cuts. It's better to find a problem, fix it, and send it back for a rerender right away than when you've mentally moved on to other things.

Finally, if you see something bad that appears in just one or two frames, like a hair that goes wild or a black or white dot compositing artifact, remember that Blender's Image Editor is exactly that: an editor. Although the paint tools are limited, as we learned in Chapter 4, they still may be good enough to touch up a few rendering mistakes.

Staying Organized

When you reach this stage of production, you will have a lot to think about and even more to keep track of. A simple spreadsheet, either made in the decreasingly ubiquitous Microsoft Excel or any of the free alternatives, such as OpenOffice.org or Google's Google Docs, will work. Figure 15.73 shows the spreadsheet that was used to track final production of *The Beast*. The columns are:

- Final lighting
- Composite built and checked
- Final animation testing
- Farm render check
- Rendering
- Final renders checked

	Shot	Light	Composite	Final Anim	Farm Check	Render	Render Check	
1	**The Beast production schedule**							
2								
4	shot01	X	X	X	X	X	X	
5	shot02	X	X	X	X	X	X	
6	shot03	X	X	X	X	X	X	
7	shot04	X	X	X	X	X	X	
8	shot05	X	X	X	X	X	X	
9	shot06	X	X	X	X	X	X	
10	Shot06.1	X	X	X	X	X	X	
11	Shot06.2	X	X	X	X	X	X	
12	shot07	X	X	X	X	X	X	
13	Shot07.1	X	X	X	X	X	X	
14	Shot07.2	X	X					
15	shot08	X	X					
16	Shot08.1	X	X	X	X	O		
17	shot09	X	X					
18	shot10	X	X	X	X	O		
19	shot11	X	X					
20	shot12							
21	Shot12.1							
22	Shot12.2							
23	Shot12.3							
24	shot13							
25	Shot13.1							
26	Shot13.2	X	X	X	X	O		
27								
28								
29								
30								
31								
32								

Figure 15.73 *A production spreadsheet for tracking shots*

As you proceed with your project, you can use a simple system for tracking the status of each shot. When an action from the list has been successfully completed, just place an "X" in the cell on the chart. For actions that might take awhile, such as rendering, an "O" can be placed in the chart to indicate that that portion of the project is "Out" or "In Progress." In this way, you can tell at a glance what stage each shot is at, as well as the overall progress of the production.

Summary

Preparing for a final render and composite for each of your shots requires you to finalize lighting and confirm the existence and proper relative linking of all assets. The shot is examined for elements and backgrounds that can be extracted into still plates, and the remaining objects are split into Render Layers to facilitate compositing.

When you have achieved a solid final render on your local workstation, you can perform a lower quality render test of the whole shot to give a last look at the animation. When you are happy with it, it is time to render.

If you will be using a render farm or some computer away from your main workstation for rendering, you copy the entire directory of production assets to the new location. The relative links you built throughout the project will preserve all of your assets. When using a render farm, you either control each node by hand and use the Touch/No Overwrite method or use a dedicated render farm solution such as Farmerjoe.

When rendering is finished, examine the frames for artifacts and any problems you may have missed before.

Outbox

After finishing the processes in this chapter, you will have a directory structure full of the rendered frames that will make up your final animation.

The Peach Perspective

On lighting characters: How do you strike a balance between optimally lighting the characters in each shot so that it looks its absolute best on its own while maintaining consistent lighting from shot to shot?

Andy: Consistency turned out to be the main issue for us, not only for lighting characters. There are a lot of shots where it was really hard to match the light to the previous, or the next ones. Most of the time, the characters were lit and rendered separately from the environment. Luckily our movie has a lot of close-ups, so this was fairly easy in many cases. It's a good starting point to create a general light setup for the entire scene first and then split it up into different shots. But still, to find the right balance overall, it's important to know the mood and feel of every shot and how it transfers into the next one. The best way to do this is to make a color palette for the entire movie or a colorized storyboard.

On compositing: How wildly do the composited shots vary from what you obtained straight out of the renderer? Or how much of an improvement in final image quality was due to using the compositor?

Andy: A lot! The complexity of our scenes made it necessary to split the foreground layers from background. If you have a character walking in a forest, you simply cannot render everything in one go without running into memory problems.

The main problem is motion blur: Image-based vector motion blur is very fast to render and looks convincing enough most of the time. But if you're dealing with moving objects, such as furry rodents that interact with their static environment, you can get a lot of smearing artifacts. For vector blur to work properly, you have to separate the moving objects from everything that's either not moving or occluding it in the render. The same issue also exists for depth of field.

So if we hadn't used compositing, there would neither be motion blur nor depth of field.

Like I mentioned, another problem was making the characters fit into the environment. Without local color corrections, brightness, or gamma adjustments it would have been very hard to make everything appear as if it had been filmed in one setting. With this color correction we were able to make the colors of the characters more cartoony and lively. Otherwise we would have spent months tweaking lights, moving objects, changing materials until eventually every-thing is "in camera," but this is not very efficient or healthy for that matter.

Nowadays, movies hardly ever come straight out of the renderer. There is much more flexibility and freedom in rendering out passes and combining them after rendering. And of course, compositing is near real time. You can work faster, you spend less time waiting for your render to finish. In *Big Buck Bunny* the compositor was not only used to enhance the image. The whole movie was assembled in the compositor. No compositing: no movie. I would say that's a rather big improvement in image quality.

Final Edit and Output

Objectives

- Putting all of the renders together
- Color correction and more post effects
- Editing for timing
- Sound, music, and Foley
- Output formats

Inbox

- Final rendered frames for entire animation
- Mixed dialog files for each shot

Putting All of the Renders Together

At this point in the project, you should have a /renders/ directory full of individual shot directories, which in turn are full of rendered frames. In *The Beast*, the renders directory contained 19 GB of OpenEXR files. Figure 16.1 shows the rough cut of the animation with preliminary animation clips in place, being replaced by final OpenEXR Image Sequence strips. Because you already have a working Sequence editor file for the evolving animation, putting these renders into place for the final animation should be fairly easy.

It should be, but it actually isn't that simple. If you really want to, you can just open the work-in-progress BLEND file that you built your story reel around, replace the low quality animation sequence strips with the high quality OpenEXR rendered image sequences, and be done with it. But what happens if, while optimizing the lighting and RGB curves for each individual shot, the overall color or brightness of the shots don't sync up? You can't have two different views of the same scene—separate shots in reality—each with a completely different look.

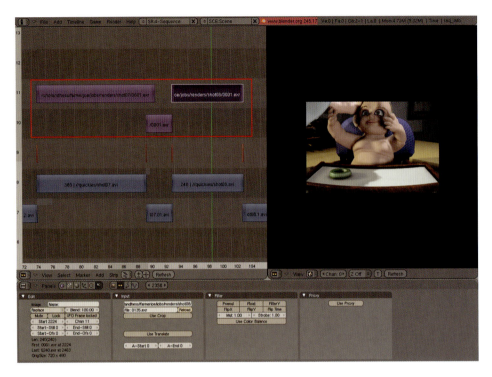

Figure 16.1 *Some clips replaced by the final renders*

What we need is to have a way to color correct and otherwise alter the incoming frames before adding them to the final edit. The best technique is to bring the frames first through the compositor, then into the Sequence Editor. So that each shot's frames can have their own compositing network, a BLEND file will be created with a master Scene that will house the Sequence Editor with another Scene for each additional shot.

Figure 16.2 shows the evolved story reel BLEND file that will form the basis for the final edit. Change the name of the active Scene to something descriptive such as "FinalCut." Then add a new Empty Scene, using the main header's

Figure 16.2 *The story reel BLEND file*

Scene drop-down, as in Figure 16.3. This scene will be used as a template for final compositing on all of your shots. In *The Beast*, this Scene is named shot01, following the naming convention used throughout the project.

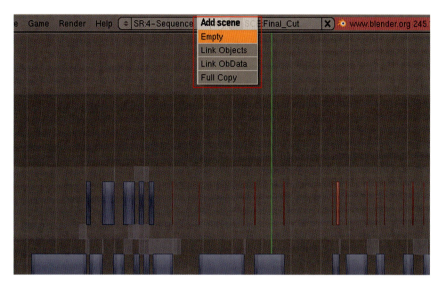

Figure 16.3 *Adding a new empty scene*

WARNING

Due to a glitch in the way that Blender processes composites and Scenes, you need to make sure that this new Scene has a Camera. If the new Scene is blank, add a Camera object anywhere in a 3D view. Nothing will actually render, but without a camera in the 3D space, the render pipeline will ignore that Scene altogether. Beyond that, all that you will use in this scene is the Node Editor.

Figure 16.4 shows the Node Editor activated with the default Render Layer node removed and an Image node added. Use the node's **Load New** function to locate the first OpenEXR file of the first shot. Figure 16.5 highlights the **Image Type** button on the node, which, when set to **Sequence** mode, gives access to an additional set of options.

To get the node to recognize the entire sequence of images for the shot, you will

Figure 16.4 *The Node Editor with an Image input node*

need to know how many rendered frames are in the shot, as well as the starting frame number. This information will be obvious upon examination of the directory containing the rendered frames. For shot 01 of *The Beast* there were 471 frames, beginning with frame number 350. Enter the total number of frames in the shot in the **Frs:** field. Then, enter 1 less than the first frame number in the **Offs:** field. For example, if the first frame number of your shot is 729, you would enter 728. So, if the first frame number is **1**, then the default value of **0** will work fine. Finally, enable the **Auto Refresh** button in the lower left of the node. Figure 16.6 shows the Image node set up for shot 01 from *The Beast*.

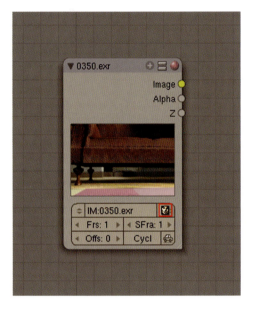

Figure 16.5 *The first image selected and set to Sequence mode*

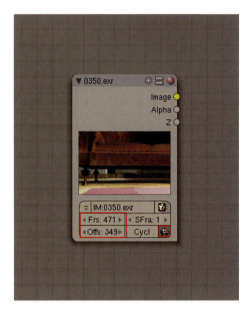

Figure 16.6 *An Image input node set up for an Image Sequence*

> **NOTE**
> The different "frame range" settings on this node can be a little confusing. The **Frs** field tells how many frames overall appear in the Image Sequence. **Sfra** stands for "Start Frame," which is the frame in the current Scene where Blender will start advancing the frames of the Image Node. In other words, if you set **Sfra** to 56, Blender will show only the first frame of the image sequence until frame 56, after which it will begin to advance the images. Finally, **Offs** tells the node how to determine which numbered image to show in which frame. If you use an offset of 100, for example, Blender will look for an image numbered 285 on scene frame number 185 (image # + Offset = Frame). Offsets can be negative.

If you have set it up correctly, advancing the Scene frame will cause the preview image in the node to advance too. Before proceeding with the rest of this node tree, set the proper frame range in this Scene's Render buttons. This will be from frame 1 through the number of frames in this shot plus 1.

Figure 16.7 shows the Render buttons for the frames from shot 01 of *The Beast*. Its range is from frame 1 through frame 472 (471 total frames plus 1). It is also important to set the proper render size and frame rate to make sure that everything works in the final composite. You can disable **OSA**, **Shadows**, **SSS**, and all other render options because you won't actually be rendering anything. Enable **Do Composite**, and connect the Image input node to the Composite output node.

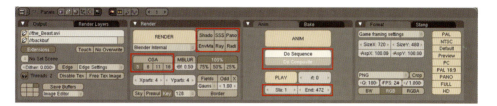

Figure 16.7 *The Render buttons for the Shot 01 composite*

Switch back to the **FinalCut** scene that will hold the Sequence Editor strips. In the Sequence Editor, **Add** a **Scene** strip, selecting **Shot01** (or whatever you named it) from the menu that pops up. This adds a strip to the sequencer that represents the compositing result from the Scene you just created. You can see the composite if you add a Sequencer Preview window. Figure 16.8 shows the first shot brought in as a Scene strip.

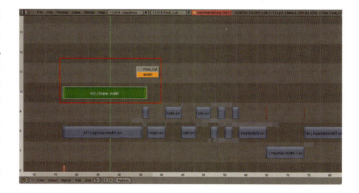

Figure 16.8 *A Scene strip added to the existing sequence*

To add a new shot, go back to the compositing scene, which is called "shot01" in this example. From the Scene menu on the main header, **Add** a new Scene, but this time use the **Full Copy** option. This means that you just need to rename this new Scene ("shot 02", etc.), **Load** a new starting image in the Image node and adjust the frame ranges on the node and in the Render buttons. Each new scene can then be added to the Sequence as a Scene strip, replacing the preliminary and OpenGL renders already in place. Figure 16.9 shows this in process, with several of the old render strips (blue) replaced with

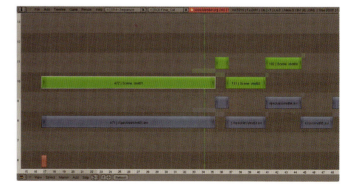

Figure 16.9 *The Sequencer on the way to including all of the final shot renders*

329

new Scene strips (green). Notice that the old animatic strips and even the story board strips are still in place. When the Sequence is rendered, neither will appear in the final product, or even cost you any time. However, it is a good idea to keep them around as a reference if you should mess up or get confused when adding and editing the Scene strips.

> **NOTE**
> Don't go adding all of your shots as new Scenes just yet! There is more to do in these node networks, as we'll learn in the next section.

Due to a bug in Blender's compositor, you may need to add an additional step here. During the final render for the entire animation including these Scene strips, I found that the compositing portion of the pipeline was occasionally refusing to give back the RAM it had used, leading to a crash after a while. To avoid this, I had to render around two thousand frames at a time, quit Blender, then resume for the next few thousand frames. As you cannot render to the video formats incrementally like this, I was forced to render into a single long series of .PNG files. When I finally had a sequence of .PNGs representing the entire animation, I simply brought them back into the Sequencer, muted all the Scene, animatic, and storyboard strips, and rendered my final animation files all in one shot. Depending on the complexity of your final compositing setup and how many different shots are in your production, you most likely will not have to do this, but it is good to know what's going on if you start experiencing crashes at this late stage.

Color Correction and More Post Effects

Before we begin creating new scenes for each shot and adding Scene strips to the Sequencer, we should finish the basic composite network for the first shot. We will add controls for color correction and any other postprocessing effects that we would like to control on a shot-per-shot level. In *The Beast*, a glow was added to each shot. While this glow could have been added in the composite setup during the initial render, effects like this are destructive. Even though they enhance things visually, they irretrievably change the information that was contained in the raw render. If you added effects during the render stage and later changed your mind or saw that the effects did not work well from shot to shot, there would be no way to go back short of rerendering everything.

If you build a good node network for the first shot, every time you duplicate that Scene for subsequent shots the node network will already be in place. In addition to using an **RGB Curves** node to match overall color across shots, there are a number of effects that can be found in the node editor. Figures 16.10 through 16.13 show several node types, along with the effect they produce.

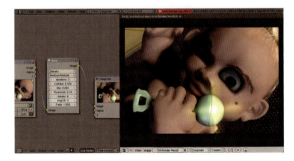

Figure 16.10 *Glare*

Figure 16.11 *Directional Blur*

Figure 16.12 *Lens Distortion*

Figure 16.13 *Sharpen*

Another common effect, an overall glow, can be accomplished with a series of nodes. Figure 16.14 shows the configuration for such an effect, and Figure 16.15 shows the results. An RGB Curve is applied to the main image to significantly darken it. This darkened image is blurred to a degree that depends on the shot then is recombined with the original image through a Screen Mix node. The Sequence Editor has an integrated Glow strip effect, but this method gives much better and more controllable results.

Additionally, this network can be replicated with different blur and intensity values so that a very diffuse glow can be given to soften the image, and a tighter glow can be added to mimic highlight bloom.

For *The Beast*, only this glow network and an RGB Curves color correction node were used in the compositing feed of the final Sequence.

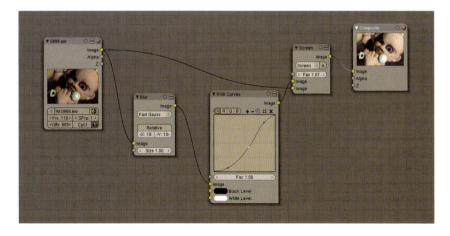

Figure 16.14 *The node configuration for glow*

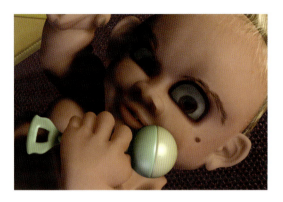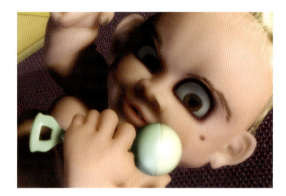

Figure 16.15 *Before and after the glow network*

You will build an initial composite for the first shot, which will be duplicated with each subsequent shot that you configure in a new Scene. When you are finished, your final BLEND file will have one Scene for every shot in the production, each with its own Image node for that shot's rendered image sequence, its own color correction and effects nodes, and its own render settings. With these Scenes created and populated with the correct final frames, you can return to the **FinalComp** Scene that contains the main Sequence.

Setting the current frame marker back and forth between consecutive shots and viewing the results in a Sequence Preview window, you can get a feeling for how the color and brightness of the shots compare. If they are supposed to be contiguous but the colors shift from shot to shot, you can simply change Scenes to the one with the shot that needs a color adjustment, push the RGB Curves around a bit, then check back in the Sequencer to see the result.

Your goal is to make shots that are part of the same scene flow together visually.

NOTE

Once you have a compositing network created for a shot and are happy with the results, you need to enable the "Free Unused" button on the header of your compositor window. This button discards compositing results on-the-fly, potentially saving a great deal of memory when working with animation. Failure to use this feature could result in RAM-related crashes during final render. You will want to disable it, though, if you need to tweak your node network, as it disables the node result caching that makes the compositor so nice to work with.

Editing for Timing

Most likely, you will be using the edit of the animation that you have refined throughout the production process. Even though you tested the story reel on people many moons ago and developed the timing of the animation through hard work during the animatic phase, it is still worth testing one last time. The best way to check that edit is to render out the animation and watch it in real time. Before we discuss the different video

formats, this editing preview can be done in the same fashion as earlier previews. The **Avi Jpeg** format will produce an animation that plays in real time with reasonably good quality.

As you watch the preview render, try to look at the following:

- Are there any shots where the motion stopped or slowed unnaturally near the end or began slowly? This could indicate that you need to cut the shot a little sooner so that the end of the animation from that file is not as obvious. The viewer should be left with the impression that the characters' lives continue after the end of the shot, not that they are winding down.
- Look for transitions between camera angles where the motion seems to be incorrect. This could be a "teleport," where the character pops from one pose to another or if a portion of an action seems to repeat itself across the cut.
- Items (or even characters) that completely appear or disappear from shot to shot could indicate a prop management problem.

Any of these are indications that you need to adjust the boundaries of the shots in the Sequence Editor, or perhaps even go back to your original shot files to fix a few things and, unfortunately, re-render. If you only need to adjust timing, you can use the Sequence Editor's selection and transformation tools discussed in Chapter 4.

One more way to check the timing of the edit is to do what multimillion dollar productions do: Show the animation to a small, interested test audience. If you have done your job as a visual storyteller correctly, the animation should (for the most part) make sense without sound effects, music, or even dialog. After your test audience watches it, get their reactions. If you hear lots of questions about, "What did this mean?" or, "What happened there?" you may need to lengthen the shots a bit in those sections. Cutting away too quickly from an action or scene can ruin the viewer's comprehension of what happened.

Have them watch it a second time, and observe them as they watch. Look for any lack of attention at any point, especially from more than one viewer at a time. This indicates that, at least for the moment, you've lost them. They've seen it once before and subconsciously know that they can skip it this time. Consider trimming that shot a bit in the editor, if possible.

Sound, Music, and Foley

In Chapter 12, we added and mixed dialog, exporting a single WAV file that represented all of the spoken sounds in a single shot. These soundtracks can now be brought into the main Sequence along with the final renders. If you kept your frame ranges consistent in the shot files as you worked, the per-shot sound files should match their Image Sequence counterparts frame for frame. Figure 16.16

Figure 16.16 *Adding the dialog strips to the Sequence*

shows the Sequencer with several sound files (teal) placed above their corresponding image strips. Notice how the boundaries of the WAV file strips match those of the Scene strips exactly.

When all of the dialog strips have been added, it is a good idea to export the entire project to an animation file for a real-time check. However, as you worked to get things to sync-up in Chapter 12, all of the dialog should match properly unless something has gone horribly wrong.

Music

You have several options for music. First, you could simply not have any. Although this is the simplest way to go, it would severely cripple the impact of your animation. People are accustomed to hearing music, even far in the background, during most visual entertainment. It has become ingrained in our expectations. Therefore, to omit it would be to go directly against those expectations and would have to be done very deliberately and for a specific effect. Don't do it.

The second option is to find a piece of music that you already have that is of an appropriate length and character to match your animation. Remember that almost all of the music you have in your private collection is just that: private. Unless you are only going to show your animation to friends and family, *do not use copyrighted music*. Whether or not you agree with the current state of copyright law in your country, the last thing that you need is a letter from a lawyer after your animation racks up 40,000 views on YouTube. There is plenty of music out there that is either public domain or free for noncommercial use, which brings us to the third option.

Use Creative Commons music (`http://creativecommons.org/legalmusicforvideos`). Creative Commons is a fairly new licensing method that allows artists to make their works free for others to use and build upon, as long as certain criteria are met. This could be anything from simply giving credit to agreeing not to commercially distribute the new work. The Creative Commons music page given here has links to many websites that make great music available to people exactly like yourself who are looking for a background to their video project. As you browse through and sample this music, there are a couple of things to keep in mind. First, if you choose to use any of it, make sure that you respect the terms of the artists' licenses. They were courteous enough to provide you with a resource of available music, and you should return that courtesy.

Also, most artists do not require you to do so, but it is always nice to send them a simple email with a link to your finished project so they can marvel at the cool ways their decision to make their music available has benefited the world. Finally, because this music is not "sold in stores," it isn't constrained or monitored by the systems that many of us are used to seeing in the traditional music industry. This means that anything that might be labeled with an "adult" or "explicit" content sticker on a store shelf or mainstream music website will not necessarily be labeled as such here. Some Creative Commons websites contain tags and filters for this sort of thing, but you can never be quite sure what you're getting until you've heard it yourself. The point is that you probably shouldn't listen to all of your music for the first time with the stereo cranked and little kids in the room.

Can I Use Any Song with a CC License on It?

(This text is found on the Creative Commons website (creativecommons.org) and is used by permission of the Creative Commons Attribution 3.0 License.)

You need to make sure that what you want to do with the music is okay under the terms of the particular Creative Commons license it's under. CC-licensed music isn't free for all uses, only some—so make sure to check out the terms (you can find these by clicking on each song's license icon).

Most importantly, you need to use music that is not licensed under a No Derivative Works license. This means that the musician doesn't want you to change, transform, or make a derivative work using their music. Under CC licenses, syncing the music to images amounts to transforming the music, so you can't legally use a song under a CC No Derivative Works license in your video.

Also, make sure to properly credit the musician and the track, as well as express the CC license the track is under. For example, you might include text like this at the end of your video:

This video features the song "Desaprendere (Treatment)" by fourstones, available under a Creative Commons Attribution-Noncommercial license.

The final option for adding music to your animation is to get someone to perform a composition specifically made for your work. If you are a musician, just ask yourself nicely. All is not lost, though, if you are not. You may have a friend (or friends, though this far into such an involved project, the plural form of the word is unlikely) who is in a band or does some recording. They may be interested in getting some wider distribution for their work, or in putting something such as a soundtrack on their musical resume. Calling back to the prior suggestions when looking for voice actors, the craigslist.org Gigs section can also provide a useful resource of musicians looking for work.

If you can find someone with enough skill and who will work within your budget (free!), you can come out with a superior musical product. Have the musicians watch the animation a couple of times. If necessary, and if they're interested, explain a bit about the themes of the story. There may be specific musical hits you would like them to work in.

For *The Beast*, I found several musicians who were looking to polish their craft of composing for videos and animations. Beyond a general musical style (upbeat jazz), the only direction I provided to them was that in the last few shots, when the Beast shoots the mother with the sprayer, the music should crescendo to some weird, nasty jazz chords, like the Beast shouting "Oh no!" in his head. Then, silence, with only a little bit of rhythm to keep things going as the mother yells at him. Finally, the original theme kicks back in when the mother picks him up. If you've already watched *The Beast* (and really, you should have by this point), you know that the composer, Leeran Z. Raphaely (`http://lzr.cc`), did a fantastic job. The best compliment you can give a composer on your project is that he or she did exactly what you wanted, but had never imagined, and that is certainly what he did.

When you have music that you are both allowed to use and that suits the tone of the animation, add it as an additional strip that spans the entire Sequence. Figure 16.17 shows the Sequence from The Beast with the music strip added.

Sound Effects and Foley

Sound effects can add another level of believability to your animation. In fact, like music and motion blur, it is something we don't notice when it's done well, but it will leave a horrible hole when it's missing.

There are two sources for sound effects for your animation: prerecorded and live. The Freesound project (`http://freesound.iua.upf.edu/`) is a massive database of searchable sounds under a Creative Commons license that

Figure 16.17 *Music is added*

are perfect for use in short animations. Everything from crowd noise to car engines to pots crashing on a floor can be found there and can be easily synced to your animation in the Sequence Editor.

Some sounds, such as the footsteps of a main character, are more easily performed live. The art of creating sound effects for a video (live action or animated) in real time in front of a microphone is called Foley. The procedure is to watch the animation, making a list of the sound effects you will need to generate. Then you figure out how to make those sounds. When you have your noise makers assembled, you array them about you in your recording space, play the animation, and start running around like a madman trying to keep up.

In this way, you can follow along with a character's footsteps exactly by putting on shoes with hard heels and walking on a wooden floor or a piece of plywood. Snap a celery stalk for a breaking bone. Clap your hands for a slap. The great thing about doing Foley work, besides being fun, is that when you are done, all of your sound effects are in a single sound strip, already synced to the animation and ready for inclusion in the Sequence Editor. Of course, you are not constrained by the Foley Artists' Union to do everything in a single pass. Depending on the complexity of your animation, you may need several passes to record every sound you have noted.

If you do any live recording of your own sound effects and have used anything from the Freesound library, consider breaking your own recordings up into discreet sounds and donating them to Freesound for others to use.

Output Formats

Way back in Chapter 4, you decided on an aspect ratio and frame rate for your animation, most likely with your eventual output targets in mind. Blender gives you a bunch of options for creating videos, but only one lets you output a video with the sound already embedded.

Here are some suggestions for possible distribution channels for your animation and how Blender can help.

The Wrappers

Blender can output to three different video wrapper formats: .AVI, .MOV and .MPEG. Although they have each evolved from their origins, these three are still associated in some people's minds with Windows (AVI), Macintosh (MOV), and the Internet (MPEG). In reality, all computer systems have the ability to play

all of these formats now, especially with tools like the free VLC video player, available at `http://www.videolan.org/` and on the disc included with this book.

So the question becomes, "Who is most likely to see your video?" If you think that people with Windows will be your largest audience (most likely), you will want to use the .AVI wrapper. If it will be Mac people, use .MOV. For a general, platform-neutral experience, choose MPEG.

> **NOTE**
>
> Currently the AVI wrapper is unavailable to Mac users, although it is accessible through FFMPEG, which is discussed in a following section.

The actual compression methods that you choose will also be determined by your target audience.

Web Distribution

Most people will see your animation over the Internet. This could be via a direct download from your own website or some other web host, or one of the Flash-based streaming sites such as YouTube or Vimeo.

When offering your animation as a download from your own website it is common practice, and quite polite, to offer different versions that let the viewer balance their connection speed with their desire for quality. Typically, you would offer a high quality version that could be as large as 100 MB if your web host will handle it, a medium quality version of less than 50 MB, and a low quality version of under 15 MB.

You can control the final file size by adjusting a couple of factors. The first is the animation codec itself and its own quality settings. Each of the different wrapper types for animation have their own interface for choosing codecs and quality. Figure 16.18 shows the Xvid codec chosen for an .AVI wrapped animation. Xvid (xvid.org) is a free, open source video compressor that can produce excellent results and would be ideal for encoding your animation. Using the Xvid codec for the final cut of *The Beast* produced a file of 117 MB on its highest quality setting.

Under the .MOV (QuickTime) wrapper, the newly added H.264 codec shown in Figure 16.19 provides an equivalent functionality. *The Beast* was rendered to a 472 MB file with H.264 on its highest quality settings.

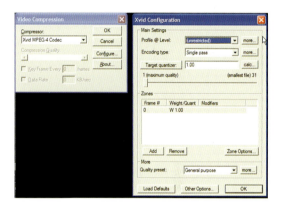

Figure 16.18 *Choosing Xvid from the AVI Codecs output format*

Figure 16.19 *H.264 with the QuickTime wrapper*

Finally, the MPEG codecs, which are accessible through the FFMPEG option in Blender's animation formats menu, provide a platform-neutral encoding experience. Figure 16.20 shows the additional Scene buttons panels that appear upon choosing FFMPEG. Note that one of the panels is labeled Audio. FFMPEG is the only way to export both audio and video out of Blender in a single file. The .AVI and .MOV options in the main Format panel will not allow you to do this.

Figure 16.20 *The FFMPEG Video and Audio panels*

However, by choosing FFMPEG in the main Format panel, you can choose either .AVI or .MOV and their accompanying codecs on the new Video panel, and export them with Audio embedded. The FFMPEG controls offer one other benefit: simple control of the final file size by directly setting the encoding bit rate. On the Video panel, the rate is listed in "kb/s," which stands for kilobits per second. The default value is 6000 kb/s, or about 0.73 MB per second. At this quality level, the entire 4 minute running time of *The Beast* creates a file that is around 175 MB. Through experimentation and simply trying different encoding rates and watching the result, you can see how low you have to go to achieve the file size you are aiming for.

At 4 minutes in length, a "medium" download of 50 MB as designated earlier would require a bit rate of around 1,700 kb/s. At that rate, the quality will certainly be noticeably worse. One thing that you can do to produce a nicer looking file at a lower bit rate is to reduce the overall resolution. Fortunately, this is as simple as either changing the output resolution in the master Sequence file, or clicking one of the 75%, 50%, or 25% buttons, shown in Figure 16.21. Reducing the output resolution while maintaining the bit rate (1,700 in this case) gives a better final result because the bits that are allocated to the video stream can be used on fewer pixels of a smaller image.

Figure 16.21 *Changing final output resolution with the percentage buttons*

> **NOTE**
>
> To calculate a bit rate from a target file size, use the following procedure: Divide the target size in MB by the length of the animation in seconds. This gives you the number of MB per second of the final file. Multiply this by 1024, the number of bytes in 1 MB. Multiply that result by eight, which is the number of bits in a byte ((size in MB ÷ Seconds) × 1024 × 8). The final result is the number in kb/s that you need to enter into the Video panel.

So when preparing files for download from the web, you first choose a file size that in turn dictates the bit rate. Then you encode the file at full resolution and watch it to judge the quality. If it looks terrible, keep that bit rate and drop the image resolution. Adjust the parameters until you achieve a happy medium. It should also be mentioned that different codecs give varying degrees of quality at the same bit rate. The ones mentioned here (Xvid, H.264) give very good results for the amount of space they use, although new codecs are always under development and old ones constantly undergo refinements.

While providing high quality downloads on your web space is a great way to show off the quality of your work, video streaming sites such as YouTube and Vimeo provide a way to let many people see your animation without any strain on your own servers. When working with these streaming sites, the best strategy is to provide them with the largest file you can stand to send. Their systems will downsample and recompress the video appropriately. Most of the streaming services require you to sign up (usually by providing a valid email address and creating a password) before uploading a video, and each has different format requirements and terms of service. Be prepared for a significant loss in quality, though. The resize and recompression can produce something that is sometimes unrecognizable to a discerning artist.

What this means is that there is one more easy way to service your audience: a streaming site for people who want to just watch it in a "drive by" fashion, without any commitment to a download, and different sizes and qualities of downloads for people who are more interested.

> **NOTE**
> The free video streaming site vimeo.com allows users to upload and watch HD video. If you are looking for a distribution method for an HD version of your animation without killing your own servers, Vimeo is worth a look.

Audio

If you are using the traditional .AVI and .MOV wrappers accessed from the Format panel, you will need to export your audio as you did when adding and mixing per-shot dialog files. The Mixdown button on the Sequencer panel of the Sound buttons (Figure 16.22) will create a single .WAV file of all audio strips in the Sequence Editor. You would then need to use a third-party utility to marry the audio and video.

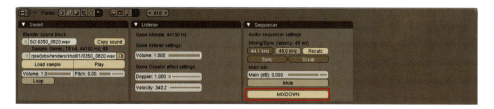

Figure 16.22 *Mixdown from the Sound buttons*

Much simpler, though, is to use the FFMPEG tools mentioned previously and encode the audio and video directly into the file in one step. Figure 16.23 shows the available options for audio encoding. PCM is an uncompressed format and will add substantially to the final size of the video. MP3 is the common music format found around the web, and it is a good choice for your direct downloads because it offers decent quality with a reduced file size. Below the format menu is a control to set the bit rate of the audio.

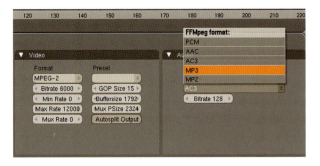

Figure 16.23 *The Audio panel for FFMPEG export*

> **NOTE**
> Some Mac users have reported problems when using FFMPEG for export, especially when including audio. If FFMPEG export does not work properly on your Mac system, you are always welcome to pony up the $30 that Apple charges for QuickTime Pro, which will do the job nicely.

To embed the Sequencer audio directly into a video file, you just need to enable the Multiplex Audio button.

DVD

Another way you may want to distribute your animation is on DVD. The odds are that you have access to a DVD burner in your computer system or know someone who has one. DVD burners usually come with some kind of software for creating DVDs that are then capable of playing in most commercial DVD players. This software will perform the necessary encoding for you to ensure that the video and audio are compliant with the official DVD specification. Even though Blender has the capability to generate the files in the proper format, it is really better to let the specialist software handle that final step.

The one thing you do want to avoid, though, is having the DVD authoring software resample (resize) your video. So while you should try to offer the DVD the highest quality that you can provide as far as bit rate, you will want to hit the DVD specification's resolution exactly. NTSC (U.S.) DVD resolution is 720 × 480 pixels at either 24 or 30 frames per second. PAL DVDs are 720 × 576 pixels. You should choose the DVD format appropriate to your geographic region.

The simplest way to accomplish this size conversion is by just entering those numbers into the Format panel in the Render buttons. Blender will resample the frames in the Sequence Editor, producing a presized file for the DVD authoring software to work with. As long as the original images were rendered in either a 4:3 or 16:9 aspect ratio, the two that DVD supports, the resulting DVD will look fine. If you did not use one of the standard aspect ratios, though, prepare to see your images oddly squashed. Figure 16.24 shows a frame from *The Beast* resampled to DVD resolution.

Figure 16.24 *A frame of* The Beast *resampled for DVD. Note the squashing*

If DVD is going to be your flagship release, though, you will want to avoid resampling altogether and render your animation directly into the correct resolution. As the native DVD formats use nonsquare pixels, this requires a dip into an arcane setting: the Pixel Aspect Ratio. Rather than go through the formulas for pixel dimensions and aspect ratios, we will just present four illustrations (Figures 16.25 through 16.28), one for each combination of aspect ratio and format. These values were arrived at by using the formulas present on several websites documenting DVD formats and confirmed by test rendering an animated sphere, opening the resulting animation in VLC and forcing the correct screen aspect ratio.

> **WARNING**
>
> These Pixel Aspect Ratio values should only be used if you are rendering natively into DVD resolution. If you are just using the Sequencer to resample an animation into the correct resolution, you should not use the PAR settings.

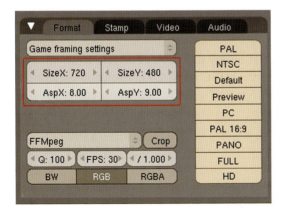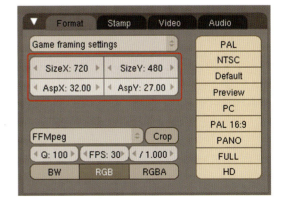

Figure 16.25 *NTSC DVD 4:3 (720 × 480, 8:9)*　　　　**Figure 16.26** *NTSC DVD 16:9 (720 × 480, 32:27)*

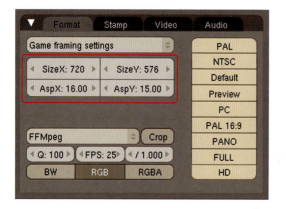

Figure 16.27 *PAL DVD 4:3 (720 × 576, 16:15)*

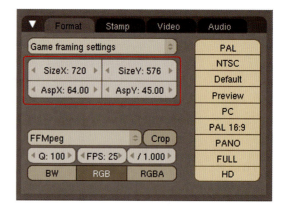

Figure 16.28 *PAL DVD 16:9 (720 × 576, 64:45)*

The topics of video resolutions, aspect ratios, and different DVD and digital video standards are vast, and there is much disagreement and misunderstanding about it, even among longtime professionals. The truth is that unless you are watching a final production on well calibrated video equipment and use measurement tools, the instructions provided here will give you a result that is more than good enough. For people determined to be psychotic about these things, I have found this web page particularly instructive: `http://lipas.uwasa.fi/~f76998/video/conversion/`.

> **NOTE**
> When preparing a file for DVD authoring, include the audio in the PCM format.

If you are rerendering your animation for inclusion on a DVD and it requires you to change your aspect ratio and resolution settings, take care to preview your renders. Any backgrounds that you rendered at different settings will not match the new renders and therefore will not composite properly. While this sort of remastering can be a giant pain if DVD was not your initial target, it is worth it for the increase in quality you will see in your final product. Of course, if you're just putting it on DVD so your Aunt Ethel who doesn't own a computer can see it, take your best resolution animation file, feed it to your DVD authoring program, and let it do its less-than-ideal magic.

Summary

When creating the completed edit of your animation, the rendered frames from each shot are first brought into separate Scenes for color correction and special effects, then they are added to the Sequence Editor as Scene strips for final composition. The compositor can be used at this stage to balance color and brightness across different shots and to add overall effects such as glow or sharpening. Although it should be fairly well refined by now, timing and the exact starting and ending of the shot can still be adjusted. The per-shot dialog files are added to the Sequence along with both live and library sound effects.

When everything is together, you can output your finished animation in a variety of formats, depending on your target audience.

Outbox

Finished animation files, suitable for distribution to everyone from your own loving mother to the great kings of old, had they lived to see such marvels as you have created.

The Peach Perspective

On editing: By the time you are performing a final edit, you have lived with your project for months and probably seen each shot dozens and dozens of times. Were you still making changes in timing and cuts during editing, or did things go together exactly as you'd always planned?

Sacha: Changes were made during the entire production, even some in the end. But the later a change needs to happen, the harder it is to integrate it. Having more experience might help not to get into these situations too much. Get it right as early as possible.

Afterword

The Beast: After the Diaper

Like any project, *The Beast* was never really finished. It was only considered "done" because at some point for the book, I had to stop working on it. No project is perfect, and this one was no exception.

There are a lot of things I don't like about *The Beast*. In several instances, I broke my own rules and failed to take the advice I gave in this book, almost all of them due to time constraints. So what don't I like about it?

What's the problem?	If I had had more time. . .
The lighting is not nearly as visually unified across different shots as I would like.	I would have done twice the number of test renders—which was sometimes in the 20s or 30s to begin with—for a better final result; on some shots I just had to say, "There's no more time. I have to render."
I didn't spend anywhere close to an appropriate amount of time refining overlap. Often the characters move without proper physical motivation.	I would have built overlap for every joint on every shot, really analyzing where the motion was coming from and heading to.
The final render is too low resolution.	I would have rerendered everything in both HD and optimized for DVD.
The set is too sparse and is missing some telling details. Also, there is no way out of the set into other areas of the "house!"	I would have added more set dressing, especially curtains, ceiling lamps, and some way to get from the existing part of the set into the other parts of the "house."
The story's theme is not integrated into the details as broadly as I would have liked.	I would have added additional set dressing and some other details to have enhanced the visual reinforcement of the story's theme.
It's too long.	I would have made it shorter, but I wouldn't have needed more time to do that.

Afterword

Of course, this just shows how you have to draw the line somewhere. Could I have squeezed another 40 hours into the schedule to make one of these "should haves" a reality? Maybe. But at some point, you just have to give your project up to the wide world and hope that it's good enough.

Hopefully the ugly little guy, his mom and the two dogs will have given you some inspiration and guidance as you begin your own project. They've certainly taught me a lot. If this book helps you to bring your animation to a successful conclusion, I would love to see it! You can reach me at `animation@harkyman.com`. Very few things make me happier than getting an email from someone I don't yet know who says. "Take a look at what you helped me make . . . "

Index

Index

Index